PLANTS AND FLOWERS

1,761 Illustrations for Artists and Designers

EDITED BY
ALAN E. BESSETTE
AND
WILLIAM K. CHAPMAN

DOVER PUBLICATIONS, INC.
New York

ILLUSTRATION CREDITS

Illustrations no. 212–218, 220–223, 229–231, 235–238 and 241–243—N. L. Britton and J. N. Rose, *The Cactaceae*, vols. I–III (courtesy of the Carnegie Institution of Washington); no. 414–417, 419–425, 429–433, 438, 441–444, 447–457 and 459–461—Oakes Ames and Donovan Stewart Correll, *Orchids of Guatemala*, Fieldiana: Botany, Vol. 26, Nos. 1 and 2 (courtesy of the Field Museum of Natural History, Chicago).

The following also provided selected illustrations: Macmillan, Ltd. (London); State of Kansas Cooperative Extension Service, Kansas State University; State of Michigan Cooperative Extension Service, Michigan State University; State of New York Cooperative Extension Service, Cornell University; Douglas and Doris Swarthout of Berry Hill Bookshop, Deansboro, N.Y.; and United States Department of Agriculture, Cooperative Extension Service.

Copyright © 1992 by Dover Publications, Inc.
All rights reserved under Pan American and International Copyright Conventions.

Published in Canada by General Publishing Company, Ltd., 30 Lesmill Road, Don Mills, Toronto, Ontario.
Published in the United Kingdom by Constable and Company, Ltd., 3 The Lanchesters, 162–164 Fulham Palace Road, London W6 9ER.

Plants and Flowers: 1,761 Illustrations for Artists and Designers is a new work, first published by Dover Publications, Inc., in 1992.

DOVER *Pictorial Archive* SERIES

Manufactured in the United States of America
Dover Publications, Inc., 31 East 2nd Street, Mineola, N.Y. 11501

Library of Congress Cataloging-in-Publication Data

Plants and flowers : 1761 illustrations for artists and designers / edited by Alan E. Bessette and William K. Chapman.
 p. cm.—(Dover pictorial archive series)
 Includes bibliographical references and index.
 ISBN 0-486-26957-4 (pbk.)
 1. Botanical illustration. 2. Plants—Pictorial works. 3. Flowers—Pictorial works. I. Bessette, Alan. II. Chapman, William K., 1951– . III. Series.
QK98.2.P53 1992
581′.022′2—dc20
 92-5448
 CIP

ACKNOWLEDGMENTS

We wish to thank Valerie Conley, Carol Gargas and Jean Zerbe for their valuable technical assistance and suggestions for improvement of the manuscript.

We also thank Arleen Rainis for proofreading the manuscript.

CONTENTS

INTRODUCTION

Artists, illustrators, craftspersons and others have long expressed a need for a comprehensive illustrated guide to plants of the world. This book has been compiled to answer this need. It contains 1,761 illustrations of the major plant groups throughout the world. Both wild species and plants of commerce are thoroughly represented. The plants are organized by major headings according to family relationships, uses and habitats.

The illustrations presented herein were chosen from numerous sources, including popular nature guides, richly illustrated scientific texts and original botanical monographs (see the List of Sources, below). To be accepted for this work, illustrations had to meet criteria of scientific accuracy, artistic style and suitability for reproduction. They reproduce well without significant loss of quality.

Whenever possible, both common and botanical Latin names are given for each species. The Latin names given are those of current usage wherever this could be determined. In many cases, it was necessary to update the Latin names from those that appeared with the illustrations at the original time of publication.

LIST OF SOURCES

Adams, W. H. Davenport. *Everyday Objects or Picturesque Aspects of Natural History*. Boston: D. Lothrop, 1872.

Allen, Grant. *The Plants*. Stories of the Universe. New York: Review of Reviews, 1909.

Ames, Oakes, and Correll, Donovan Stewart. *Orchids of Guatemala*. Fieldiana: Botany. Vol. 26, Nos. 1 and 2. Chicago: Natural History Museum, 1952, 1953.

Andrews, E. F. *Botany All the Year Round*. New York: American Book Co., 1903.

Andrews, E. F., and Lloyd, Francis E. *A Practical Course in Botany*. New York: American Book Co., 1911.

Armstrong, Margaret, with Thornber, J. J. *Field Book of Western Wild Flowers*. New York: Putnam, 1915.

Atkinson, George Francis. *First Studies of Plant Life*. Boston: Ginn & Co., 1901.

Atkinson, George Francis. *Mushrooms: Edible, Poisonous, Etc*. Ithaca, N.Y.: Andrus & Church, 1900.

Bailey, L. H., ed. *Cyclopedia of American Agriculture*. 3d ed. 4 vols. Vol. II. New York: Macmillan, 1907, 1911.

Beecroft, W. I. *Who's Who Among the Wildflowers*. New York: Moffat, Yard, 1910.

Bentley, H. L. *A Report upon the Grasses and Forage Plants of Central Texas*. U.S. Department of Agriculture. Bull. No. 10. Washington: Government Printing Office, 1898.

Bergen, Joseph Y. *Elements of Botany*. Boston: Ginn & Co., 1897.

Bergen, Joseph Y. *Elements of Botany*. Rev. ed. Boston: Ginn & Co., n.d.

Bergen, Joseph Y. *Foundations of Botany*. Boston: Atheneum, 1901.

Breck, Joseph. *New Book of Flowers*. New York: Orange Judd, 1866.

Britton, N. L., and Rose, J. N. *The Cactaceae*. Vols. I–III. Washington: Carnegie Institution, 1919, 1920, 1922.

Britton, Nathaniel Lord, and Brown, Addison. *An Illustrated Flora of the Northern United States*. . . . Vol. II. New York: Scribner's, 1897.

Campbell, Douglas Houghton. *Elements of Structural and Systematic Botany*. . . . Boston: Ginn & Co., 1890.

Coulter, A. M. *Plant Relations: A First Book of Botany*. 2nd ed. New York: D. Appleton, 1903.

Creevey, Caroline A. *Harper's Guide to Wild Flowers*. New York: Harper, 1912.

Dana, Mrs. William Starr. *How to Know the Wild Flowers*. 4th ed. New York: Scribner's, 1893.

Dana, Mrs. William Starr. *How to Know the Wild Flowers*. "New" ed. New York: Scribner's, 1900.

Darlington, Henry T., et al. *Some Important Michigan Weeds*. Special Bulletin 304. East Lansing, Mich.: Michigan State College, May 1951.

Darwin, Charles. *The Various Contrivances by Which Orchids Are Fertilised by Insects*. 2d ed. London: John Murray, 1904.

Deane, Fannie A. *Wonders from Sea and Shore*. Boston: D. Lothrop, 1888.

Dingee & Conard Co. *The New Guide to Rose Culture*. West Grove, Pa.: Dingee & Conard, n.d.

Ellison, Patricia, et al. *Common Wild Flowers of New York State*. Extension Bulletin 990. New York State College of Agriculture and Life Sciences, n.d.

Everything for the Garden 1911. New York: Peter Henderson, 1911.

Francis, Mary Evans. *The Book of Grasses*. The New Nature Library. Vol. 8, pt. 2. Garden City, N.Y.: Doubleday, Page, 1912, 1914.

Friend, Hilderic. *Flowers and Flower Lore*. 3d ed. London: Swan Sonnenschein, Le Bas & Lowrey, 1886.

Fuller, Andrew S. *Small Fruit Culturist*. New York: Orange Judd, 1887.

Gates, Frank C., and Dickens, Mrs. Albert. *Wild Flowers in Kansas*. Report of the Kansas State Board of Agriculture for the Quarter Ending December, 1932. Topeka, Kans.: Kansas State Board of Agriculture, 1934.

Gibson, W. Hamilton. *Our Edible Toadstools and Mushrooms*. . . . New York: Harper, 1895.

Gibson, William Hamilton, with Jelliffe, Helena Leeming. *Our Native Orchids*. New York: Doubleday, Page, 1905.

Gray, Asa. *How Plants Grow, A Simple Introduction to Structural Botany*. Botany for Young People and Common Schools. New York: Ivison, Blakeman, Taylor, 1881.

Hall, Abbie G. *Botany for Public Schools*. Chicago: Geo. Sherwood, n.d.

Henderson, Peter. *Garden and Farm Topics*. New York: Peter Henderson, 1884.

Hodge, Clifton F. *Nature Study and Life*. Boston: Ginn & Co., 1902.

Kearney, Thomas H., Jr. *Notes on Grasses and Forage Plants of the Southeastern States*. U.S. Department of Agriculture. Bull. No. 1. Washington: Government Printing Office, 1895.

Keeler, Harriet L. *Our Garden Flowers*. New York: Scribner's, 1910.

Keeler, Harriet L. *Our Native Trees and How to Identify Them*. New York: Scribner's, 1900.

Knowlton, F. H., and Pollard, Charles Louis, eds. *The Plant World. An Illustrated Monthly Journal*. . . . Vol. III. Washington: The Plant World Company, 1900.

Lamson-Scribner, F. "New or Little Known Grasses," in U.S. Department of Agriculture. Studies on American Grasses. Bull. No. 8. Washington: Government Printing Office, 1897.

Lamson-Scribner, F., and Merrill, Elmer D. *The North American Species of Chaetochloa*. U.S. Department of Agriculture. Studies on American Grasses. Bull. No. 21. Washington: Government Printing Office, 1900.

Lange, D. *Handbook of Nature Study*. New York: Macmillan, 1901.

Lounsberry, Alice, and Rowan, Mrs. Ellis. *A Guide to the Trees*. New York: Frederick A. Stokes, 1900.

Lounsberry, Alice, and Rowan, Mrs. Ellis. *A Guide to the Wildflowers*. 4th ed. New York: Frederick A. Stokes, 1899.

The Mammoth Cyclopædia. The Leisure Hour Library. No. 263. Vol. I. New York: F. M. Lupton, 1889.

Marilaun, Anton Kerner von. *The Natural History of Plants*. Trans. by F. W. Oliver. Half-vol. I. New York: Henry Holt, n.d.

Mathews, F. Schuyler. *Familiar Flowers of Field and Garden*. 4th ed. New York: D. Appleton, 1897.

Mathews, F. Schuyler. *Familiar Trees and Their Leaves*. New York: D. Appleton, 1911.

Mathews, F. Schuyler. *Field Book of American Trees and Shrubs*. New York: Putnam, 1915.

Mathews, F. Schuyler. *Field Book of American Wild Flowers*. New ed. New York: Putnam, 1902, 1912.

McIlvaine, Charles, and Macadam, Robert K. *One Thousand American Fungi*. New ed., rev. by Charles Frederick Millspaugh. Indianapolis: Bobbs-Merrill, 1911.

Morley, Margaret Warner. *Flowers and Their Friends*. Boston: Ginn & Co., 1897.

Morley, Margaret Warner. *A Song of Life*. Chicago: A. C. McClurg, 1899.

Mushroom Culture: Its Extension and Improvement. The Country Series of Farm, Garden, and Rural Books for General Use, ed. W. Robinson. N.p., [1870].

Newell, Jane H. *Outlines of Lessons in Botany*. Part II. Boston: Ginn & Co., 1893.

Newman, Edward. *A History of British Ferns, and Allied Plants*. London: Van Voorst, 1894.

Ogden, E.L. "Leaf Structure of Jouvea and of Eragrostis Obtusiflora," in U.S. Department of Agriculture. Studies on American Grasses. Bull. No. 8. Washington: Government Printing Office, 1897.

Parsons, Frances Theodora. *How to Know the Ferns*. 5th ed. New York: Scribner's, 1909.

Parsons, Samuel, Jr. *Landscape Gardening*. New York: Putnam, 1891.

Sargent, Frederick Leroy. *Plants and Their Uses*. New York: Henry Holt, 1913.

Smith, Jared G. *Fodder and Forage Plants, Exclusive of the Grasses*. U.S. Department of Agriculture. Bull. No. 2. Washington: Government Printing Office, 1896.

Smith, Worthington George. *Synopsis of the British Basidiomycetes*. London: British Museum, 1908.

Sprague, Isaac, and Gray, Asa. *The Genera of the Plants of the United States*. Vol. I. New York: Putnam, 1849.

Stevens, William Chase. *Introduction to Botany*. Boston: D. C. Heath, 1902.

Strasburger, E., et al. *A Text-Book of Botany*. Trans. H. C. Porter. London: Macmillan, 1898.

Sudworth, George B. *Forest Trees of the Pacific Slope*. U.S. Department of Agriculture, Forest Service. Washington: Government Printing Office, 1908.

Sunbeams of Health and Temperance. Battle Creek, Mich.: Health Pub., 1887.

Torrey, John. *A Flora of the State of New York*. Vols. I and II. Albany, N.Y.: Carroll and Cook, 1843.

U.S. Department of Agriculture. *Grass: The Yearbook of Agriculture 1948*. Washington: U.S. Government Printing Office, 1948.

U.S. Department of Agriculture. *Growing Ginseng*. Farmers' Bulletin Number 2201. Washington: U.S. Government Printing Office, n.d.

Williamson, John. *Ferns of Kentucky*. Louisville, Ky.: Morton, 1878.

Wood, Alphonso. *How to Study Plants*. New York: American Book Co., 1895.

Wood, Alphonso, and Willis, Oliver R. *The New American Botanist and Florist*. Rev. ed. New York: American Book Co., 1870, 1889.

Wright, Julia McNair. *Sea-side and Way-side*. Nature Readers. No. 3. Boston: D. C. Heath, 1891, 1903.

Youmans, Eliza A. *The First Book of Botany*. New and enlarged ed. New York: D. Appleton, 1876.

PLANTS AND FLOWERS

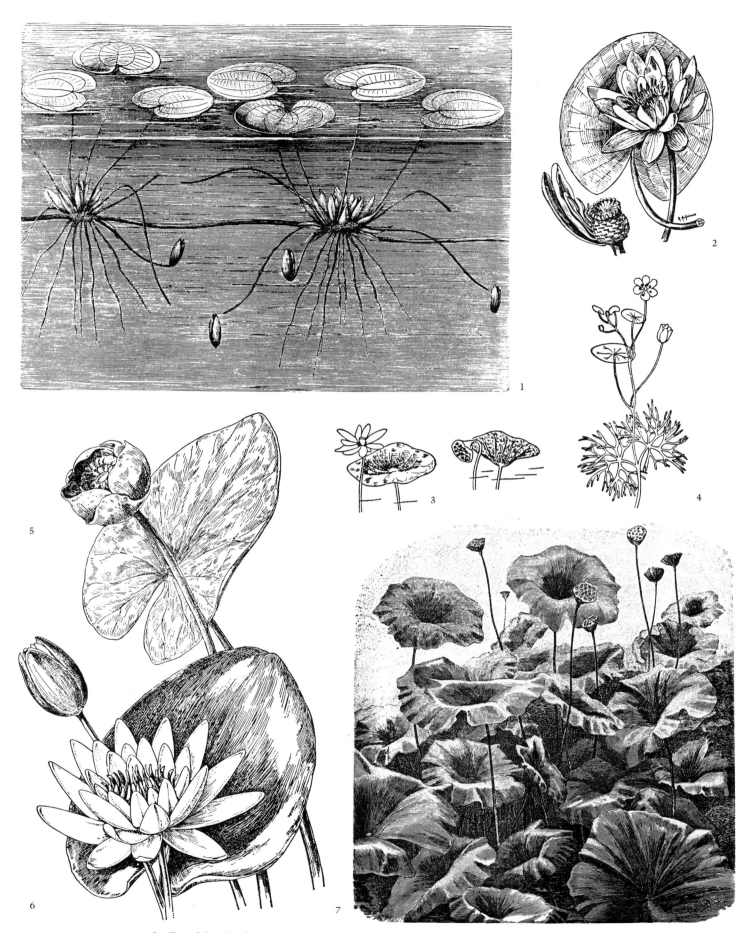

1. Frogbit (*Hydrocharis morsus-ranae*). **2, 6.** Fragrant Water Lily (*Nymphaea odorata*). **3.** American Water Lotus (*Nelumbo lutea*). **4.** Fanwort (*Cabomba caroliniana*). **5.** Spatterdock (*Nuphar advena*). **7.** Lotus Lily (*Nelumbium speciosum*).

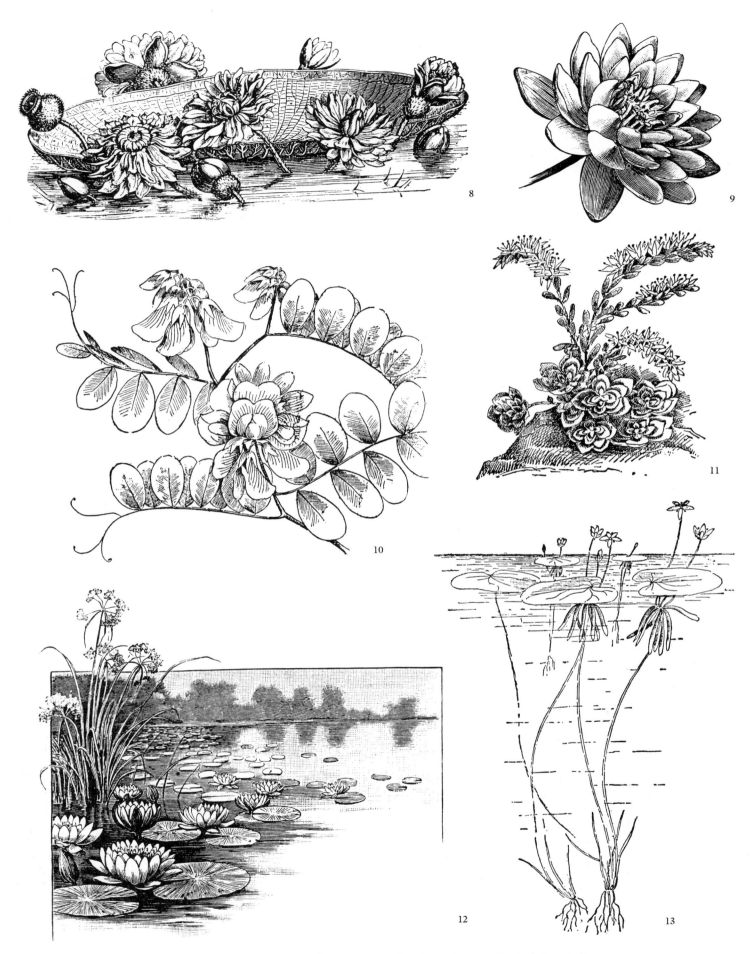

8. Ornamental Water Lilies. **9.** Water Lily (*Nymphaea* sp.). **10.** Beach Pea (*Lathyrus japonicus*). **11.** Nevins's Stonecrop (*Sedum nevii*). **12.** Aquatic Plants: Pond Lilies and Sedges. **13.** Floating Heart (*Nymphoides cordata*).

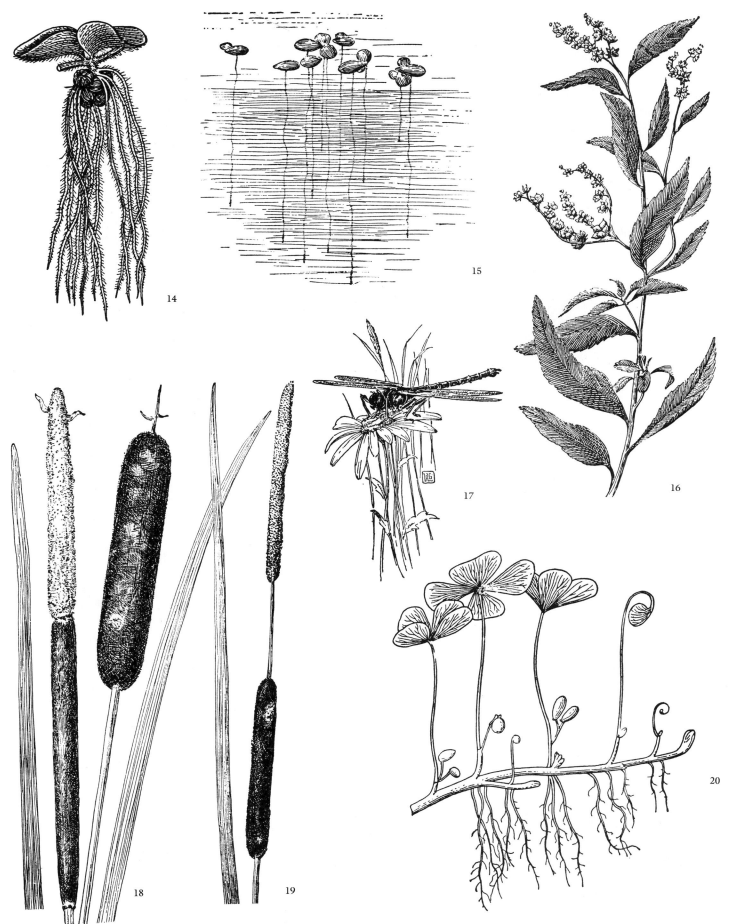

14. Floating Fern (*Salvinia minima*). **15.** Duckweed (*Lemna minor*). **16.** Ditch Stonecrop (*Penthorum sedoides*). **17.** Dragonfly on Daisy. **18.** Common Cattail (*Typha latifolia*). **19.** Narrow-leaved Cattail (*Typha angustifolia*). **20.** European Water Clover (*Marsilea quadrifolia*).

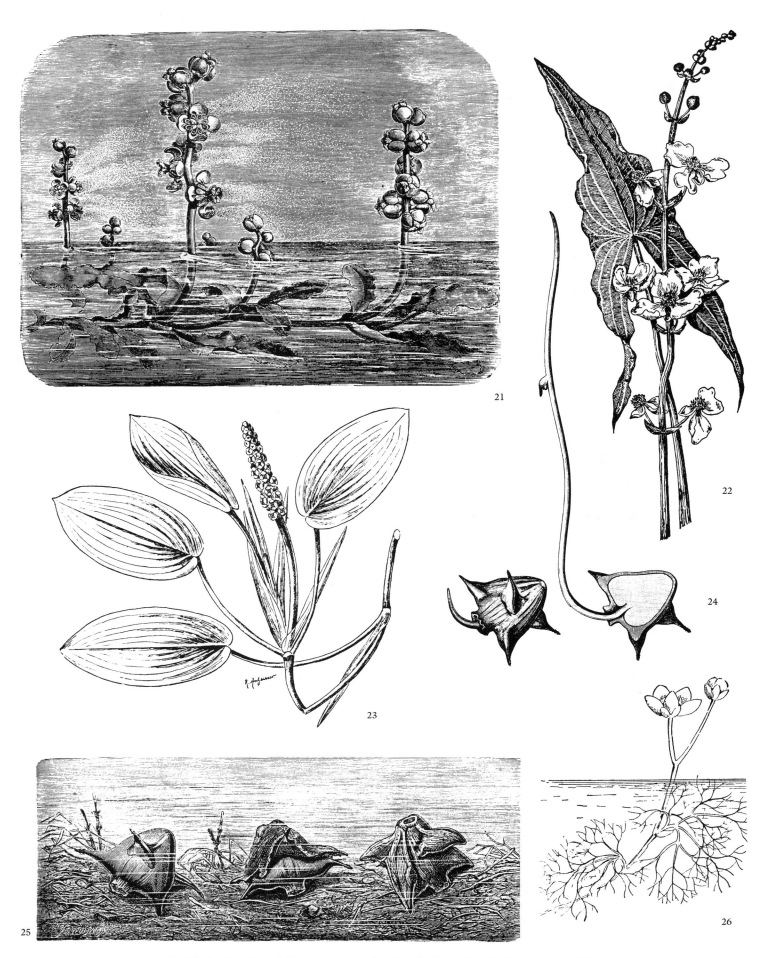

21. Curly Pondweed (*Potamogeton crispus*). **22.** Arrowhead (*Sagittaria latifolia*). **23.** Floating Pondweed (*Potamogeton natans*). **24, 25.** Water Chestnut (*Trapa natans*). **26.** Yellow Water Crowfoot (*Ranunculus flabellaris*).

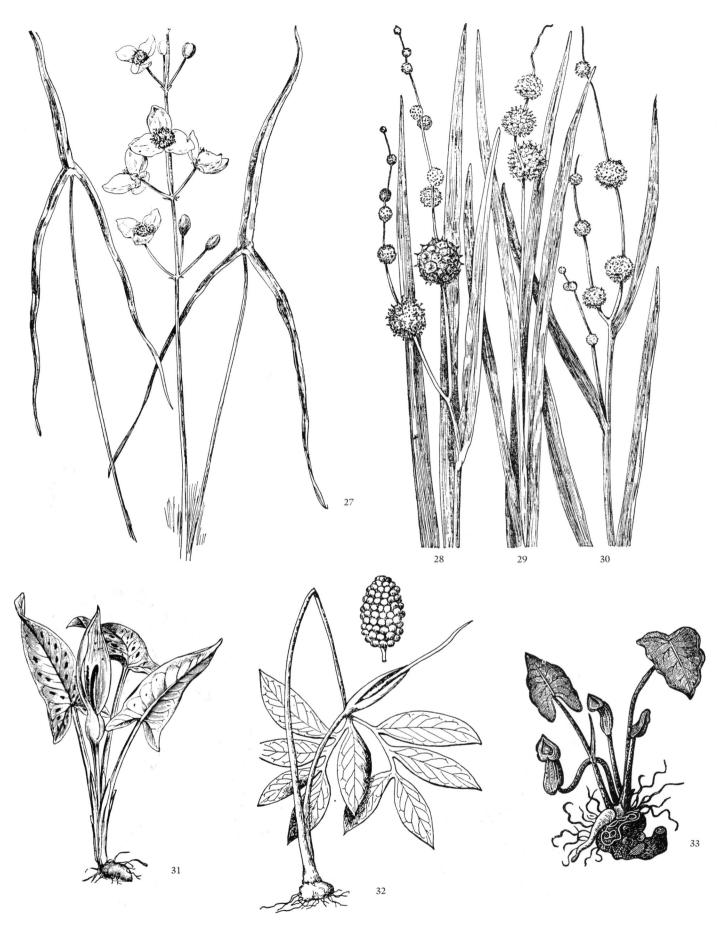

27. Arrowhead (*Sagittaria latifolia*). **28.** Great Bur Reed (*Sparganium simplex*).
29. Branching Bur Reed (*Sparganium eurycarpum*). **30.** Branching Bur Reed
(*Sparganium americanum*). **31.** Lords and Ladies (*Arum maculatum*). **32.** Drag-
onroot (*Arisaema dracontium*). **33.** Swamp Arum (*Arum arisarum*).

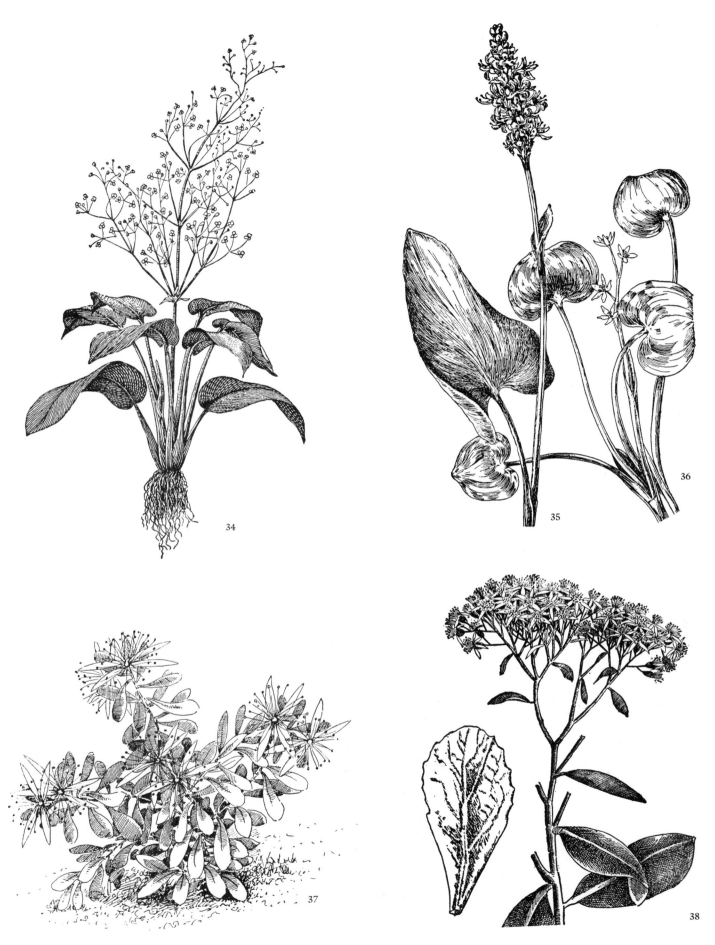

34. Water Plantain (*Alisma subcordatum*). **35.** Pickerel Weed (*Pontederia cordata*). **36.** Mud Plantain (*Heteranthera reniformis*). **37.** St.-Andrew's-Cross (*Hypericum hypericoides*). **38.** Live-Forever (*Sedum telephioides*).

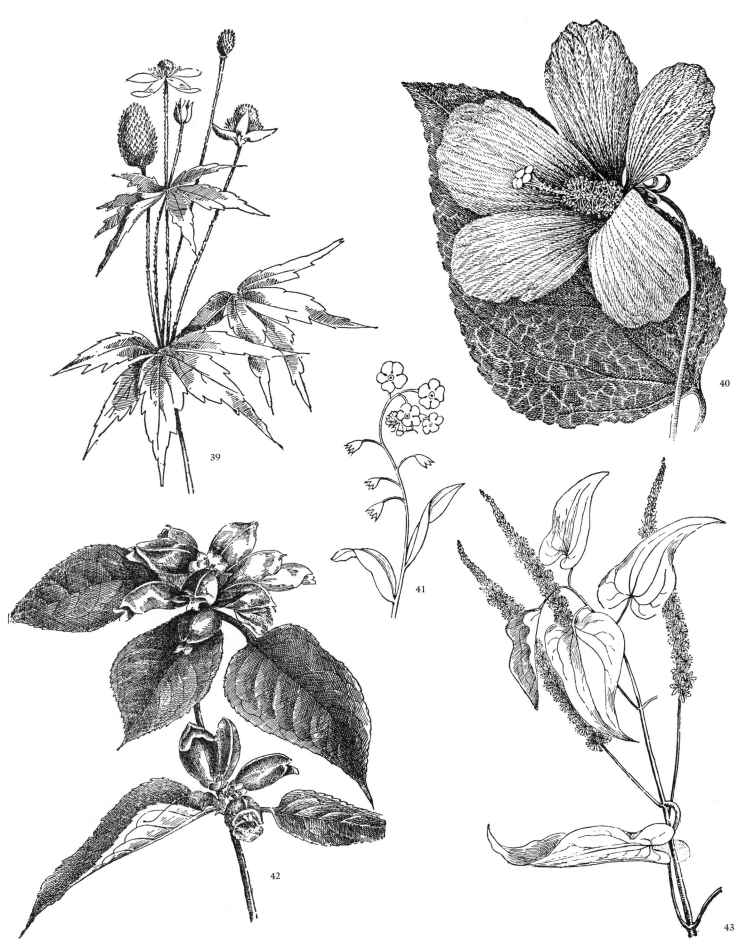

39. Tall Anemone (*Anemone virginiana*). **40.** Rose Mallow (*Hibiscus moscheutos*).
41. Forget-Me-Not (*Myosotis scorpioides*). **42.** Turtlehead (*Chelone lyonii*). **43.**
Lizard's-Tail (*Saururus cernuus*).

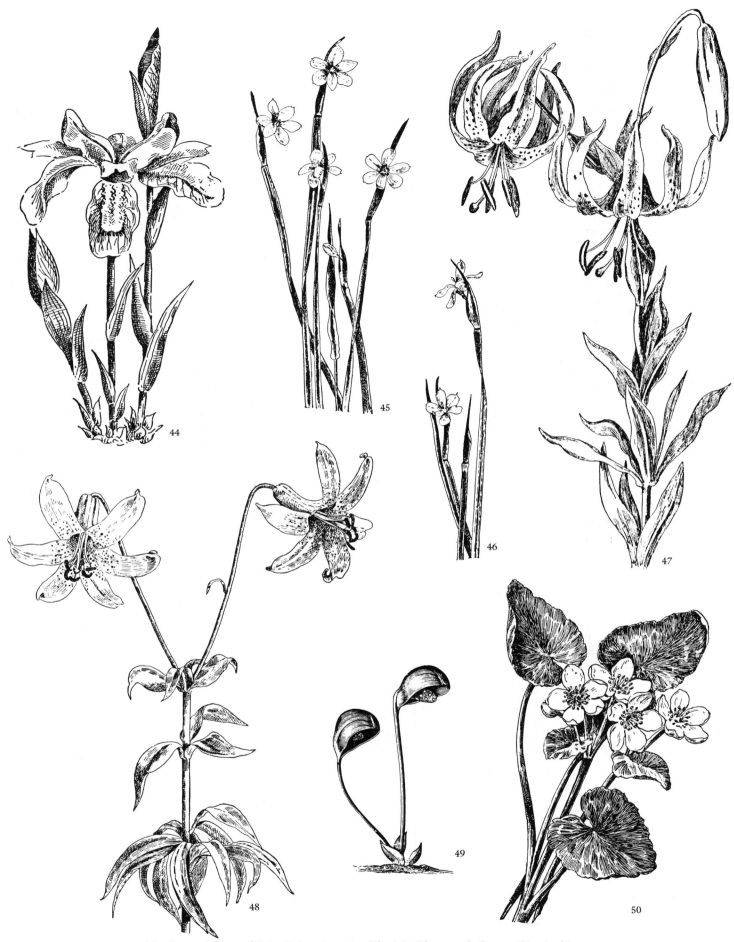

44. Crested Dwarf Iris (*Iris cristata*). **45, 46.** Blue-eyed Grass (*Sisyrinchium angustifolium*). **47.** Turk's-Cap Lily (*Lilium superbum*). **48.** Meadow Lily (*Lilium canadense*). **49.** Stinking Hood (*Ariopsis peltata*). **50.** Marsh Marigold (*Caltha palustris*).

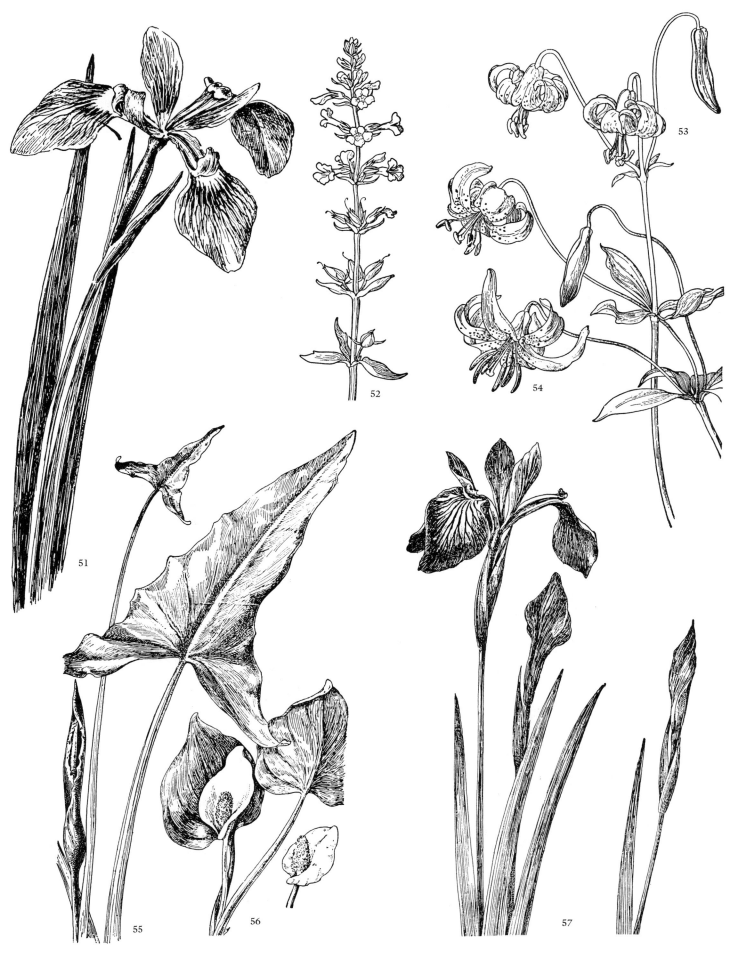

51, 57. Blue Flag (*Iris versicolor*). **52.** Stemodia (*Stemodia durantifolia*). **53.** Columbia Lily (*Lilium columbianum*). **54.** Leopard Lily (*Lilium pardalinum*). **55.** Arrow Arum (*Peltandra virginica*). **56.** Water Arum (*Calla palustris*).

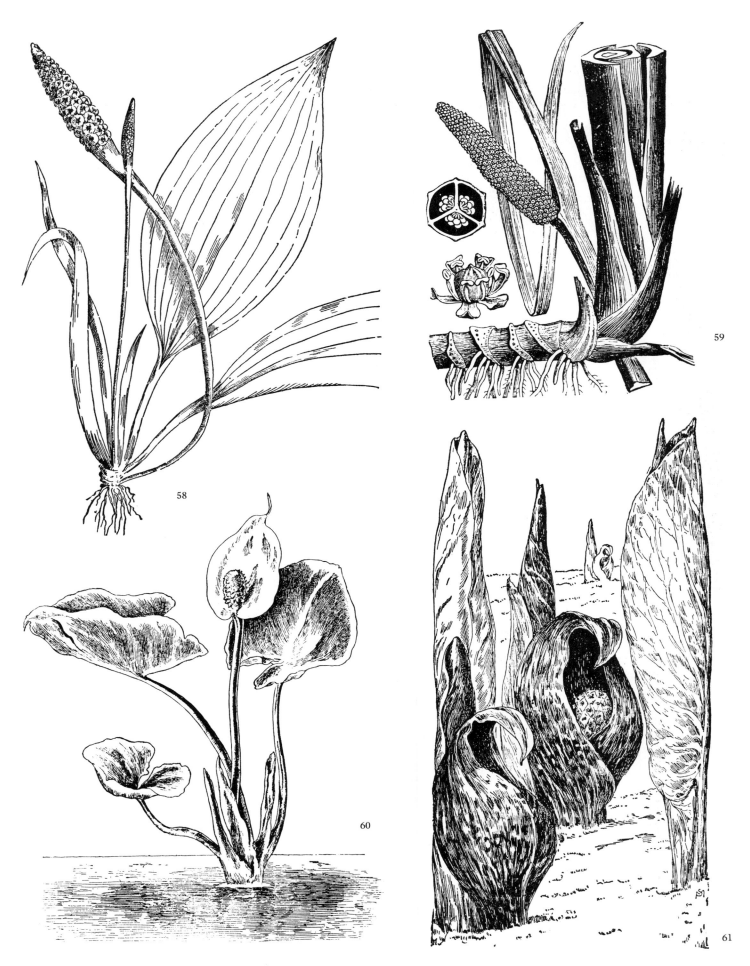

58. Golden-Club (*Orontium aquaticum*). **59.** Sweet Flag (*Acorus calamus*). **60.** Water Arum (*Calla palustris*). **61.** Skunk Cabbage (*Symplocarpus foetidus*).

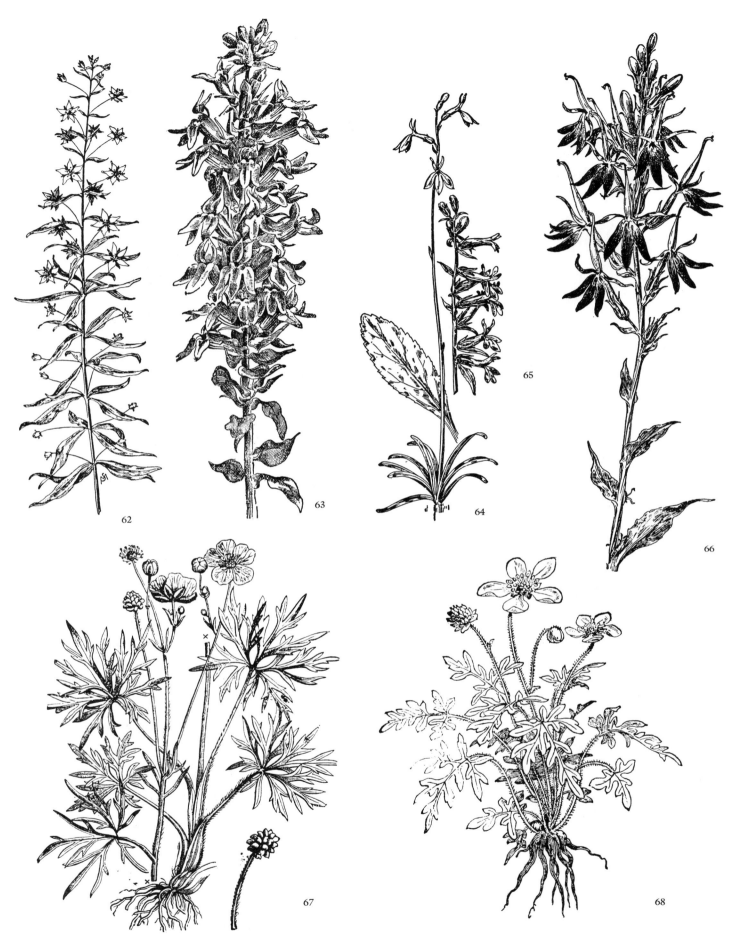

62. Whorled Loosestrife (*Lysimachia quadrifolia*). **63.** Great Lobelia (*Lobelia siphilitica*). **64.** Water Lobelia (*Lobelia dortmanna*). **65.** Downy Lobelia (*Lobelia puberula*). **66.** Cardinal Flower (*Lobelia cardinalis*). **67.** Tall Buttercup (*Ranunculus acris*). **68.** Early Buttercup (*Ranunculus fascicularis*).

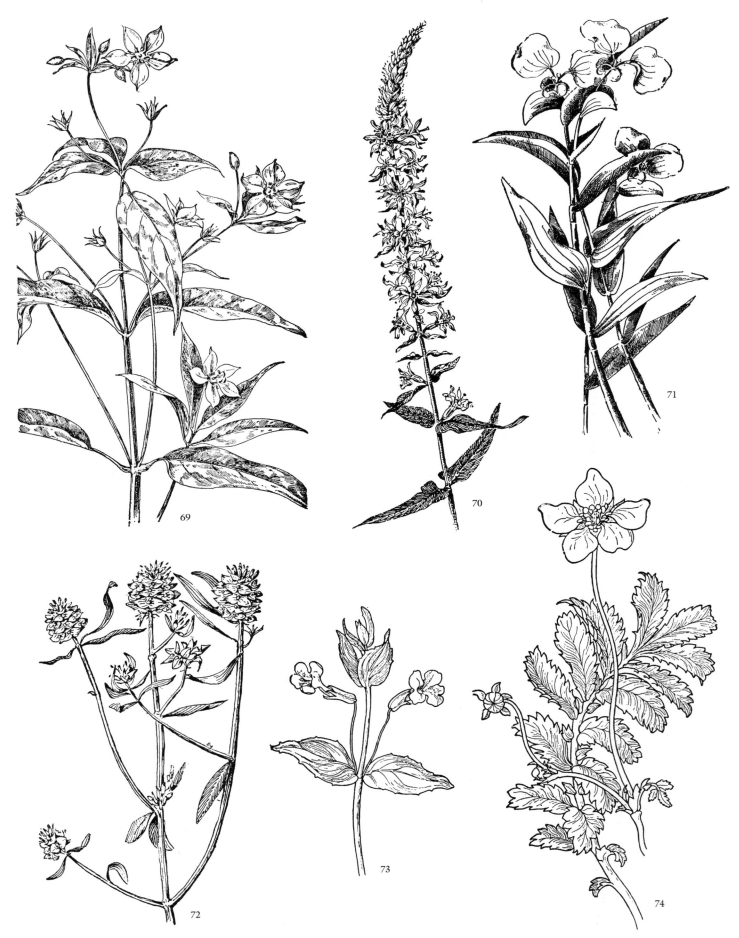

69. Fringed Loosestrife (*Lysimachia ciliata*). **70.** Purple Loosestrife (*Lythrum salicaria*). **71.** Slender Dayflower (*Commelina erecta*). **72.** Marsh Milkwort (*Polygala cruciata*). **73.** Musk Plant (*Mimulus moschatus*). **74.** Silverweed (*Potentilla anserina*).

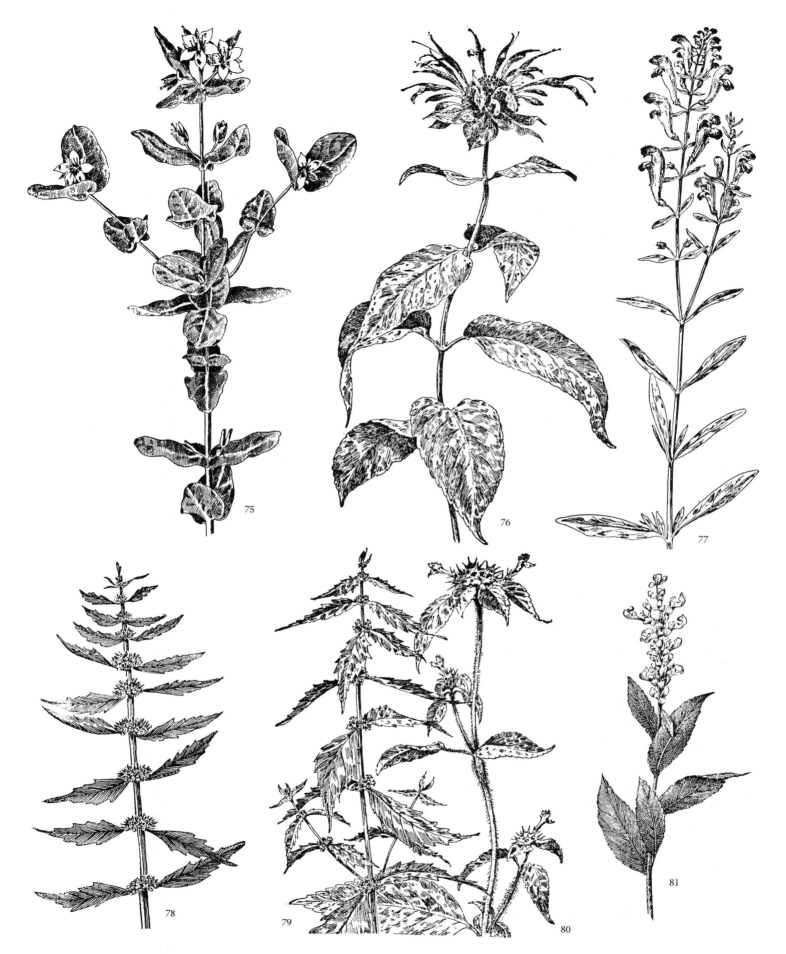

75. Marsh St.-John's-Wort (*Hypericum virginicum*). **76.** Wild Bergamot (*Monarda fistulosa*). **77.** Larger Skullcap (*Scutellaria integrifolia*). **78, 79.** Virginia Bugleweed (*Lycopus virginicus*). **80.** Hemp Nettle (*Galeopsis tetrahit*). **81.** American Germander (*Teucrium canadense*).

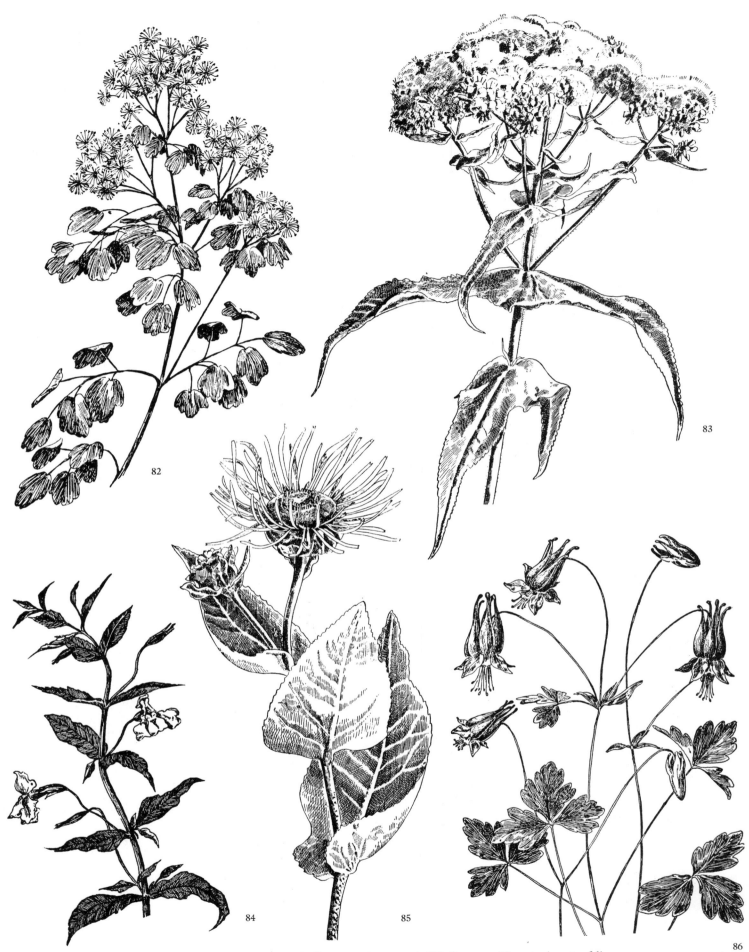

82. Tall Meadow Rue (*Thalictrum polygamum*). 83. Boneset (*Eupatorium perfoliatum*). 84. Monkey Flower (*Mimulus ringens*). 85. Elecampane (*Inula helenium*). 86. Wild Columbine (*Aquilegia canadensis*).

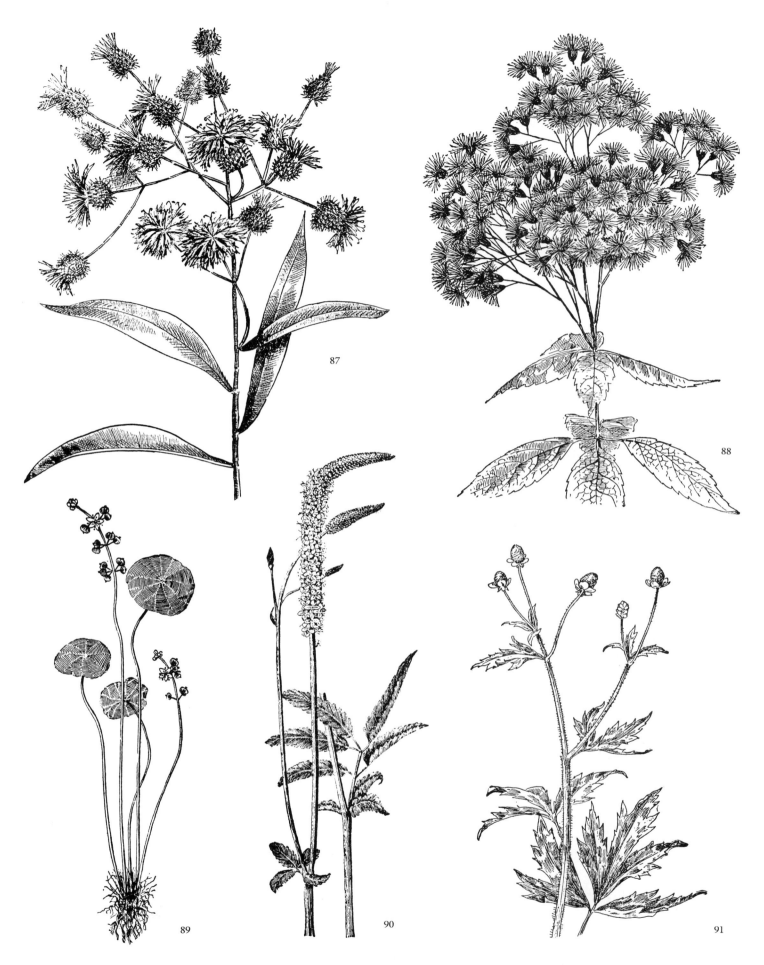

87. Ironweed (*Vernonia noveboracensis*). **88.** Joe-Pye Weed (*Eupatorium pur-pureum*). **89.** Water Pennywort (*Hydrocotyle umbellata*). **90.** Canadian Burnet (*Sanguisorba canadensis*). **91.** Bristly Crowfoot (*Ranunculus pensylvanicus*).

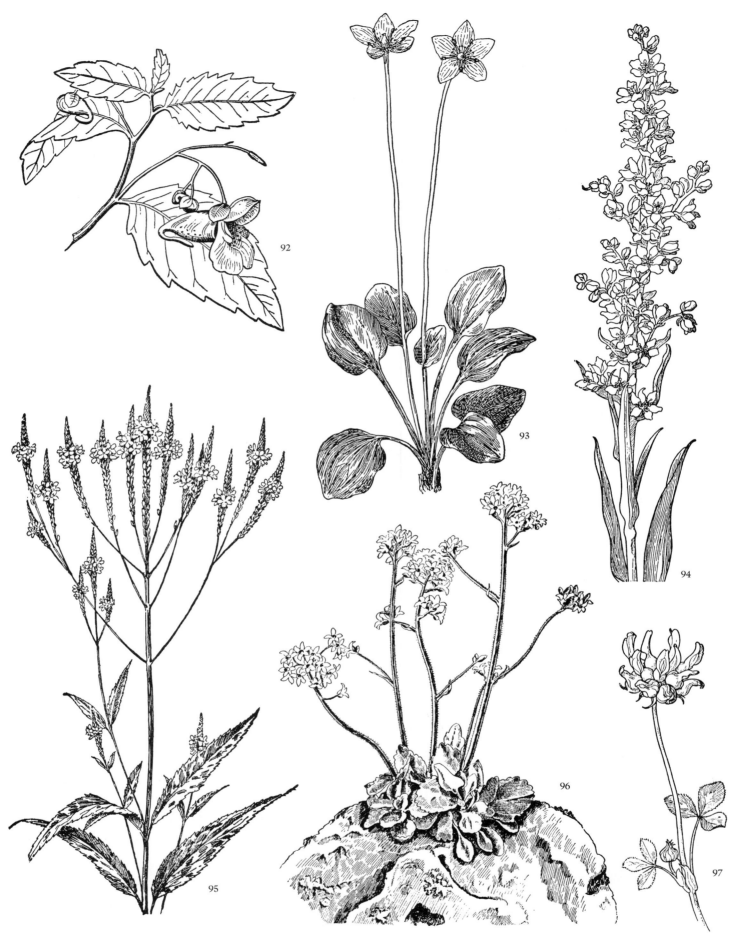

92. Spotted Jewelweed (*Impatiens capensis*). **93.** Grass-of-Parnassus (*Parnassia glauca*). **94.** Corn Lily (*Veratrum californicum*). **95.** Blue Vervain (*Verbena hastata*). **96.** Early Saxifrage (*Saxifraga virginiensis*). **97.** Western Sour Clover (*Trifolium fucatum*).

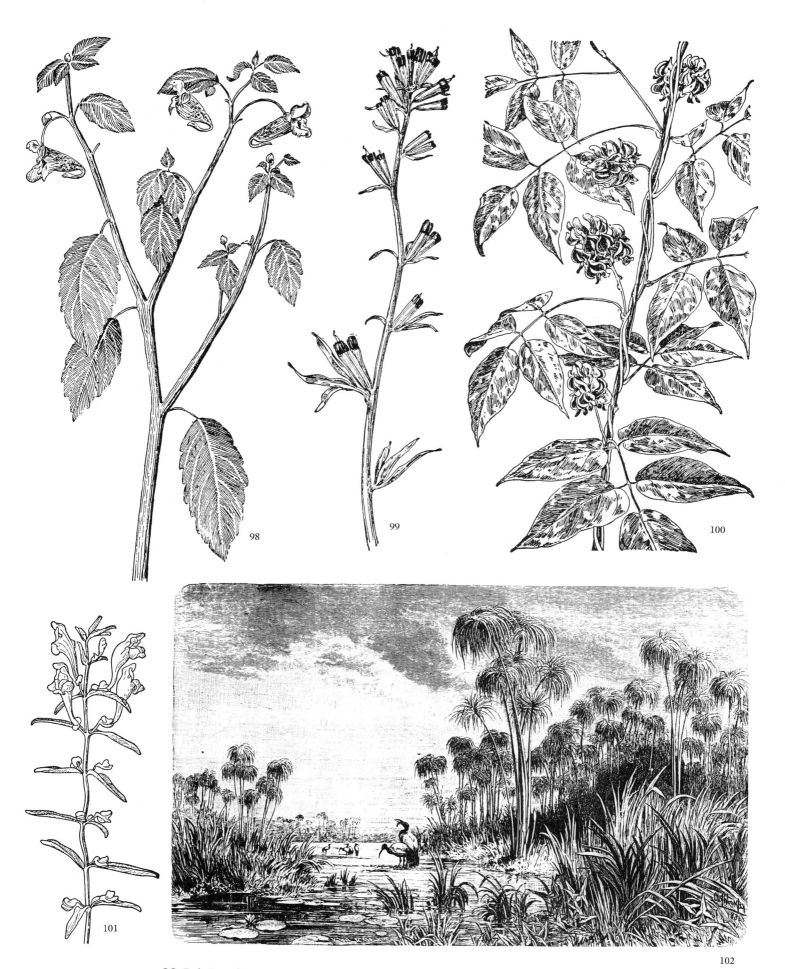

98. Pale Jewelweed (*Impatiens palida*). **99.** Painted Cup (*Castilleja coccinea*). **100.** Groundnut (*Apios americana*). **101.** Western Skullcap (*Scutellaria angustifolia*). **102.** Papyrus (*Cyperus papyrus*).

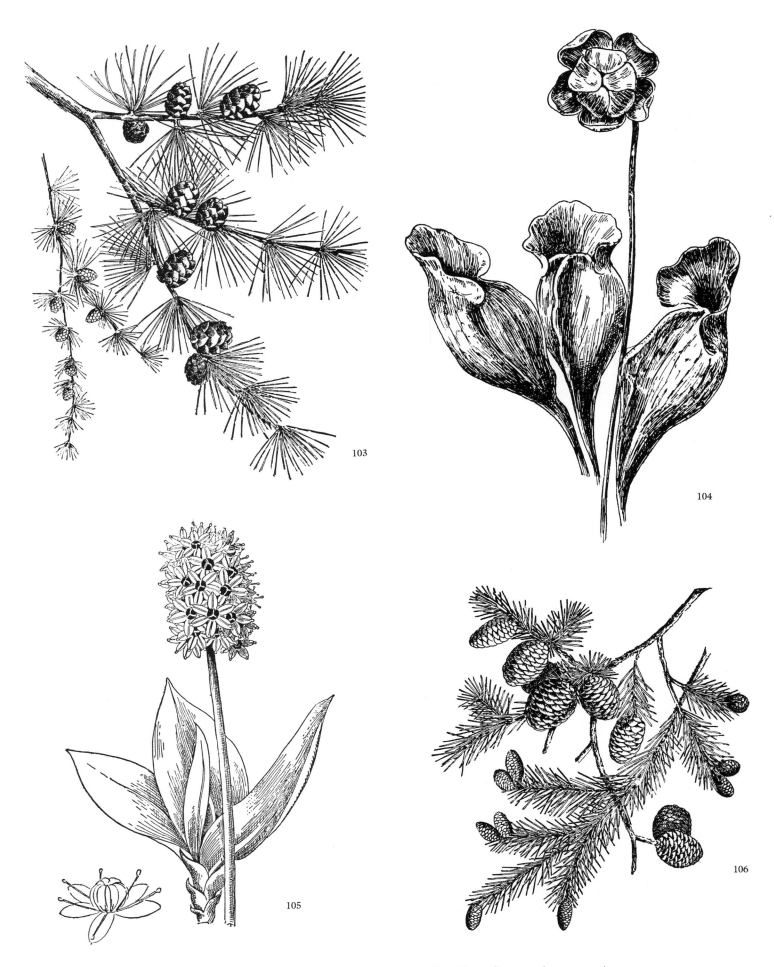

103. American Larch (*Larix laricina*). **104.** Pitcher Plant (*Sarracenia purpurea*).
105. Swamp Pink (*Helonias bullata*). **106.** Black Spruce (*Picea mariana*).

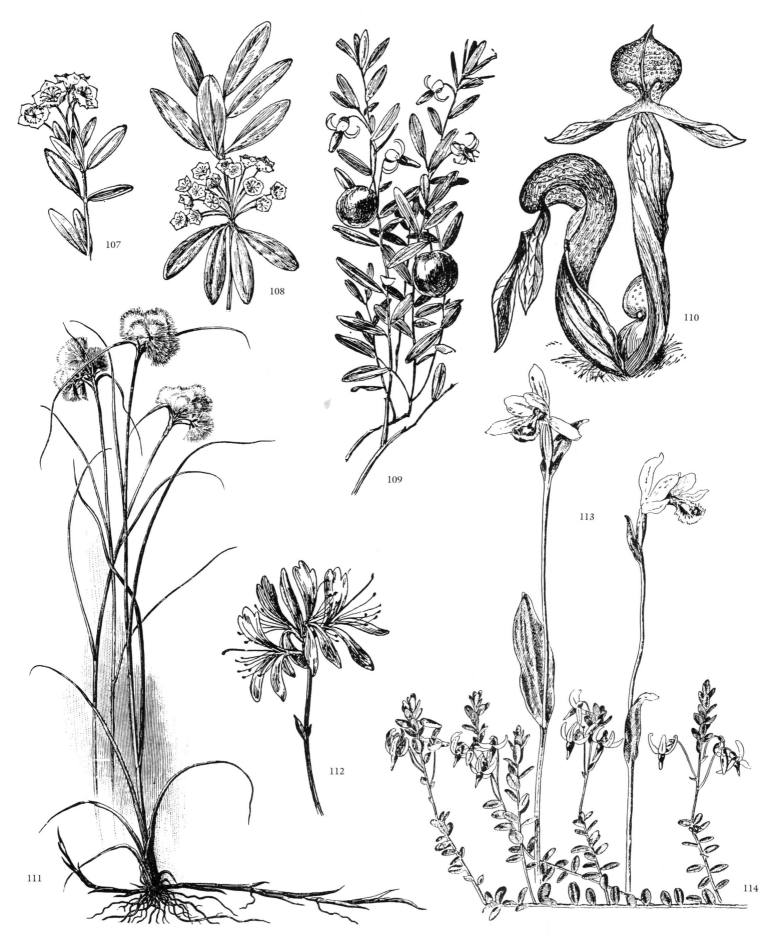

107. Pale Laurel (*Kalmia poliifolia*). **108.** Sheep Laurel (*Kalmia angustifolia*).
109, 114. Large Cranberry (*Vaccinium macrocarpon*). **110.** Cobra Pitcher Plant
(*Darlingtonia californica*). **111.** Cotton-Grass (*Eriophorum angustifolium*). **112.**
Rhodora (*Rhododendron canadense*). **113.** Adder's Mouth (*Pogonia ophioglos-
soides*).

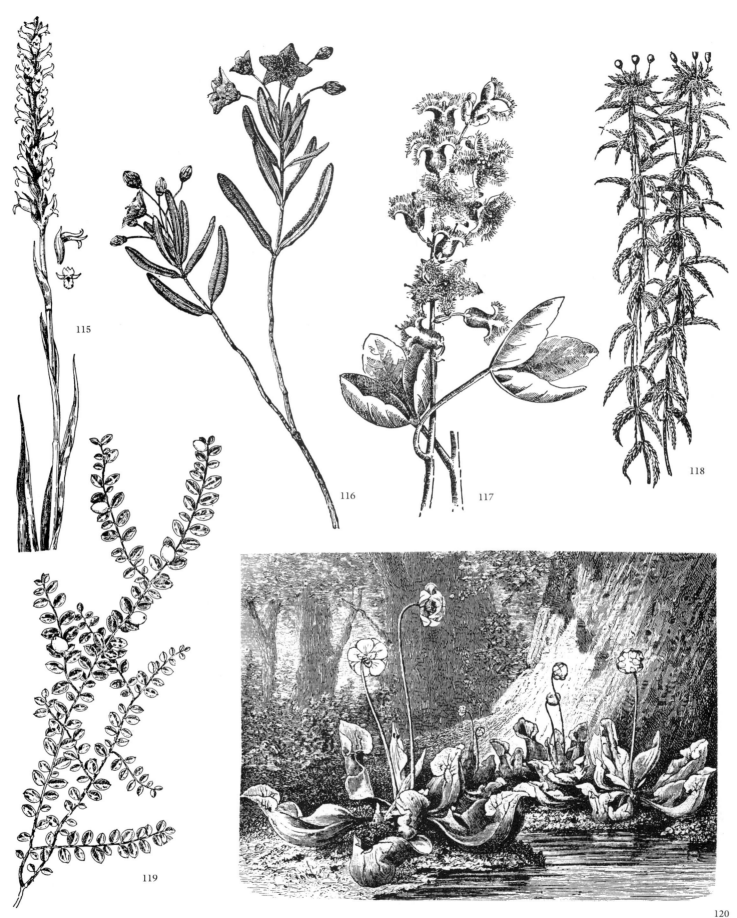

115. Hooded Ladies' Tresses (*Spiranthes romanzoffiana*). **116.** Pale Laurel (*Kalmia poliifolia*). **117.** Buckbean (*Menyanthes trifoliata*). **118.** Peat Moss (*Sphagnum cymbifolium*). **119.** Creeping Snowberry (*Gaultheria hispidula*). **120.** Pitcher Plant (*Sarracenia purpurea*).

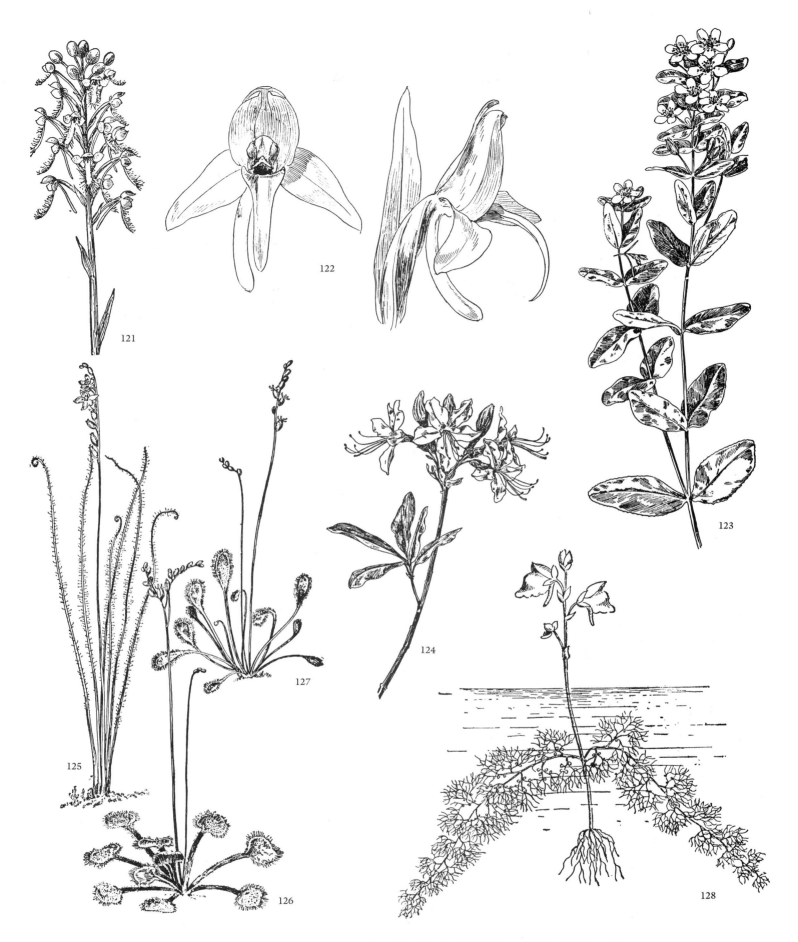

121. Yellow Fringed Orchid (*Habenaria ciliaris*). **122.** Bog-Candle (*Habenaria dilatata*). **123.** Marsh St.-John's-Wort (*Hypericum virginicum*). **124.** Pinxter Flower (*Rhododendron periclymenoides*). **125.** Thread-leaved Sundew (*Drosera filiformis*). **126.** Round-leaved Sundew (*Drosera rotundifolia*). **127.** Long-leaved Sundew (*Drosera longifolia*). **128.** Common Bladderwort (*Utricularia vulgaris*).

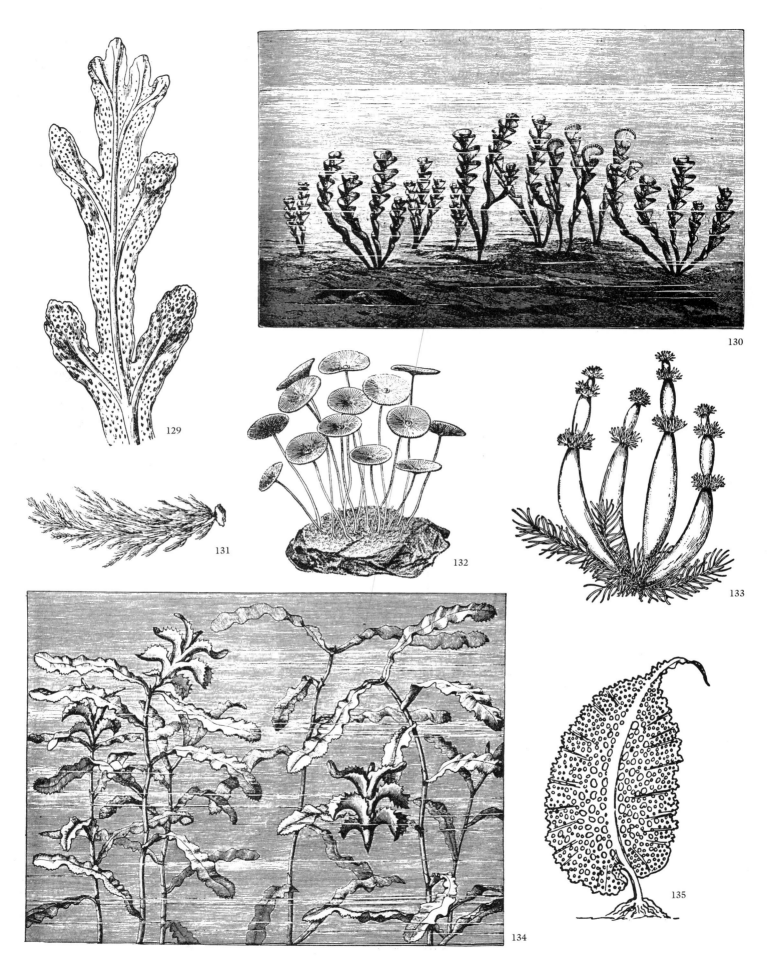

129. Rockweed (*Fucus platycarpus*). **130.** *Riella helicophylla.* **131.** *Cladophora* sp. **132.** *Acetabularia mediterranea.* **133.** Featherfoil (*Hottonia inflata*). **134.** Curly Pondweed (*Potamogeton crispus*). **135.** *Agarum gmelini.*

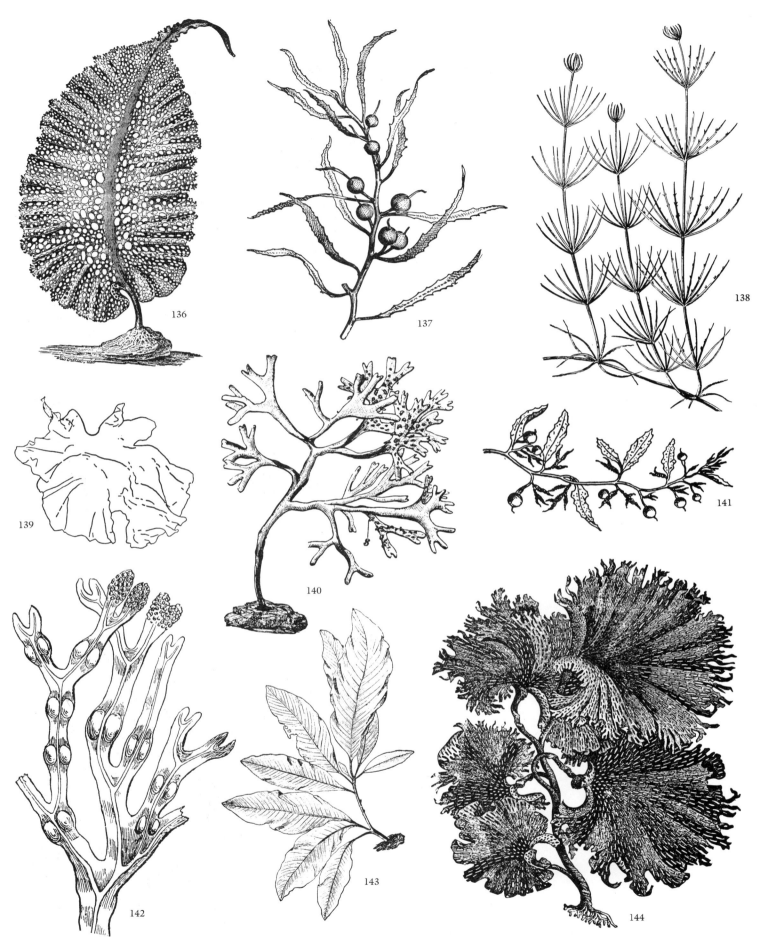

136. *Agarum gmelini.* **137, 141.** Sargassumweed (*Sargassum bacciferum*). **138.** Chara (*Chara fragilis*). **139.** Sea Lettuce (*Ulva lactuca*). **140.** *Gigartina mamillosa.* **142.** Bladderwrack (*Fucus vesiculosis*). **143.** *Delesseria sanguinea.* **144.** *Thallasiophyllum clathrum.*

145. *Rhodymenia* sp. 146. *Limnophila* sp. 147, 150. Water Buttercup (*Ranunculus fluitans*). 148. Chara (*Chara fragilis*). 149. Irish Moss (*Chondrus crispus*).

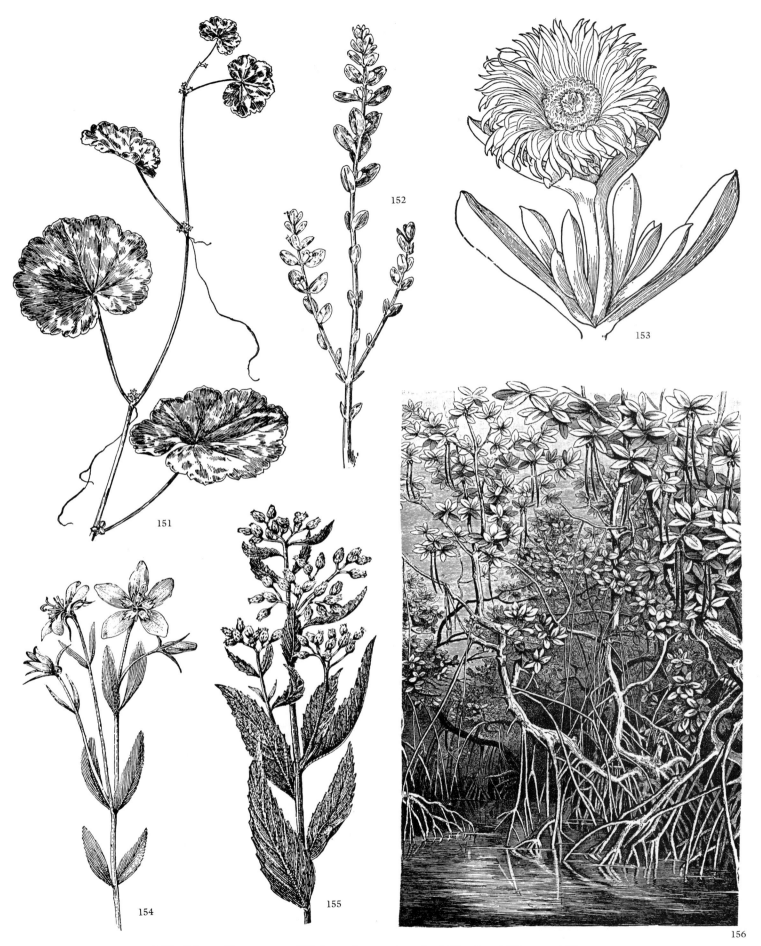

151. Water Pennywort (*Hydrocotyle americana*). **152.** Sea Milkwort (*Glaux maritima*). **153.** Sea Fig (*Carpobrotus chilensis*). **154.** Sea Pink (*Sabatia stellaris*). **155.** Salt-Marsh Fleabane (*Pluchea purpurescens*). **156.** Mangrove (*Rhizophora mangle*).

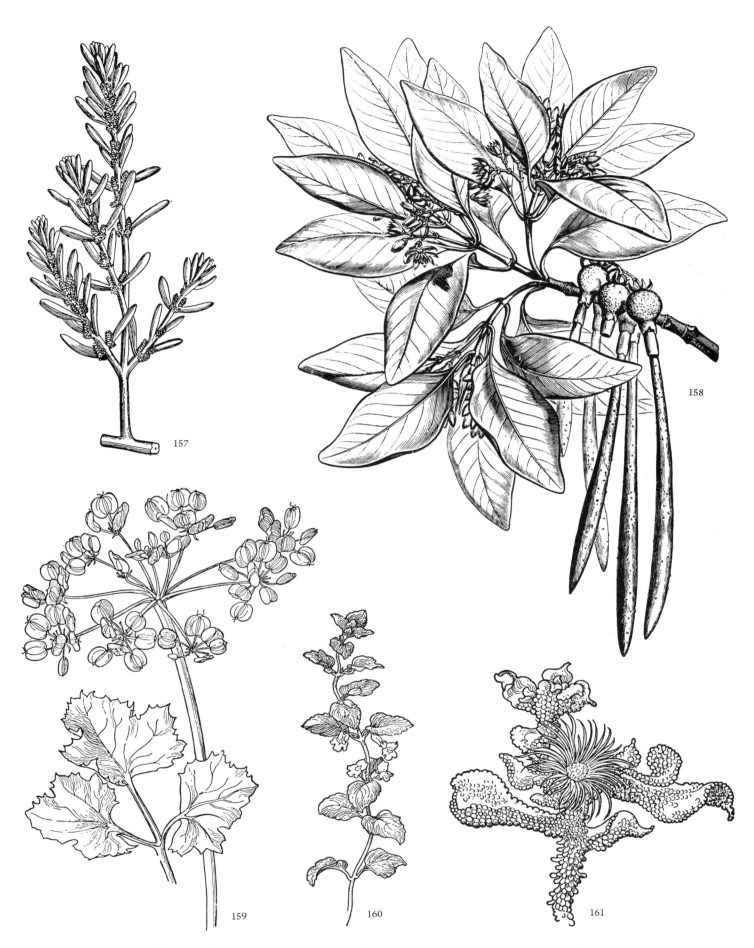

157. Sea Blite (*Suaeda maritima*). **158.** Mangrove (*Rhizophora mangle*). **159.** *Peucedanum euryptera*. **160.** Yerba Buena (*Satureja douglasii*). **161.** Ice Plant (*Mesembryanthemum crystallinum*).

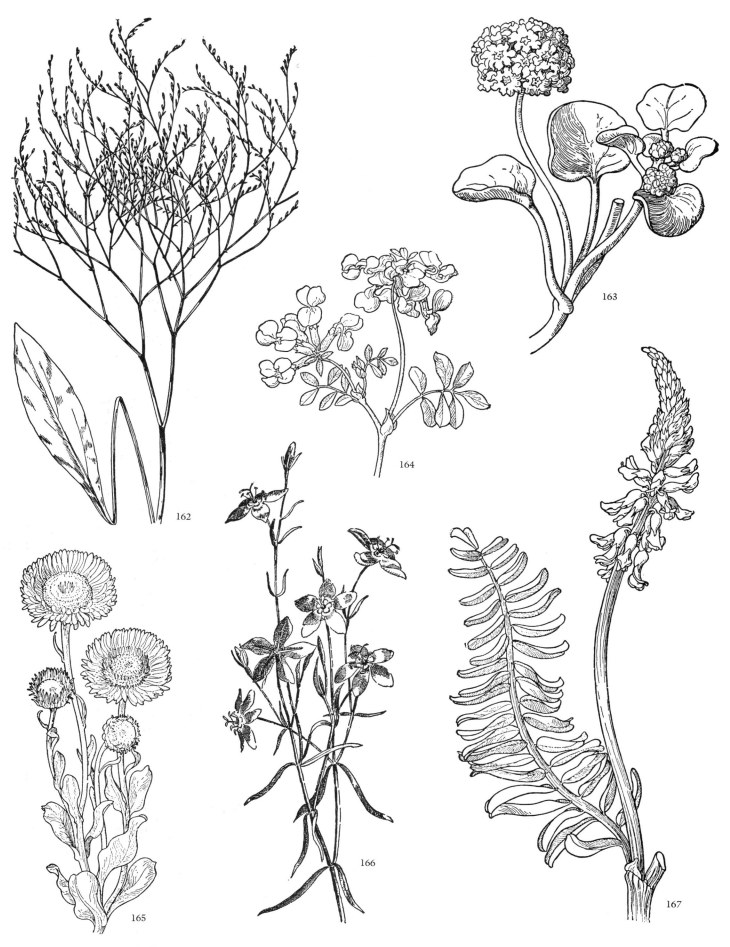

162. Marsh Rosemary (*Limonium carolinianum*). **163.** Yellow Sand Verbena (*Abronia latifolia*). **164.** Pretty Birdfoot (*Anisolotus formosissimus*). **165.** Seaside Daisy (*Erigeron glaucus*). **166.** Slender Sea Pink (*Sabatia campanulata*). **167.** Western Wildweed (*Astragalus menziesii*).

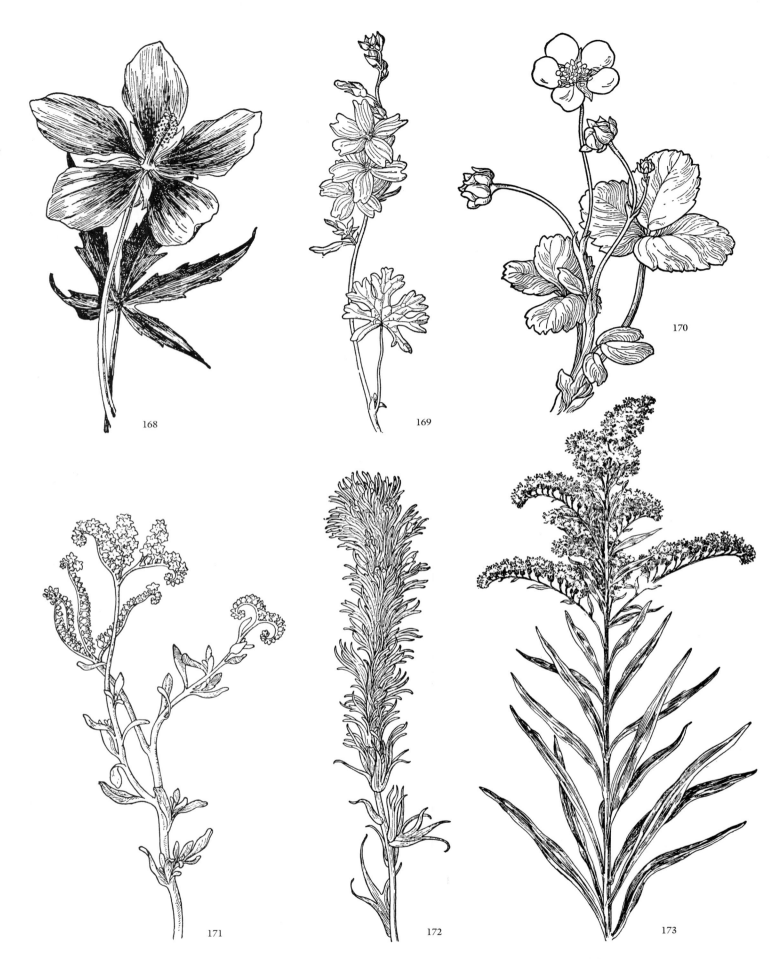

168. Scarlet Rose Mallow (*Hibiscus coccineus*). **169.** Checkerbloom (*Sidalcea malviflora*). **170.** Sand Strawberry (*Fragaria chiloensis*). **171.** Seaside Heliotrope (*Heliotropium curassavicum*). **172.** Escobita (*Orthocarpus densiflorus*). **173.** Seaside Goldenrod (*Solidago sempervirens*).

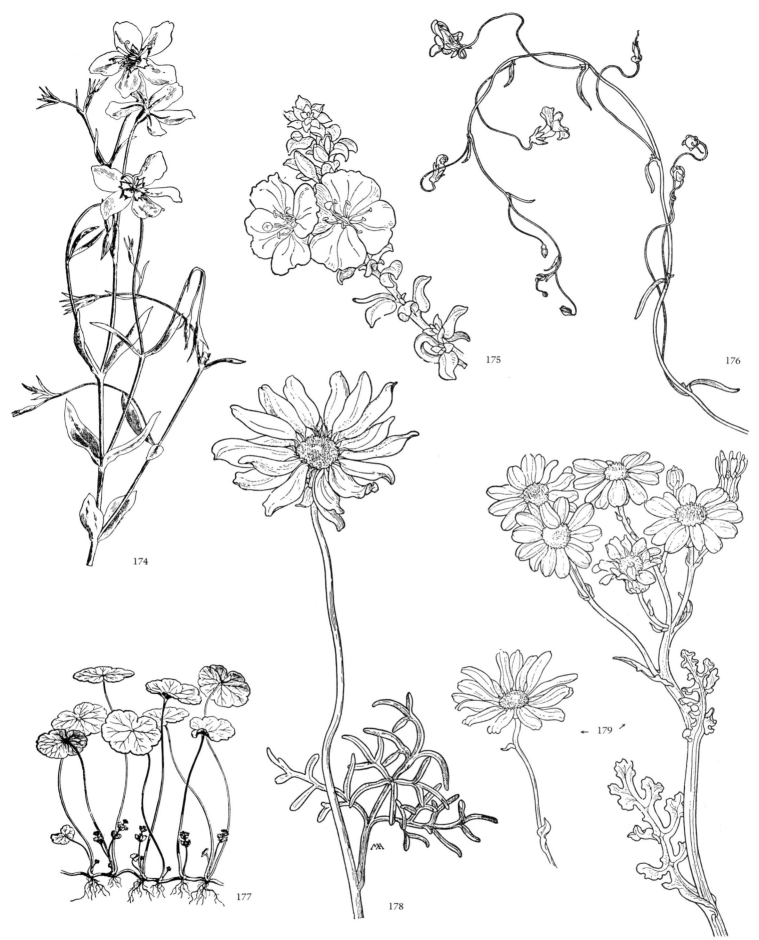

174. Sea Pink (*Sabatia stellaris*). **175.** California Encelia (*Encelia californica*). **176.** Trailing Snapdragon (*Antirrhinum strictum*). **177.** Beach Pennywort (*Hydrocotyle vulgaris*). **178.** Sea Dahlia (*Coreopsis maritima*). **179.** African Senecio (*Senecio elegans*).

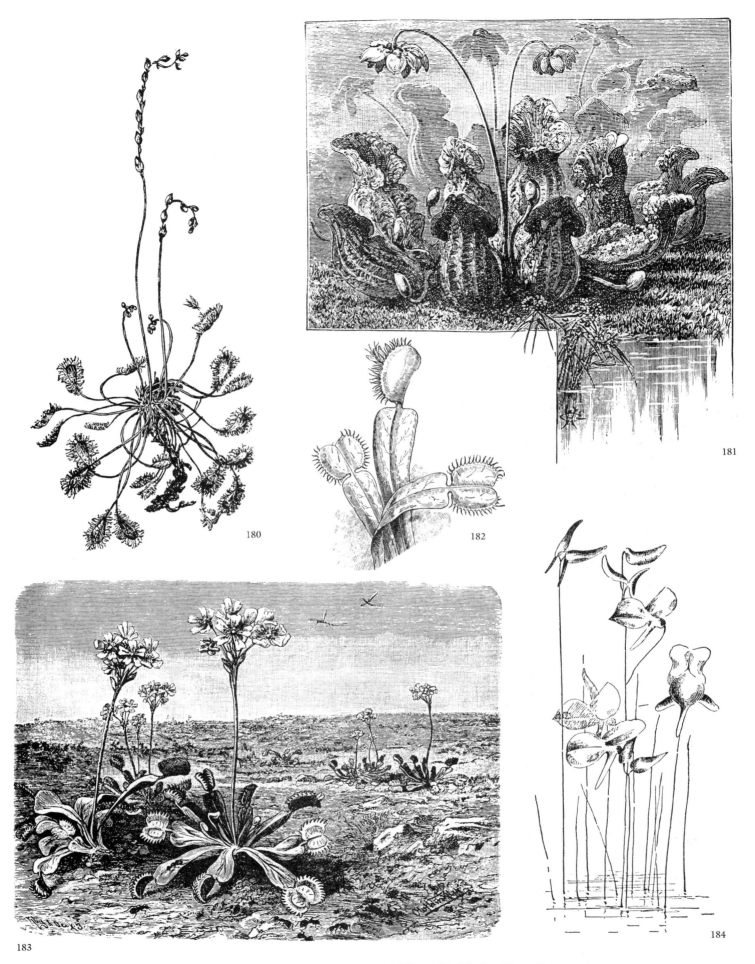

180. Round-leaved Sundew (*Drosera rotundifolia*). **181.** Pitcher Plant (*Sarracenia purpurea*). **182, 183.** Venus Fly Trap (*Dionaea muscipula*). **184.** Horned Bladderwort (*Utricularia cornuta*).

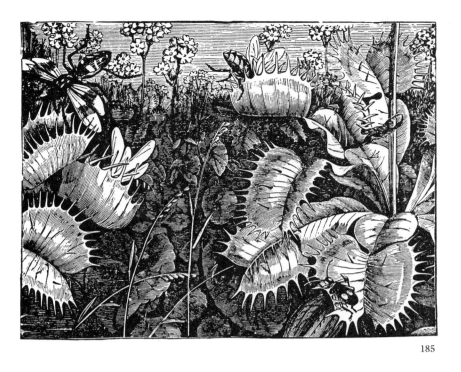

185

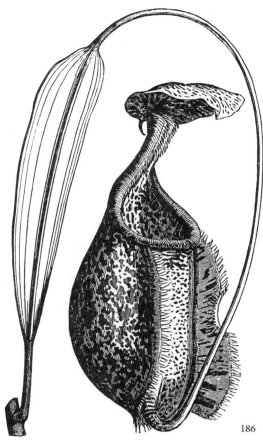

186

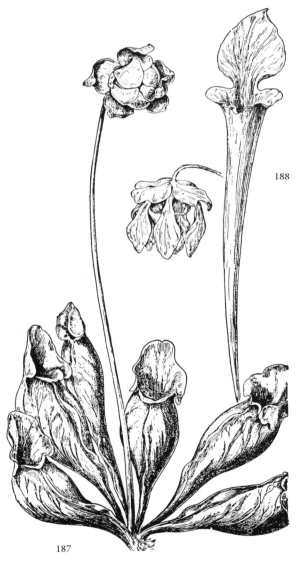

188

187

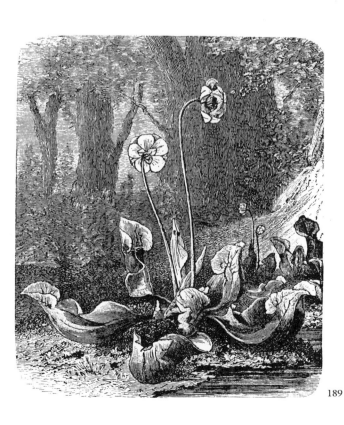

189

185. Venus Fly Trap (*Dionaea muscipula*). **186.** Monkey Cup (*Nepenthes* sp.).
187, 189. Pitcher Plant (*Sarracenia purpurea*). **188.** Trumpet Pitcher Plant
(*Sarracenia flava*).

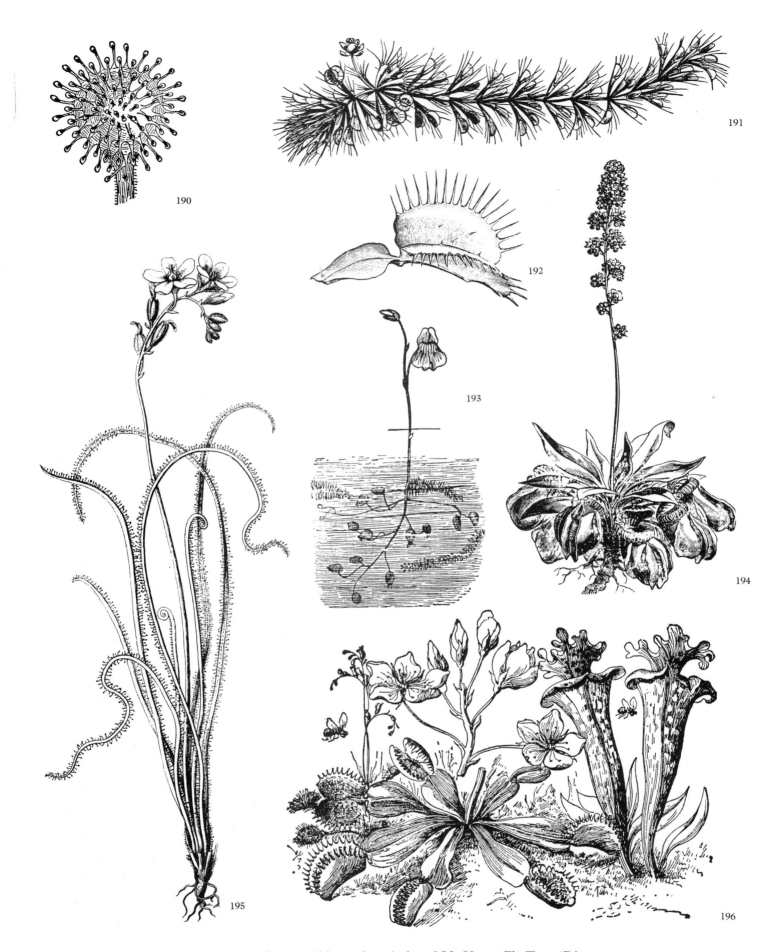

190. Sundew Leaf. **191.** *Aldrovanda vesiculosa.* **192.** Venus Fly Trap (*Dionaea muscipula*). **193.** Bladderwort (*Utricularia grafiana*). **194.** Death Cup (*Cephalotus follicularis*). **195.** Thread-leaved Sundew (*Drosera filiformis*). **196.** Insect-eating Plants.

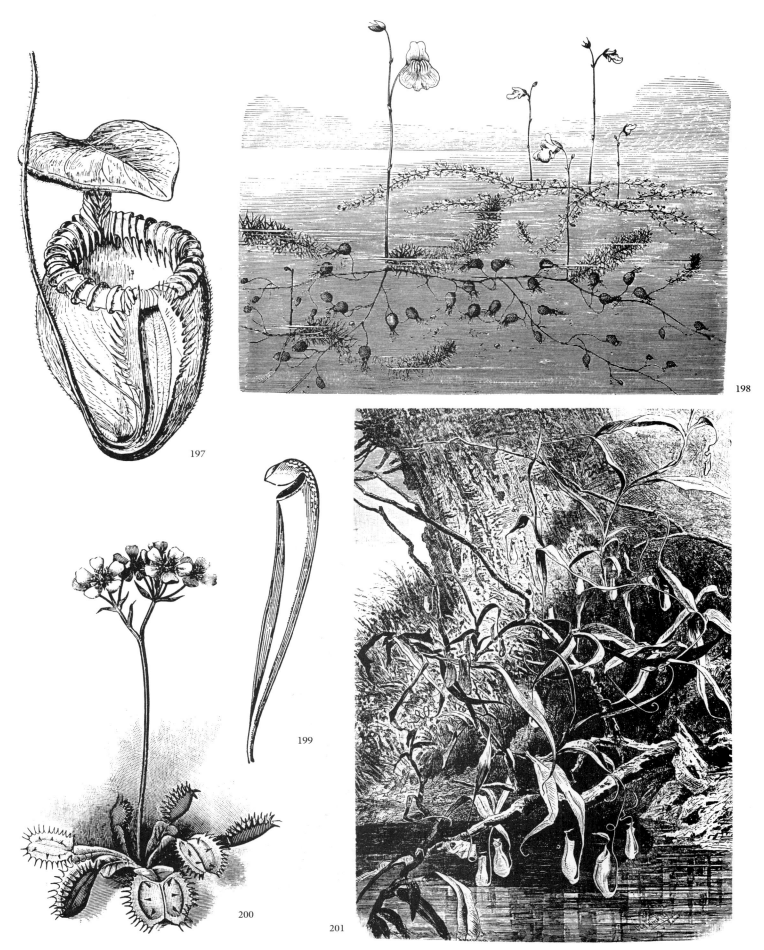

197. Ringed Monkey Cup (*Nepenthes villosa*). **198.** Bladderworts; left: *Utricularia grafiana*; right: *Utricularia minor*. **199.** Spotted Pitcher Plant (*Sarracenia variolaris*). **200.** Venus Fly Trap (*Dionaea muscipula*). **201.** Twining Monkey Cup (*Nepenthes destillatoria*).

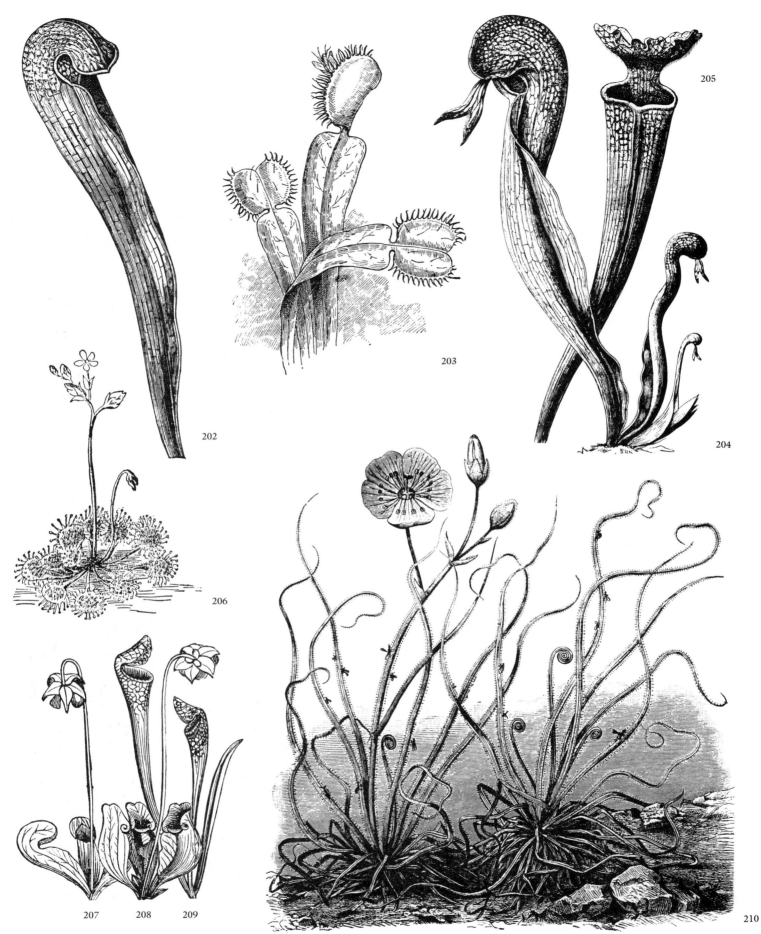

202. Spotted Pitcher Plant (*Sarracenia variolaris*). **203.** Venus Fly Trap (*Dionaea muscipula*). **204.** Cobra Pitcher Plant (*Darlingtonia californica*). **205.** Trumpet Pitcher Plant (*Sarracenia laciniata*). **206.** Sundew. **207.** Short-leaved Pitcher Plant (*Sarracenia psittacina*). **208.** Pitcher Plant (*Sarracenia purpurea*). **209.** Slender Trumpets (*Acacia heterophylla*). **210.** Fly Catcher (*Drosera lusitanicum*).

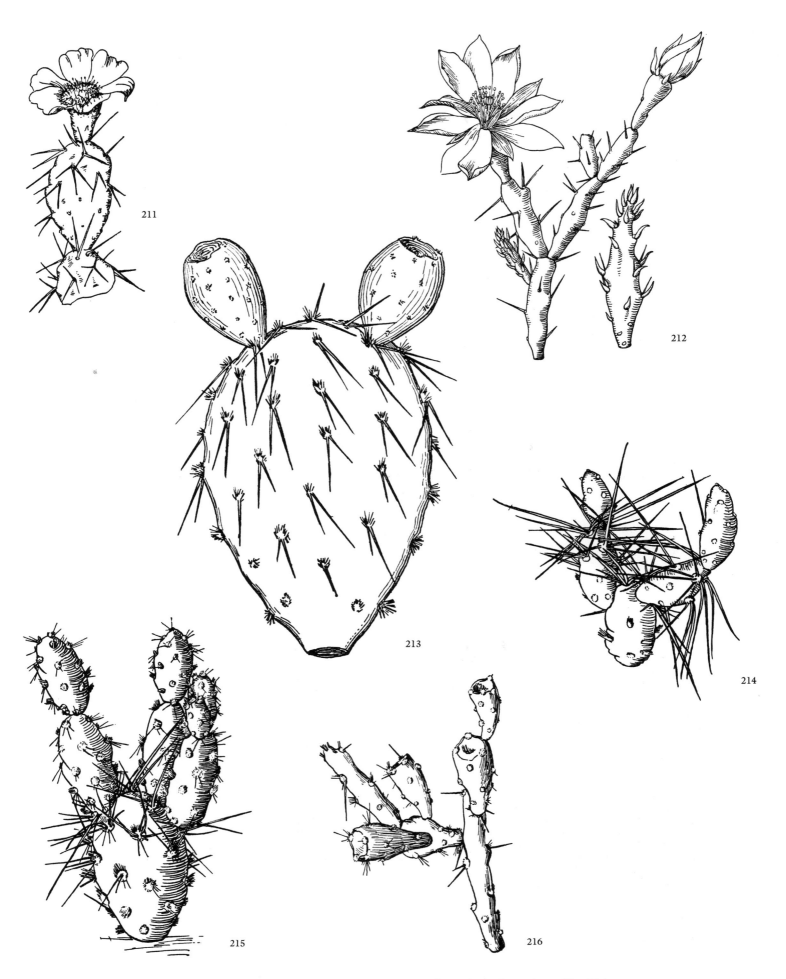

211, 213. Common Prickly Pear (*Opuntia humifusa*). **212.** *Opuntia pusilla*. **214.** *Opuntia ignota*. **215.** *Opuntia campestris*. **216.** *Opuntia arbuscula*.

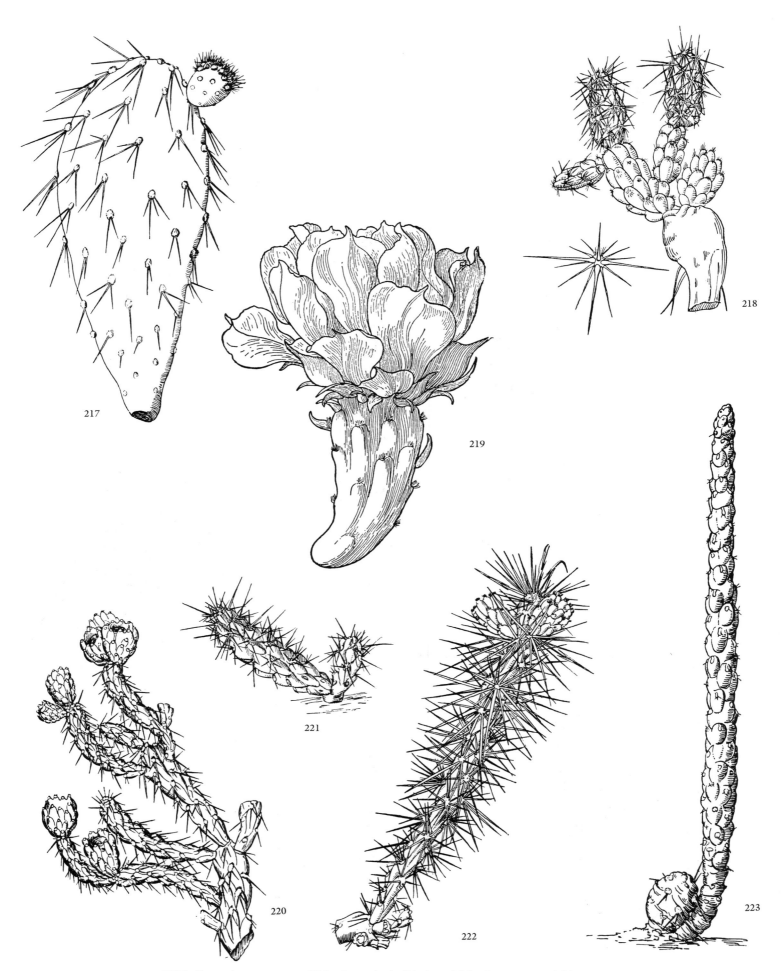

217. *Opuntia angustata.* **218.** *Opuntia bulbispina.* **219.** Common Prickly Pear (*Opuntia humifusa*). **220.** *Opuntia davisii.* **221.** *Opuntia viridiflora.* **222.** *Opuntia whipplei.* **223.** *Opuntia verschaffeltii.*

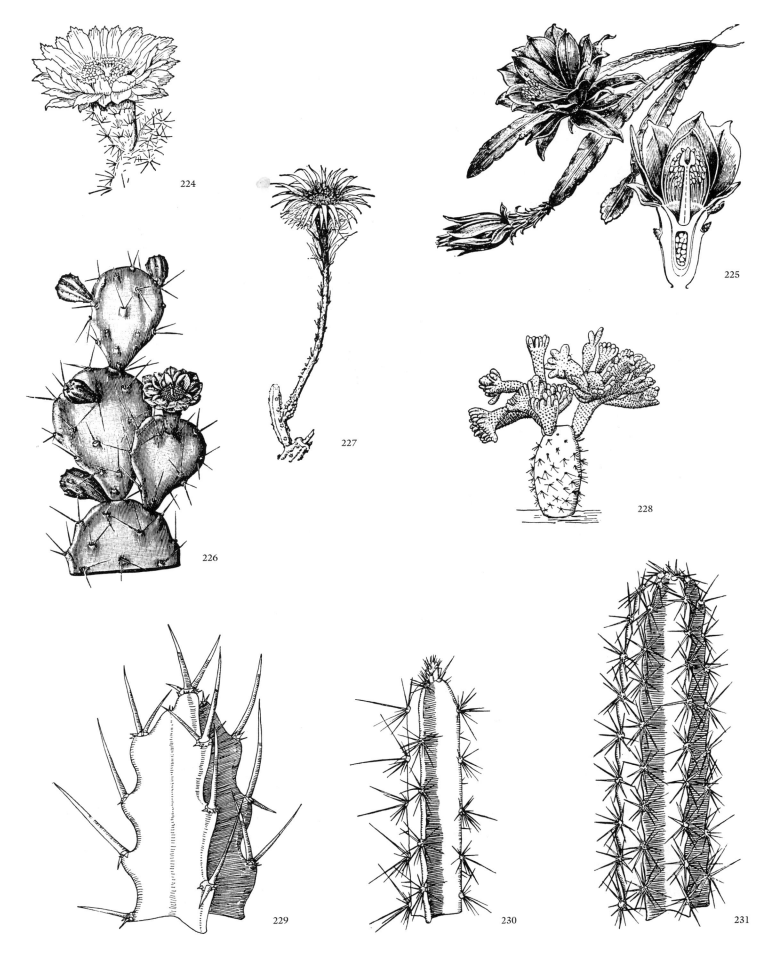

224. *Mammillaria* sp. **225.** *Schlumbergera truncata.* **226.** *Opuntia vulgaris.* **227.** *Peniocereus greggii.* **228.** Ornamental Cactus Grafted on *Opuntia clavarioides.* **229.** *Acanthocereus horridus.* **230.** *Acanthocereus occidentalis.* **231.** *Leptocereus sylvestris.*

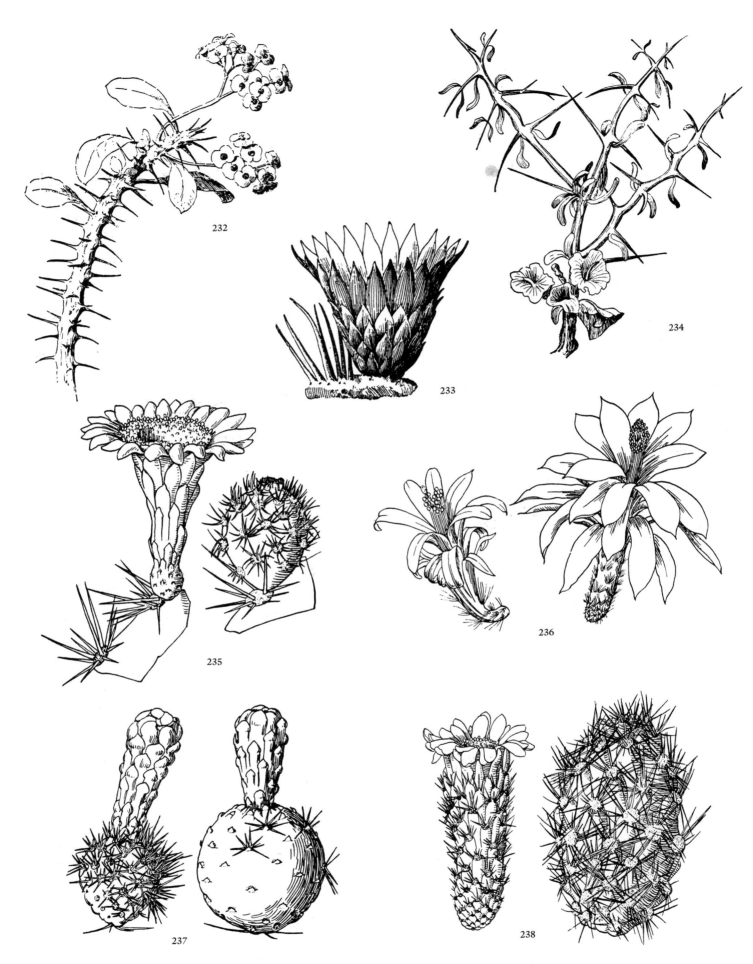

232. Crown of Thorns (*Euphorbia milii*). **233.** Cactus Flower. **234.** *Sarcobatus baileyi*. **235.** *Lemaireocereus hystrix*. **236.** Flowers of *Aporocactus* Species. **237.** *Lemaireocereus thurberi*. **238.** *Lemaireocereus laetus*.

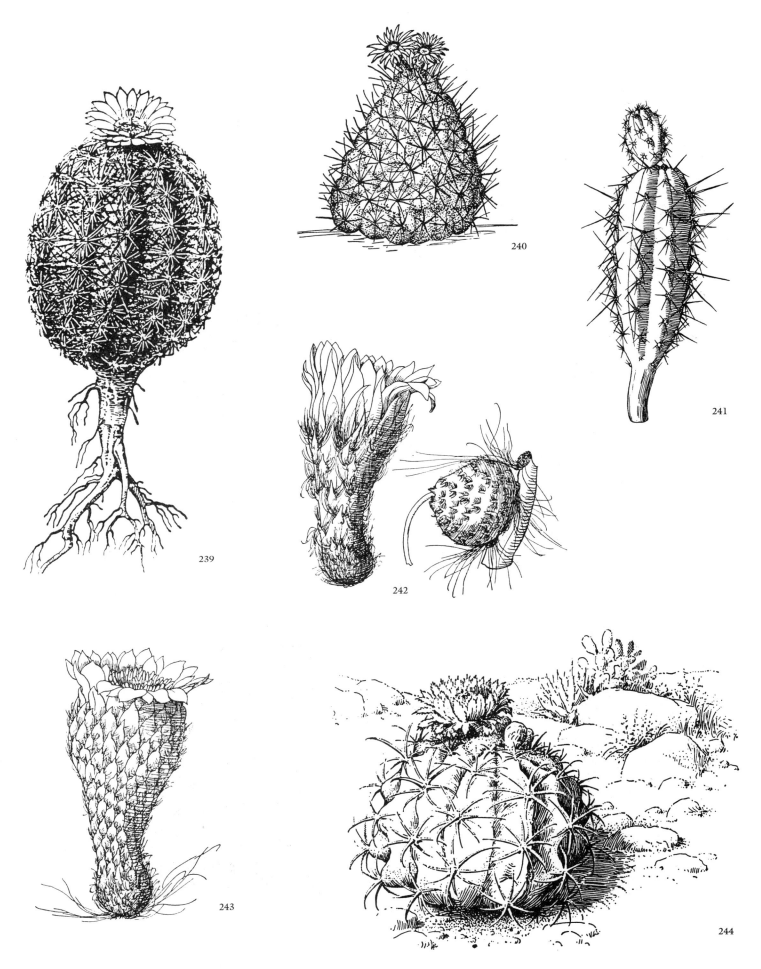

239, 244. Melon Cactus (*Melocactus* sp.). **240.** Nipple Cactus (*Coryphantha vivipara*). **241.** *Erdisia meyenii*. **242.** *Trichocereus pasacana*. **243.** *Trichocereus candicans*.

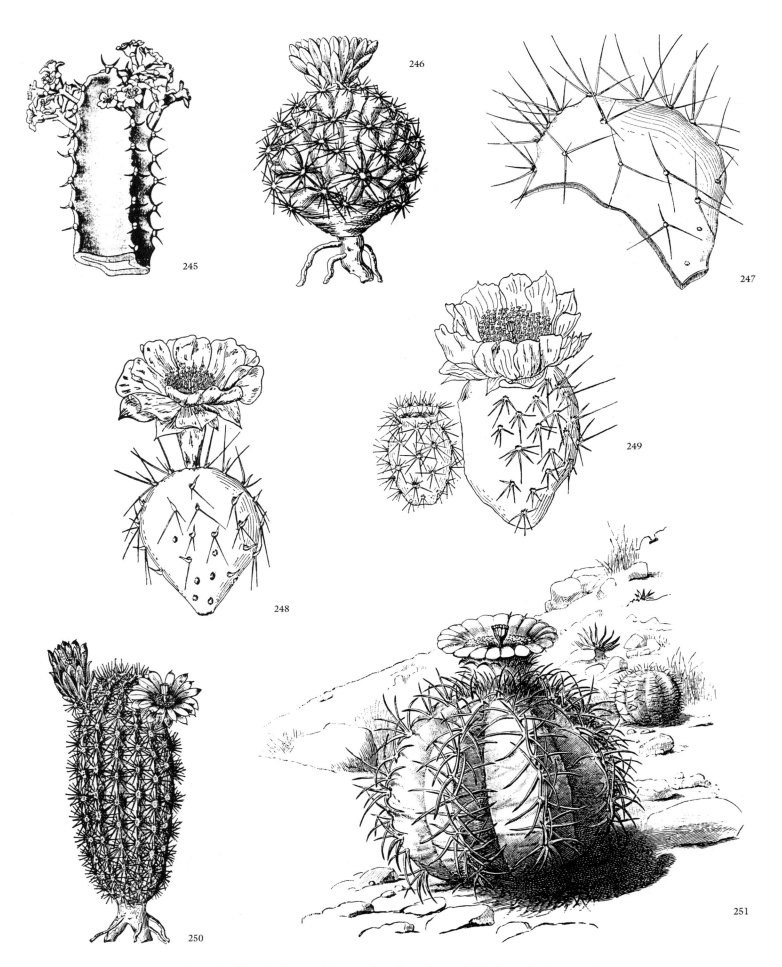

245. *Euphorbia resinifera.* **246.** *Coryphantha vivipara.* **247.** *Opuntia phaeacantha.*
248. Common Prickly Pear (*Opuntia humifusa*). **249.** *Opuntia polycantha.* **250.**
Echinocereus viridiflorus. **251.** Melon Cactus (*Melocactus* sp.).

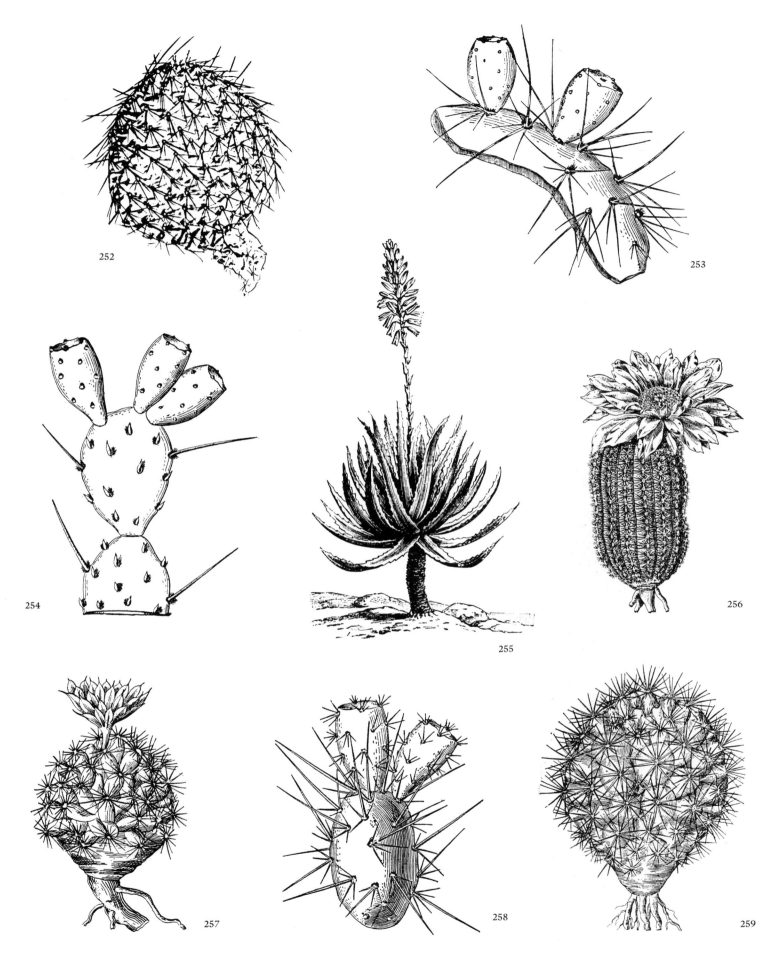

252. *Opuntia polycantha.* **253.** *Opuntia macrorhiza.* **254.** Common Prickly Pear (*Opuntia humifusa*). **255.** *Aloe socotrina.* **256.** *Echinocereus reichenbachii.* **257.** *Neobesseya missouriensis.* **258.** *Opuntia fragilis.* **259.** *Pediocactus simpsonii.*

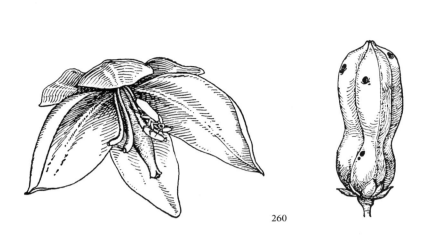

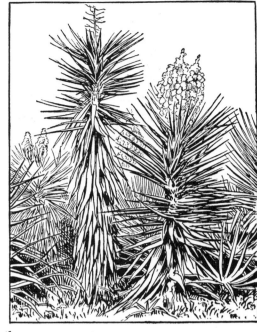

261

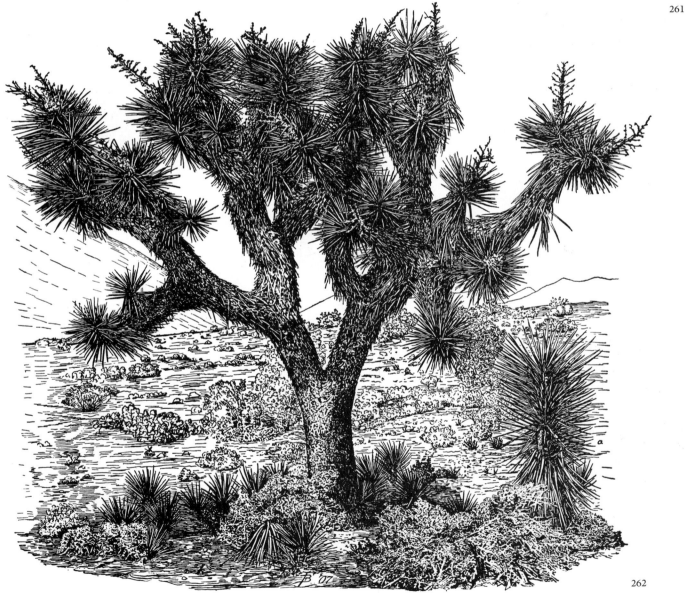

262

260. Yucca (*Yucca glauca*). **261.** Spanish Bayonet (*Yucca aloifolia*). **262.** Joshua Tree (*Yucca brevifolia*).

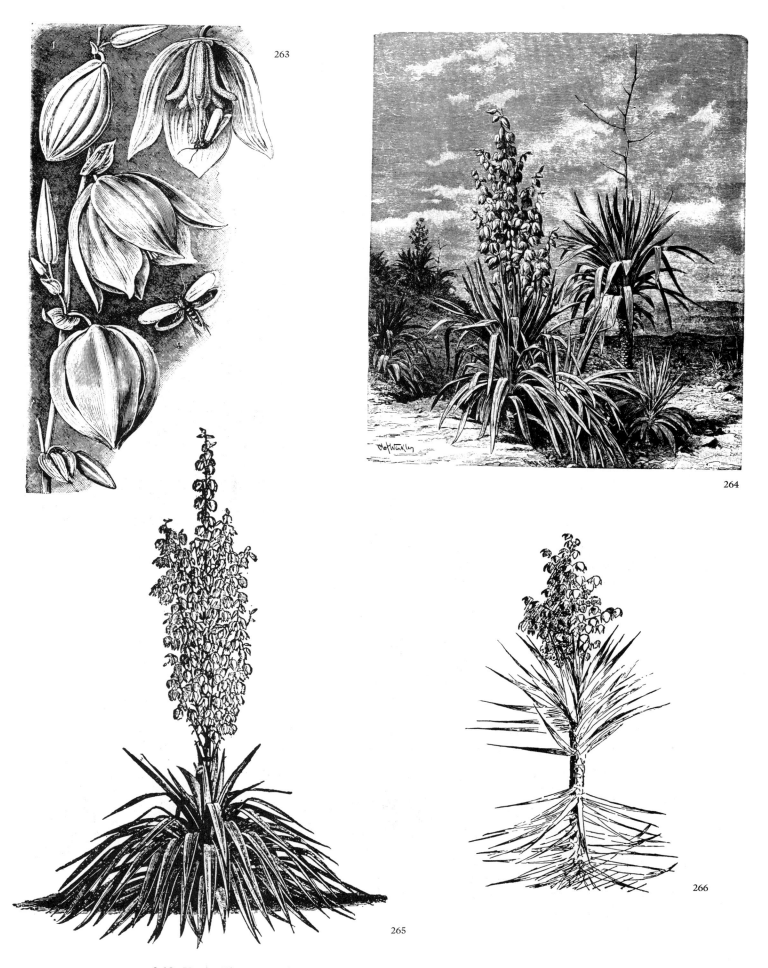

263. Yucca Flowers and Moths (*Yucca filamentosa*). **264.** Royal Yucca (*Yucca gloriosa*). **265.** Ornamental Yucca (*Yucca recurvifolia*). **266.** Spanish Bayonet (*Yucca aloifolia*).

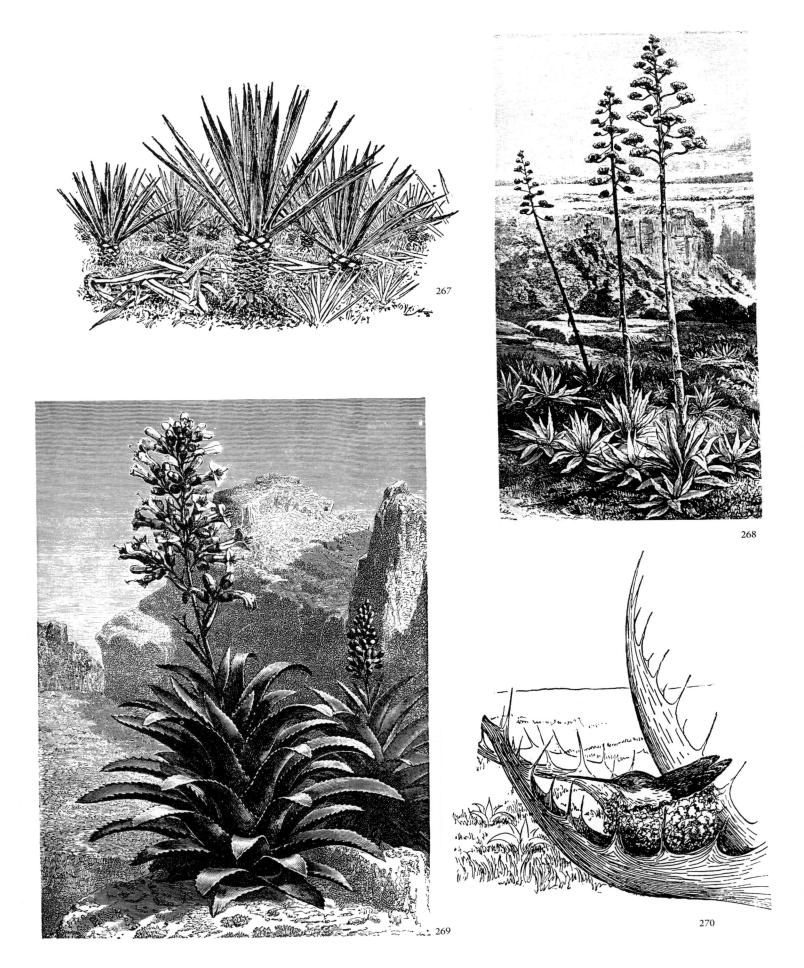

267. Henequen (*Agave fourcroydes*). **268.** Desert Agave (*Agave utahensis*). **269.** Century Plant (*Agave americana*). **270.** Bird Nesting in Agave (*Agave* sp.).

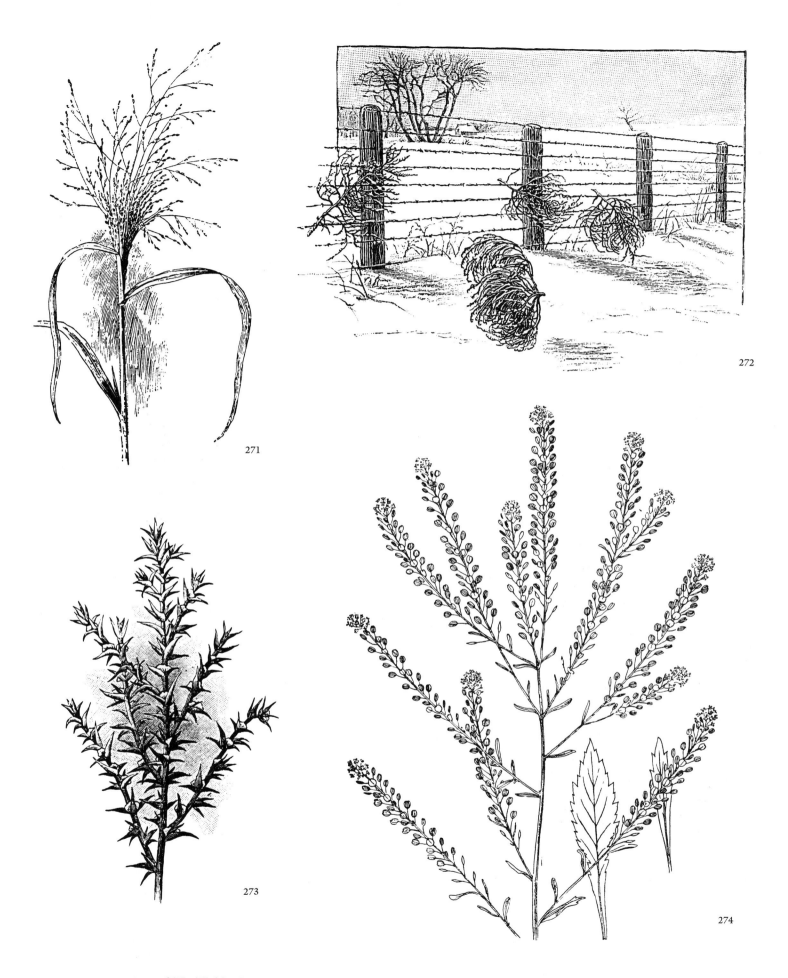

271. Tickle Grass (*Agrostis scabra*). **272.** Mature Tumbleweeds. **273.** Russian Thistle (*Salsola pestifer*). **274.** Wild Pepper Grass (*Lepidium virginicum*).

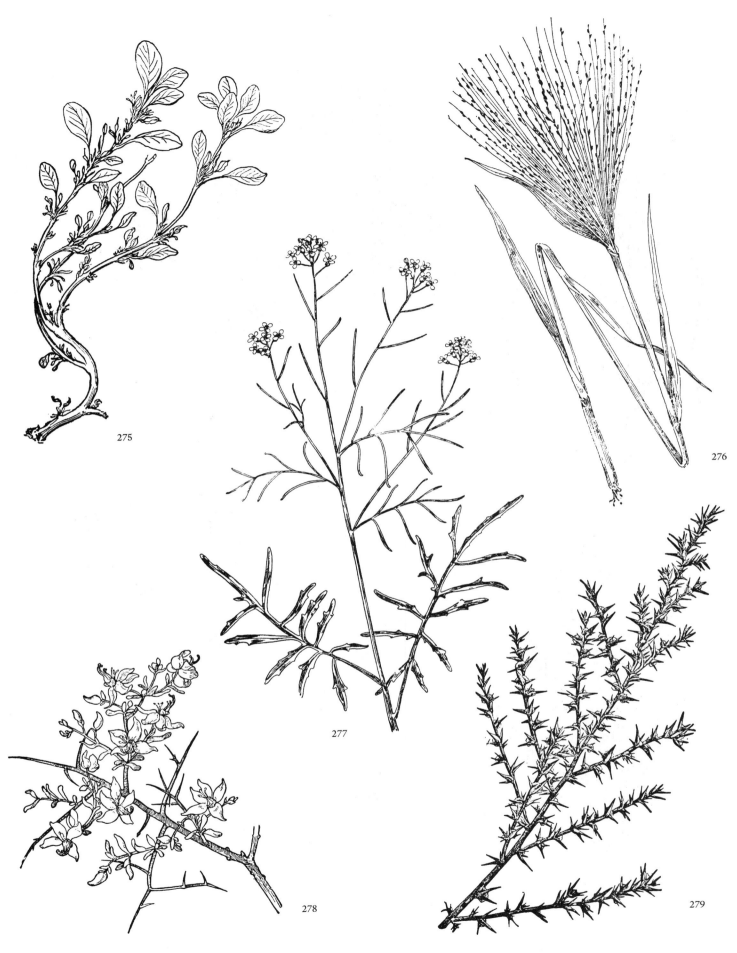

275. Tumbleweed (*Amaranthus blitoides*). **276.** Common Witch Grass (*Panicum capillare*). **277.** Tumble Mustard (*Sisymbrium altissimum*). **278.** Crimson Beak (*Krameria grayi*). **279.** Russian Thistle (*Salsola pestifer*).

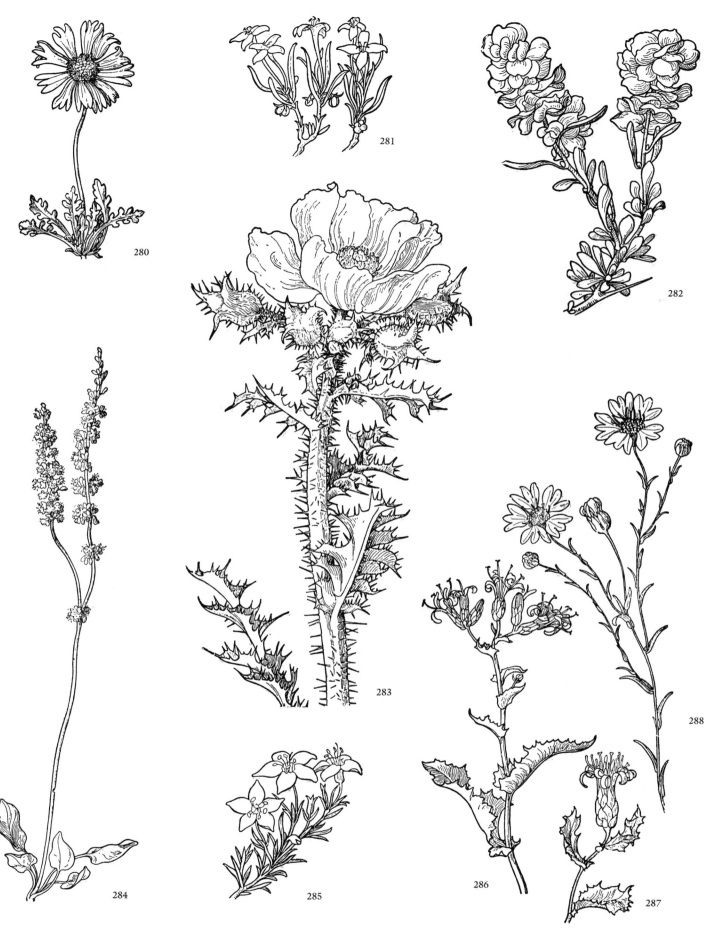

280. Arizona Gaillardia (*Gaillardia arizonica*). **281.** Desert Innocence (*Houstonia rubra*). **282.** Hop Sage (*Grayia polygaloides*). **283.** Thistle Poppy (*Argemone hispida*). **284.** Wild Buckwheat (*Eriogonum racemosum*). **285.** Blue Desert Gilia (*Gilia rigidula*). **286.** Brown-Foot (*Perezia wrightii*). **287.** Desert Holly (*Perezia nana*). **288.** Ptilonella (*Ptilonella scabra*).

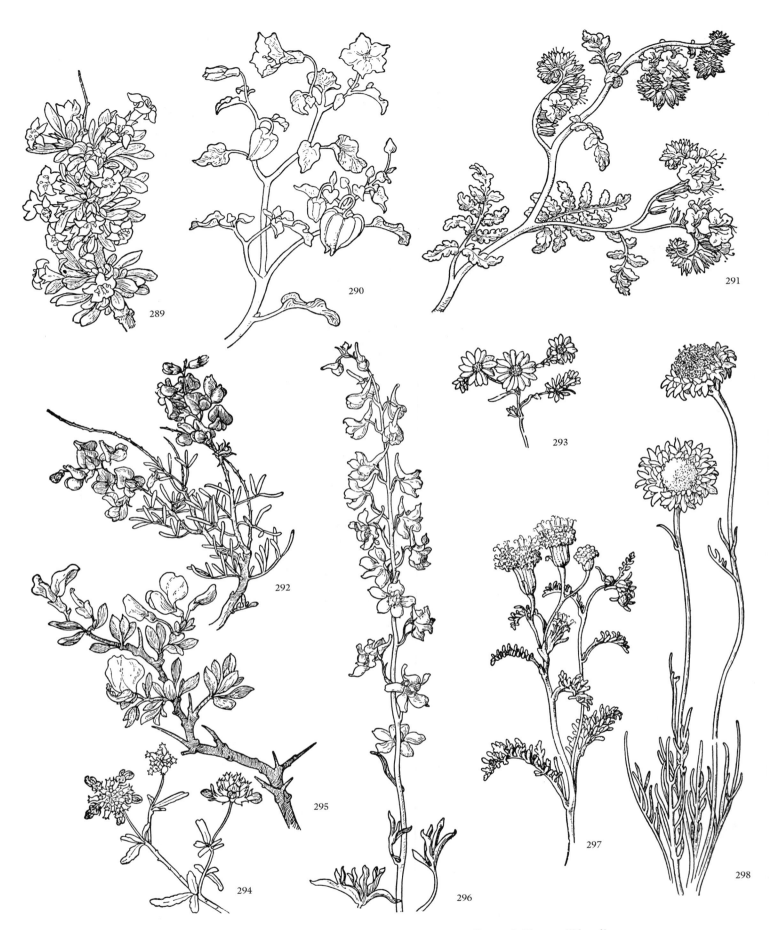

289. Desert Matrimony (*Lycium cooperi*). **290.** Desert Ground Cherry (*Physalis crassifolia*). **291.** Vervenia (*Phacelia distans*). **292.** Balsam Peabush (*Dalea californica*). **293.** Desert Star (*Erimastrum bellidoides*). **294.** Downy Desertwood (*Dalea emoryi*). **295.** Chapparal Pea (*Pickeringia montana*). **296.** Larkspur (*Delphinium hansenii*). **297.** Chaenactis (*Chaenactis douglasii*). **298.** Golden Girls (*Chaenactis lanosa*).

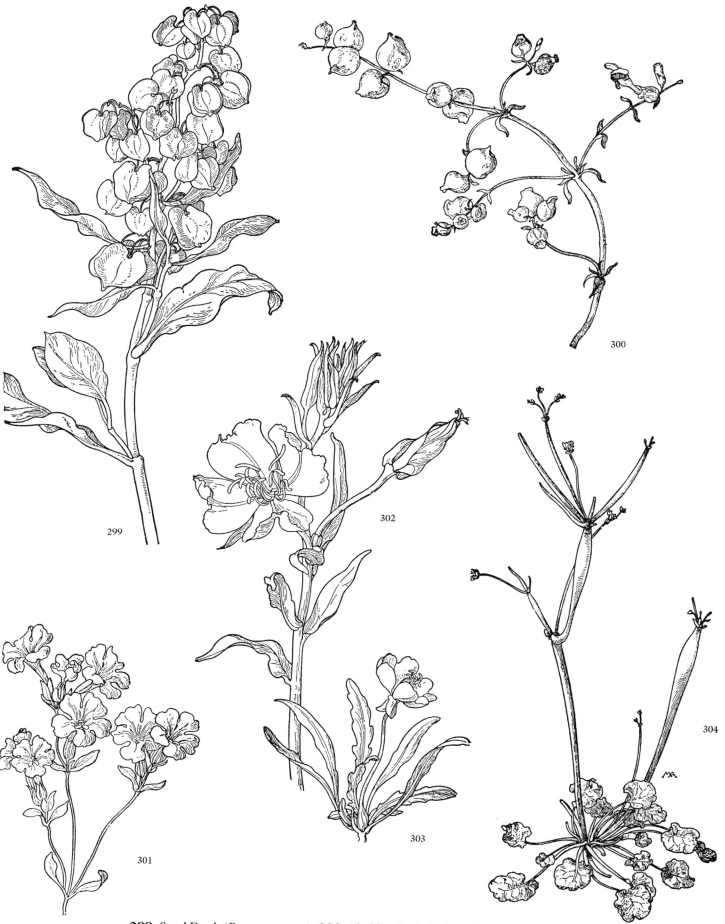

299. Sand Dock (*Rumex venosus*). **300.** Bladder-Bush (*Salazaria mexicana*). **301.** Desert Monkey Flower (*Mimulus fremontii*). **302.** Evening Primrose (*Oenothera hookeri*). **303.** Sun-Cups (*Oenothera primiveris*). **304.** Bottle-Plant (*Eriogonum inflatum*).

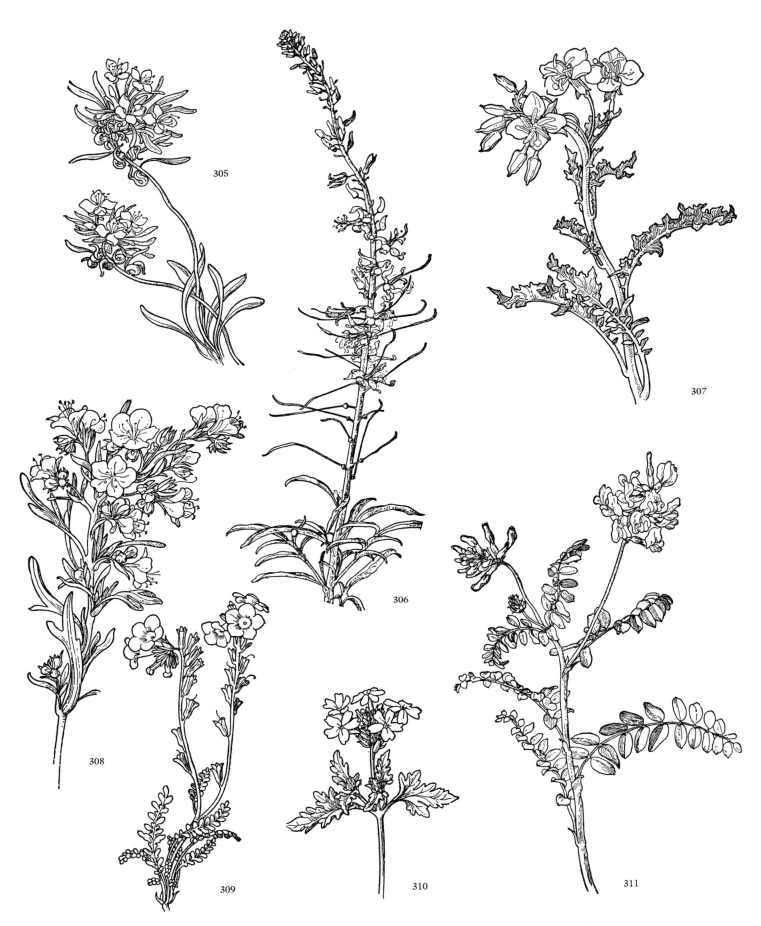

305. Desert Primrose (*Oenothera tortuosa*). 306. Golden Prince's Plume (*Stanleya pinnatifida*). 307. Chylisma (*Chylisma scapoidea*). 308. Desert Phacelia (*Phacelia linearis*). 309. Fremont's Phacelia (*Phacelia fremontii*). 310. Wild Verbena (*Verbena arizonica*). 311. Loco-Weed (*Astragalus macdougali*).

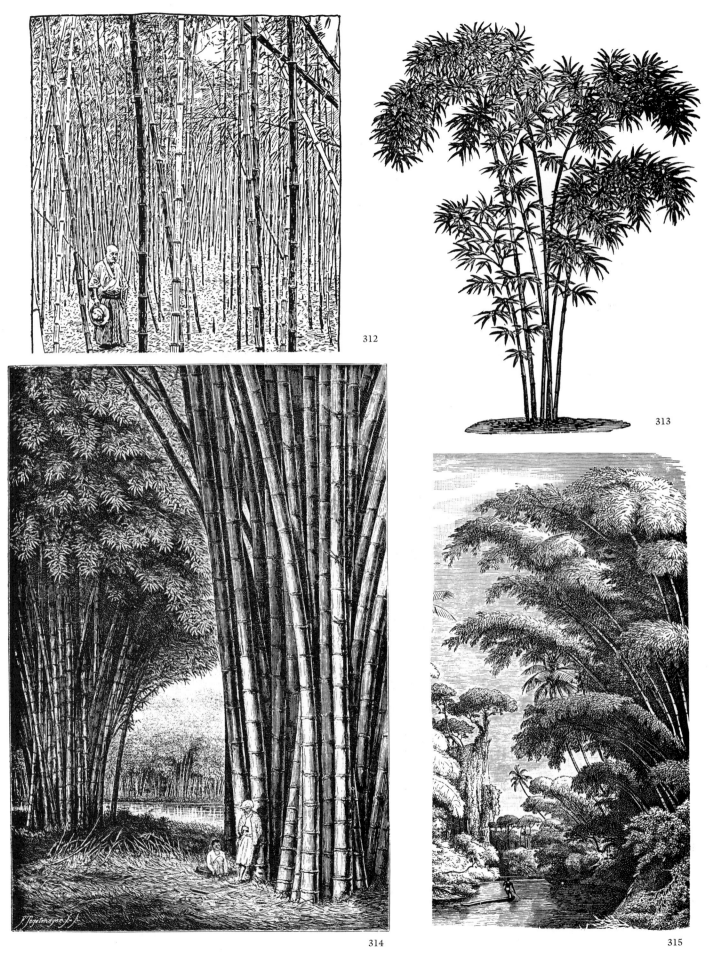

312. Paper Bamboo. **313.** Ornamental Bamboo. **314.** Bamboo in Java. **315.** Bamboo Forest in Ceylon.

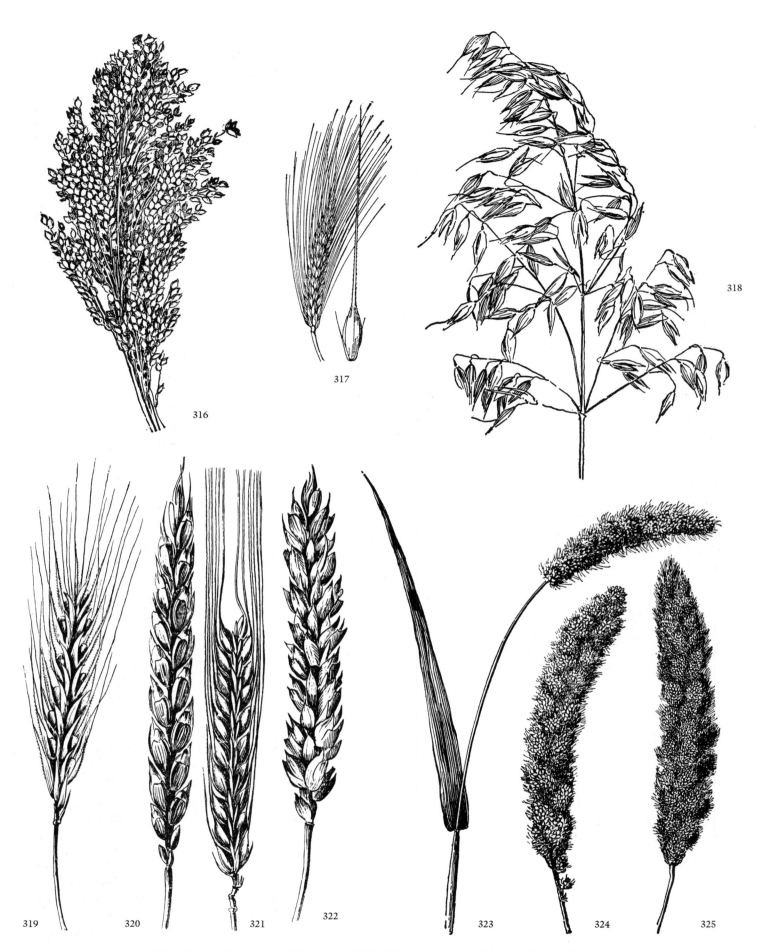

316. Proso (*Panicum miliaceum*). **317, 321.** Barley (*Hordeum vulgare*). **318.** Oats (*Avena fatua*). **319.** Rye (*Secale cereale*). **320.** Spelt (*Triticum aestivum*). **322.** Wheat (*Triticum aestivum*). **323.** Red Siberian Millet. **324.** Common Millet. **325.** German Millet.

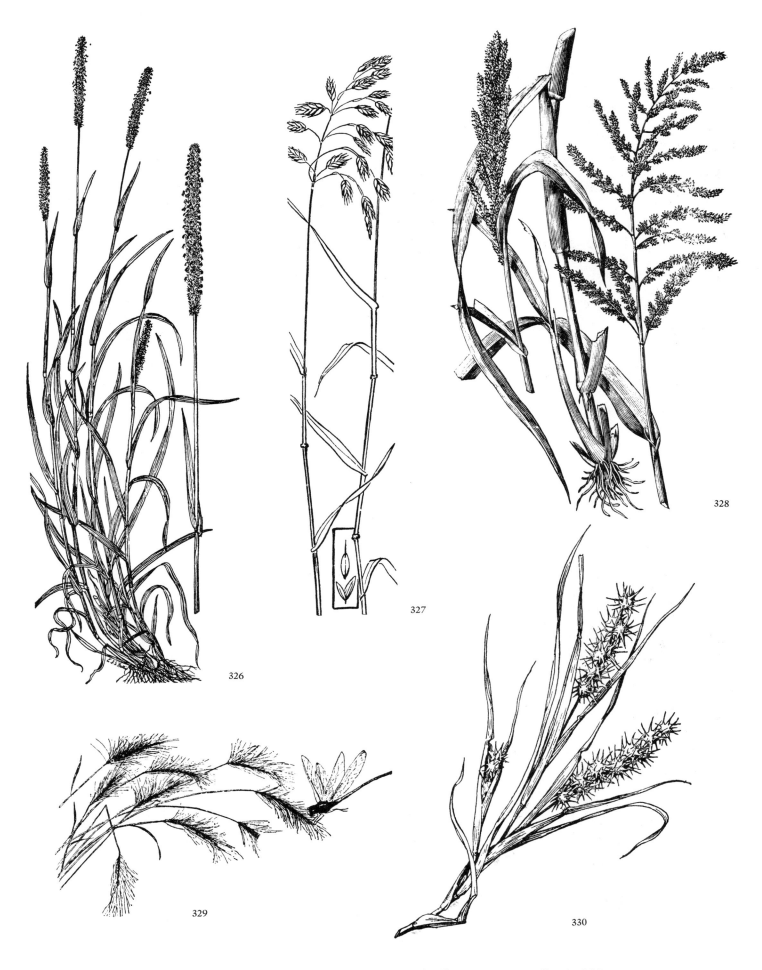

326. Timothy (*Phleum pratense*). **327.** Smooth Chess (*Bromus secalinus*). **328.** Barnyard Grass (*Echinochloa crusgalli*). **329.** Dragonfly on Wild Rye. **330.** Sandspur (*Cenchrus pauciflorus*).

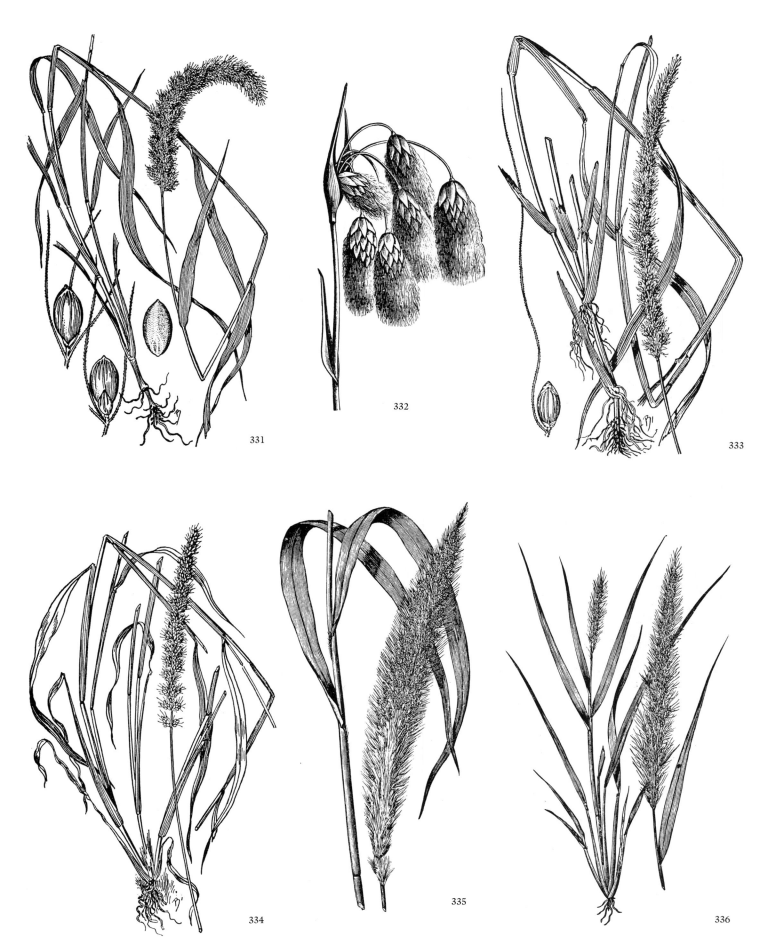

331. Foxtail Millet (*Setaria italica*). **332.** Tall Cotton-Grass (*Eriophorum angustifolium*). **333.** Carolina Foxtail (*Setaria corrugata*). **334.** Common Foxtail (*Setaria ambigua*). **335.** Giant Foxtail (*Setaria magna*). **336.** Florida Foxtail (*Setaria macrosperma*).

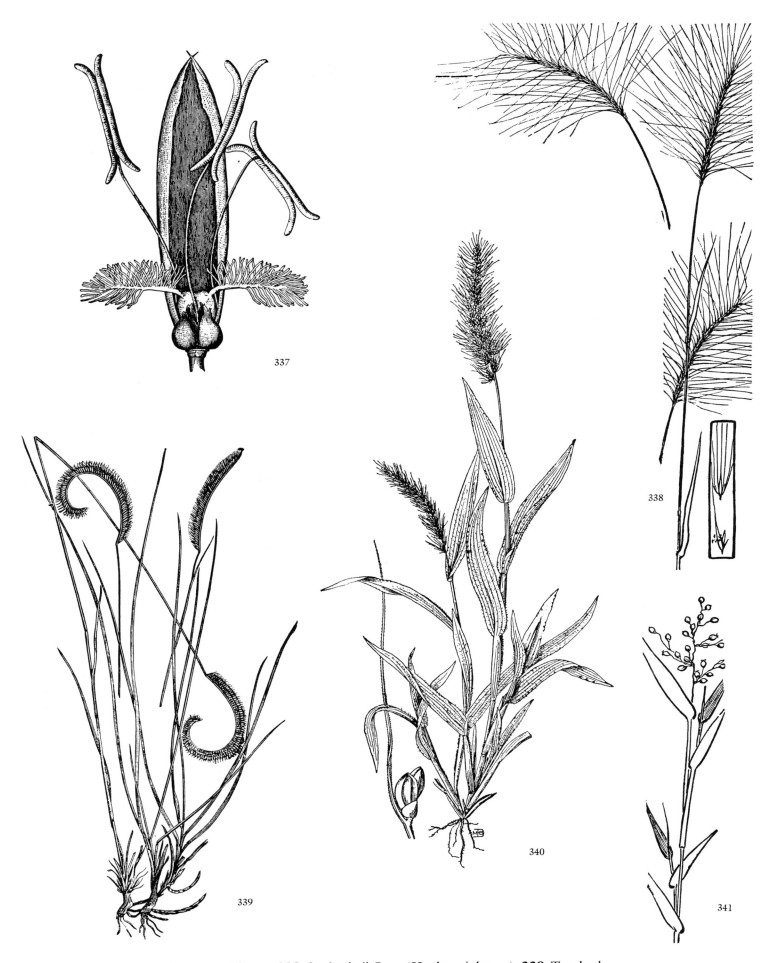

337. Grass Flower. **338.** Squirreltail Grass (*Hordeum jubatum*). **339.** Toothache Grass (*Ctenium aromaticum*). **340.** Broad-leaved Foxtail (*Setaria latifolia*). **341.** Scribner's Panic Grass (*Panicum scribnerianum*).

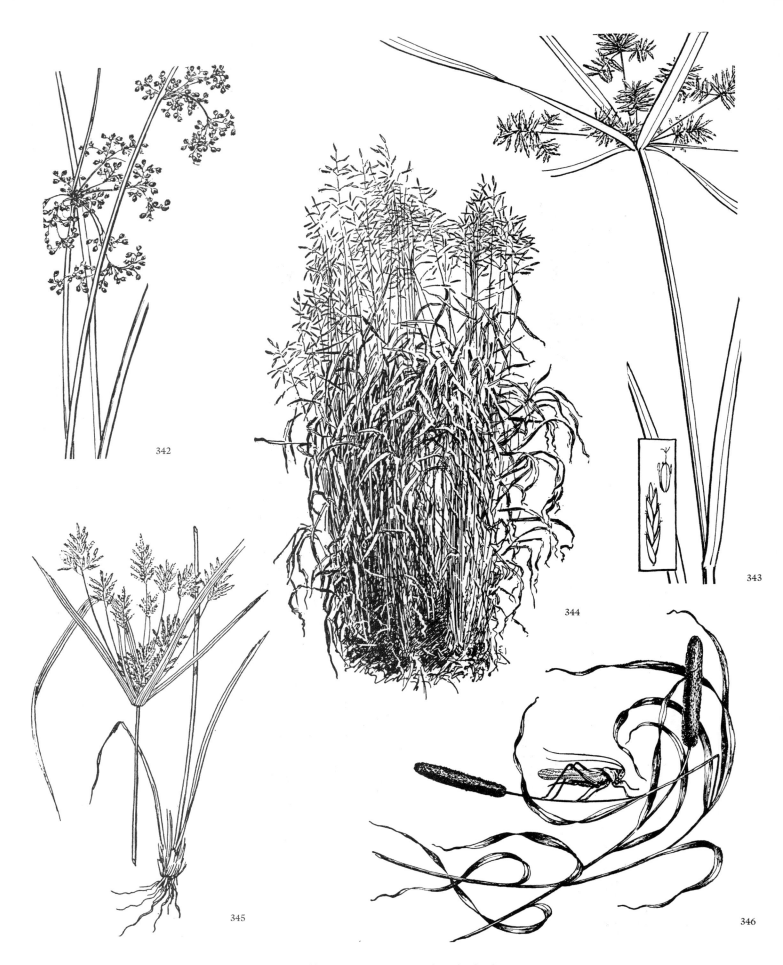

342

343

344

345

346

342. Bog Rush (*Juncus effusus*). **343.** Straw-colored Chufa (*Cyperus strigosus*). **344.** Smooth Brome (*Bromus inermis*). **345.** Yellow Nut Grass (*Cyperus esculentus*). **346.** Timothy (*Phleum pratense*).

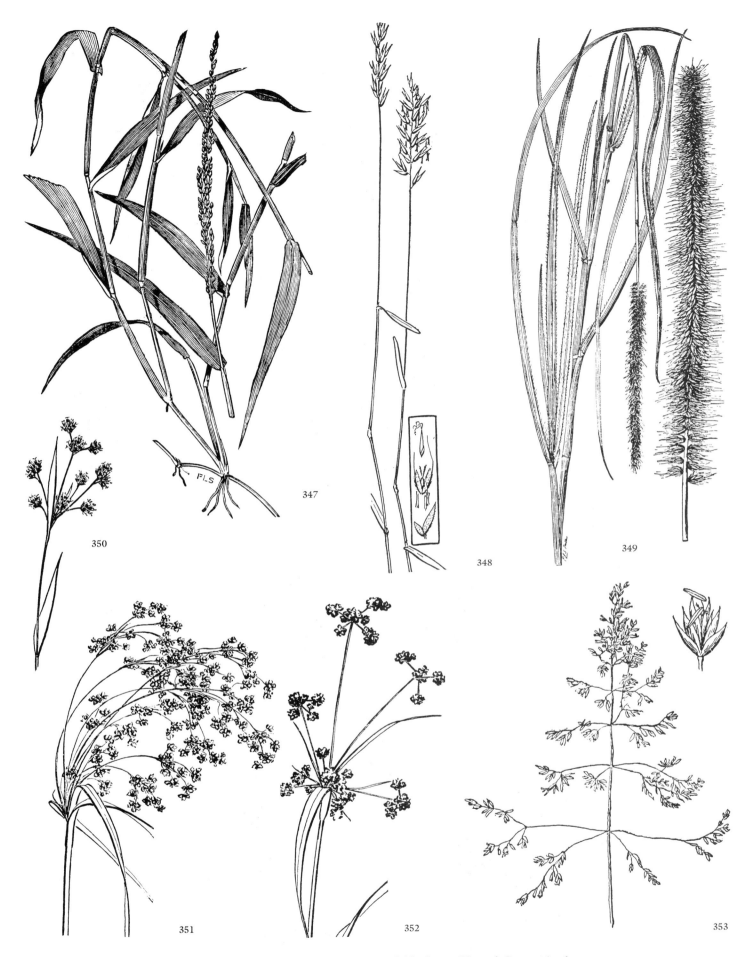

347. Colorado Grass (*Brachiaria texana*). **348.** Sweet Vernal Grass (*Anthoxanthum odoratum*). **349.** Napier Grass (*Pennisetum purpureum*). **350.** Common Wood Rush (*Luzula campestris*). **351.** Woolgrass (*Scirpus cyperinus*). **352.** Meadow Bulrush (*Scirpus atrovirens*). **353.** Kentucky Bluegrass (*Poa pratensis*).

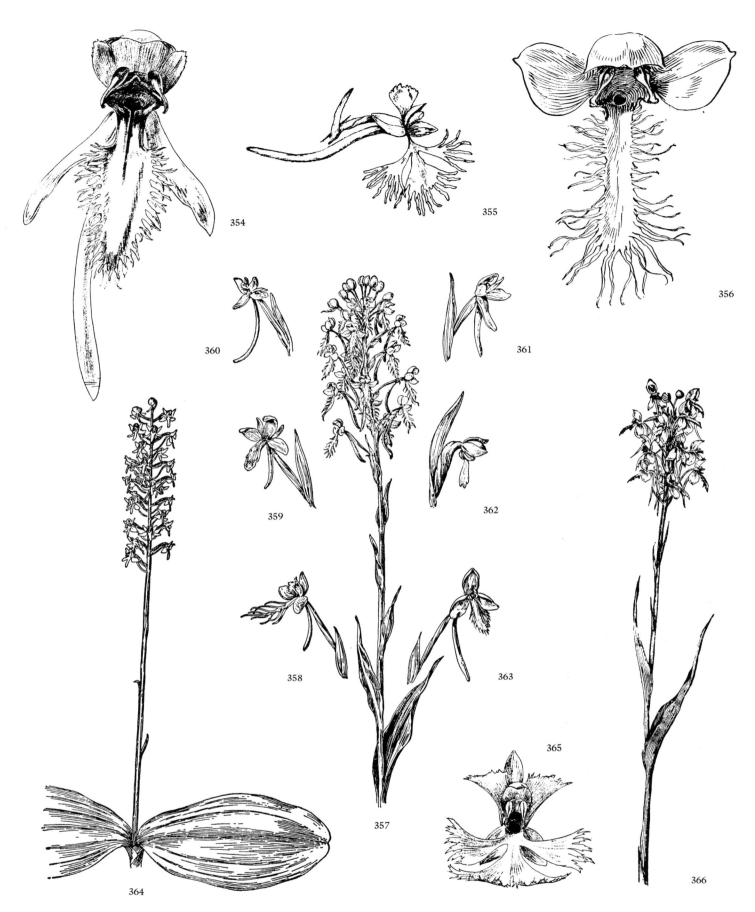

354, 363, 366. White Fringed Orchid (*Habenaria blephariglottis*). **355.** Prairie White Fringed Orchid (*Habenaria leucophaea*). **356, 357.** Yellow Fringed Orchid (*Habenaria ciliaris*). **358.** Crested Fringed Orchid (*Habenaria cristata*). **359.** Yellow Fringeless Orchid (*Habenaria integra*). **360.** Snowy Orchid (*Habenaria nivea*). **361, 364.** Large Round-leaved Orchid (*Habenaria orbiculata*). **362.** Little Green Orchid (*Habenaria viridis*). **365.** Small Purple Fringed Orchid (*Habenaria psycodes*).

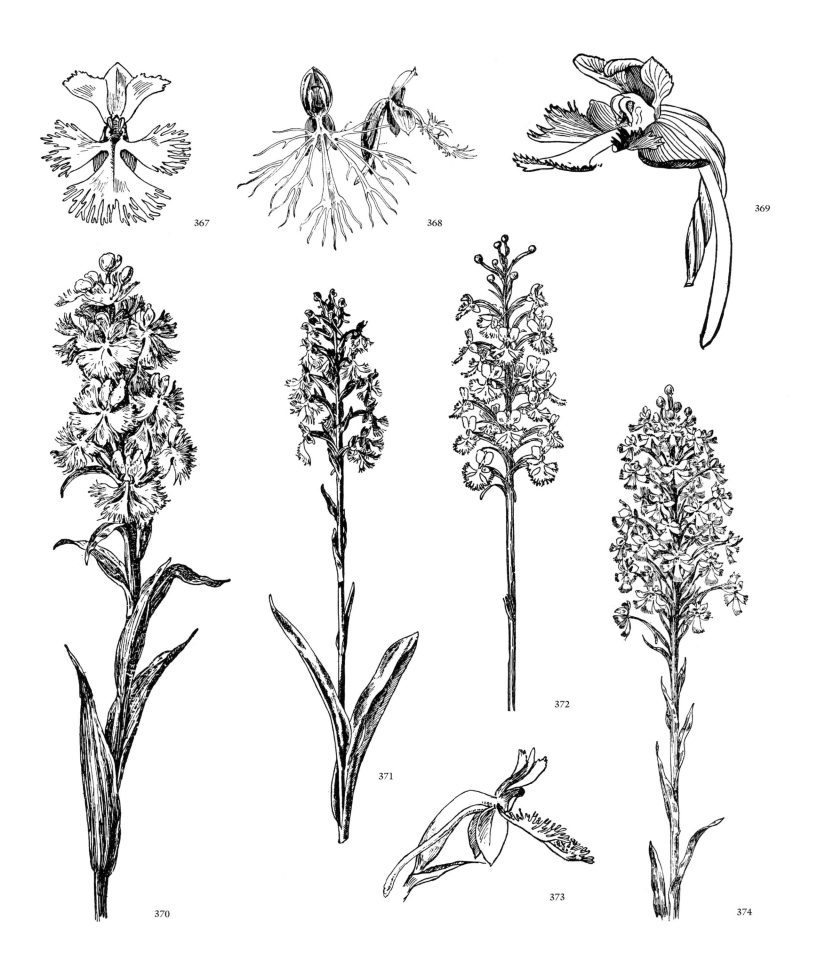

367, 370, 373. Large Purple Fringed Orchid (*Habenaria psycodes*). **368, 371.** Ragged Fringed Orchid (*Habenaria lacera*). **369, 372, 374.** Small Purple Fringed Orchid (*Habenaria psycodes*).

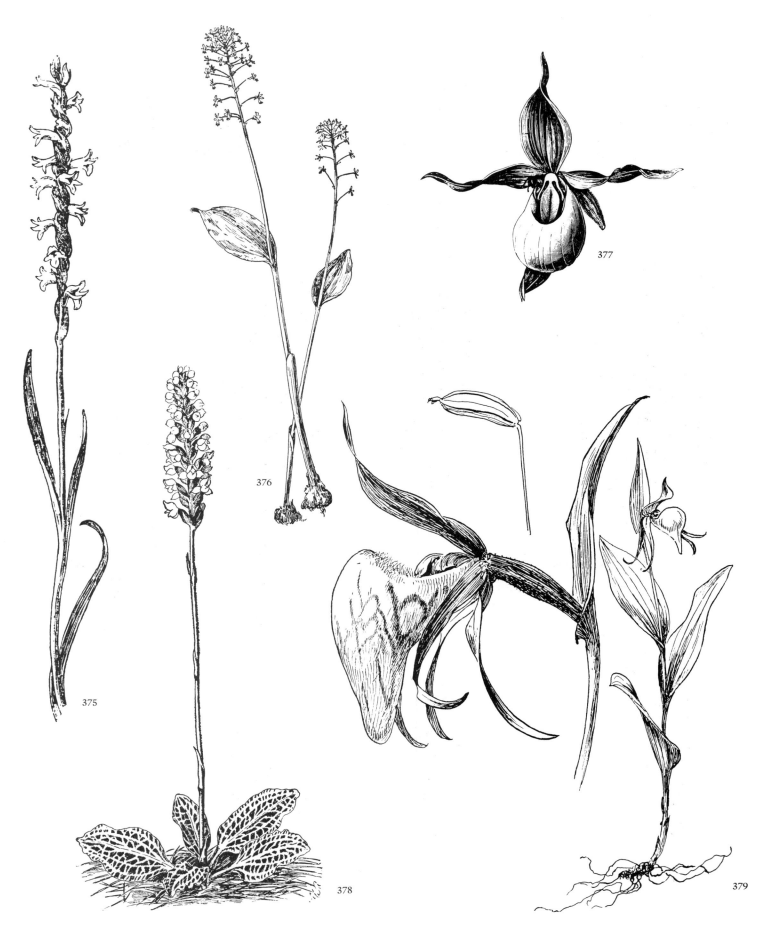

375. Nodding Ladies' Tresses (*Spiranthes cernua*). **376.** Green Adder's Mouth (*Malaxis unifolia*). **377.** European Lady's Slipper (*Cypripedium calceolus*). **378.** Downy Rattlesnake Plantain (*Goodyera pubescens*). **379.** Ram's Head Lady's Slipper (*Cypripedium arietinum*).

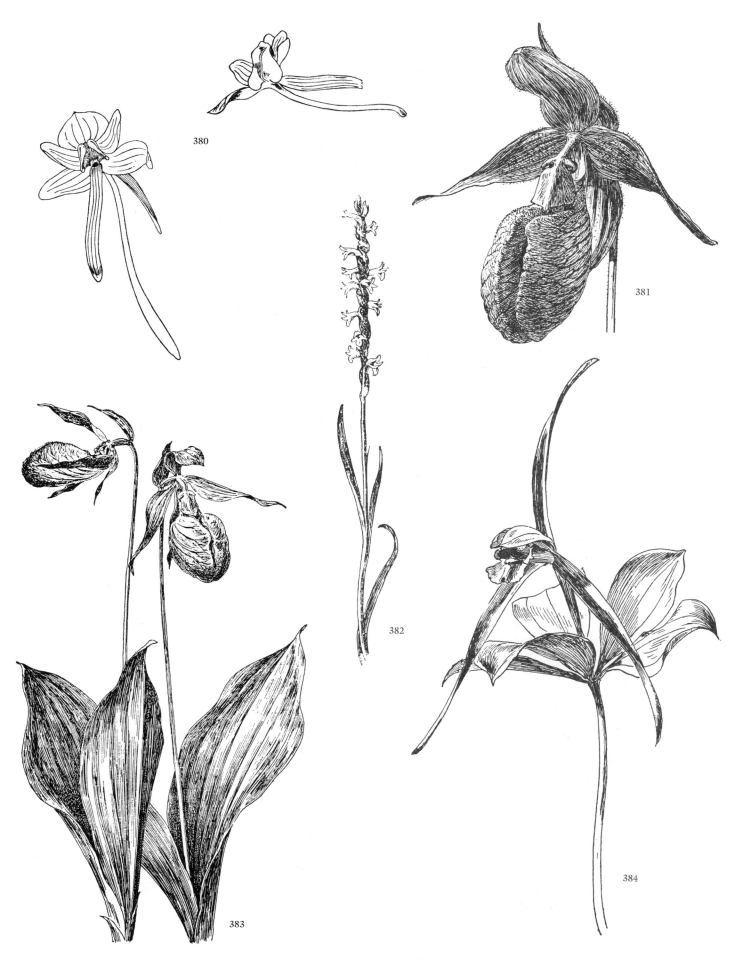

380. Bog-Candle (*Habenaria dilatata*). 381, 383. Pink Lady's Slipper (*Cypripedium acaule*). 382. Nodding Ladies' Tresses (*Spiranthes cernua*). 384. Whorled Pogonia (*Isotria verticillata*).

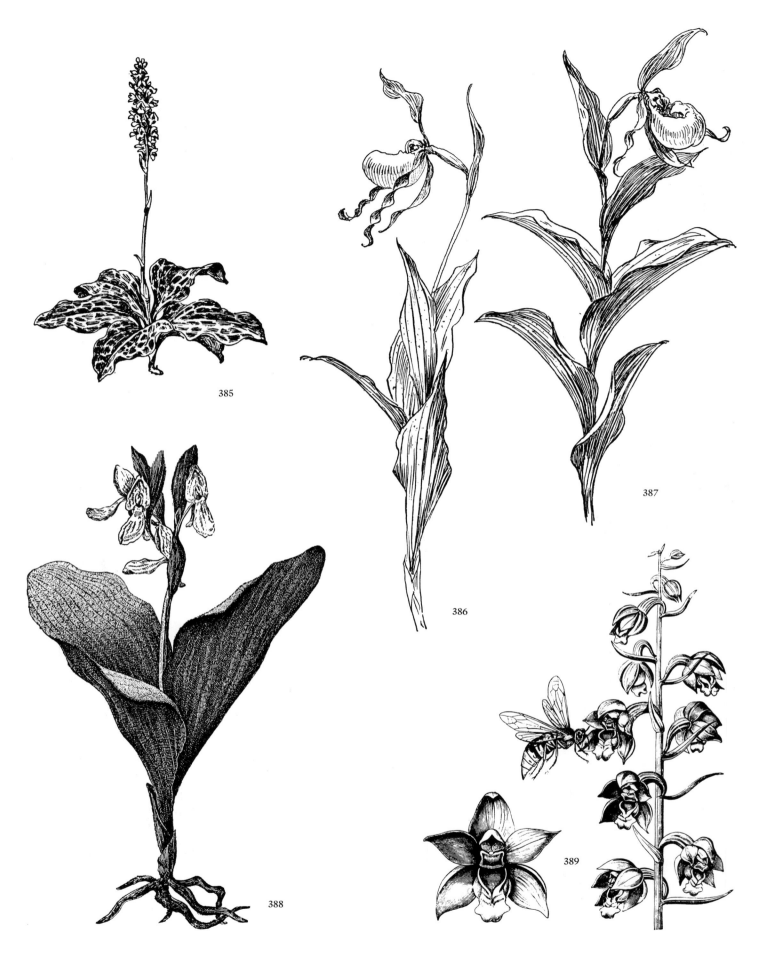

385. Downy Rattlesnake Plantain (*Goodyera pubescens*). **386.** Small Yellow Lady's Slipper (*Cypripedium calceolus* var. *parviflorum*). **387.** Large Yellow Lady's Slipper (*Cypripedium calceolus* var. *pubescens*). **388.** Showy Orchid (*Orchis spectabilis*). **389.** Helleborine Orchid (*Epipactis helleborine*).

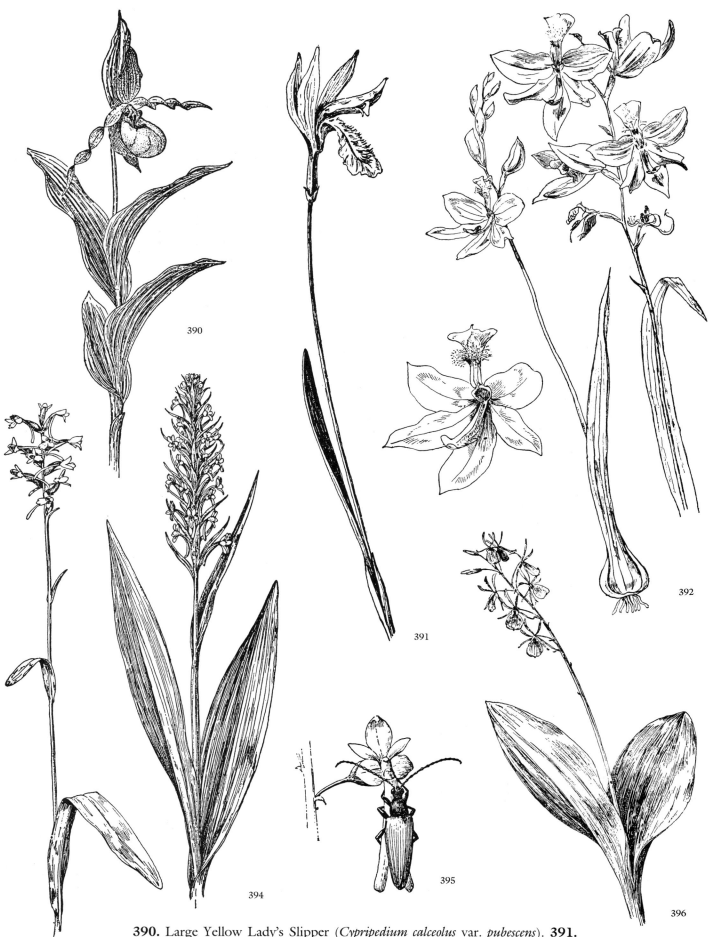

390. Large Yellow Lady's Slipper (*Cypripedium calceolus* var. *pubescens*). **391.** Dragon's Mouth (*Arethusa bulbosa*). **392.** Grass Pink (*Calopogon pulchellus*). **393.** Green Wood Orchid (*Habenaria clavellata*). **394.** Pale Green Orchid (*Habenaria flava*). **395.** Beetle on Twayblade (*Liparis* sp.). **396.** Large Twayblade (*Liparis liliifolia*).

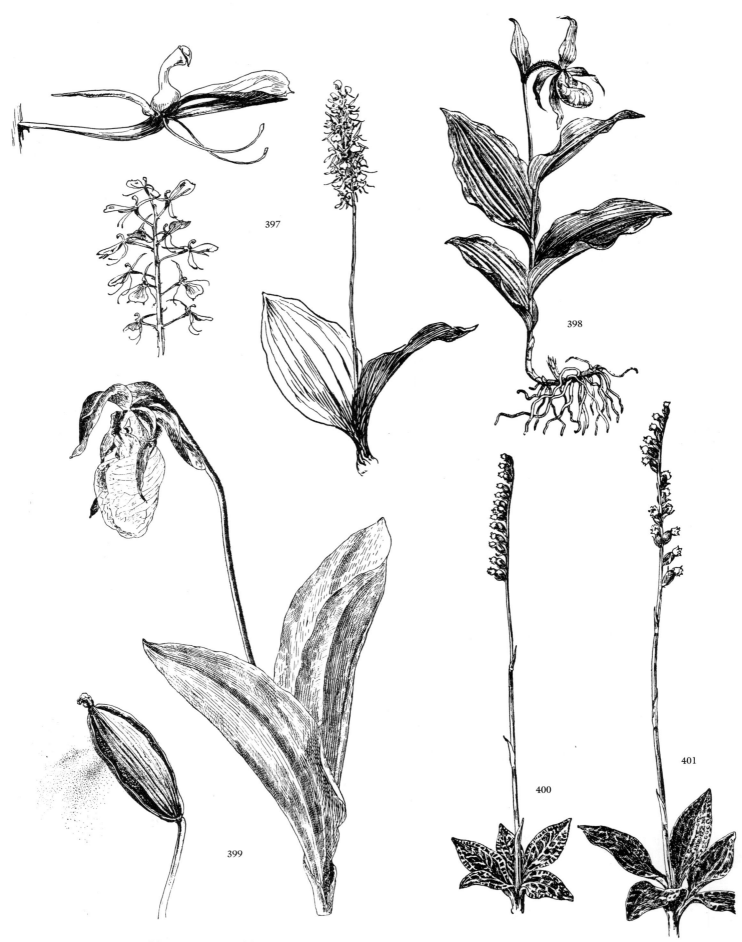

397. Large Twayblade (*Liparis liliifolia*). **398.** European Lady's Slipper (*Cypripedium calceolus*). **399.** Pink Lady's Slipper (*Cypripedium acaule*). **400.** Lesser Rattlesnake Plantain (*Goodyera repens*). **401.** Loddige's Rattlesnake Plantain (*Goodyera tesselata*).

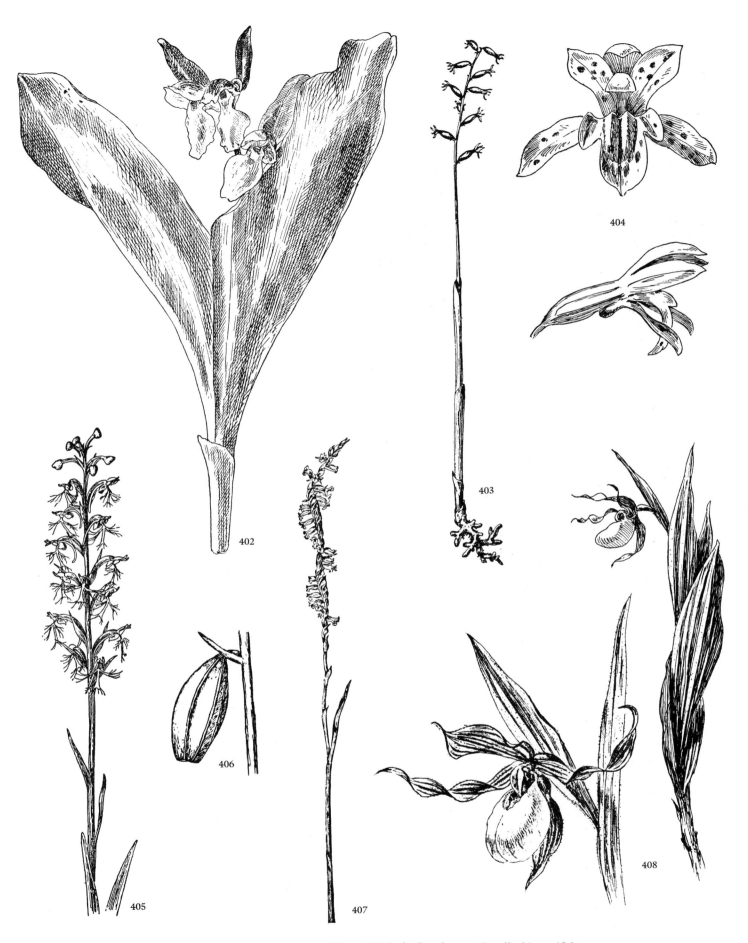

402. Showy Orchid (*Orchis spectabilis*). **403.** Pale Coralroot (*Corallorhiza trifida*). **404.** Spotted Coralroot (*Corallorhiza maculata*). **405.** Ragged Fringed Orchid (*Habenaria lacera*). **406.** Seed Pod of Coralroot (*Corallorhiza* sp.). **407.** Nodding Ladies' Tresses (*Spiranthes cernua*). **408.** Small White Lady's Slipper (*Cypripedium candidum*).

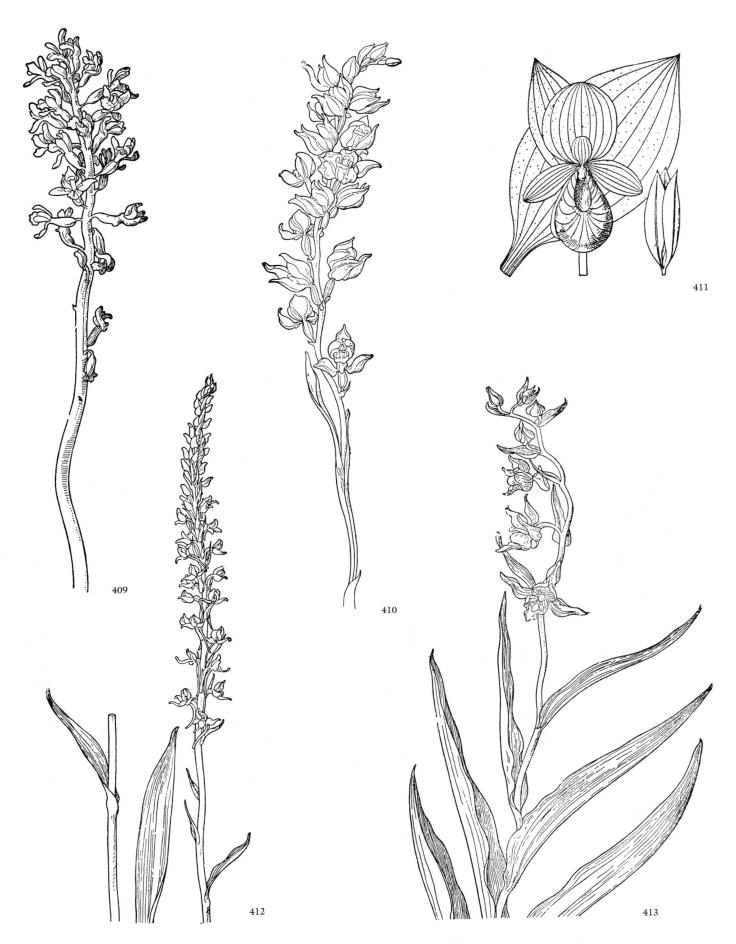

409. Western Coralroot (*Corallorhiza mertensiana*). **410.** Phantom Orchid (*Cephalanthera austinae*). **411.** Showy Lady's Slipper (*Cypripedium reginae*). **412.** Sierra Rein Orchid (*Habenaria dilatata*). **413.** Giant Helleborine Orchid (*Epipactis gigantea*).

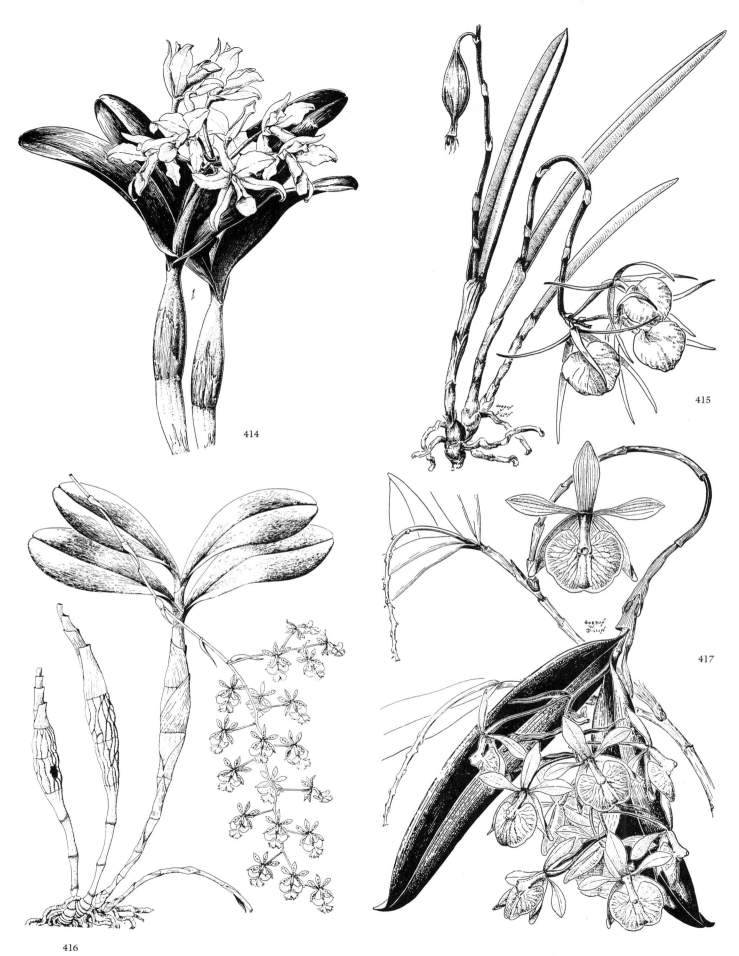

414. *Cattleya pachecoi.* **415.** *Brassavola nodosa.* **416.** *Epidendrum stamfordianum.*
417. *Epidendrum alticola.*

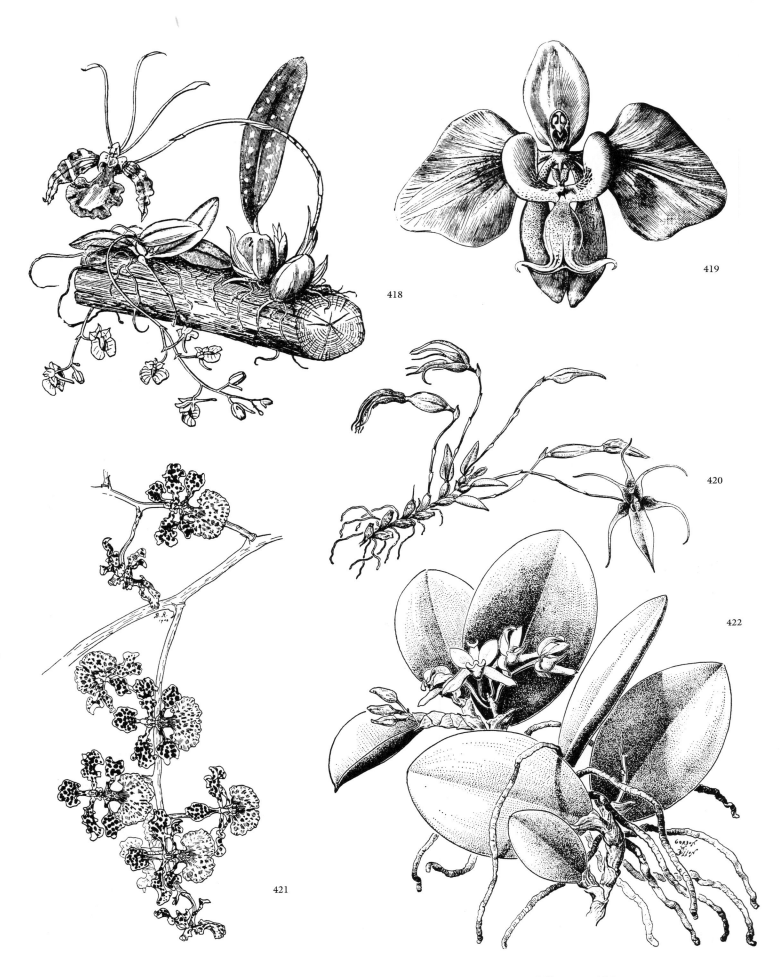

418. Air Plants of the Orchid Family. **419.** *Phalaenopsis schillerana.* **420.** *Homalopetalum pumilio.* **421.** *Oncidium luridum.* **422.** *Meiracyllium trinasutum.*

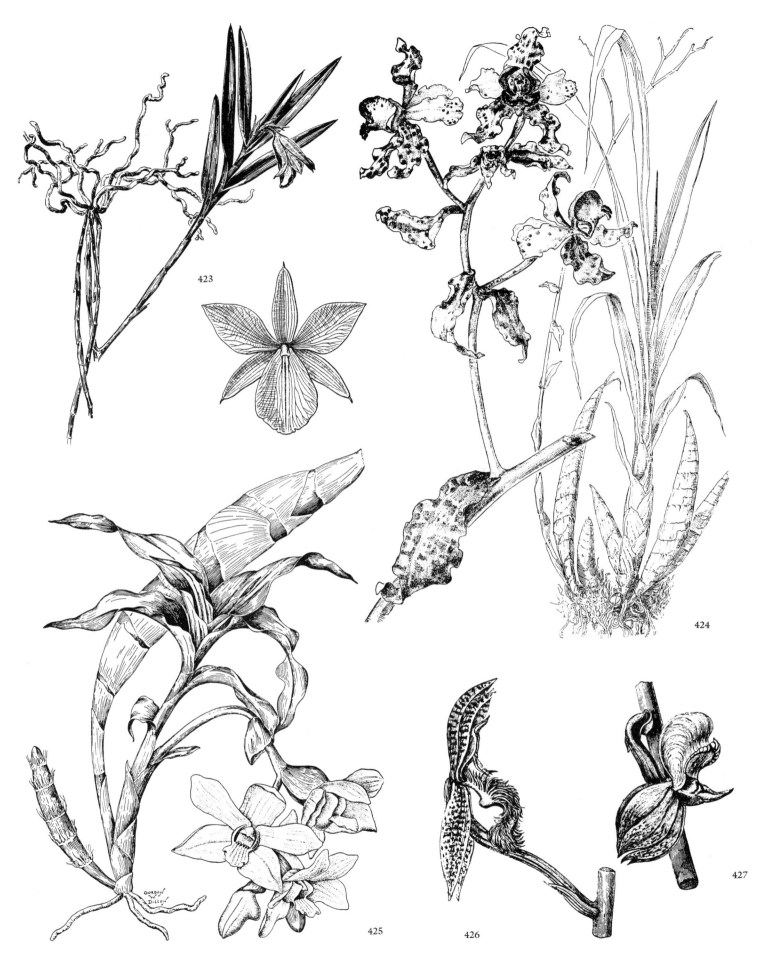

423. *Epidendrum sobralioides.* **424.** *Cyrtopodium punctatum.* **425.** *Chysis aurea.*
426. *Myanthus barbatus.* **427.** *Monachanthus viridis.*

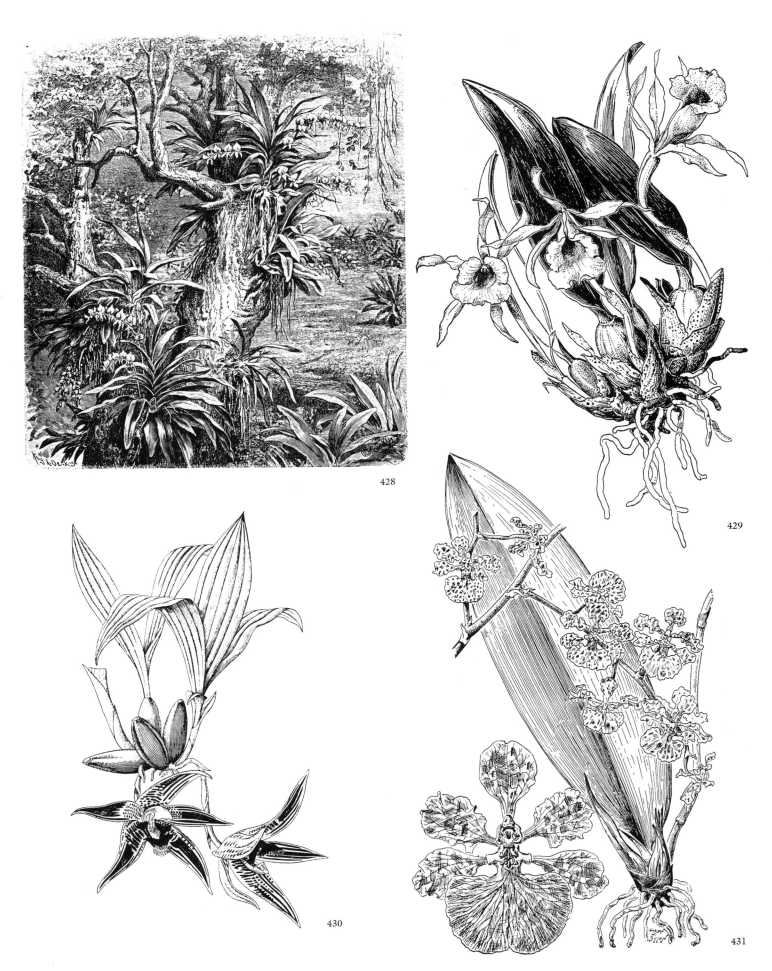

428. *Angraecum superbum.* **429.** *Trichopilia maculata.* **430.** *Paphinia cristata.*
431. *Oncidium luridum.*

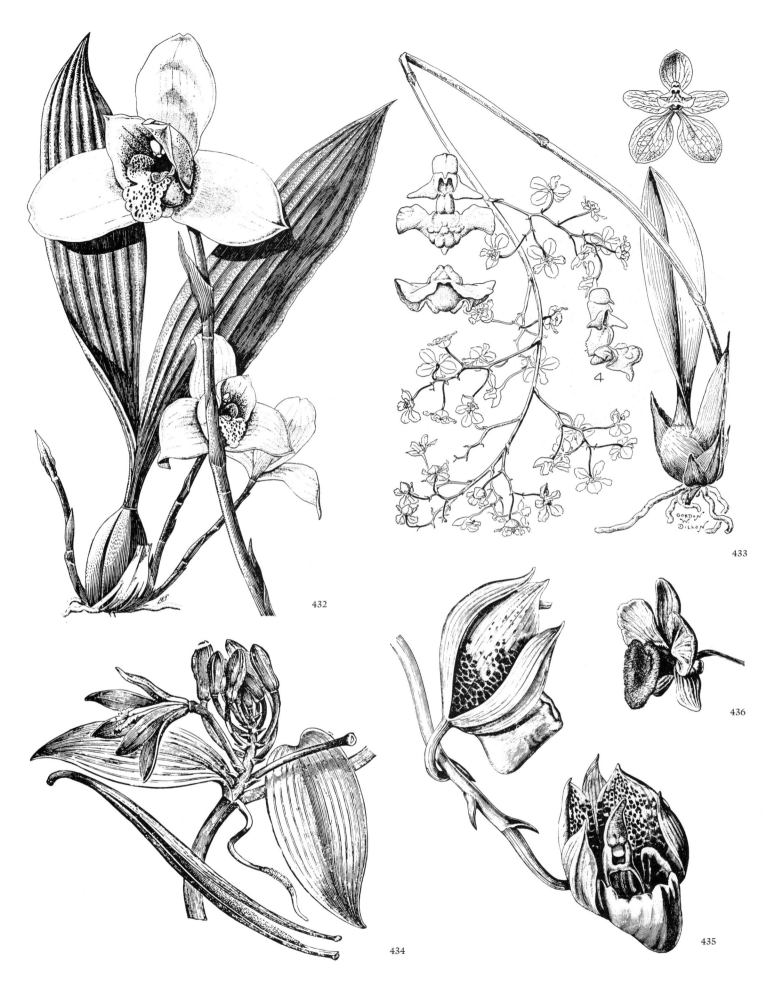

432. *Lycaste virginalis.* **433.** *Oncidium microchilum.* **434.** *Vanilla planifolia.* **435.** *Catasetum macrocarpum.* **436.** *Dendrobium fimbriatum.*

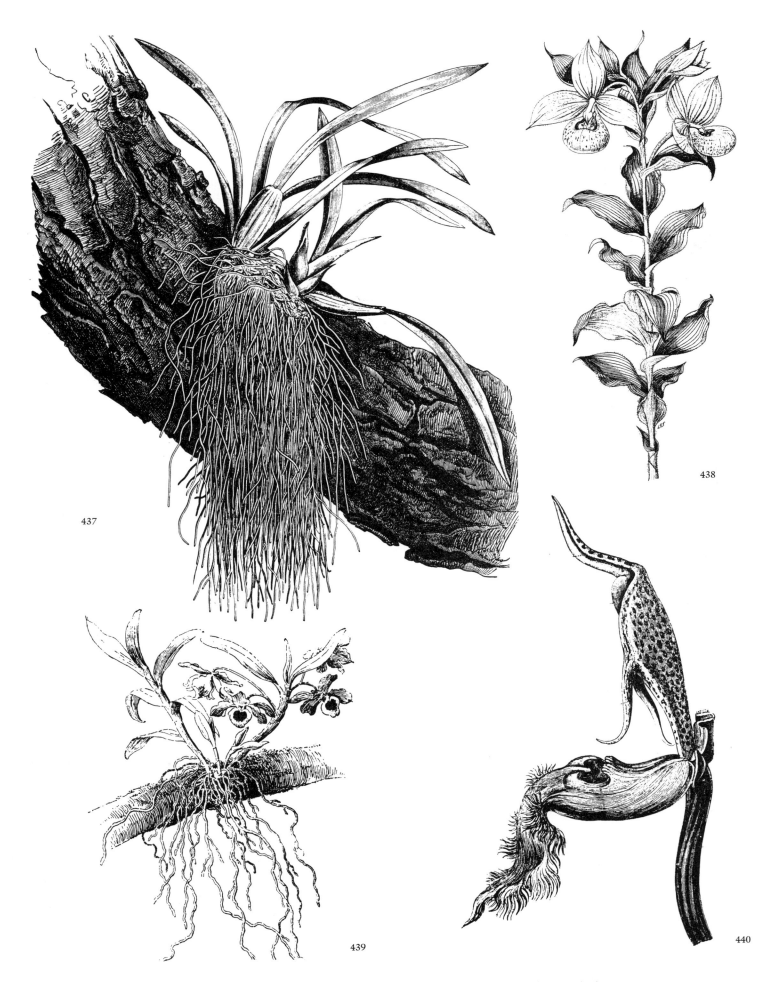

437. Aerial Roots of an Orchid. **438.** *Cypripedium irapeanum.* **439.** Tropical
Epiphyte. **440.** *Catasetum saccatum.*

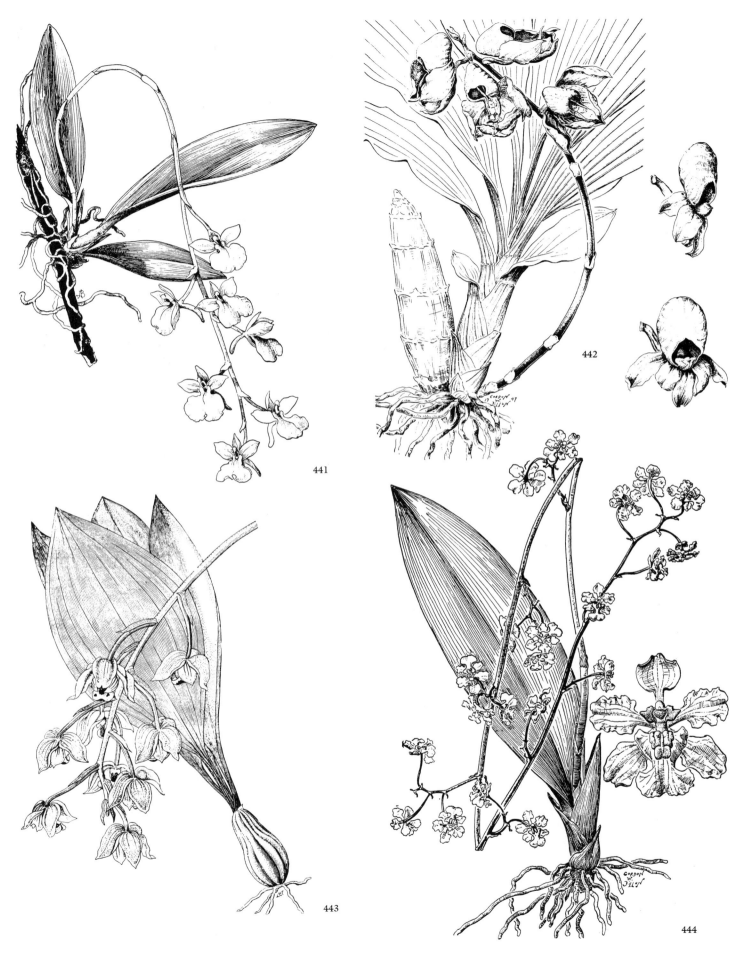

441. *Comparettia falcata.* **442.** *Catasetum integerrimum.* **443.** *Lacaena bicolor.*
444. *Oncidium carthagenense.*

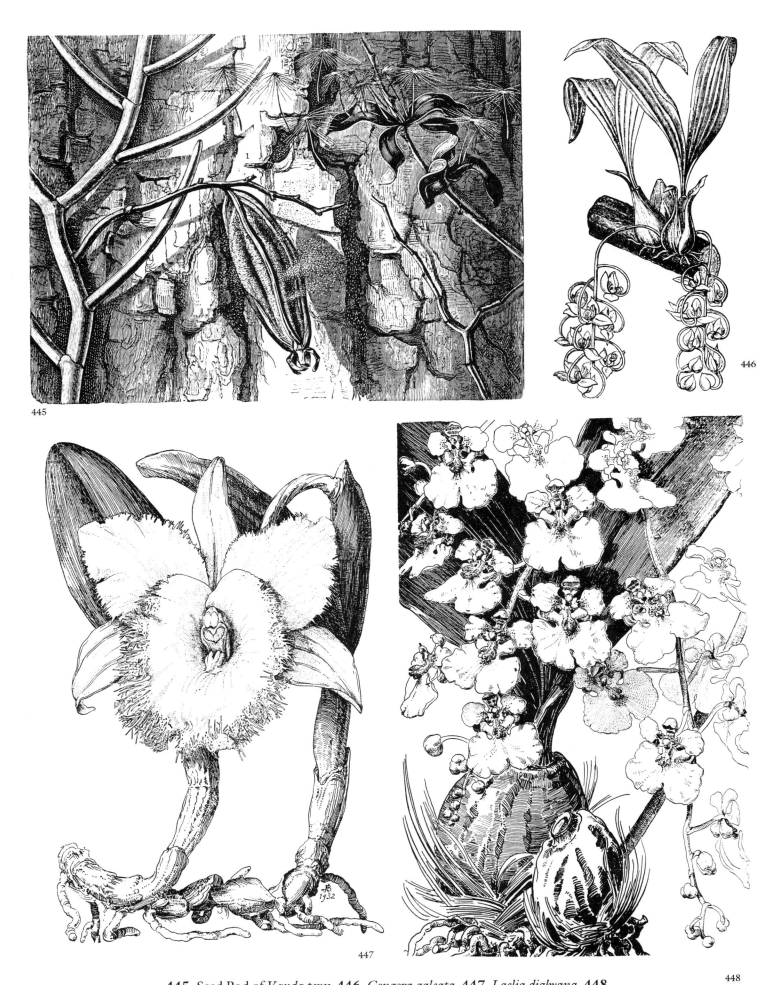

445 446 447 448

445. Seed Pod of *Vanda teres*. **446.** *Gongora galeata*. **447.** *Laelia digbyana*. **448.** *Oncidium* sp.

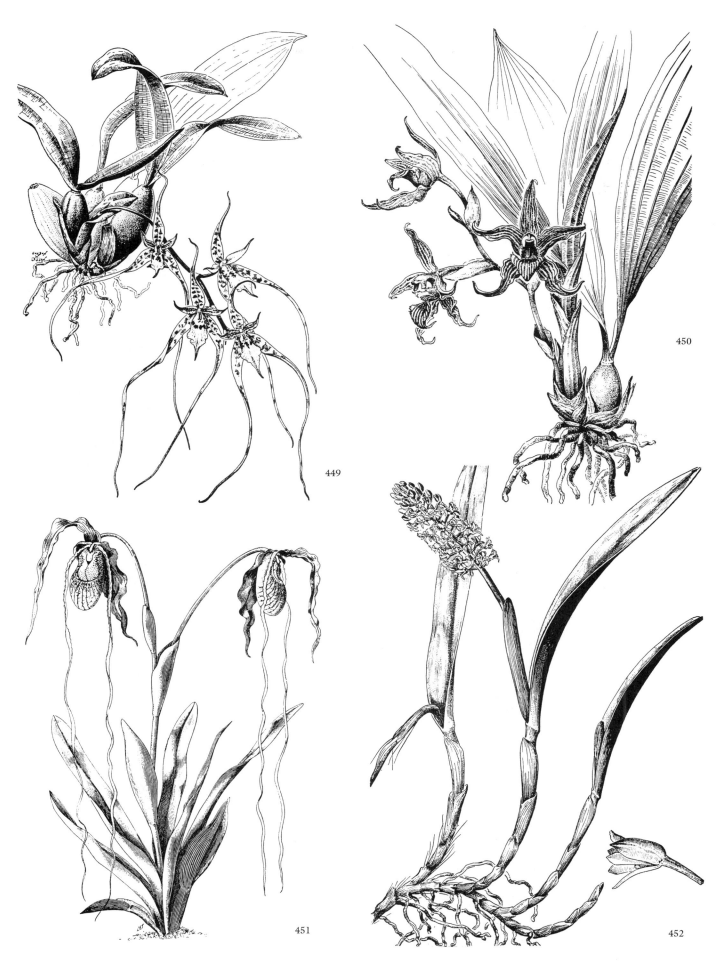

449. *Brassia caudata.* 450. *Zygopetalum grandiflorum.* 451. *Phragmipedium caudatum.* 452. *Arpophyllum alpinum.*

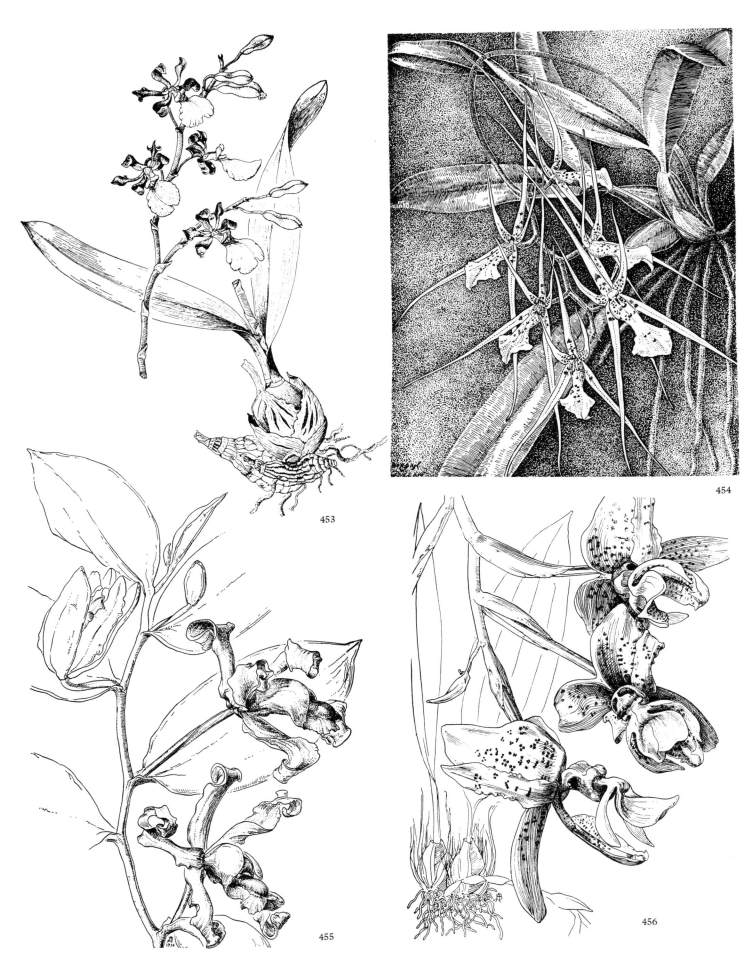

453

454

455

456

453. *Epidendrum atropurpureum.* **454.** *Brassia verrucosa.* **455.** *Vanilla pfaviana.*
456. *Stanhopea wardii.*

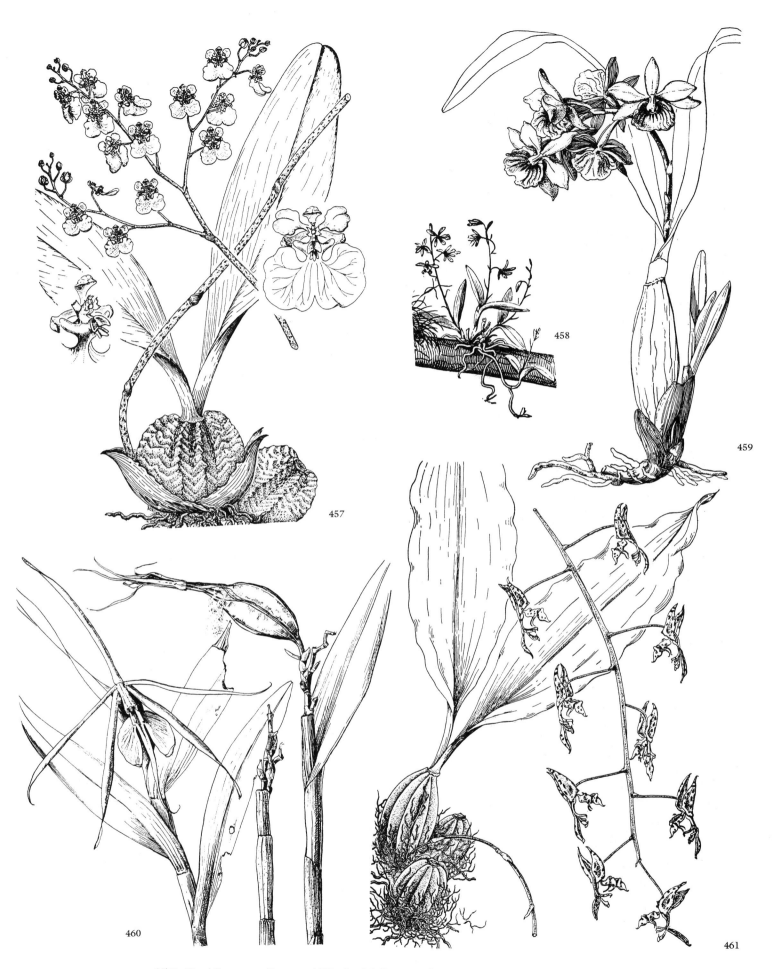

457. *Oncidium ampliatum.* 458. Aerial Roots of an Orchid. 459. *Epidendrum radiatum.* 460. *Epidendrum nocturnum.* 461. *Gongora maculata.*

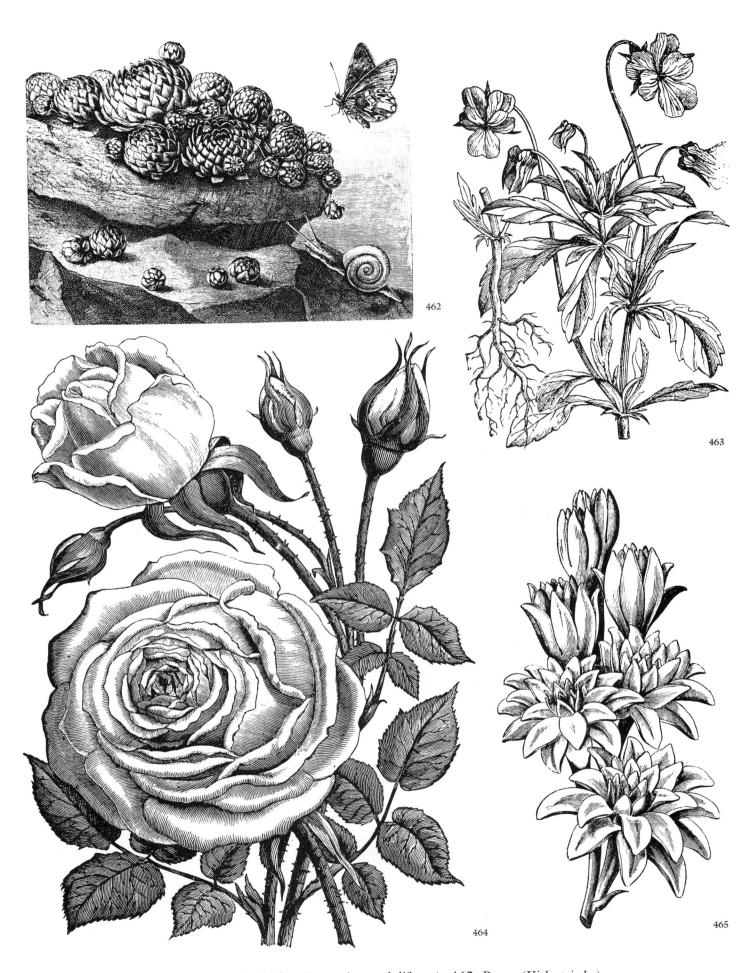

462. Hens and Chicks (*Sempervivum soboliferum*). **463.** Pansy (*Viola tricolor*).
464. Queen's Scarlet Garden Rose. **465.** Double Tuberose.

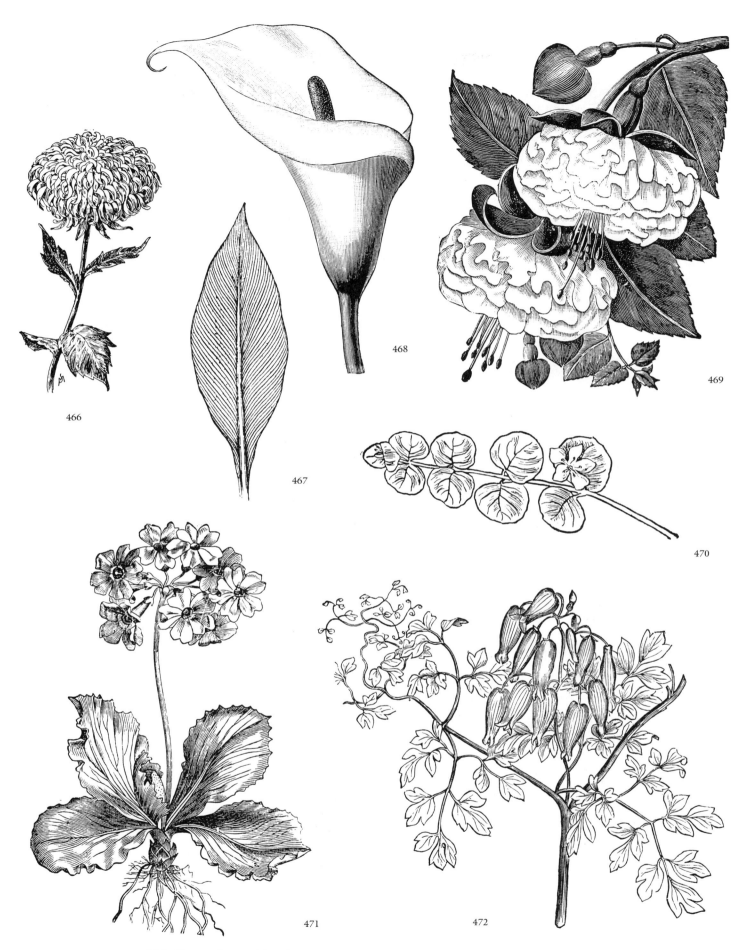

466. Comet Aster. **467.** Canna Lily Leaf. **468.** Calla Lily. **469.** Garden Fuchsia.
470. Moneywort (*Lysimachia nummularia*). **471.** European Primrose (*Primula auricula*). **472.** Climbing Fumitory (*Adlumia fungosa*).

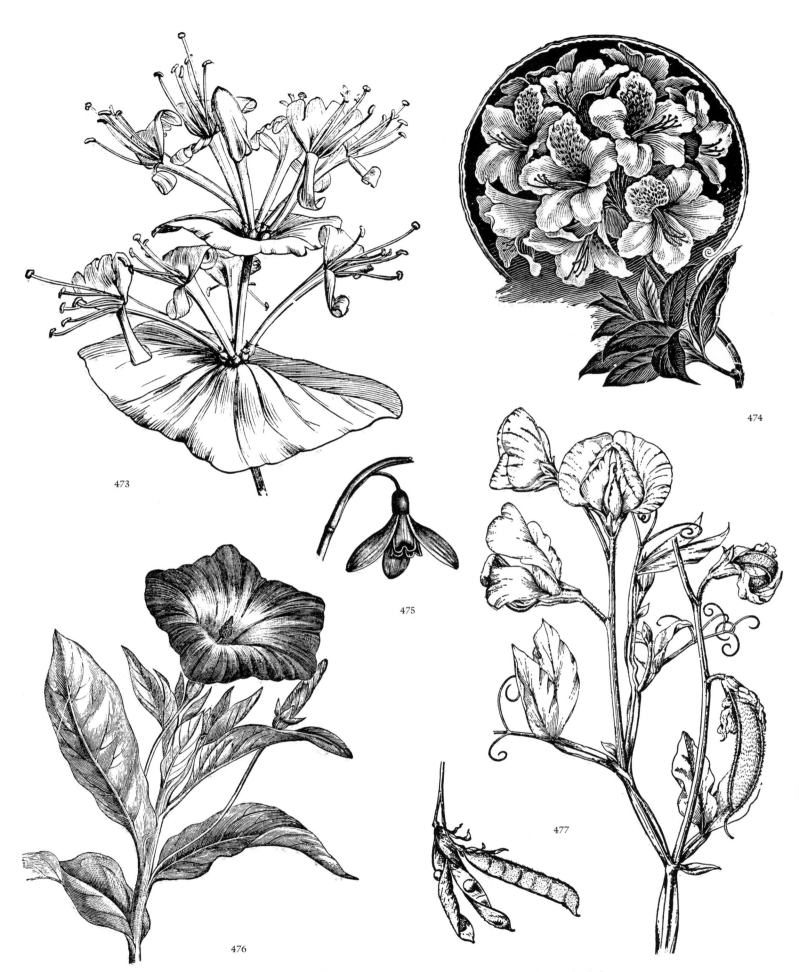

473. Glaucous Honeysuckle (*Lonicera dioica*). **474.** Garden Azalea (*Rhododendron molle*). **475.** Snowdrop (*Galanthus nivalis*). **476.** Ornamental Bindweed (*Convolvulus tricolor*). **477.** Perennial Sweet Pea (*Lathyrus latifolius*).

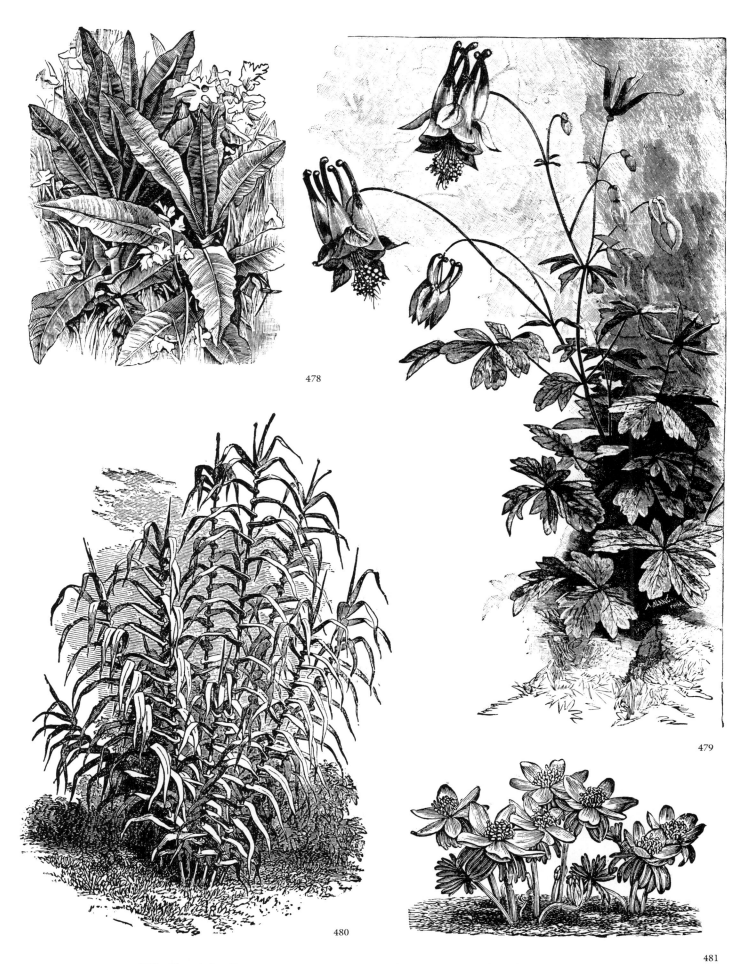

478. Abyssinian Banana (*Ensete ventricosum*). **479.** Canada Columbine (*Aquilegia canadensis*). **480.** Green-leaved Bamboo (*Arundo donax*). **481.** Winter Aconite (*Eranthis hyemalis*).

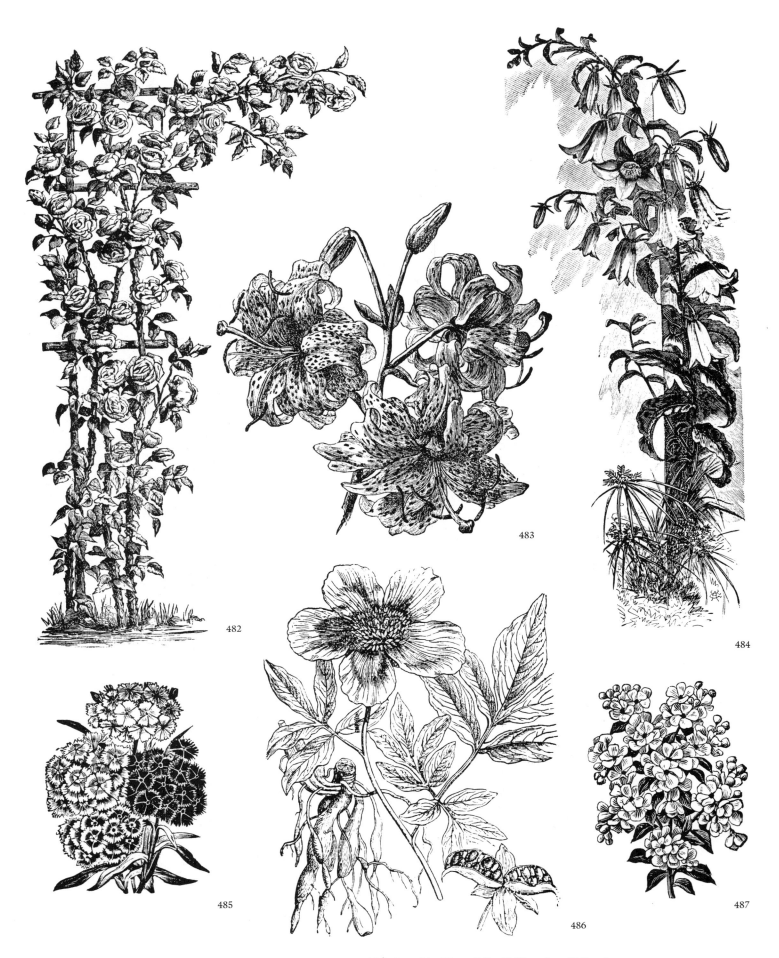

482. Prairie Queen Garden Rose. **483.** Double Tiger Lily (*Lilium lancifolium*).
484. Ornamental Harebell (*Campanula tenori*). **485.** Sweet William (*Dianthus barbatus*). **486.** Peony (*Paeonia officinalis*). **487.** *Exochorda racemosa*.

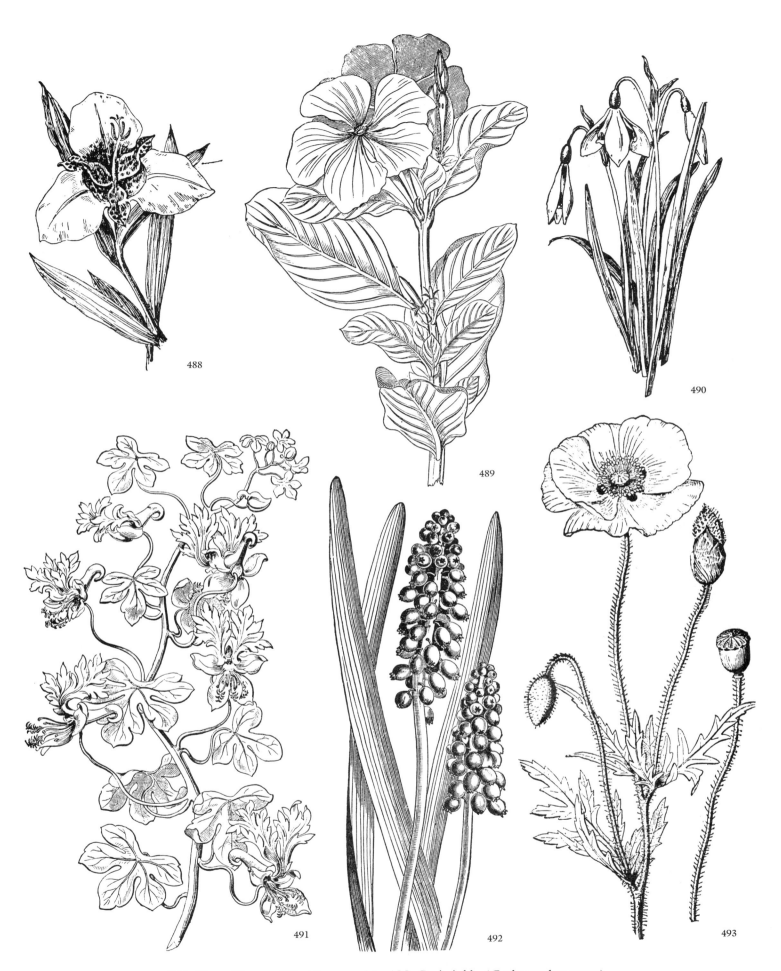

488. Tiger Flower (*Tigridia pavonia*). **489.** Periwinkle (*Catharanthus roseus*). **490.** Snowdrop (*Galanthus nivalis*). **491.** *Tropaeolium perigrinum*. **492.** Grape Hyacinth (*Muscari racemosum*). **493.** Garden Poppy (*Papaver rhoeas*).

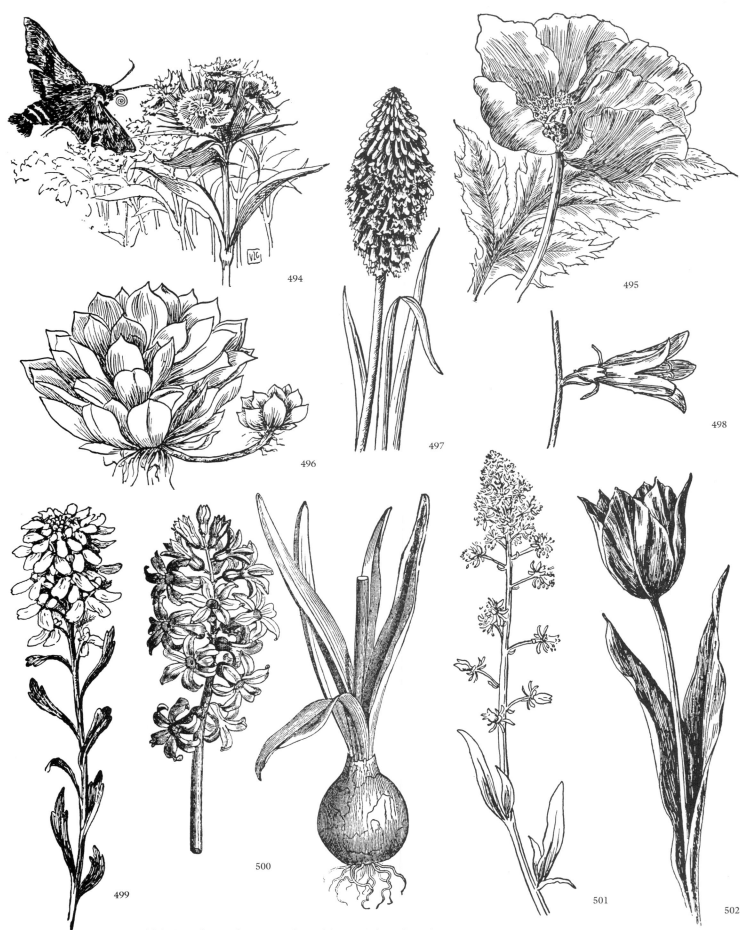

494. Hawk Moth on Garden Phlox. **495.** Oriental Poppy (*Papaver orientale*).
496. Houseleek (*Sempervivum tectorum*). **497.** Torch Lily (*Kniphofia uvaria*).
498. Creeping Bellflower (*Campanula rapunculoides*). **499.** Candytuft (*Iberis umbellata*). **500.** Hyacinth (*Hyacinthus orientalis*). **501.** Mignonette (*Reseda odorata*). **502.** Tulip (*Tulipa gesnerana*).

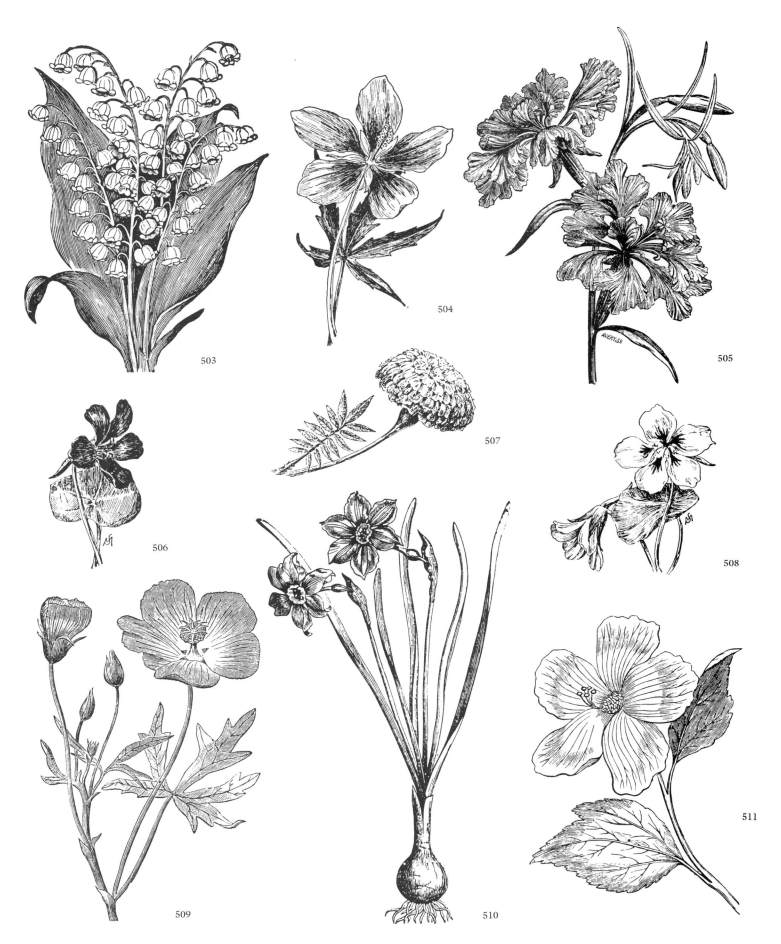

503. Lily of the Valley (*Convallaria majalis*). **504.** Scarlet Rose Mallow (*Hibiscus coccineus*). **505.** *Clarkia pulchella*. **506.** King Theodore Nasturtium. **507.** El Dorado Marigold. **508.** Asa Gray Nasturtium. **509.** Musk Mallow (*Malva moschata*). **510.** Narcissus (*Narcissus poeticus*). **511.** Garden Hibiscus (*Hibiscus moscheutos*).

ORNAMENTAL PLANTS **85**

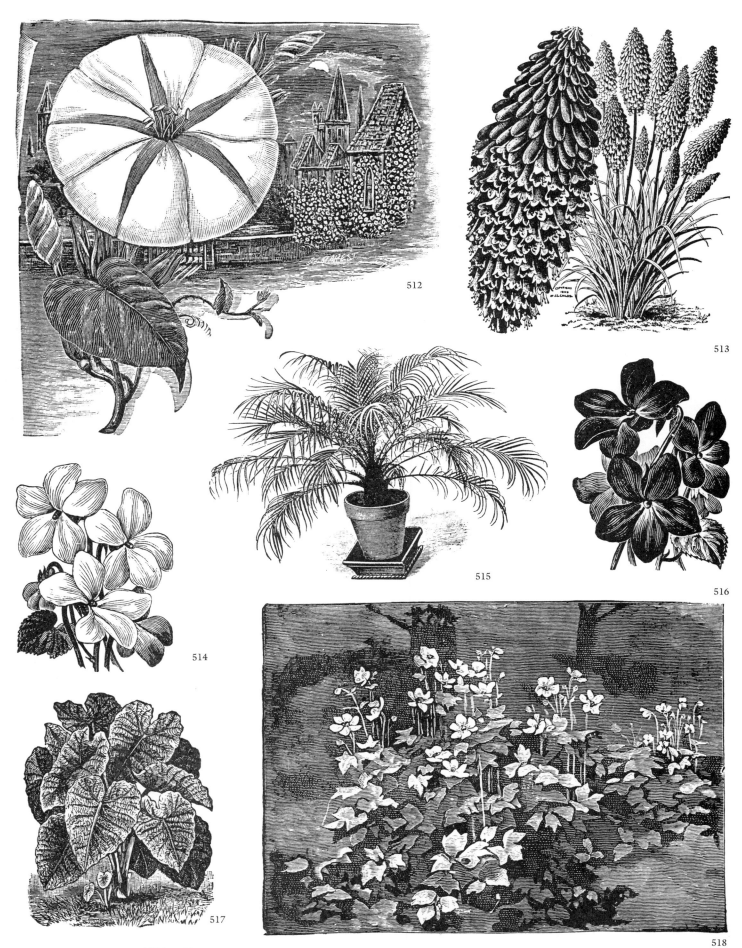

512. Giant Moon Flower (*Ipomoea maxima*). **513.** Red Hot Poker Plant (*Kniphofia* sp.). **514.** White Violet (*Viola* sp.). **515.** Garden Palm (*Phoenix roebelenii*). **516.** Blue Violet (*Viola* sp.). **517.** Elephant Ear (*Colocasia esculenta*). **518.** Japanese Windflower (*Anemone hupehensis*).

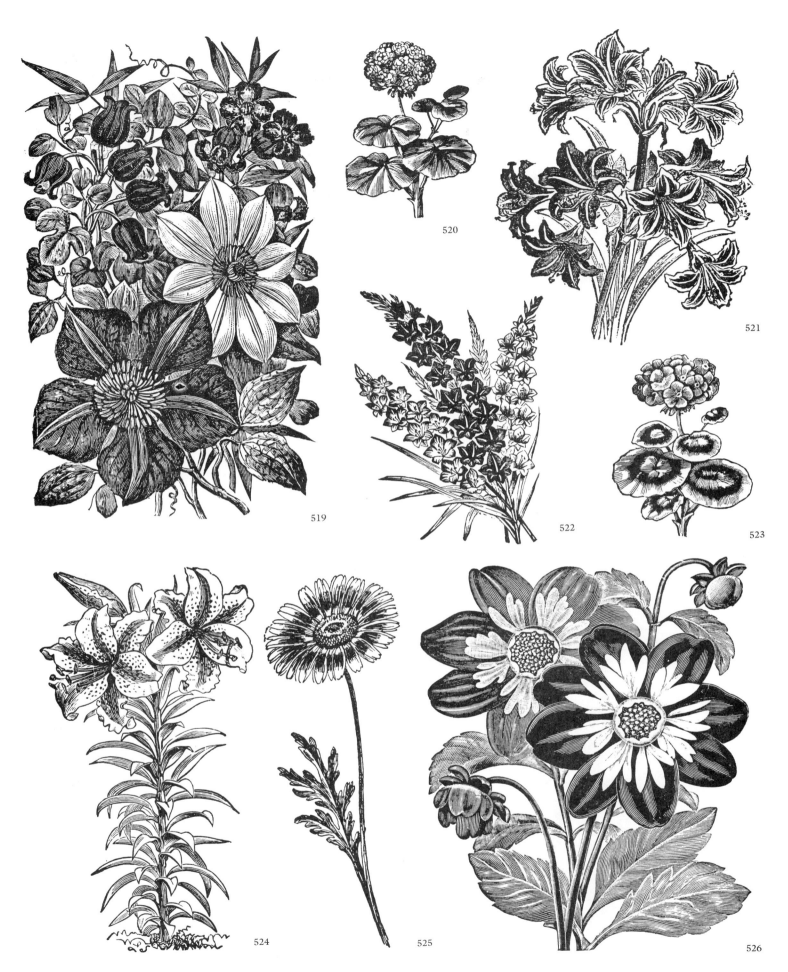

519. Ornamental Clematis Vines. **520.** Double Geranium. **521.** Amaryllis. **522.** Gladiolus. **523.** Single Geranium. **524.** Lily (*Lilium auratum*). **525.** Summer Chrysanthemum (*Chrysanthemum coronarium*). **526.** Garden Dahlia.

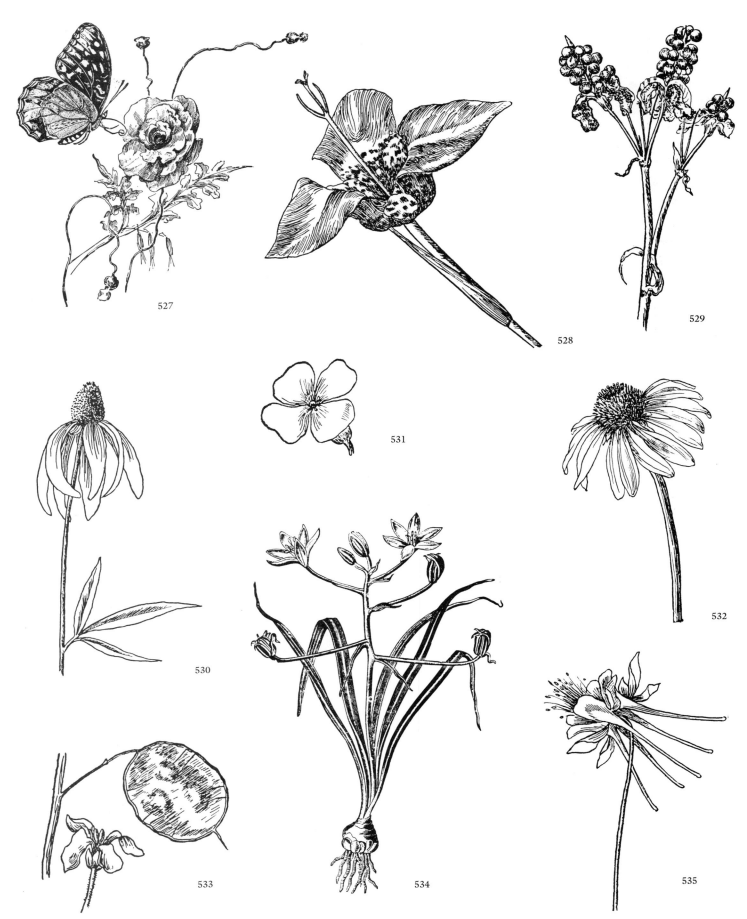

527. Butterfly on Old-fashioned Rose. 528. Tiger Flower (*Tigridia pavonia*).
529. Blackberry Lily (*Belamcanda chinensis*). 530. Prairie Coneflower (*Ratibida pinnata*). 531. Dame's Rocket (*Hesperis matronalis*). 532. Purple Coneflower (*Echinacea purpurea*). 533. Money Plant (*Lunaria annua*). 534. Star of Bethlehem (*Ornithogalum umbellatum*). 535. Golden Columbine (*Aquilegia chrysantha*).

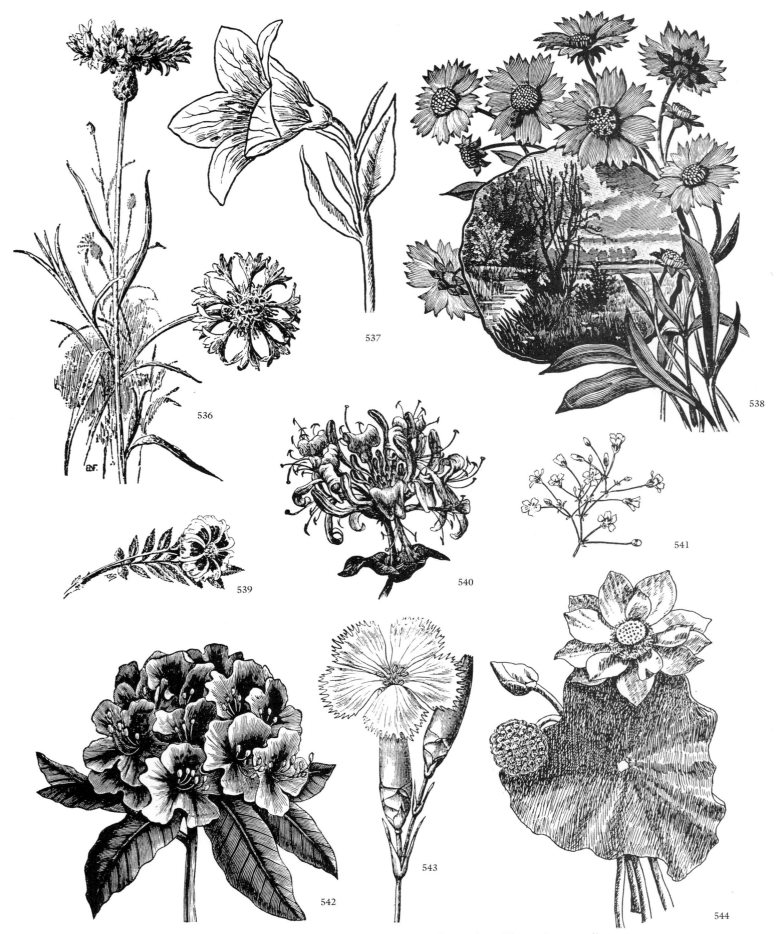

536. Bachelor's Button (*Centaurea cyanus*). **537.** Platycodon (*Platycodon grandiflorus*). **538.** *Coreopsis lanceolata*. **539.** Legion d'Honneur Marigold. **540.** European Sweet-scented Honeysuckle. **541.** Baby's Breath (*Gypsophila paniculata*). **542.** Rhododendron. **543.** Carnation (*Dianthus* sp.). **544.** Asian Water Lotus (*Nelumbo nucifera*).

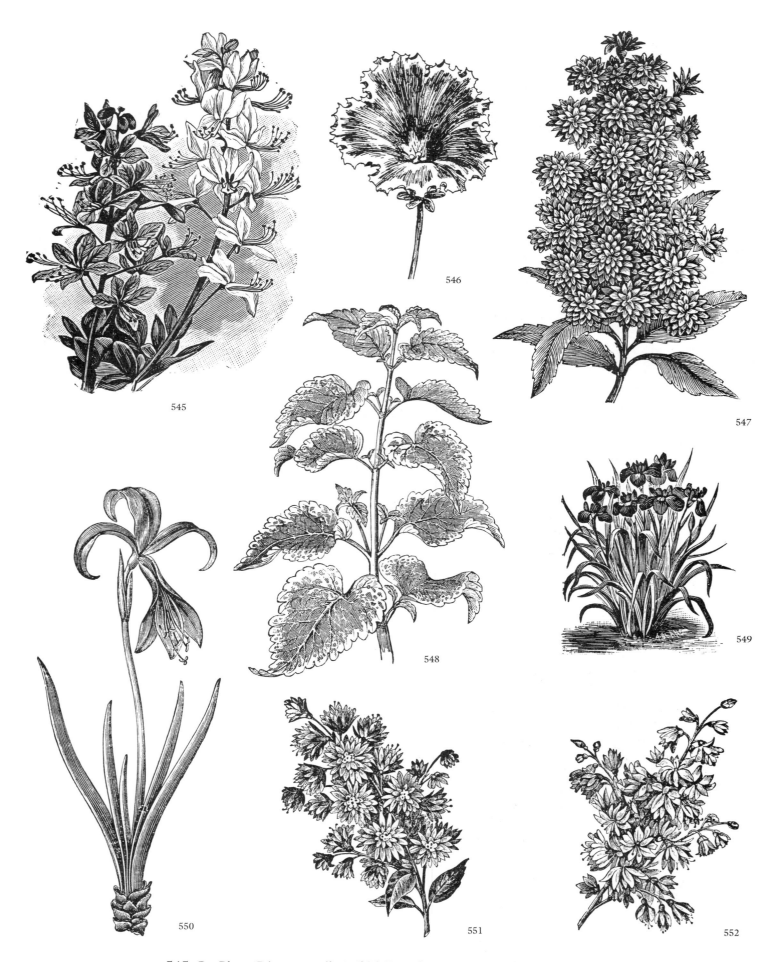

545. Gas Plant (*Dictamnus albus*). **546.** Petunia (*Petunia* sp.). **547, 551.** *Deutzia crenata.* **548.** Coleus (*Coleus blumei*). **549.** Japanese Iris (*Iris kaempferi*). **550.** Amaryllis (*Sprekelia formosissima*). **552.** *Deutzia scabra.*

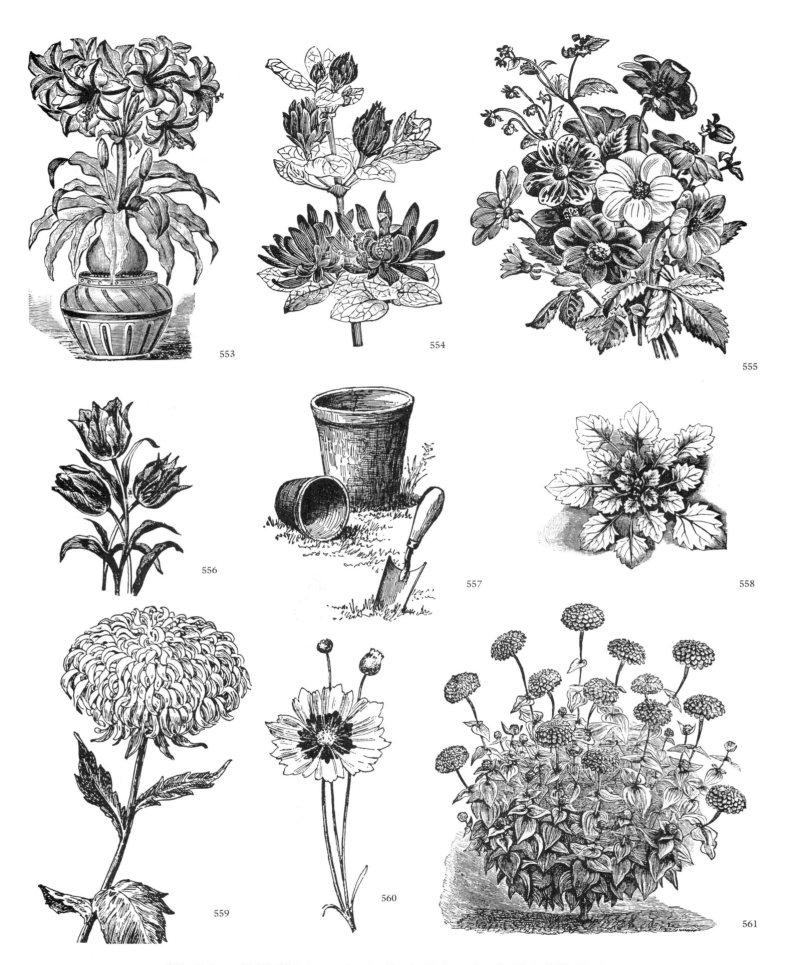

553. *Crinum kirkii.* **554.** Sweet-Scarlet Shrub (*Calycanthus floridus*). **555.** Single Dahlia. **556.** Tulip. **557.** Garden Tools. **558.** Bellflower (*Campanula cochleariifolia*). **559.** Comet Aster. **560.** Coreopsis (*Coreopsis tinctoria*). **561.** Double Zinnia.

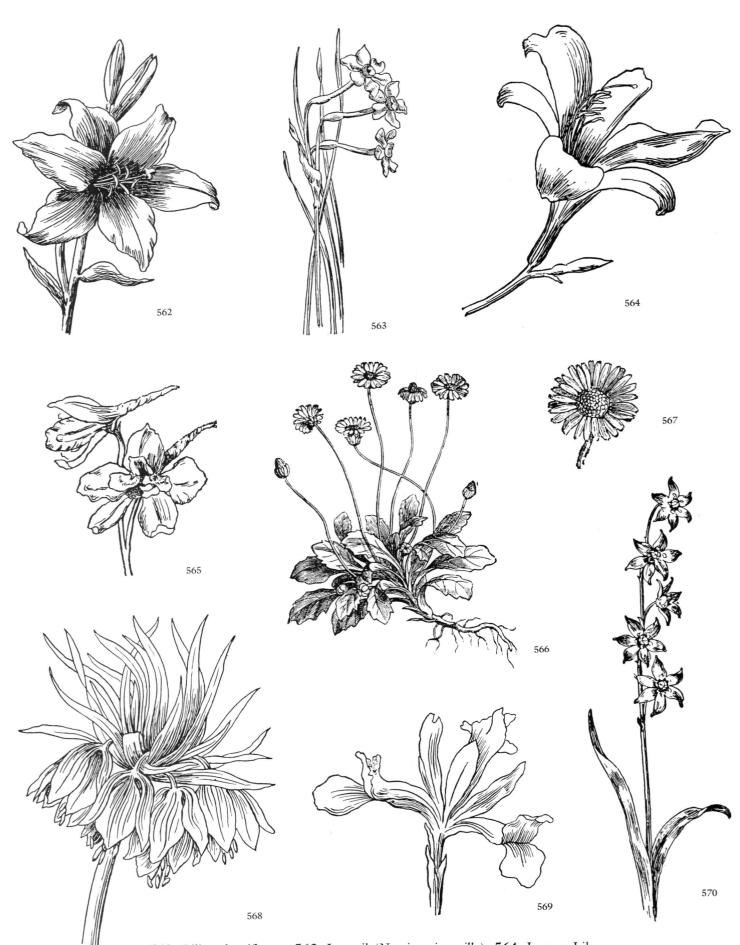

562. *Lilium longiflorum.* 563. Jonquil (*Narcissus jonquilla*). 564. Lemon Lily
(*Hemerocallis lilioasphodelus*). 565. Delphinium (*Delphinium* sp.). 566, 567.
English Daisy (*Bellis perennis*). 568. Crown Imperial (*Fritillaria imperialis*). 569.
Spanish Iris (*Iris xiphium*). 570. Squill.

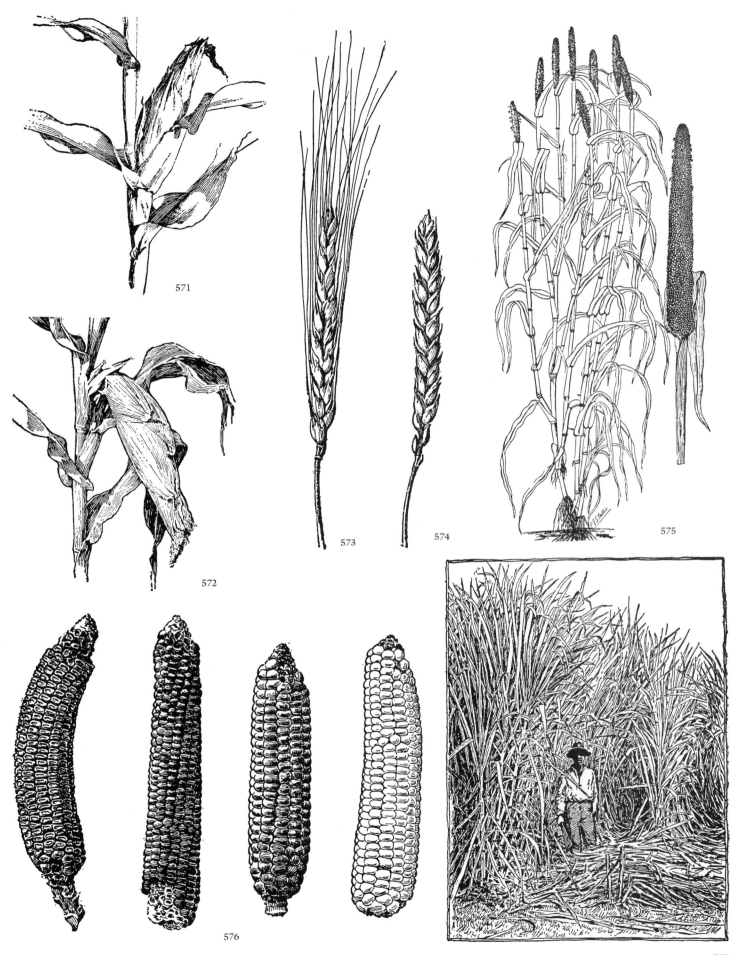

571, 572, 576. Corn (*Zea mays*). **573.** Red Wheat (*Triticum* sp.). **574.** Winter Wheat (*Triticum* sp.). **575.** Pearl Millet (*Pannisetum americanum*). **577.** Sugarcane (Saccharum officinarum).

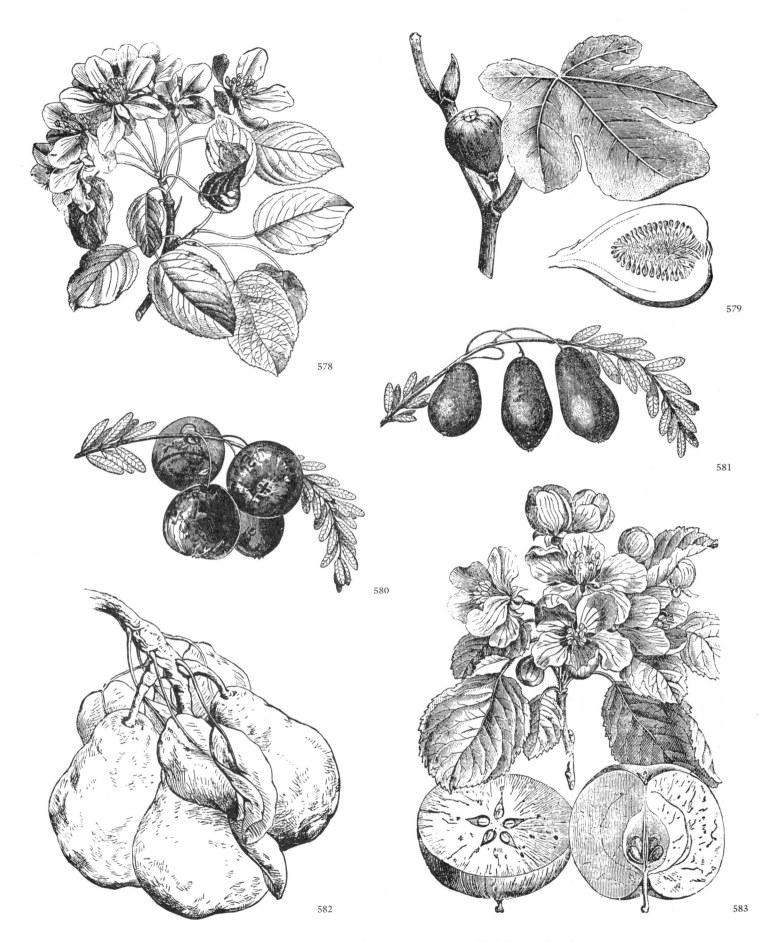

578, 582. Pear (*Pyrus communis*). **579.** Fig (*Ficus carica*). **580.** Large Cranberry (*Vaccinium* sp.). **581.** Pear-shaped Cranberry (*Vaccinium* sp.). **583.** Apple (*Malus sylvestris*).

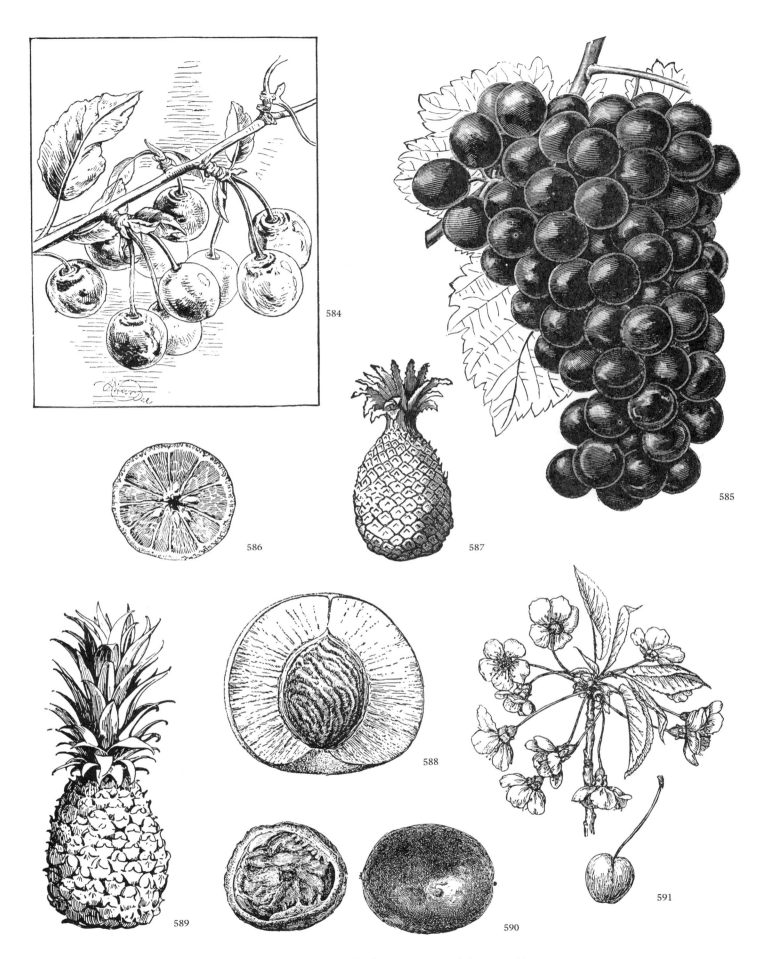

584, 591. Cherry (*Prunus avium*). **585.** Grape (*Vitus labrusca*). **586.** Tangerine (*Citrus reticulata*). **587, 589.** Pineapple (*Ananas comosus*). **588.** Peach (*Prunus persica*). **590.** Passion Flower (*Passiflora edulis*).

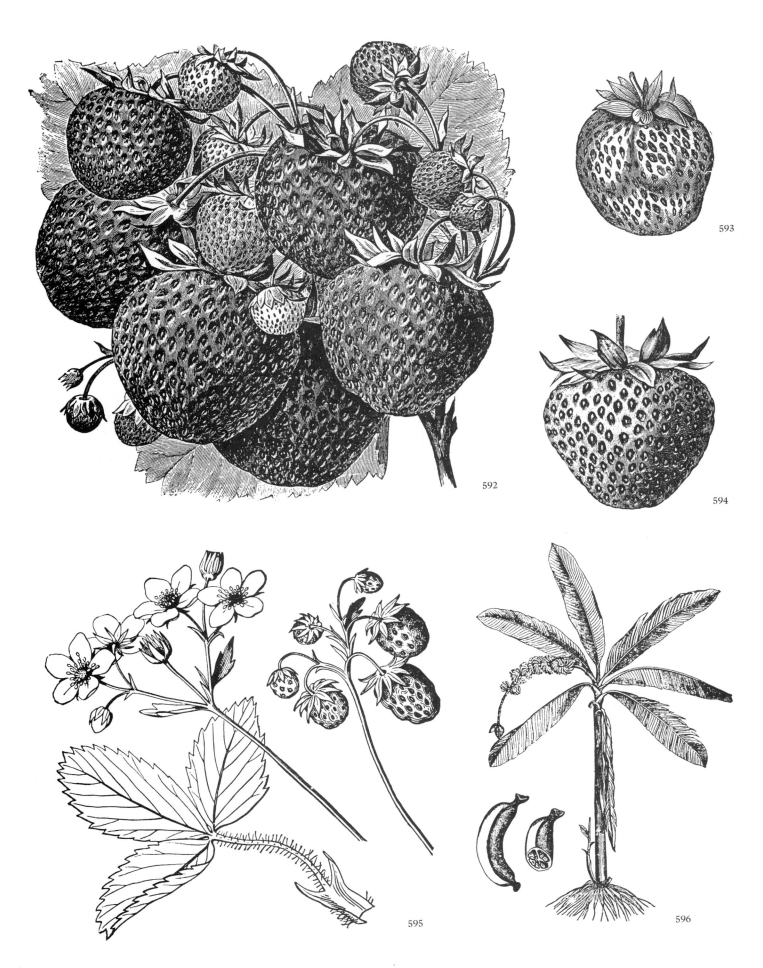

592–595. Strawberry (*Fragaria* sp.). **596.** Hemp Plant (*Musa textilis*).

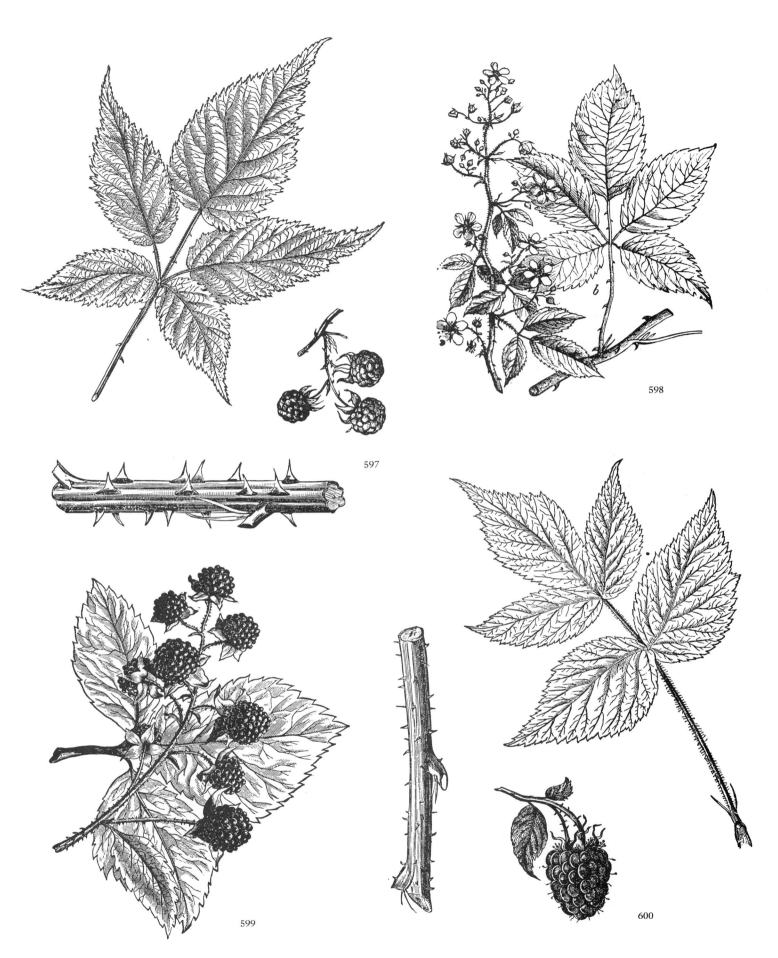

597. Leaf, Fruit and Stem of Typical Blackberry (*Rubus* sp.). **598, 599.** European Blackberry (*Rubus fruticosus*). **600.** Leaf, Fruit and Stem of Typical Raspberry (*Rubus* sp.).

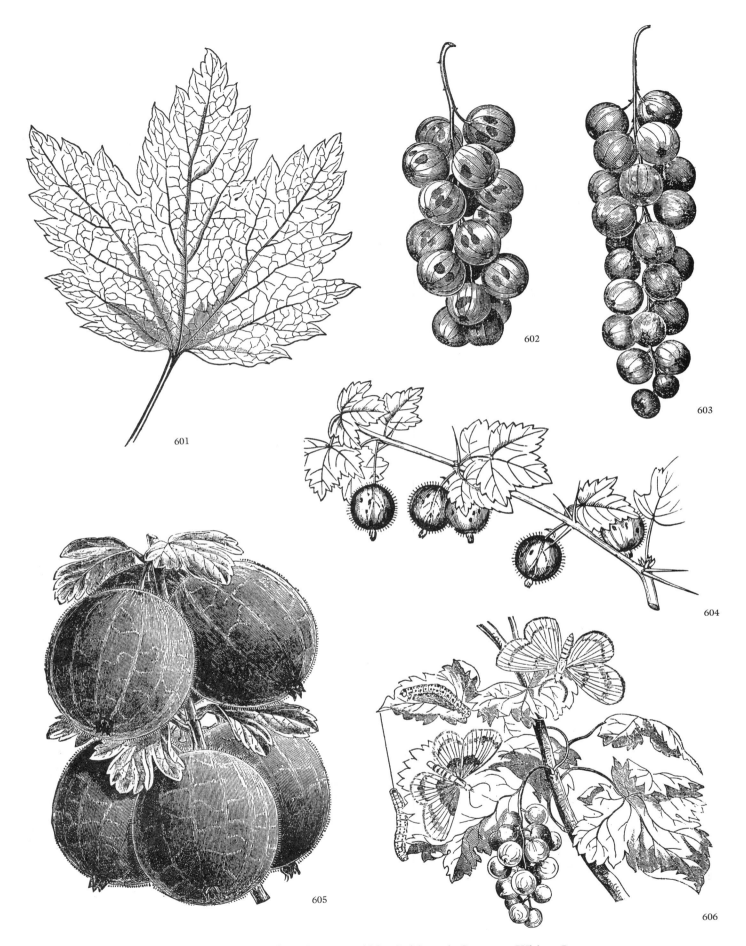

601. Gooseberry Leaf (*Ribes* sp.). **602.** Cultivated Currant—White Grape Variety (*Ribes* sp.). **603.** Cultivated Currant—Victoria Variety (*Ribes* sp.). **604.** Garden Gooseberry (*Ribes* sp.). **605.** Industry Gooseberry (*Ribes* sp.). **606.** Currant Worm on Red Currant (*Ribes sativum*).

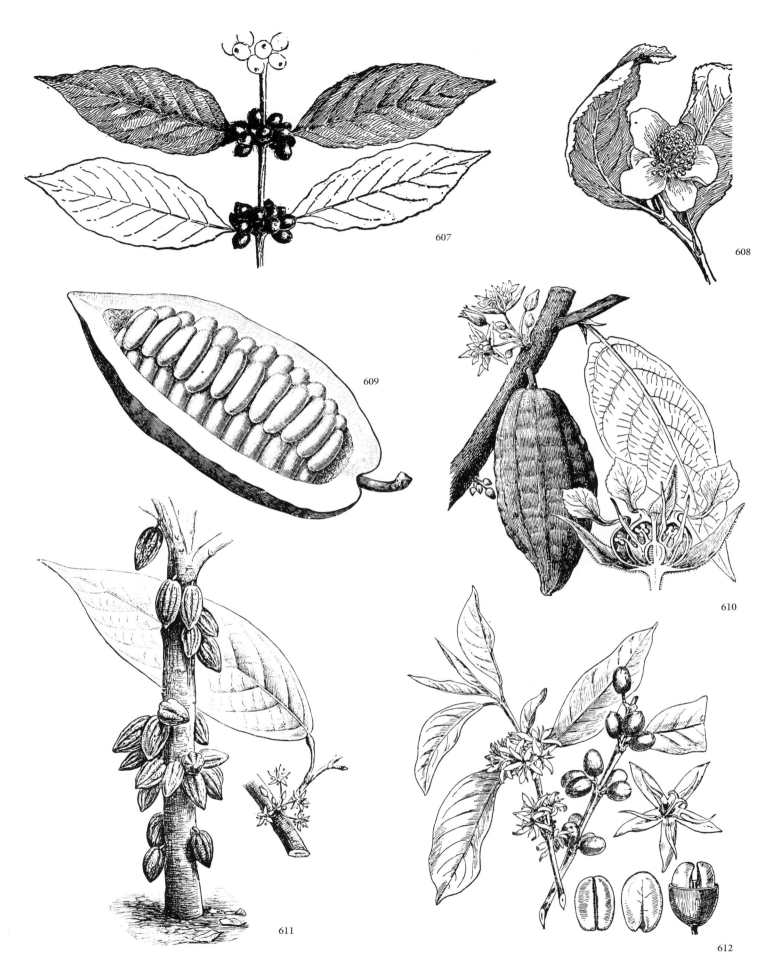

607, 612. Coffee (*Coffea arabica*). **608.** Tea Flower (*Camellia sinensis*). **609–611.** Cocoa (Chocolate) Plant (*Theobroma cacao*).

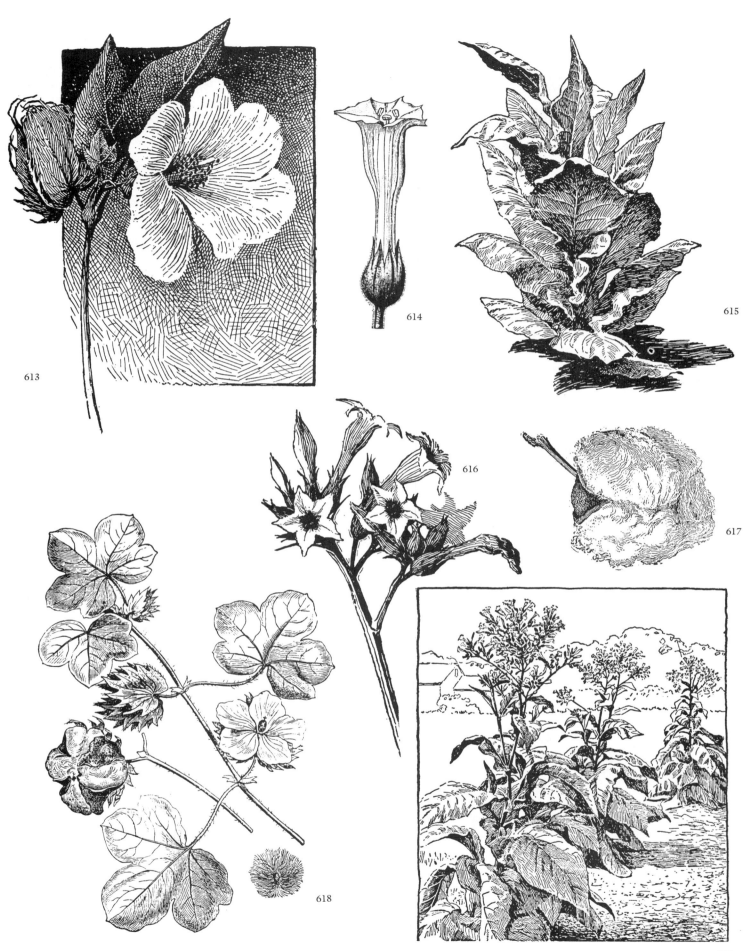

613. Cotton Flower (*Gossypium herbaceum*). **614, 616.** Flowers of Tobacco. **615, 619.** Tobacco Plant (*Nicotiana tabacum*). **617.** Cotton Boll (*Gossypium herbaceum*). **618.** Cotton (*Gossypium herbaceum*).

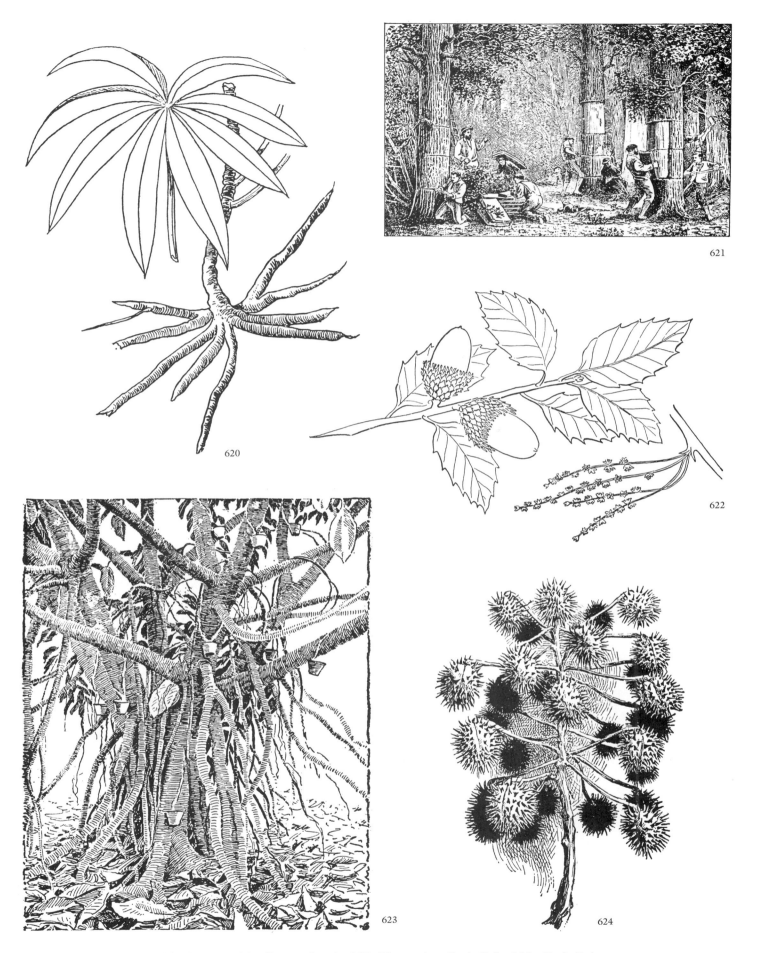

620. Cassava (*Manihot esculenta*). **621.** Harvesting Cork Oak. **622.** Cork Oak (*Quercus suber*). **623.** Rubber Tree (*Ficus elastica*). **624.** Castor Bean Plant (*Ricinus communis*).

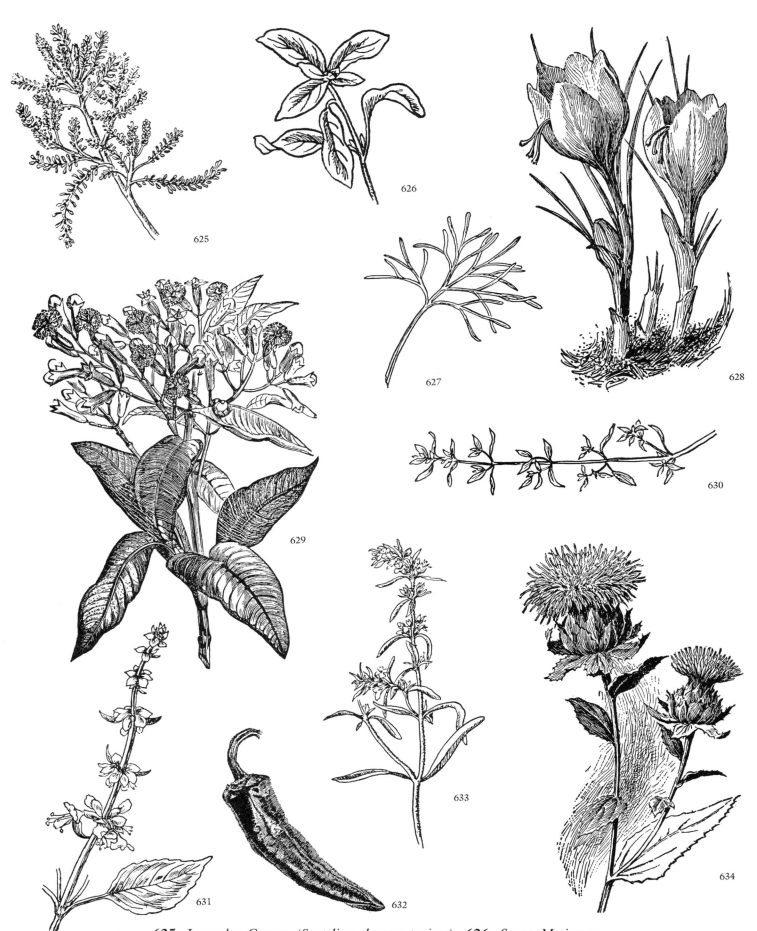

625. Lavender Cotton (*Santolina chamaecyparissus*). **626.** Sweet Marjoram (*Origanum majorana*). **627.** Southernwood (*Artemisia abrotanum*). **628.** Saffron (*Crocus sativus*). **629.** Clove Tree (*Syzygium aromaticum*). **630.** Thyme (*Thymus vulgaris*). **631.** Sweet Basil (*Ocimum basilicum*). **632.** Hungarian Paprika (*Capsicum annuum*). **633.** Summer Savory (*Satureja hortensis*). **634.** Safflower (*Carthamus tinctorius*).

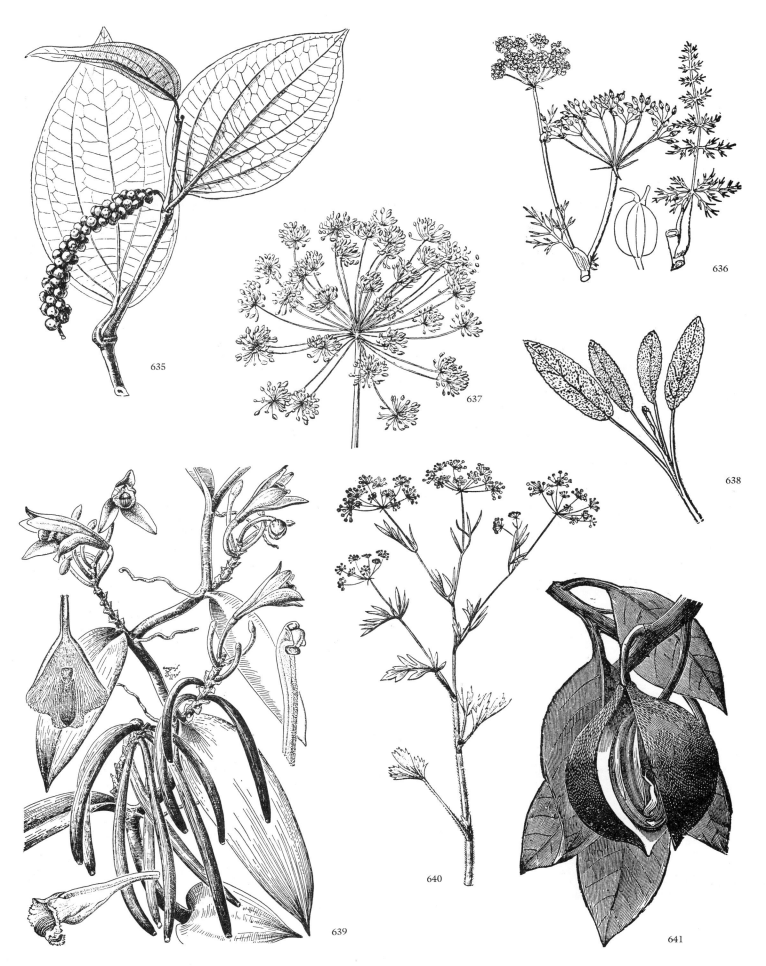

635. Black Pepper (*Piper nigrum*). **636.** Caraway (*Carum carvi*). **637.** Dill (*Anethum graveolens*). **638.** Sage (*Salvia officinalis*). **639.** Vanilla (*Vanilla planifolia*). **640.** Anise (*Pimpinella anisum*). **641.** Nutmeg (*Myristica fragrans*).

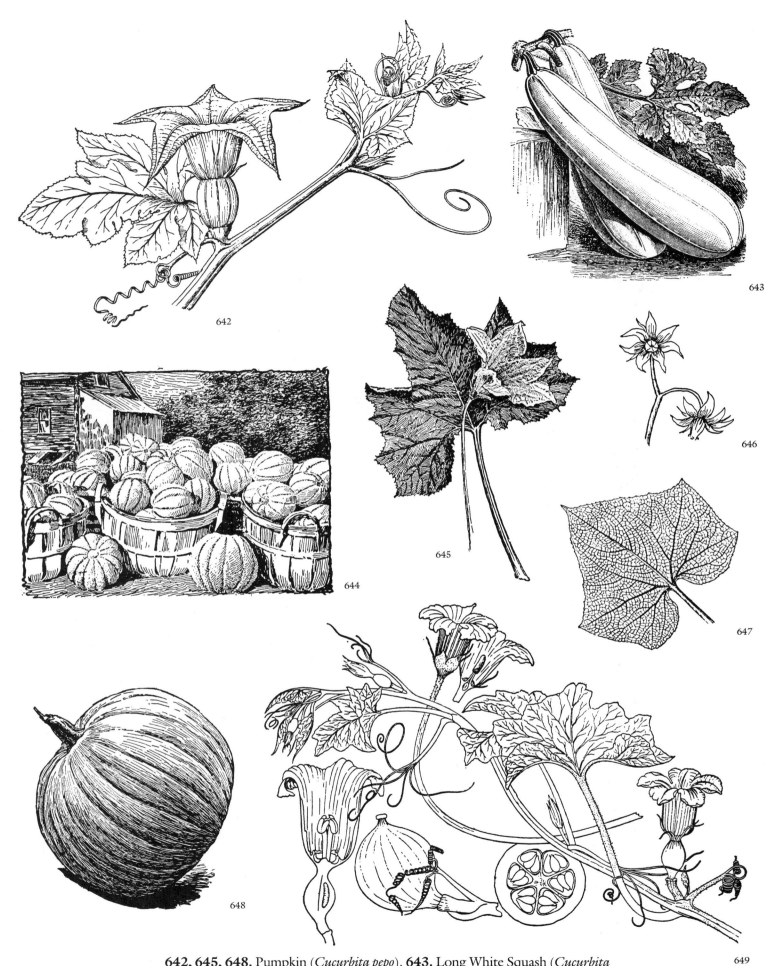

642, 645, 648. Pumpkin (*Cucurbita pepo*). **643.** Long White Squash (*Cucurbita* sp.). **644.** Muskmelon (*Cucumis melo*). **646.** Garden Tomato (*Lycopersicon lycopersicum*). **647.** Melon Leaf. **649.** Squash Vine with Flowers (*Cucurbita maxima*).

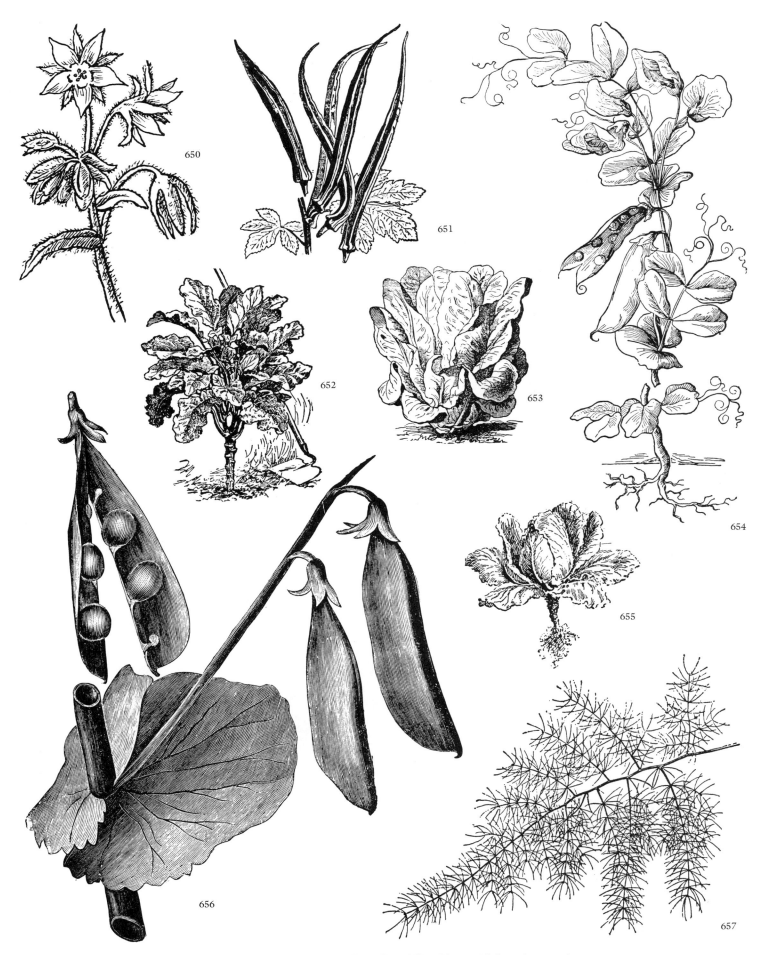

650. Common Borage (*Borago officinalis*). **651.** Okra (*Abelmoschus esculentus*). **652.** Kale (*Brassica oleracea*). **653.** Leaf Lettuce (*Lactuca sativa*). **654, 656.** Garden Pea (*Pisum sativum*). **655.** Cabbage (*Brassica oleracea*). **657.** Asparagus (*Asparagus officinalis*).

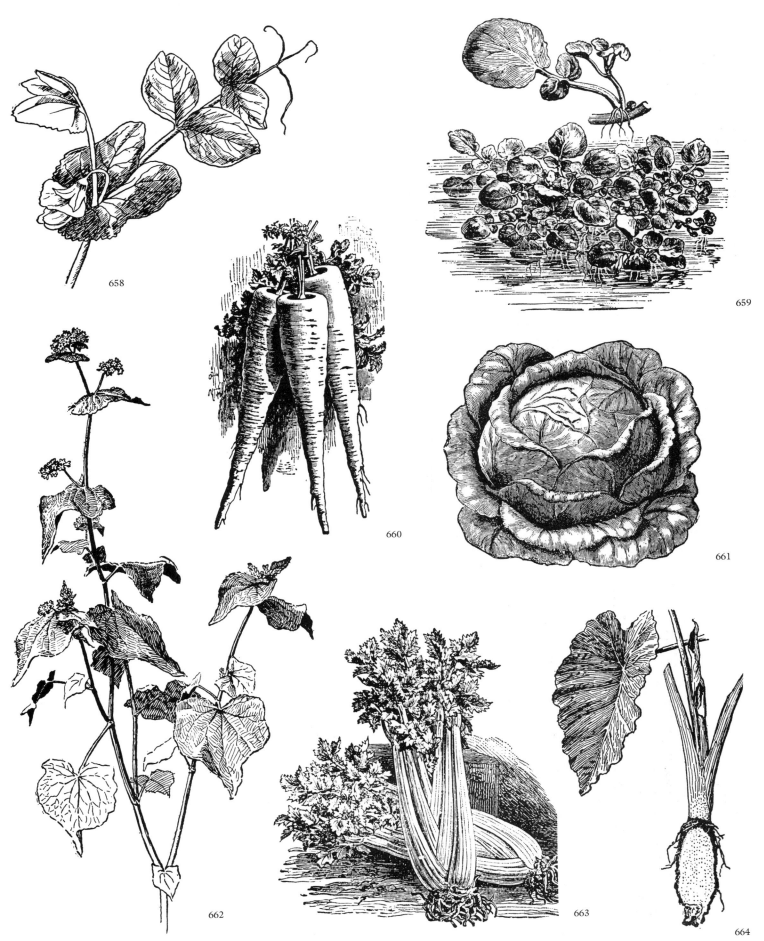

658. Garden Pea (*Pisum sativum*). **659.** Watercress (*Nasturtium officinale*). **660.** Parsnip (*Pastinaca sativa*). **661.** Summer Cabbage (*Brassica oleracea*). **662.** Buckwheat (*Fagopyrum esculentum*). **663.** Celery (*Apium graveolens*). **664.** Taro (*Colocasia esculenta*).

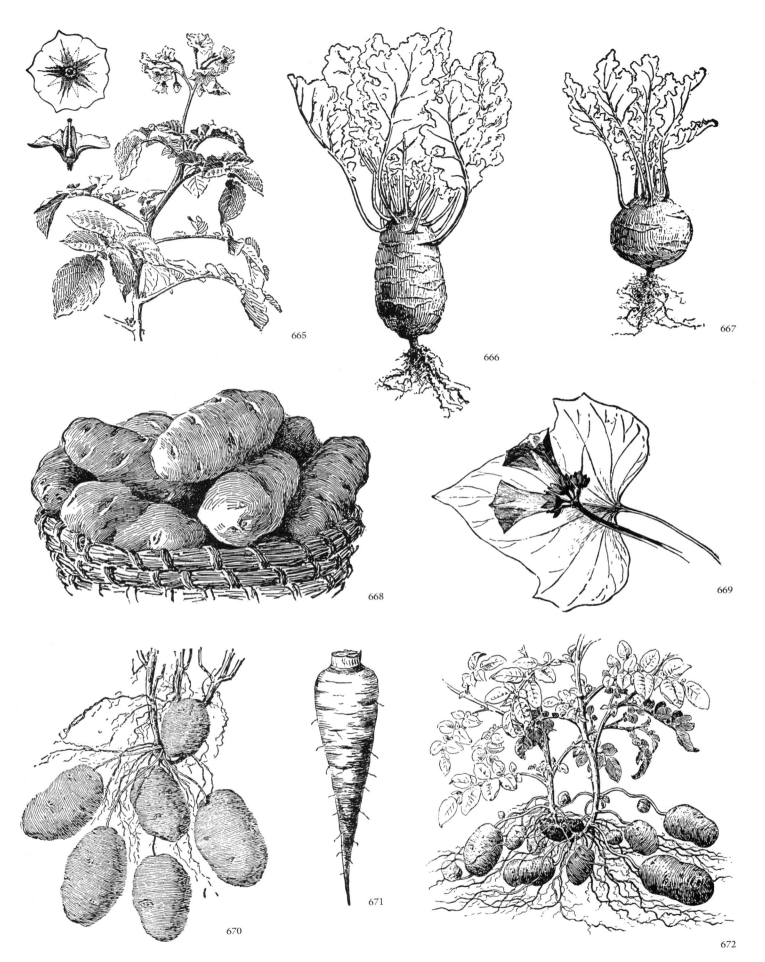

665. Flowering Spray of Potato (*Solanum tuberosum*). **666, 667.** Kohlrabi (*Brassica oleracea*). **668, 670, 672.** Potato (*Solanum tuberosum*). **669.** Sweet Potato (*Ipomoea batatas*). **671.** Carrot (*Daucus carota*).

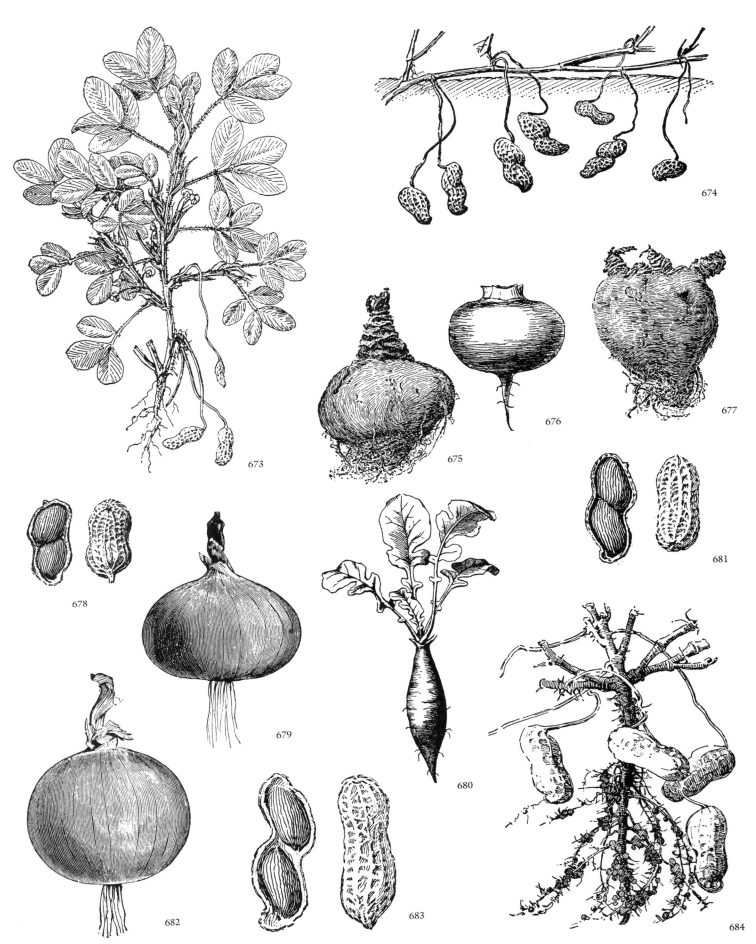

673, 674, 678, 681, 683, 684. Peanut (*Arachis hypogaea*). **675–677.** Turnip (*Brassica rapa*). **679.** Yellow Globe Onion (*Allium* sp.). **680.** Radish (*Raphanus sativus*). **682.** Southport Globe Onion (*Allium* sp.).

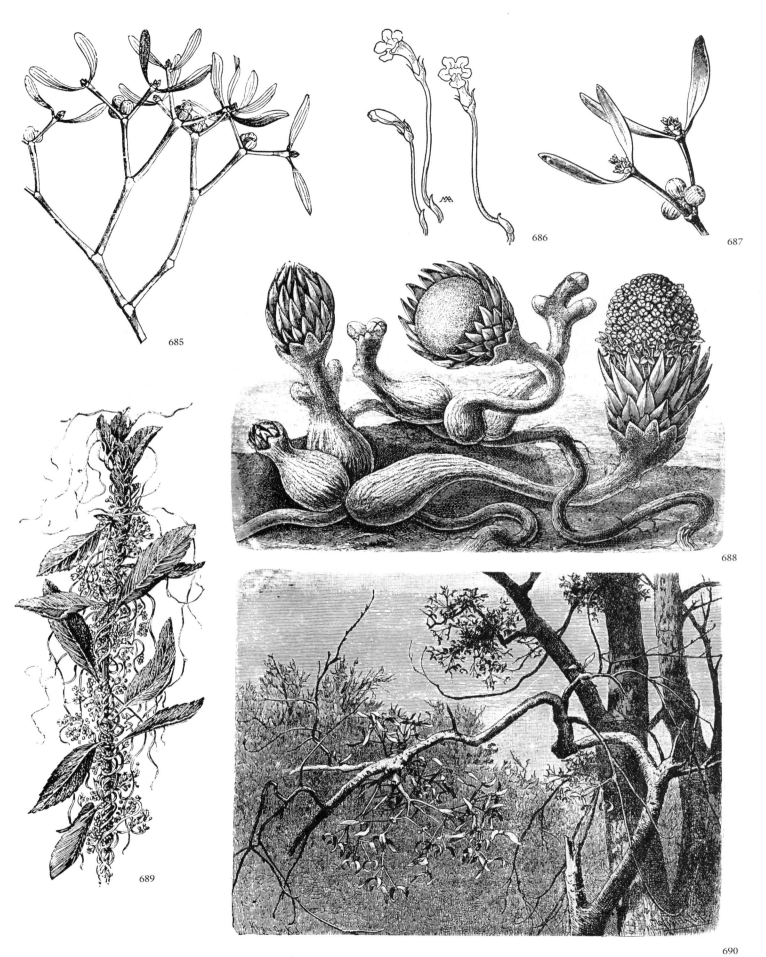

685, 690. Mistletoe (*Viscum album*). **686.** One-flowered Cancer Root (*Orobanche uniflora*). **687.** American Mistletoe (*Phoradendron serotinum*). **688.** *Langsdorffia hypogoea.* **689.** Common Dodder (*Cuscuta gronovii*).

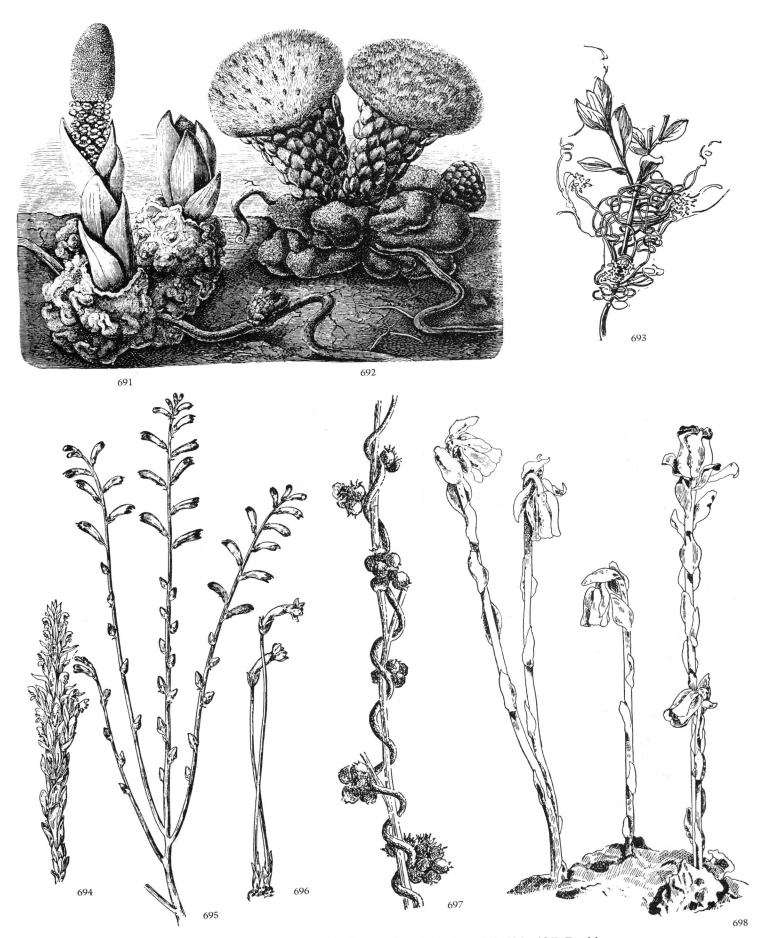

691. *Scybalium fungiforme.* **692.** *Balanophora hildenbrandtii.* **693, 697.** Dodder (*Cuscuta* sp.). **694.** Squawroot (*Conopholis americana*). **695.** Beech-Drops (*Epiphagus virginiana*). **696.** One-flowered Cancer Root (*Orobanche uniflora*). **698.** Indian Pipe (*Monotropa uniflora*).

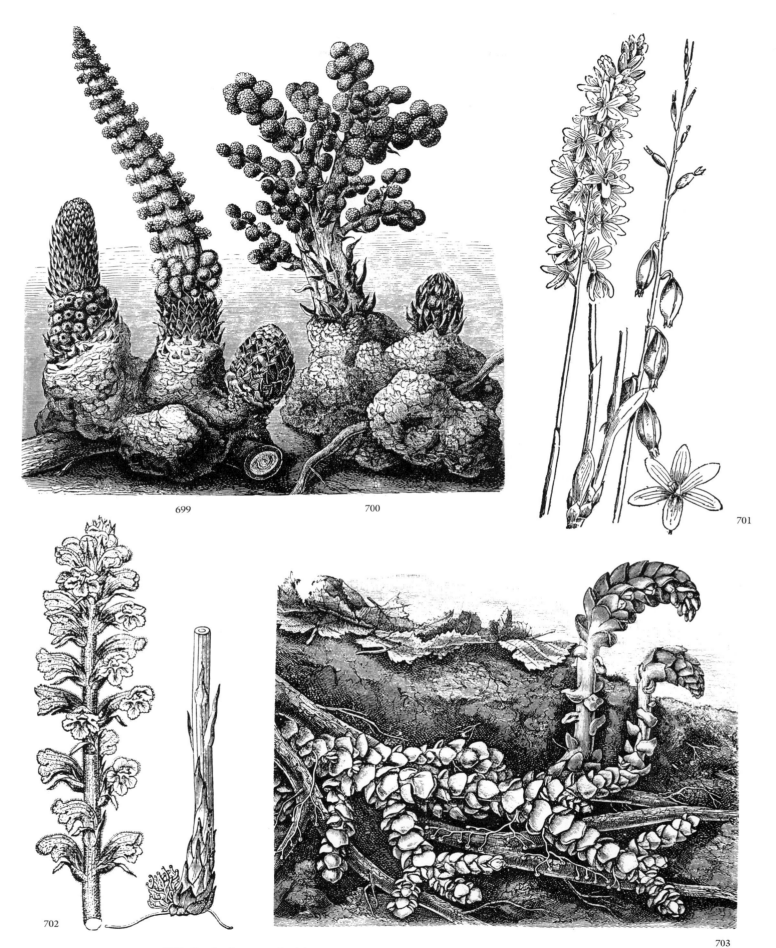

699. *Lophophytum mirabile.* **700.** *Sarcophyte sanguinea.* **701.** Striped Coralroot (*Corallorhiza striata*). **702.** Broomrape (*Orobanche rapum*). **703.** Toothwort (*Lathroea squamaria*).

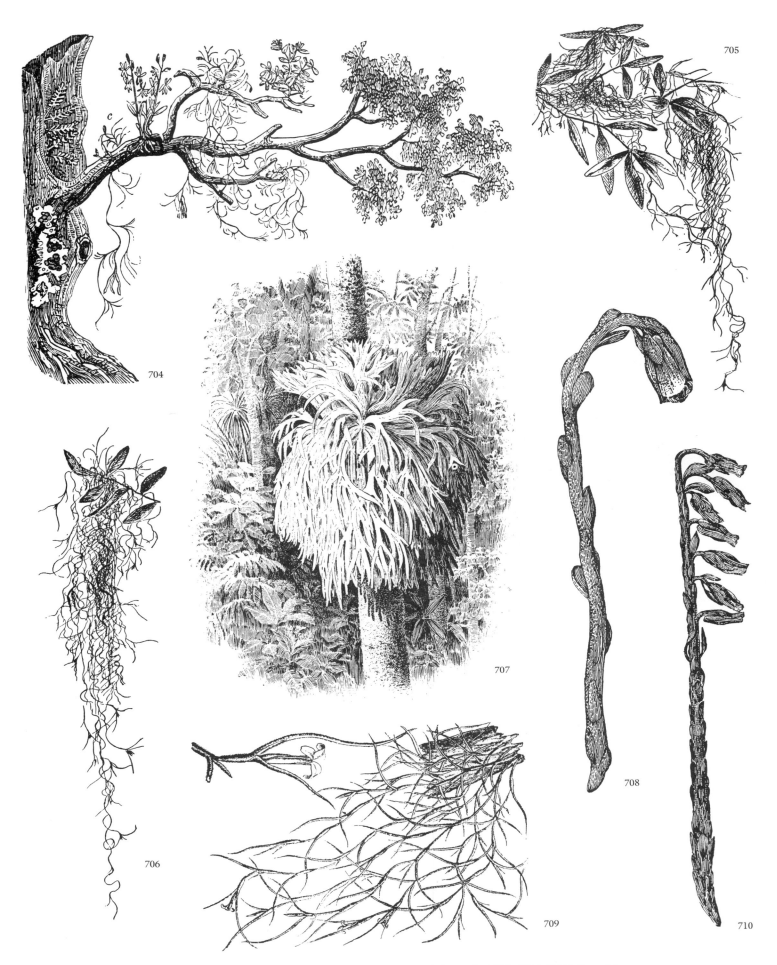

704. Southern Epiphytes and Parasites on Oak Branch. **705, 706, 709.** Spanish Moss (*Tillandsia usneoides*). **707.** Staghorn Fern (*Platycerium* sp.). **708.** Indian Pipe (*Monotropa uniflora*). **710.** Pinesap (*Monotropa hypopitys*).

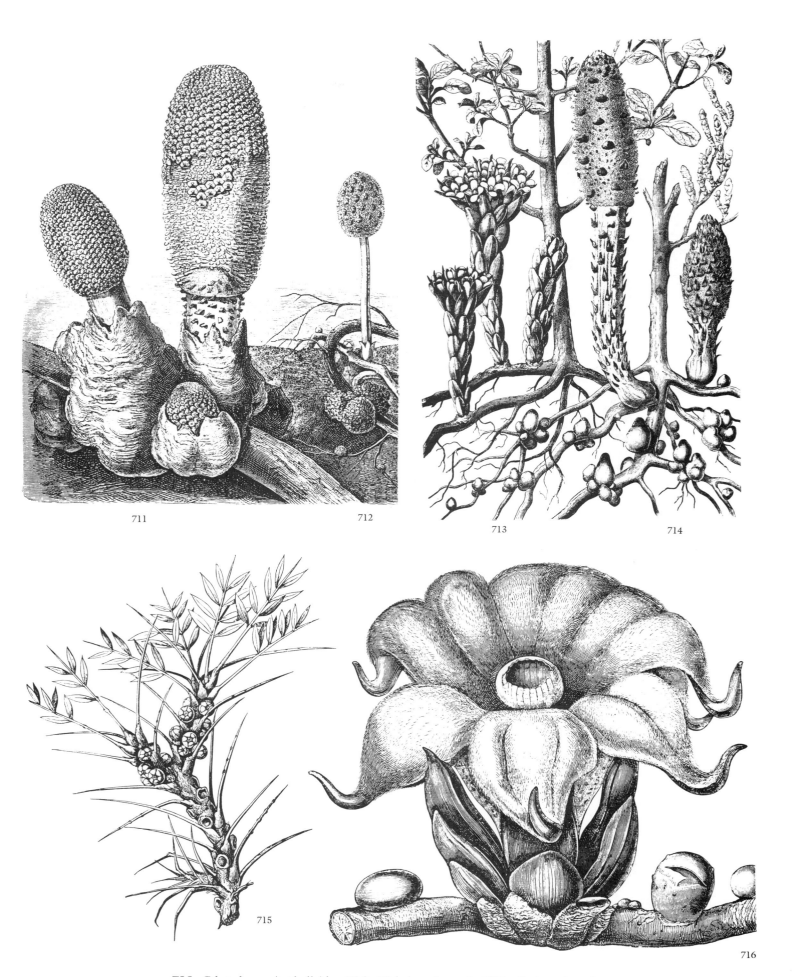

711. *Rhopalocnemis phalloides.* **712.** *Helosis gujanensis.* **713.** *Cytinus hypocistus.*
714. *Cynomorium coccineum.* **715.** *Pilostyles hausmknechtii.* **716.** Parasitic Rafflesiacea (*Brugmansia zipellii*).

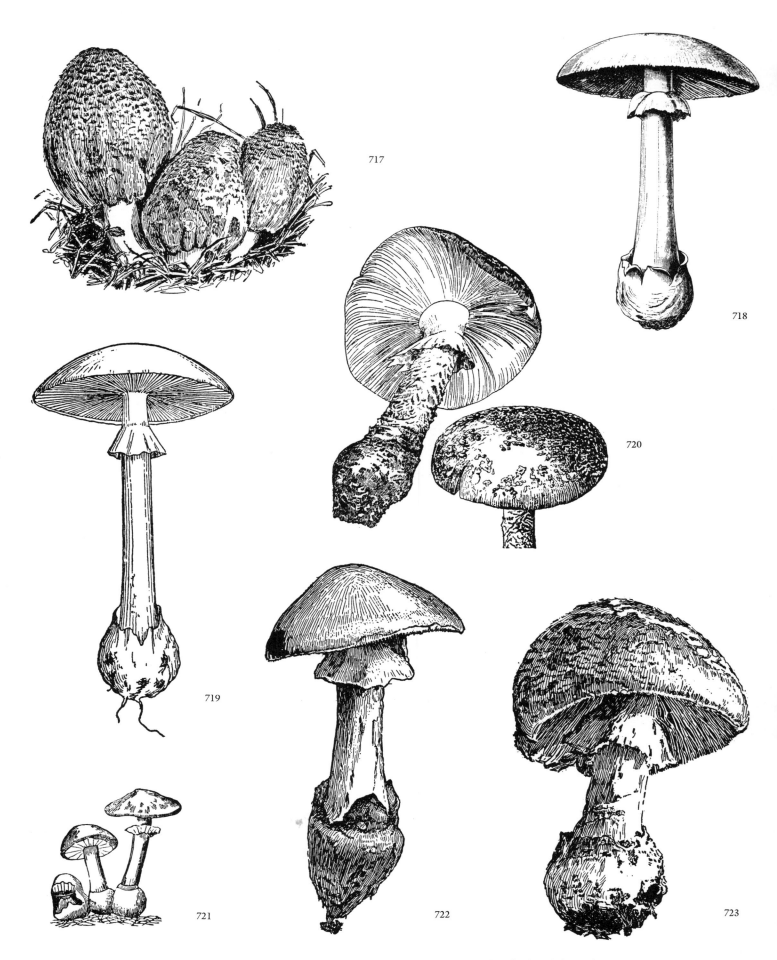

717. Alcohol Inky (*Coprinus atramentarius*). 718, 722. Death Cap (*Amanita phalloides*). 719. Destroying Angel (*Amanita virosa*). 720, 723. Fly Agaric (*Amanita muscaria*). 721. Citron Amanita (*Amanita citrina*).

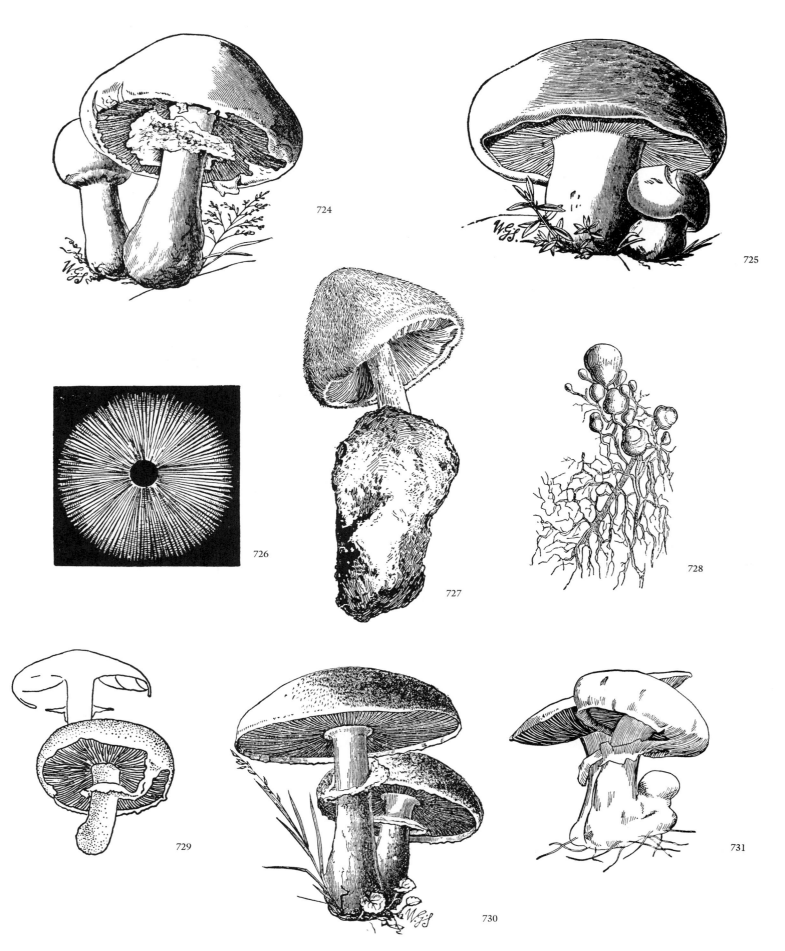

724. Horse Mushroom (*Agaricus arvensis*). **725.** St. George's Mushroom (*Tricholoma gambosum*). **726.** Spore Print. **727.** Tree Volvariella (*Volvariella bombycina*). **728.** Mushroom Buttons. **729–731.** Meadow Mushroom (*Agaricus campestris*).

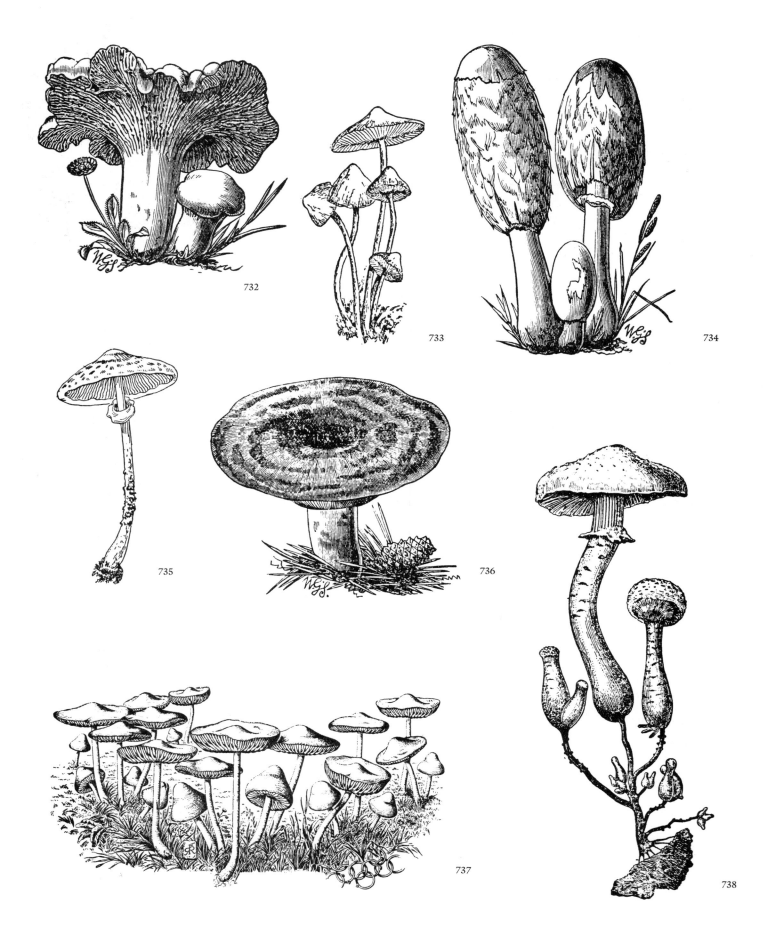

732. Chanterelle (*Cantharellus cibarius*). **733.** Common Mycena (*Mycena galericulata*). **734.** Shaggy Mane (*Coprinus comatus*). **735.** Parasol Mushroom (*Lepiota procera*). **736.** Orange-Latex Milky (*Lactarius deliciosus*). **737.** Fairy Ring Mushroom (*Marasmius oreades*). **738.** Honey Mushroom (*Armillariella mellea*).

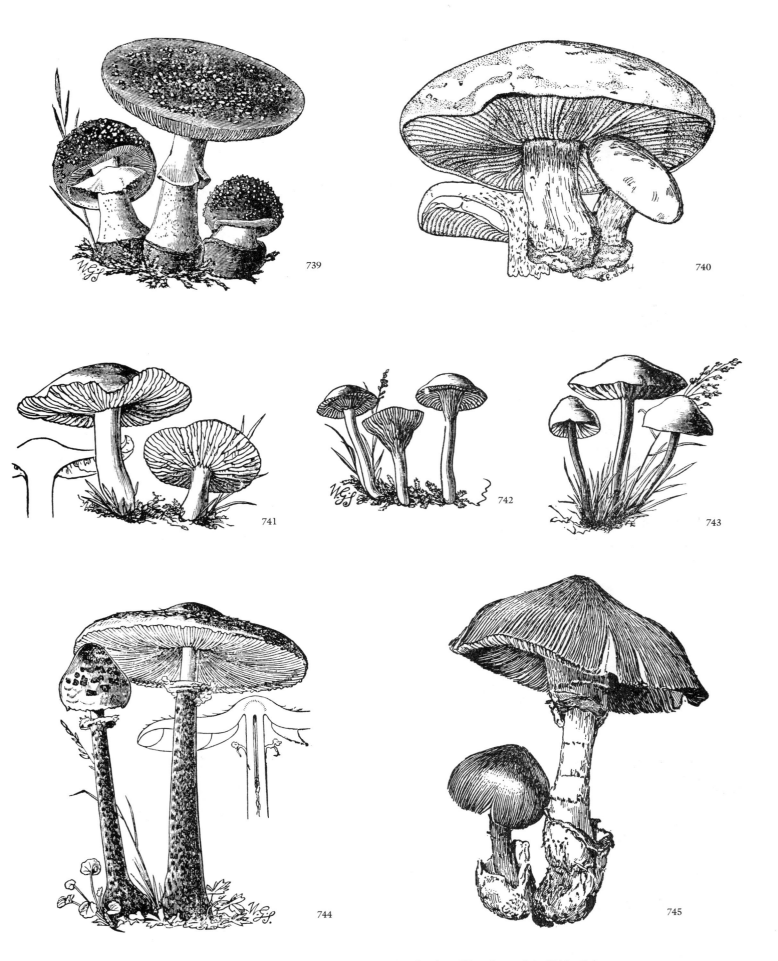

739. Blusher (*Amanita rubescens*). **740.** Blewit (*Clitocybe nuda*). **741.** Salmon Waxy Cap (*Hygrophorus pratensis*). **742.** Waxy Cap (*Hygrophorus virgineus*). **743.** Fairy Ring Mushroom (*Marasmius oreades*). **744.** Parasol Mushroom (*Lepiota procera*). **745.** American Caesar's Mushroom (*Amanita caesarea*).

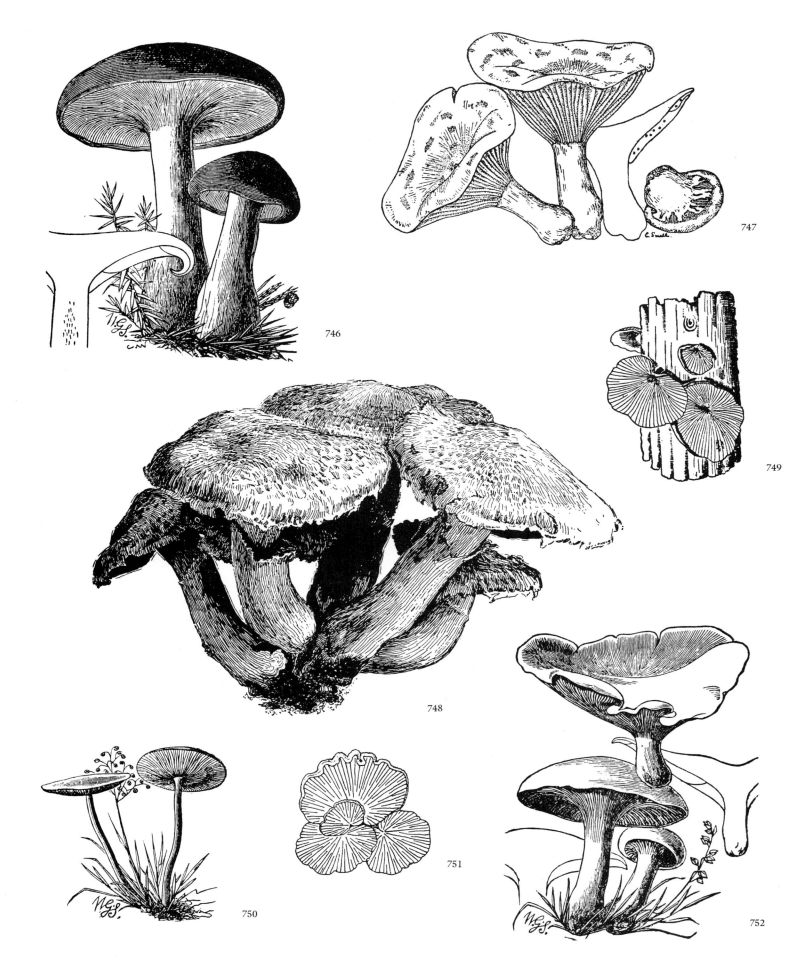

746. Cloudy Clitocybe (*Clitocybe nebularis*). **747.** Rosy Tricholoma (*Tricholoma rubicunda*). **748.** *Agaricus* sp. **749.** *Claudopus variabilis*. **750.** *Marasmius urens*. **751.** Crimped Gill (*Plicaturopsis crispa*). **752.** *Clitopilus* sp.

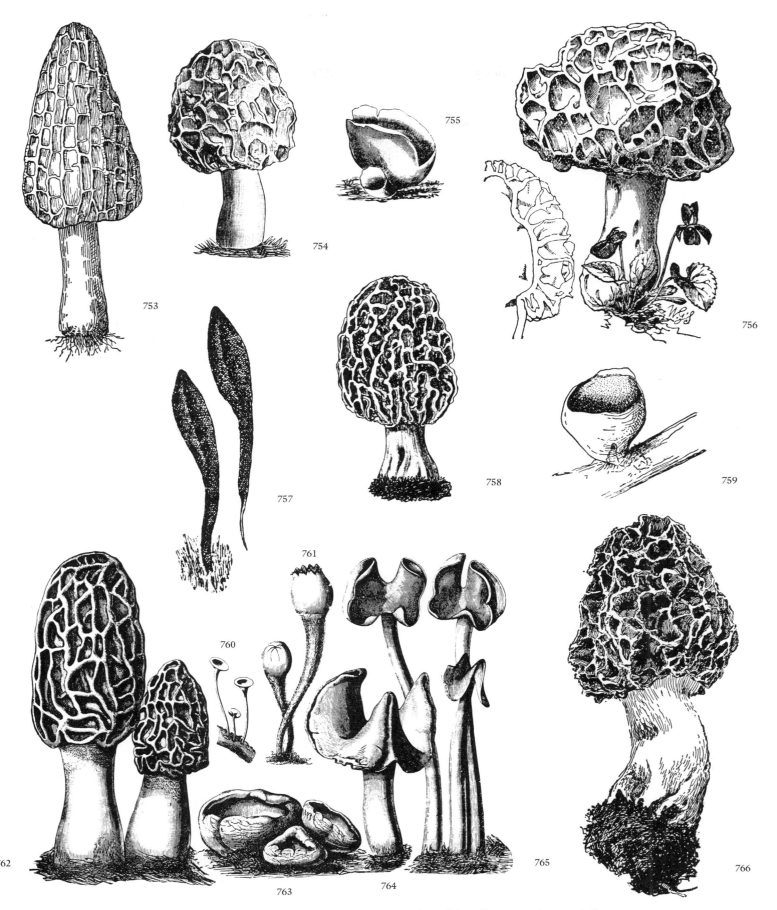

753. Conical Morel (*Morchella angusticeps*). **754, 756.** Yellow Morel (*Morchella esculenta*). **755.** Orange Peel (*Aleuria aurantia*). **757.** Earth Tongue (*Geoglossum glutinosum*). **758.** White Morel (*Morchella deliciosa*). **759.** Scarlet Elf Cup (*Sarcoscypha coccinea*). **760.** *Heliotum tuba*. **761.** *Anthopeziza winteri*. **762.** Black Morel (*Morchella elata*). **763.** Bladder Cup (*Peziza vesiculosa*). **764.** Saddle-shaped False Morel (*Gyromitra infula*). **765.** Smooth-stalked Helvella (*Helvella elastica*). **766.** Thick-footed Morel (*Morchella crassipes*).

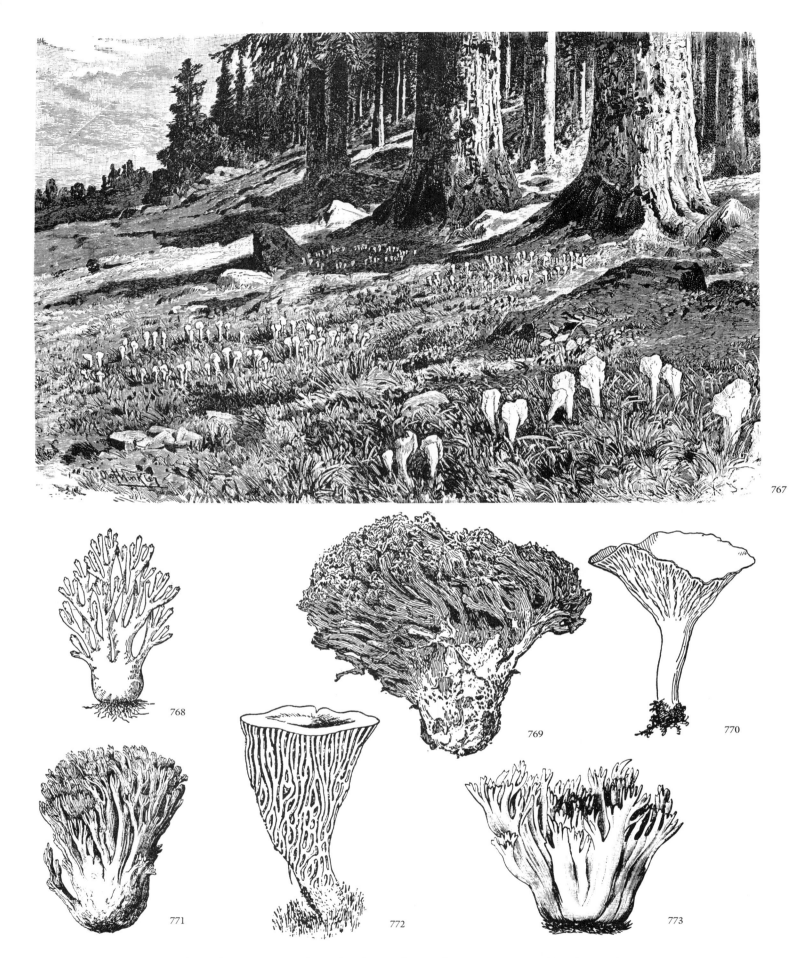

767. Fairy Fan (*Spathularia flavida*). 768. Coral (*Ramaria sp.*). 769. Clustered Coral (*Ramaria botrytis*). 770. Chanterelle (*Cantharellus cibarius*). 771. Golden Coral (*Ramaria aurea*). 772. Scaly Vase (*Gomphus floccosus*). 773. Scarlet-footed Ramaria (*Ramaria rubipres*).

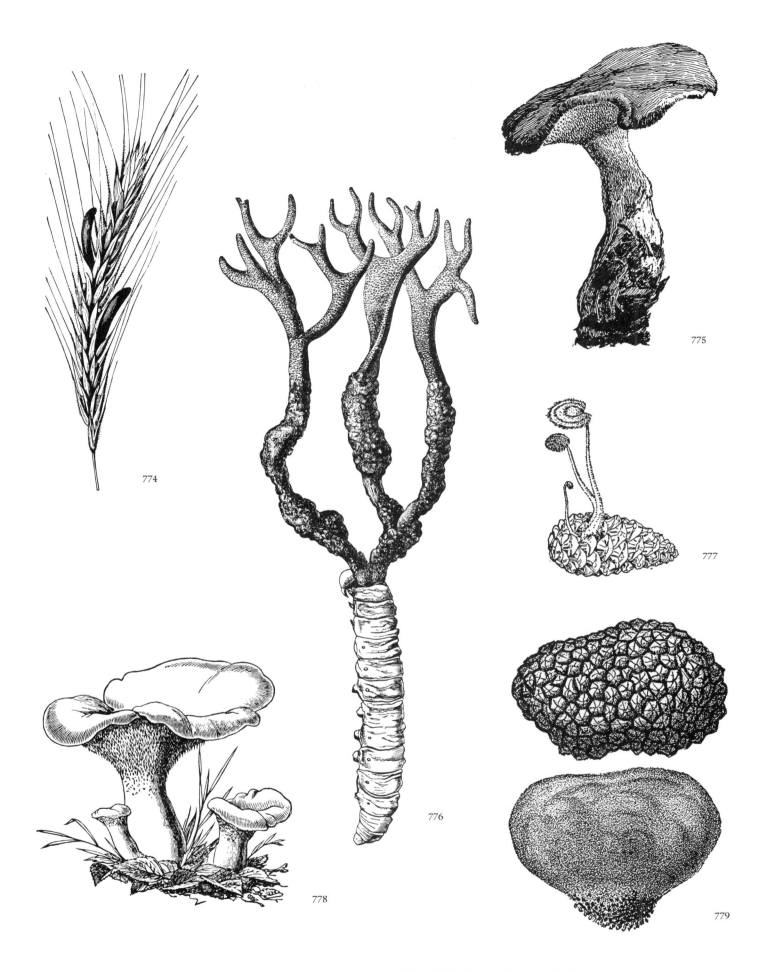

774. Ergot of Rye (*Claviceps purpurea*). **775, 778.** Sweet Tooth (*Hydnum repandum*). **776.** Staghorn Cordyceps (*Cordyceps taylori*). **777.** Pinecone Tooth (*Auriscalpium vulgare*). **779.** Black Truffle (*Tuber melanosporum*).

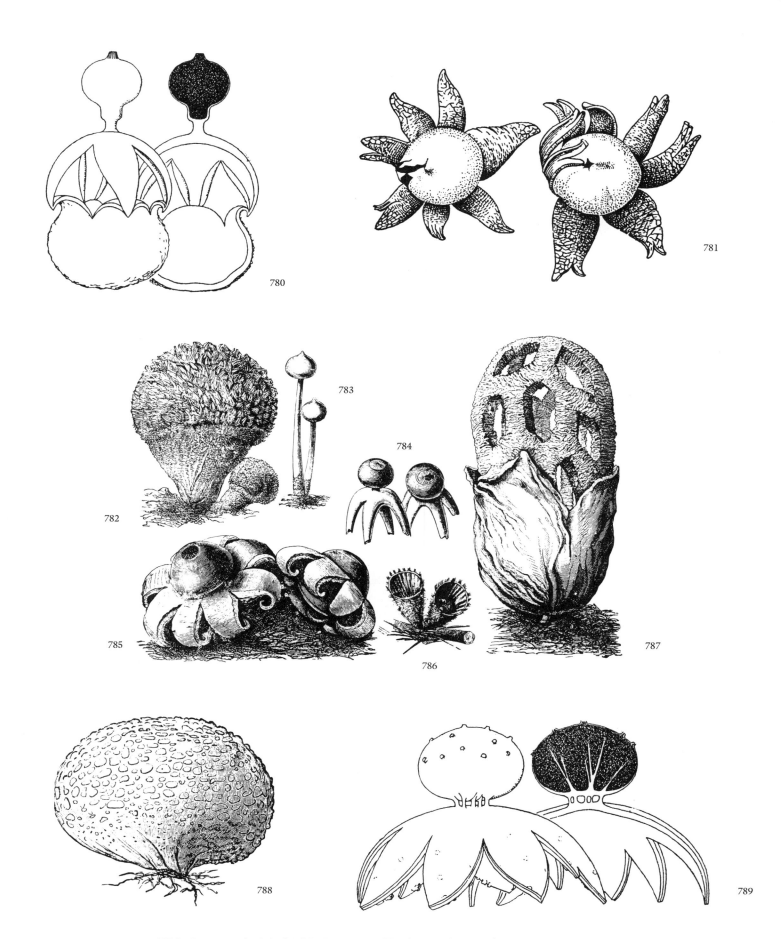

780. *Geastrum berkeleyi.* **781.** Barometer Earthstar (*Astraeus hygrometricus*). **782.** *Lycoperdon constellatum.* **783.** Stalked Puffball (*Tylostoma mammosum*). **784.** *Geastrum multifidum.* **785.** *Geastrum fornicatum.* **786.** Splash Cups (*Cyathus striatus*). **787.** *Clathrus cancellatus.* **788.** Earthball (*Scleroderma vulgare*). **789.** Saltshaker Earthstar (*Myriostoma coliforme*).

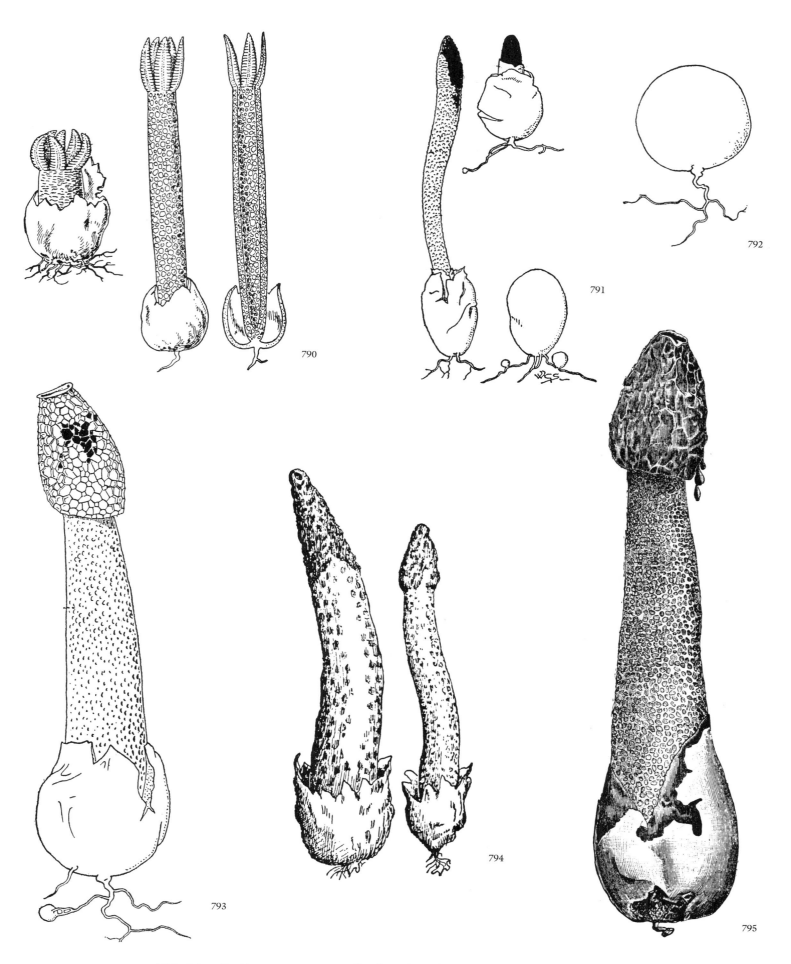

790. Lizard's Claw (*Lysurus australiensis*). **791, 794.** Dog Stinkhorn (*Mutinus caninus*). **792.** Stinkhorn Egg (*Phallus impudicus*). **793, 795.** Common Stinkhorn (*Phallus impudicus*).

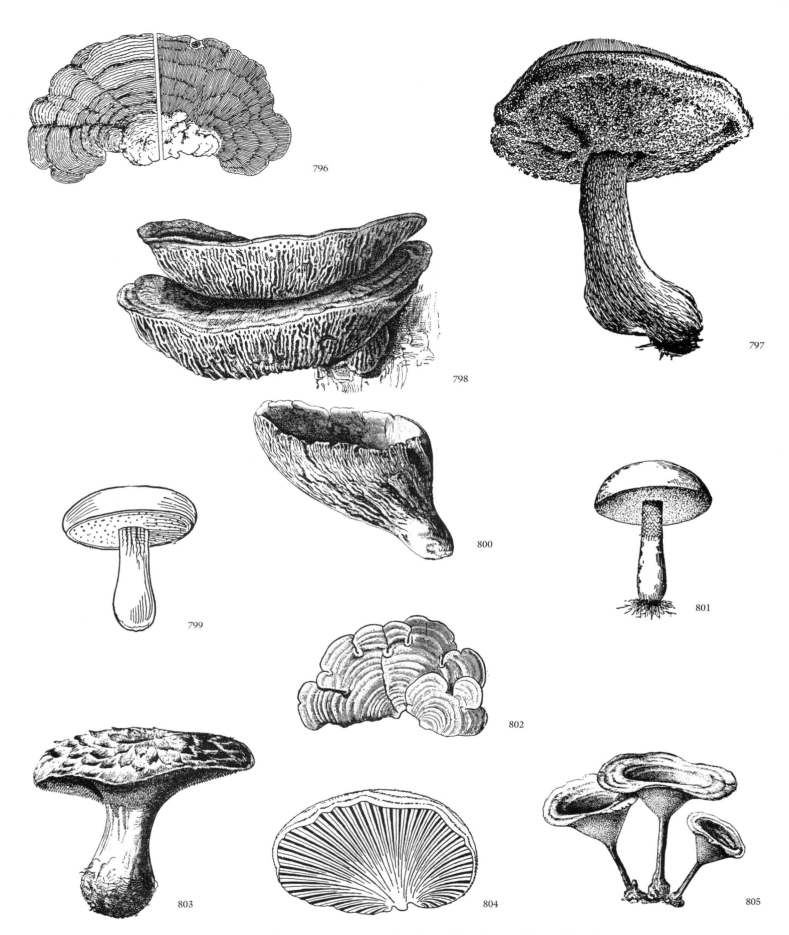

796. Multicolor Gill Polypore (*Lenzites betulina*). **797.** Bitter Bolete (*Tylopilus felleus*). **798.** Thick-Maze Oak Polypore (*Daedalea quercina*). **799.** King Bolete (*Boletus edulis*). **800.** Pig's Ear (*Gomphus clavatus*). **801.** *Boletus* sp. **802.** Mushroom Lichen (*Cora pavonia*). **803.** Scaly Tooth (*Hydnum imbricatum*). **804.** Split-Gill Polypore (*Schizophyllum commune*). **805.** Cinnamon Funnel Polypore (*Coltrichia perennis*).

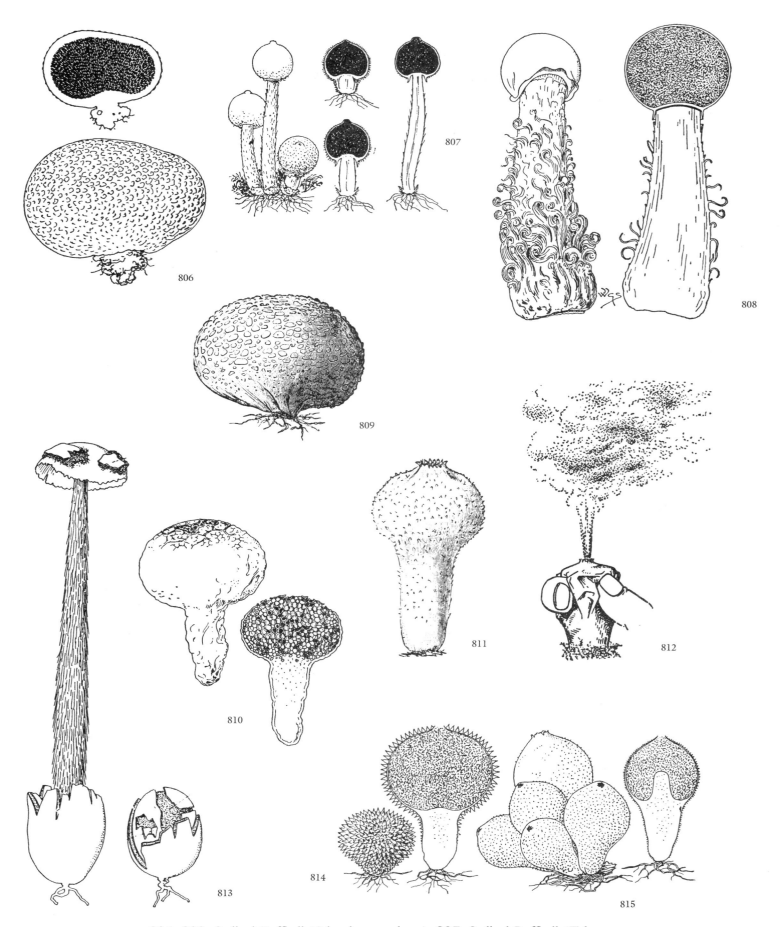

806, 809. Stalked Puffball (*Scleroderma vulgare*). **807.** Stalked Puffball (*Tylostoma mammosum*). **808.** *Oueletia mirabilis.* **810.** Dye-Maker's False Puffball (*Pisolithis tinctorius*). **811.** Gem-studded Puffball (*Lycoperdon perlatum*). **812.** Puffball and Spores. **813.** Desert Stalked Puffball (*Battarraea phalloides*). **814.** Spiny Puffball (*Lycoperdon echinatum*). **815.** Pear-shaped Puffball (*Lycoperdon pyriforme*).

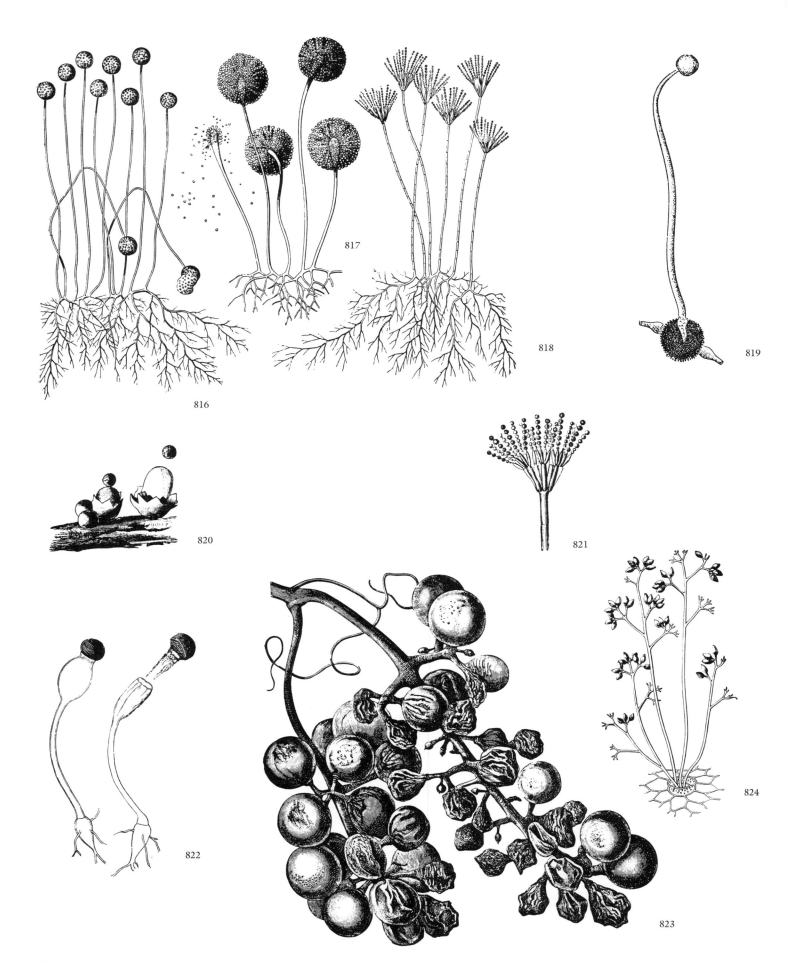

816. *Rhizopus* Mold (*Rhizopus* sp.). **817.** *Aspergillus* Mold (*Aspergillus* sp.). **818, 821.** *Penicillium* Mold (*Penicillium* sp.). **819.** Bread Mold (*Mucor mucedo*). **820.** Cannon Fungus (*Sphaerobolus stellatus*). **822.** Gunner (*Pilobolus* sp.). **823.** Grapes Attacked by Vine Mildew. **824.** Vine Mildew (*Peronospora viticola*).

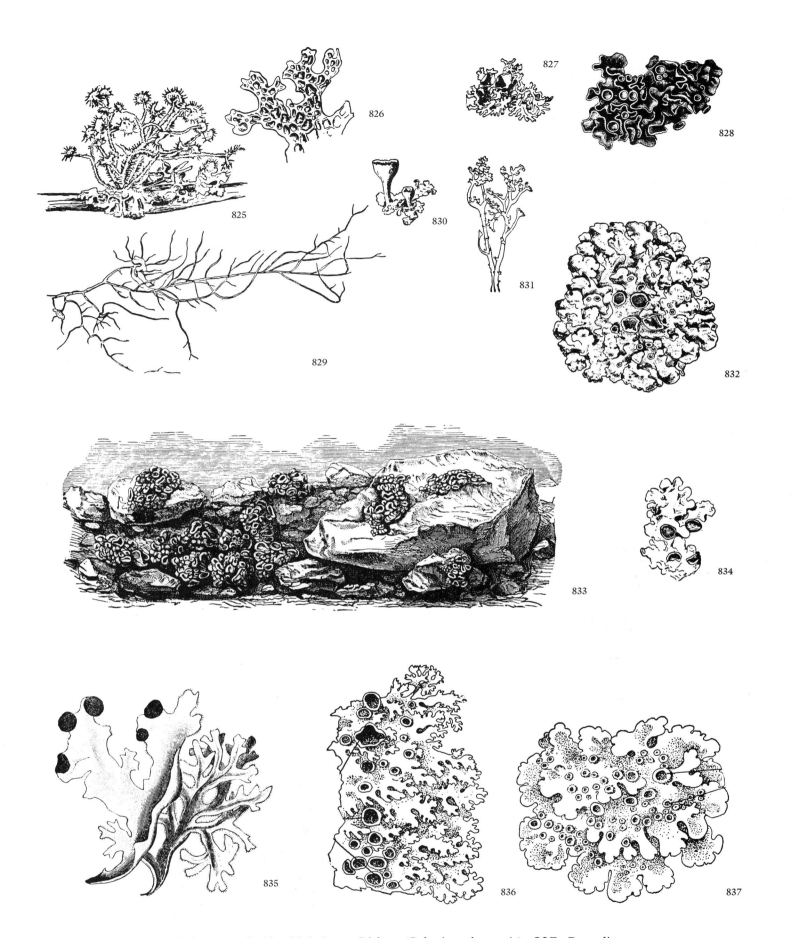

825. *Usnea florida.* **826.** Lung Lichen (*Lobaria pulmonaria*). **827.** *Parmelia colpodes.* **828.** Gelatinous Lichen (*Collema pulposum*). **829.** *Ramalina* sp. **830.** *Cladonia pyxidata.* **831.** *Cladonia furcata.* **832.** Tree Lichen (*Parmelia acetabulum*). **833.** Desert Lichen (*Lecanora esculenta*). **834.** Wilson's Lichen (*Parmelia wilsonii*). **835.** Iceland Moss (*Cetraria islandica*). **836.** Shore Lichen (*Xanthoria parietina*). **837.** Ringed Rock Lichen (*Parmelia conspersa*).

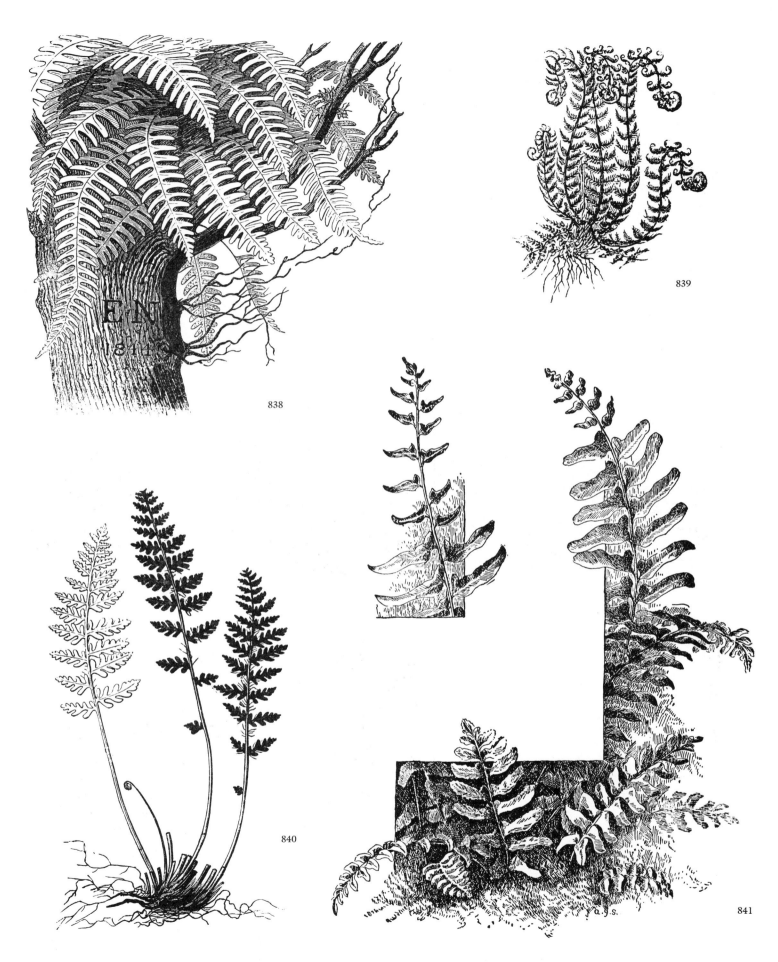

838. Ferns in Tree. **839.** Prickly Fern (*Polystichum aculeatum*). **840.** Smith's Fern (*Polypodium calcareum*). **841.** Christmas Fern (*Polystichum acrostichoides*).

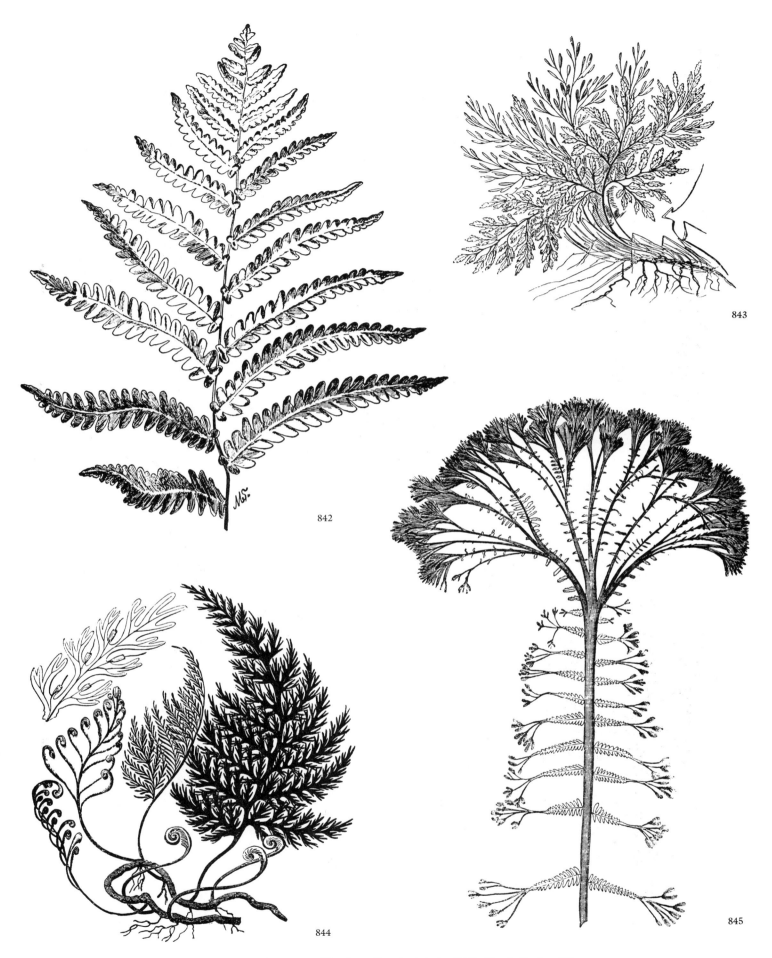

842. Virginia Chain Fern (*Woodwardia virginica*). **843.** Rock Brake (*Crypto-gramma crispa*). **844.** Bristle Fern (*Trichomanes speciosum*). **845.** Giant Fern (*Athyrium filix-foemina*).

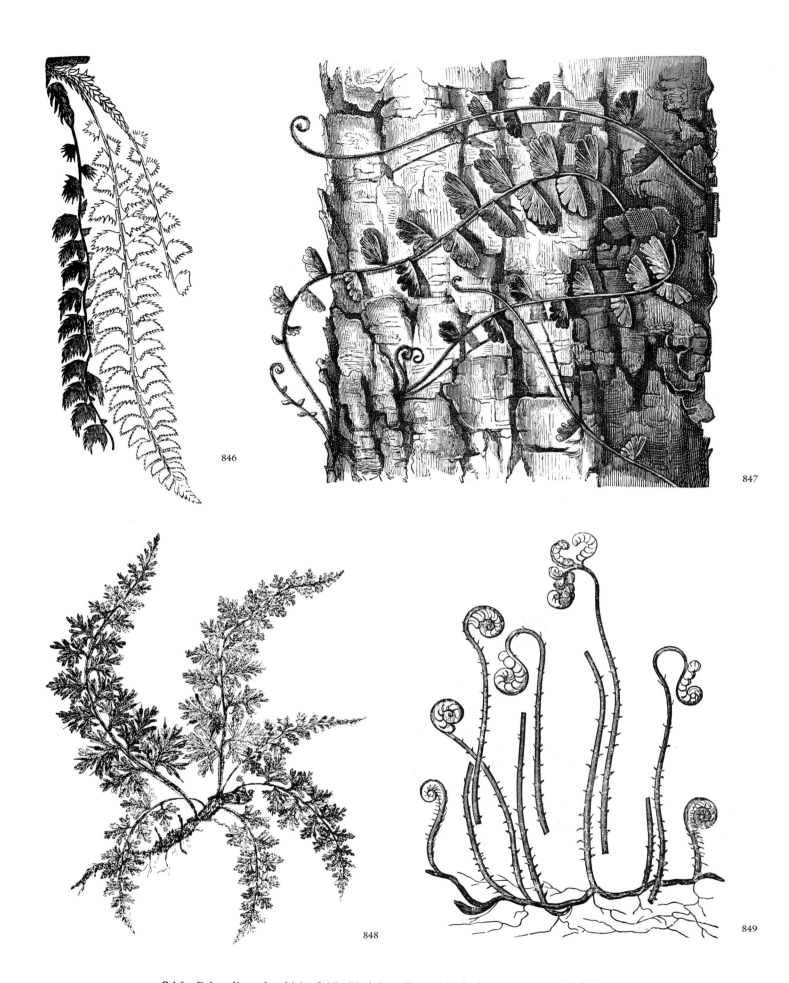

846. *Polypodium lonchitis.* **847.** Twining Fern (*Asplenium edgeworthii*). **848.** Barber's Fern (*Trichomanes radicans*). **849.** Beech Fern (*Polypodium phegopteris*).

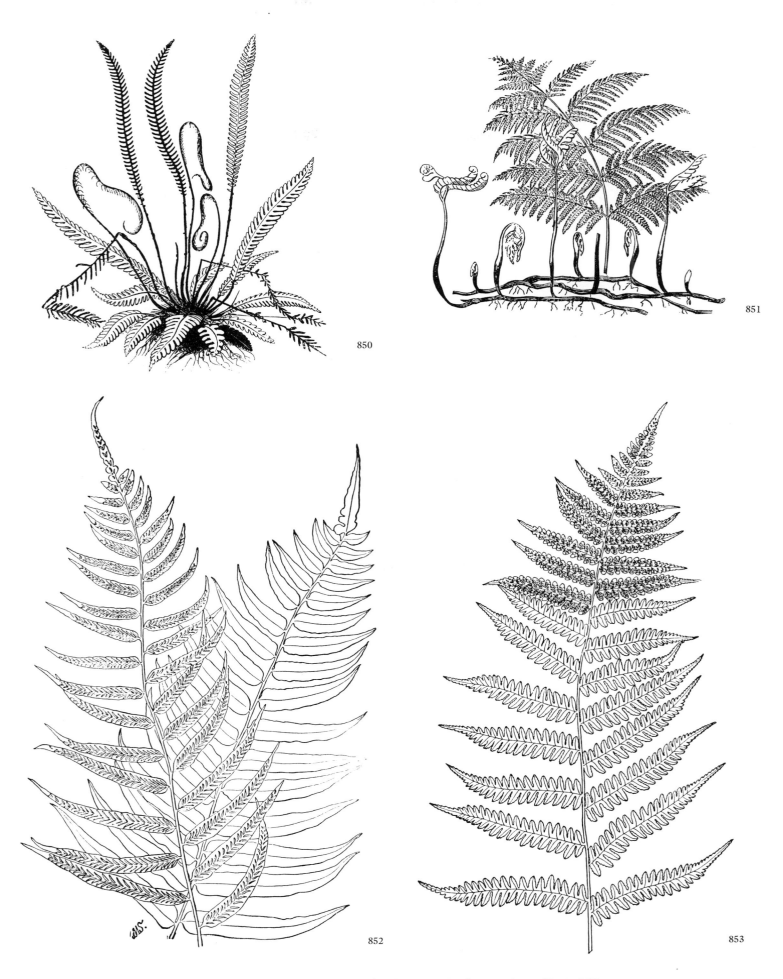

850. Hard Fern (*Blechnum boreale*). **851.** Common Brake (*Pteris aquilina*). **852.** Narrow-leaved Spleenwort (*Athyrium pycnocarpum*). **853.** Silvery Spleenwort (*Athyrium thelypteroides*).

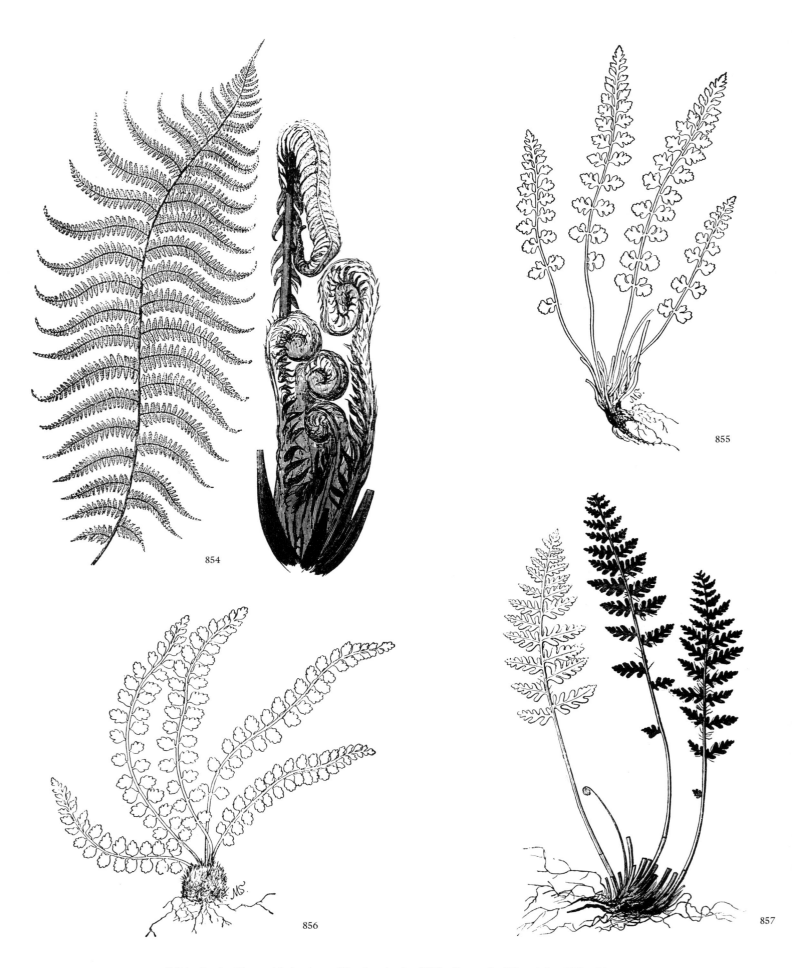

854. Lady Fern (*Athyrium filix-foemina*). **855.** Smooth Woodsia (*Woodsia glabella*). **856.** Green Spleenwort (*Asplenium viride*). **857.** Smith's Fern (*Polypodium calcareum*).

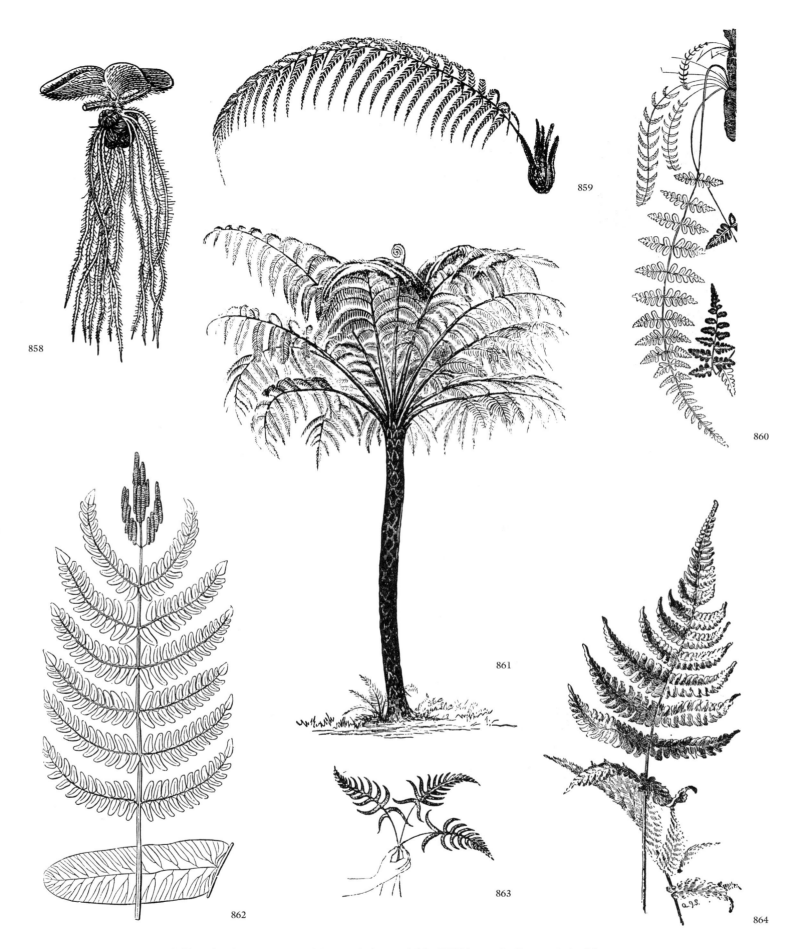

858. Floating Fern (*Salvinia minima*). **859.** Willdenow's Fern (*Polystichum angulare*). **860.** *Polypodium dentatum*. **861.** Tree Fern (*Alsophila crinita*). **862.** Royal Fern (*Osmunda regalis*). **863.** Fern Bouquet. **864.** Long Beech Fern (*Thelypteris phegopteris*).

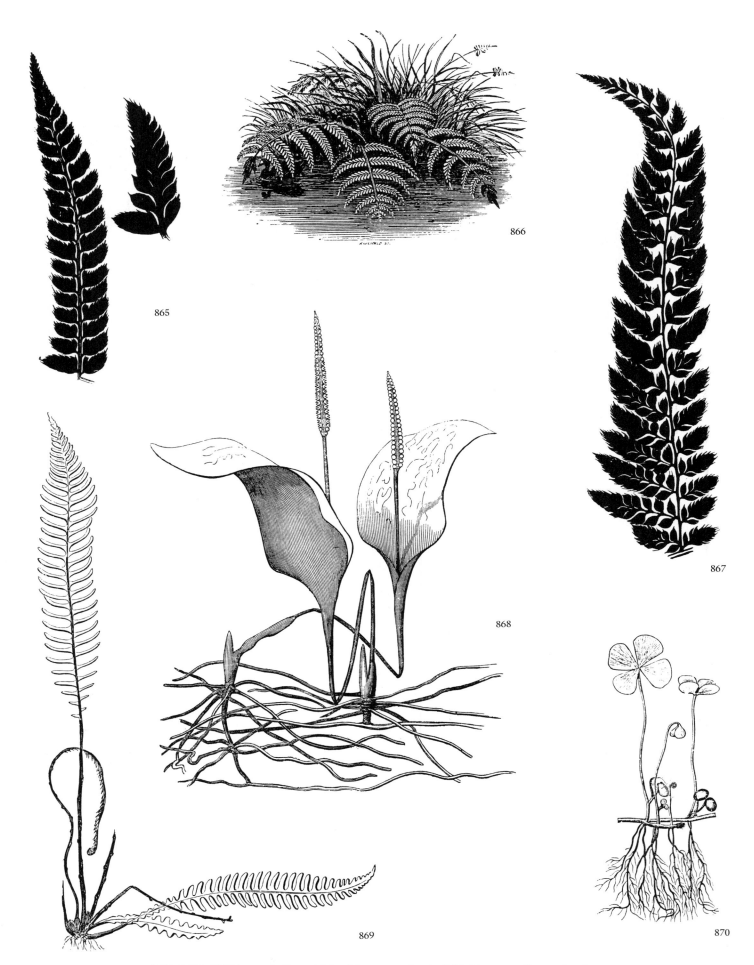

865, 867. Willdenow's Fern (*Polystichum angulare*). **866.** Ferns on Streambank.
868. Adder's Tongue Fern (*Ophioglossum vulgatum*). **869.** Hard Fern (*Blechnum spicant*). **870.** Water Clover Fern (*Marsilea quadrifolia*).

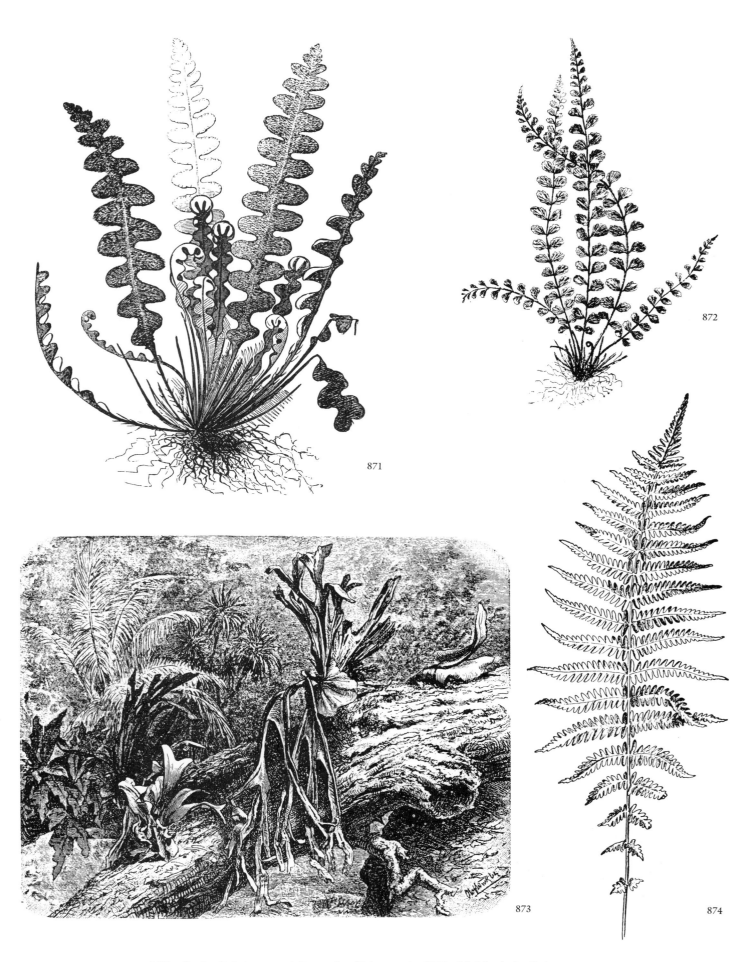

871. Scaly Spleenwort (*Ceterach officinarum*). **872.** Maidenhair Spleenwort (*Asplenium trichomanes*). **873.** Staghorn Fern (*Platycerium alcicorne*). **874.** New York Fern (*Thelypteris noveboracensis*).

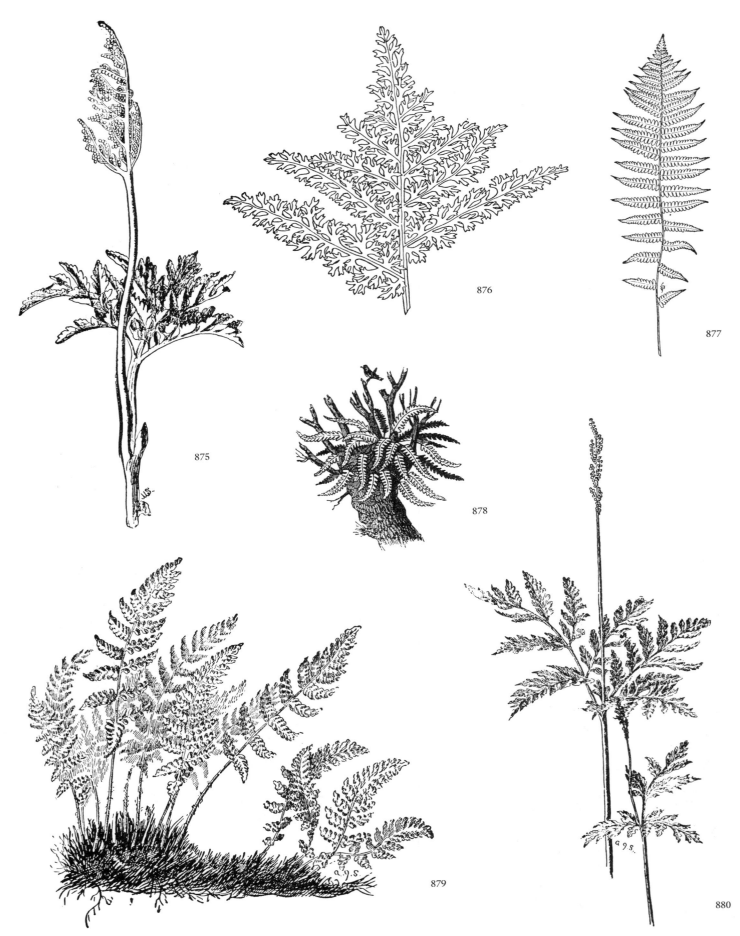

875. Ternate Grape Fern (*Botrychium ternatum*). **876.** Common Grape Fern (*Botrychium dissectum*). **877.** Silvery Spleenwort (*Athyrium thelypteroides*). **878.** Decorative Fern. **879.** Rusty Woodsia (*Woodsia ilvensis*). **880.** Rattlesnake Fern (*Botrychium virginianum*).

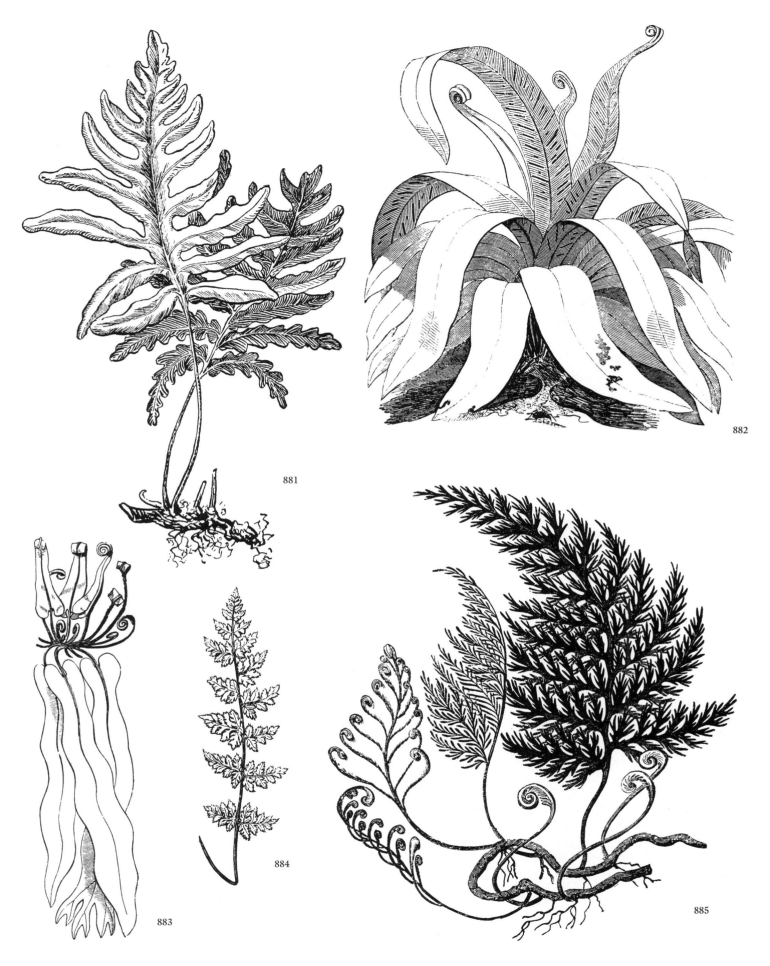

881. Sensitive Fern (*Onoclea sensibilis*). **882, 883.** Hart's Tongue Fern (*Phyllitis scolopendrium*). **884.** Brittle Fern (*Cystopteris fragilis*). **885.** Bristle Fern (*Trichomanes speciosum*).

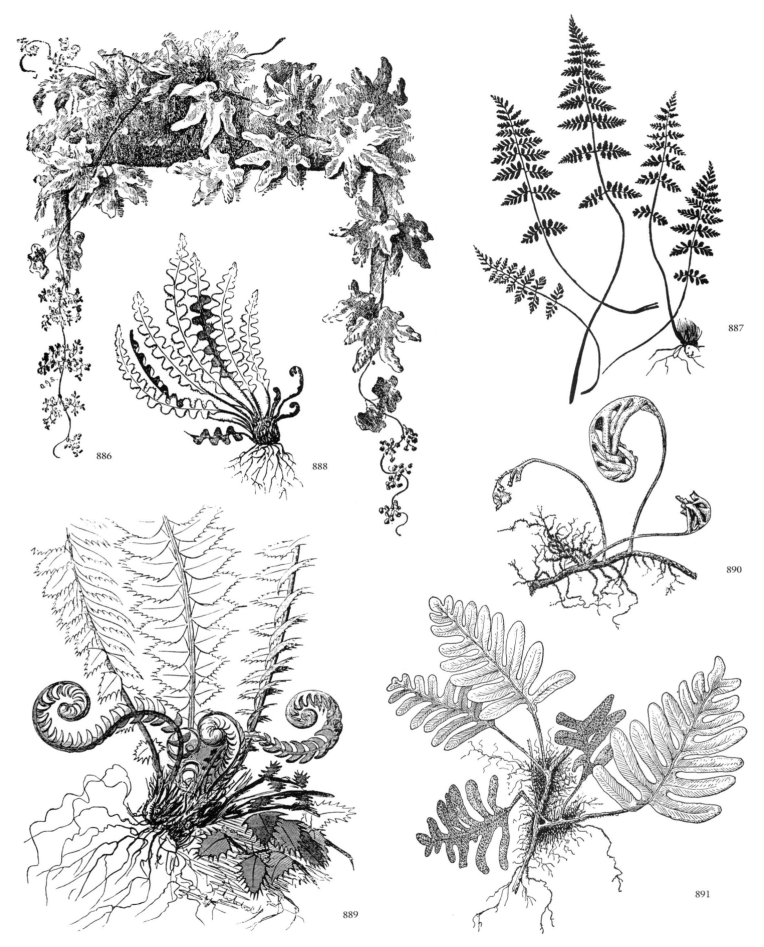

886. Climbing Fern (*Lygodium palmatum*). **887.** Brittle Fern (*Cystopteris fragilis*). **888.** Scaly Spleenwort (*Ceterach officinarum*). **889.** Holly Fern (*Polystichum lonchitis*). **890.** Resurrection Fern in Dry Weather (*Polypodium polypodioides*). **891.** Resurrection Fern in Wet Weather (*Polypodium polypodioides*).

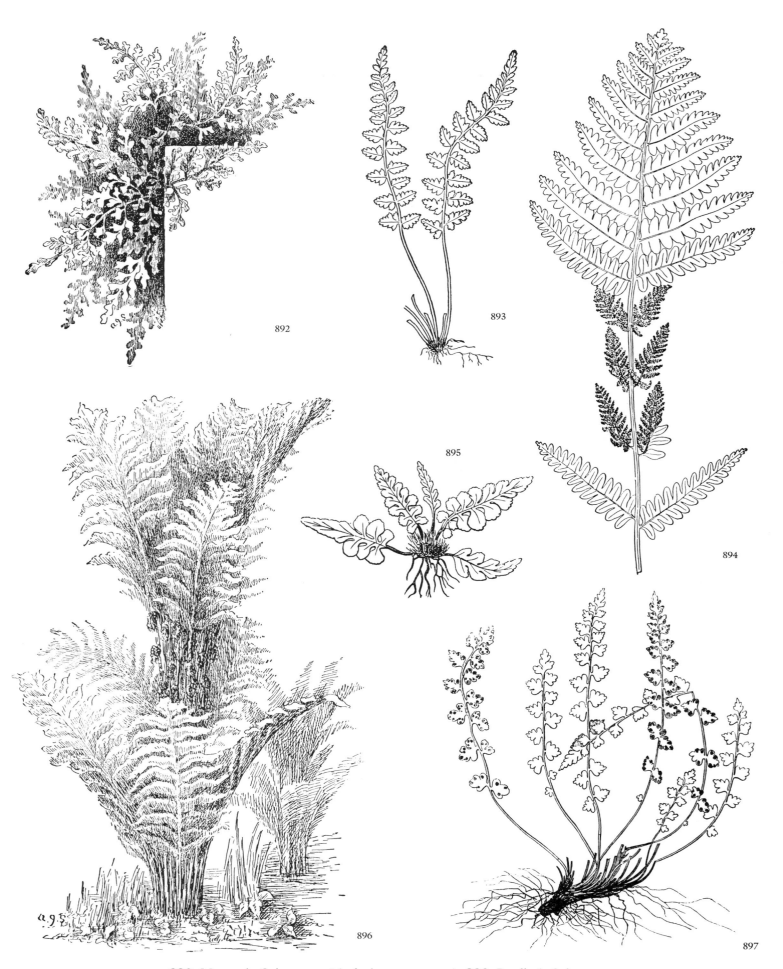

892. Mountain Spleenwort (*Asplenium montanum*). **893.** Bradley's Spleenwort
(*Asplenium bradleyi*). **894, 896.** Interrupted Fern (*Osmunda claytoniana*). **895.**
Sea Spleenwort (*Asplenium marinum*). **897.** Bolton's Woodsia (*Woodsia alpina*).

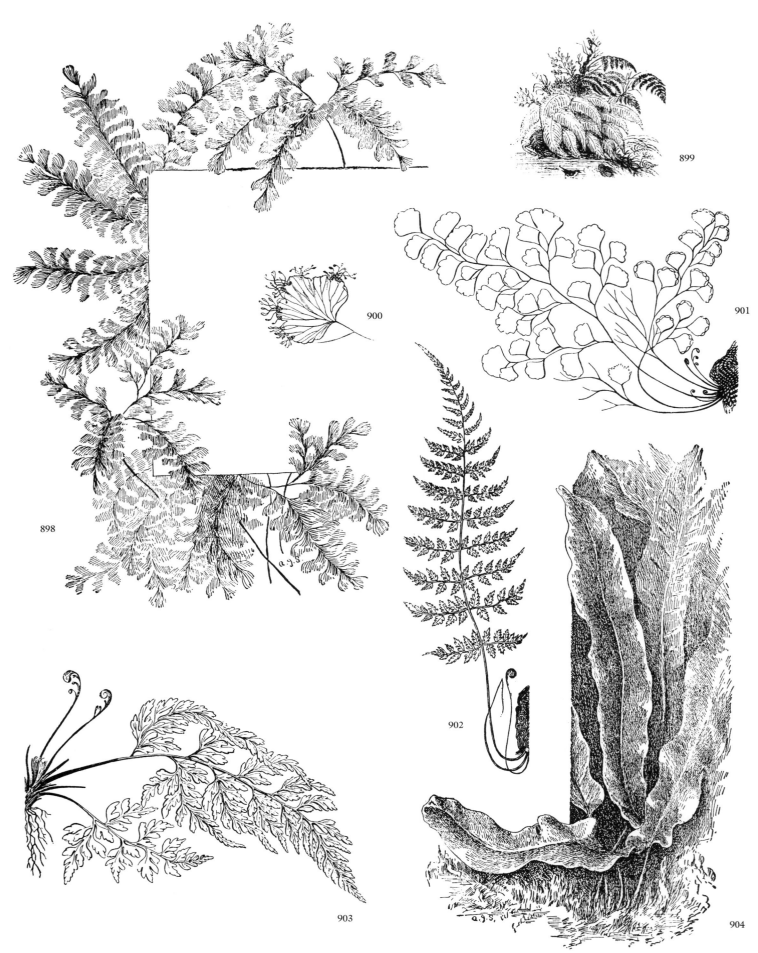

898. Northern Maidenhair Fern (*Adiantum pedatum*). **899.** Ferns with Bird. **900.** Detail of Maidenhair Fern Leaf. **901.** Southern Maidenhair Fern (*Adiantum capillus-veneris*). **902.** *Cystea fragilis*. **903.** Black Spleenwort (*Asplenium adiantum-nigrum*). **904.** Hart's Tongue (*Phyllitis scolopendrium*).

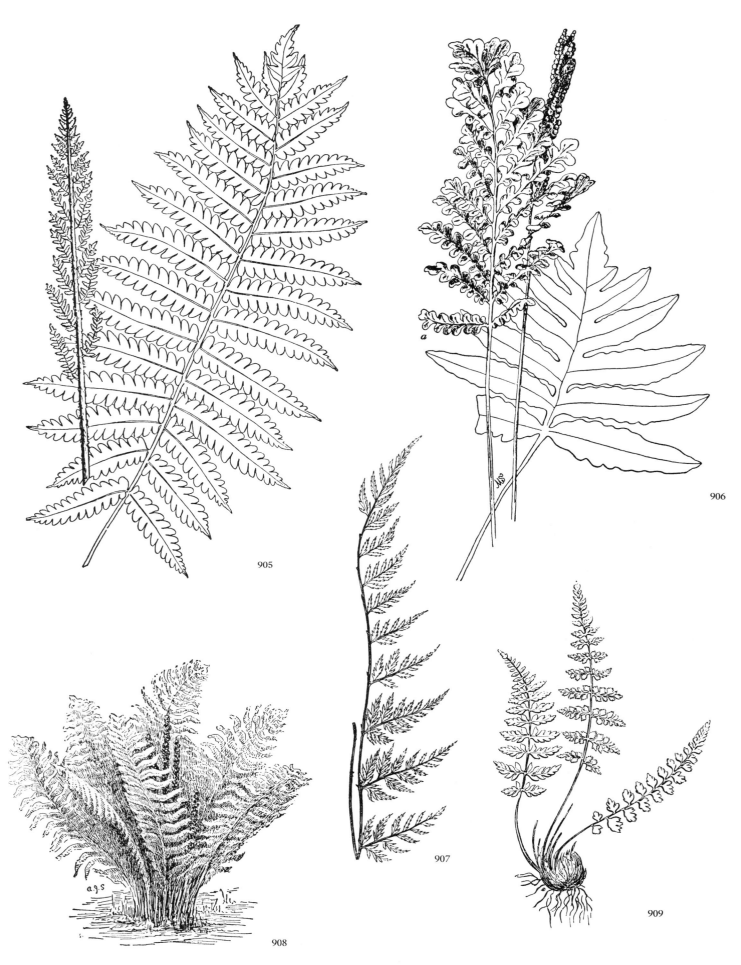

905, 908. Cinnamon Fern (*Osmunda cinnamomea*). **906.** Sensitive Fern (*Onoclea sensibilis*). **907.** *Cystea angustata*. **909.** Hudson's Spleenwort (*Asplenium lanceolatum*).

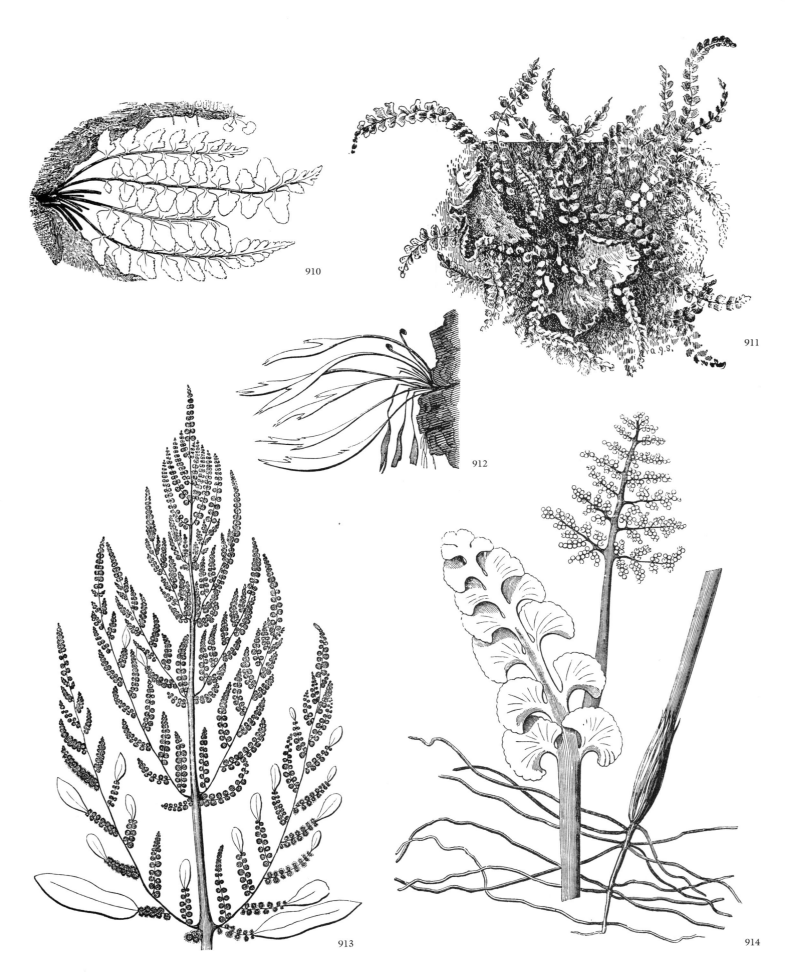

910. Sea Spleenwort (*Asplenium marinum*). **911.** Maidenhair Spleenwort (*Asplenium trichomanes*). **912.** Forked Spleenwort (*Asplenium septentrionale*). **913.** Royal Fern (*Osmunda regalis*). **914.** Moonwort (*Botrychium lunaria*).

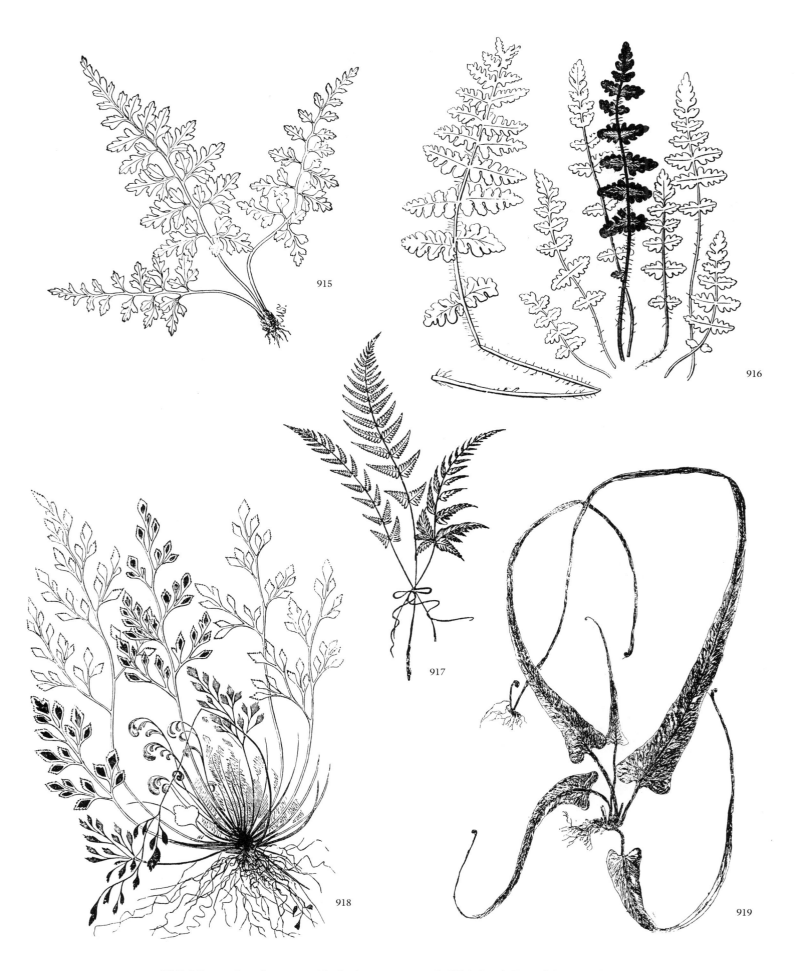

915. Mountain spleenwort (*Asplenium montanum*). **916.** Ray's Woodsia (*Woodsia ilvensis*). **917.** Decorative Fern Bouquet. **918.** Rue-leaved Spleenwort (*Asplenium ruta-muraria*). **919.** Walking Leaf Fern (*Camptosorus rhizophyllus*).

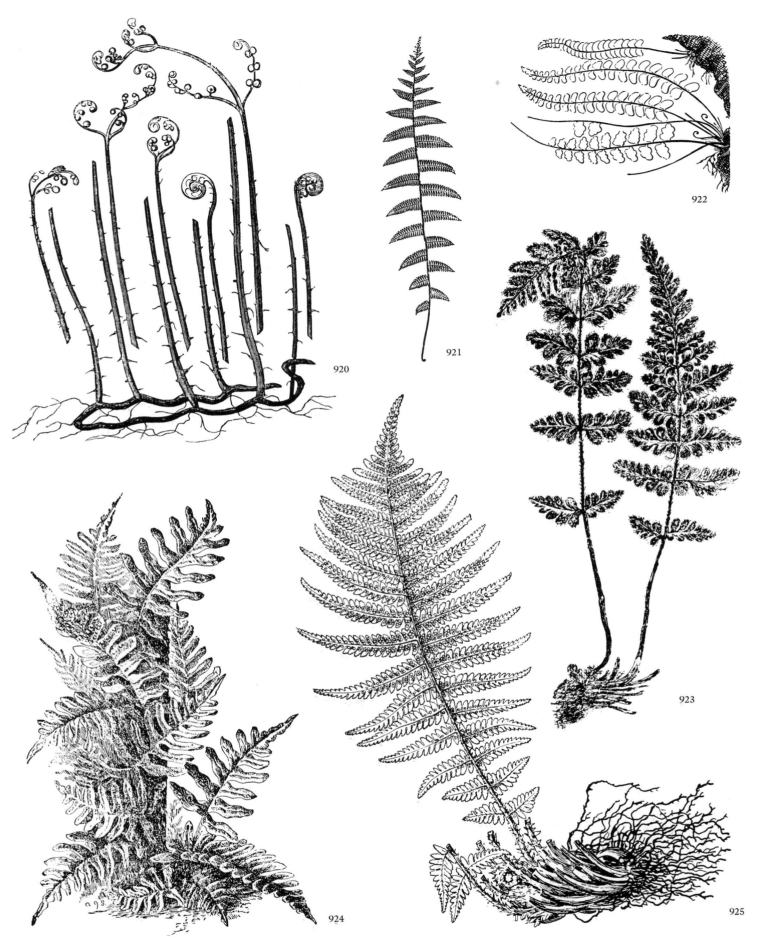

920. Smith's Fern (*Polypodium calcareum*). **921.** Lady Fern (*Athyrium filix-foemina*). **922.** Maidenhair Spleenwort (*Asplenium trichomanes*). **923.** Ray's Woodsia (*Woodsia ilvensis*). **924.** Common Polypody (*Polypodium virginianum*). **925.** Male Fern (*Dryopteris filix-mas*).

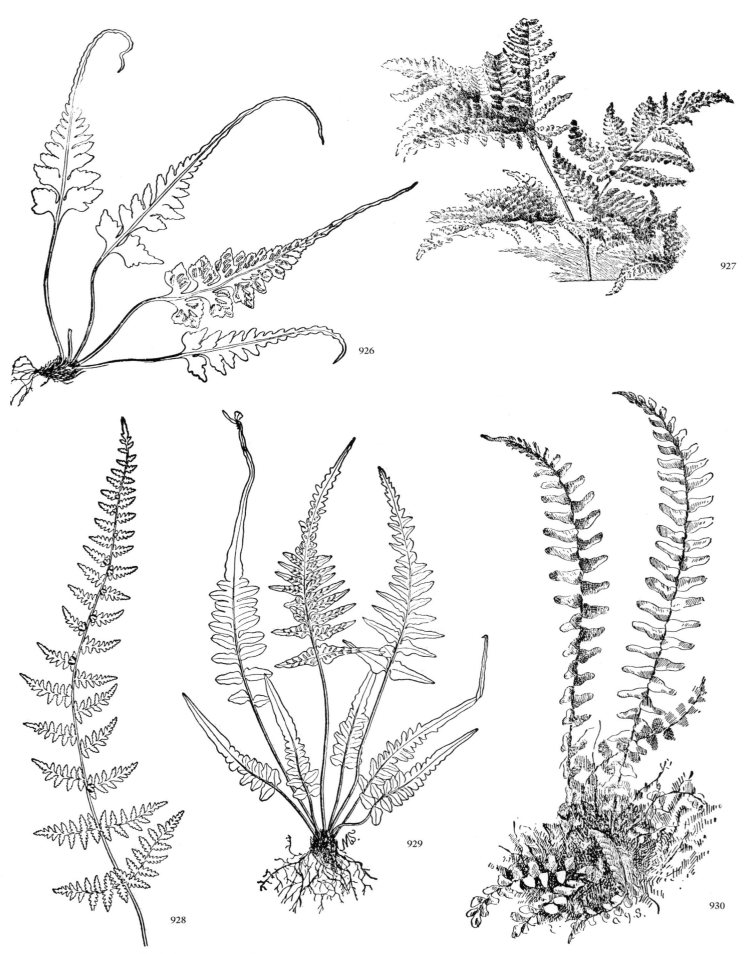

926. Pinnatifid Spleenwort (*Asplenium* sp.). **927.** Bracken (*Pteridium aquilinum*). **928.** Bulblet Bladder Fern (*Cystopteris bulbifera*). **929.** Scott's Spleenwort (*Asplenosorus × ebenoides*). **930.** Ebony Spleenwort (*Asplenium platyneuron*).

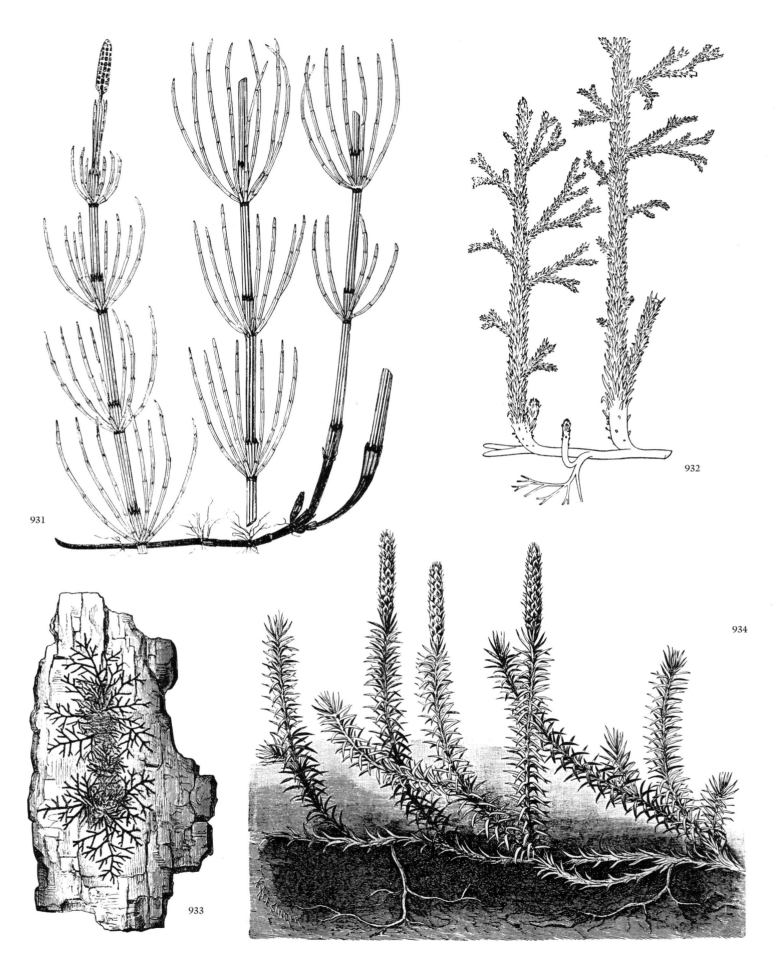

931. Marsh Equisetum (*Equisetum palustre*). **932.** *Asteroxylon mackiei* (prehistoric). **933.** Spreading Liverwort (*Frullania dilatata*). **934.** Bristly Clubmoss (*Lycopodium annotinum*).

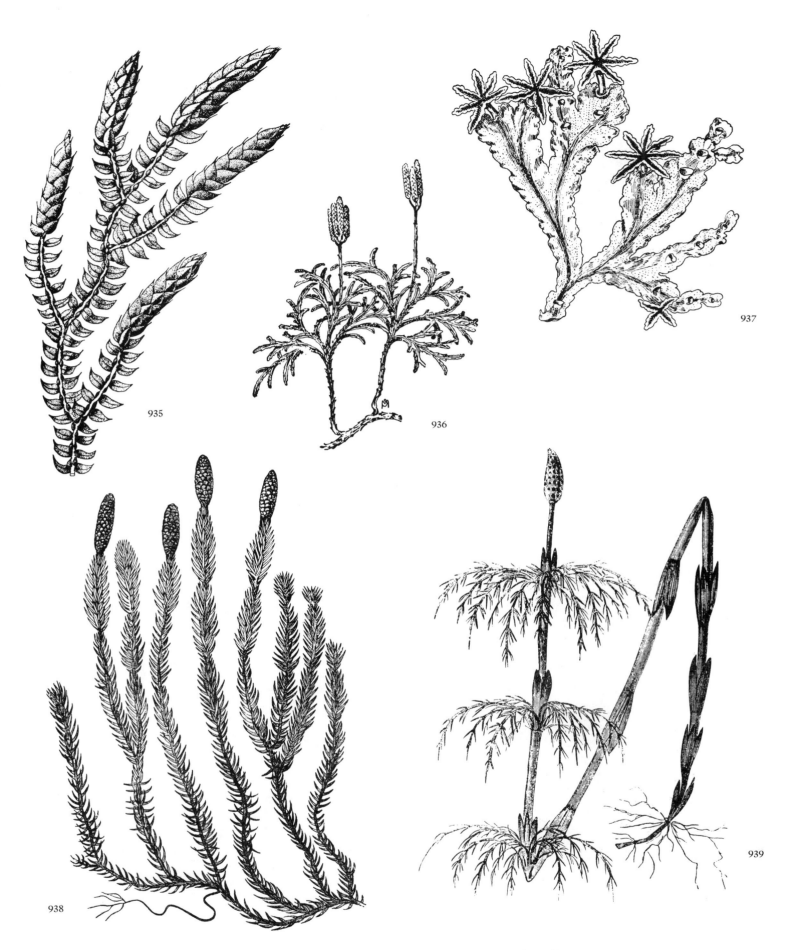

935. Rowan's Selaginella (*Selaginella martensii*). **936.** Ground Cedar (*Lycopodium complanatum*). **937.** Liverwort (*Marchantia disjuncta*). **938.** Interrupted Clubmoss (*Lycopodium annotinum*). **939.** Wood Equisetum (*Equisetum sylvaticum*).

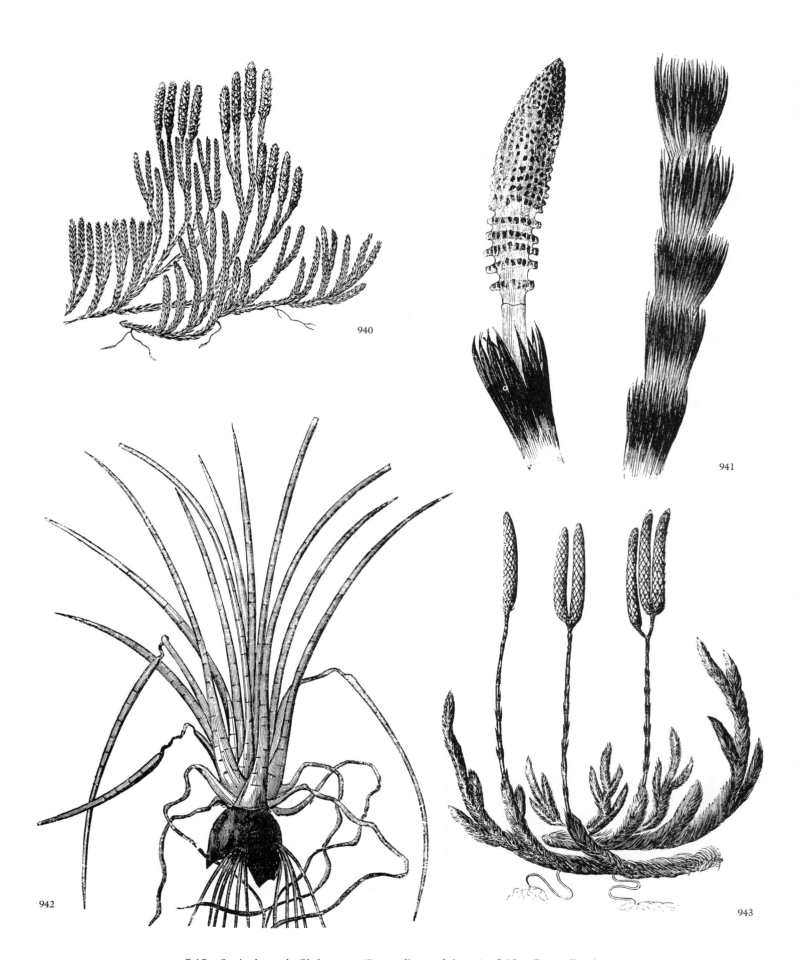

940. Savin-leaved Clubmoss (*Lycopodium alpinum*). **941.** Great Equisetum (Equisetum telmateia). **942.** Quillwort (*Isoetes lacustris*). **943.** Running Club-moss (*Lycopodium clavatum*).

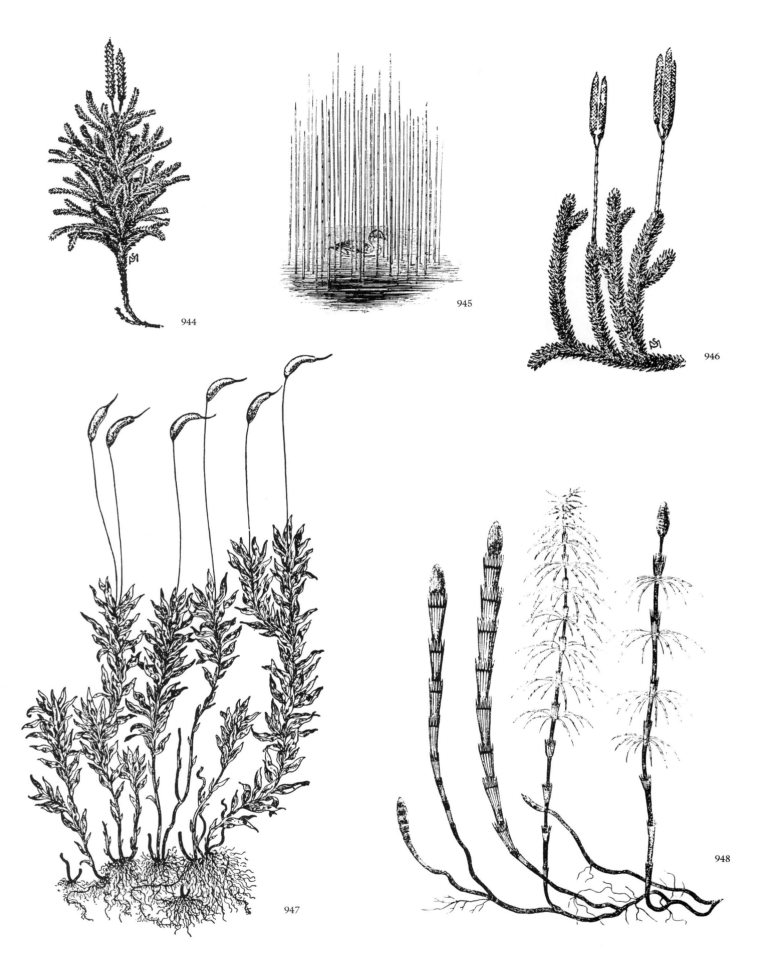

944. Princess Pine (*Lycopodium obscurum*). **945.** Water Equisetum (*Equisetum limosum*). **946.** Running Clubmoss (*Lycopodium clavatum*). **947.** Japanese Bonsai Moss (*Catharinea moorei*). **948.** Shady Equisetum (*Equisetum umbrosum*).

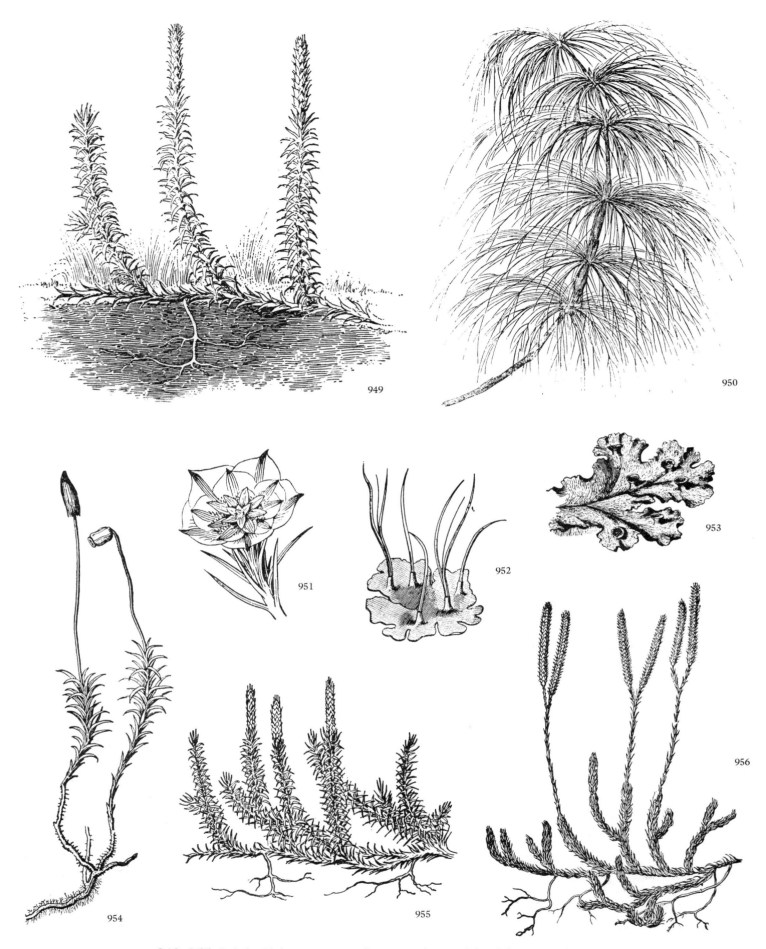

949, 955. Bristly Clubmoss (*Lycopodium annotinum*). **951, 954.** Reproductive Structure of Pigeon-Wheat Moss (*Polytrichum commune*). **952.** Horned Liverwort (*Anthoceros* sp.). **953.** Leafy Liverwort (*Marchantia polymorpha*). **956.** Running Clubmoss (*Lycopodium clavatum*).

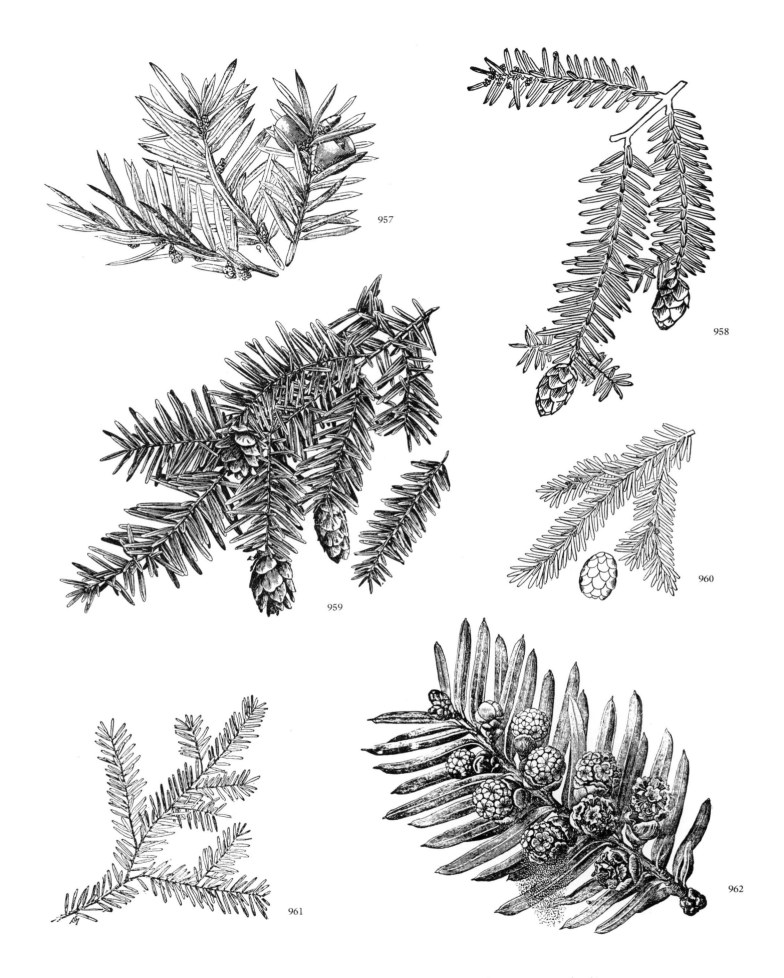

957, 962. Yew (*Taxus baccata*). **958, 960, 961.** Hemlock (*Tsuga canadensis*).
959. Western Hemlock (*Tsuga heterophylla*).

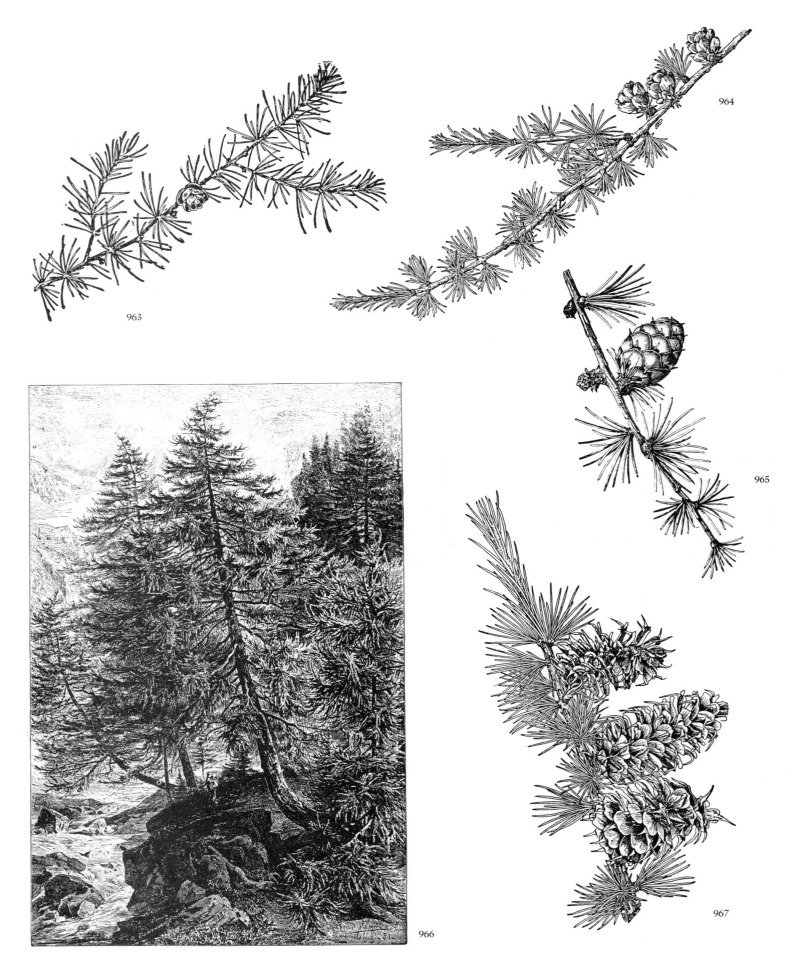

963. Tamarack (*Larix laricina*). **964.** Alaskan Larch (*Larix laricina*). **965, 966.**
European Larch (*Larix decidua*). **967.** Mountain Larch (*Larix lyallii*).

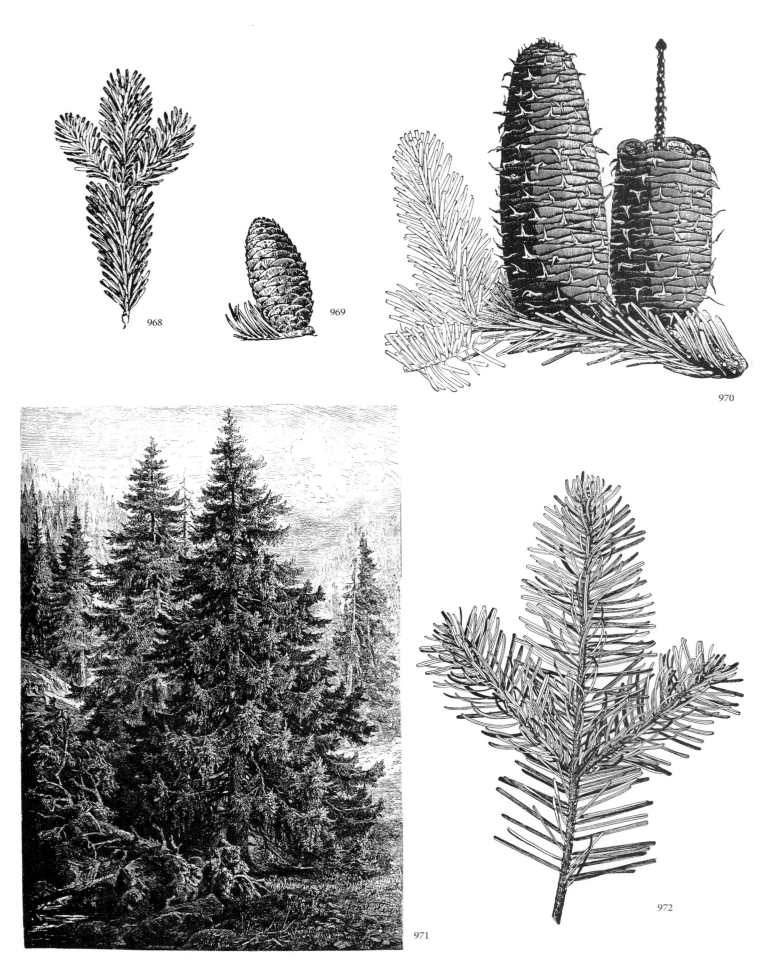

968. Fraser Fir (*Abies fraseri*). **969.** Balsam Fir (*Abies balsamea*). **970.** Western Fir (*Abies alba*). **971.** European Fir. **972.** Silver Fir (*Abies amabilis*).

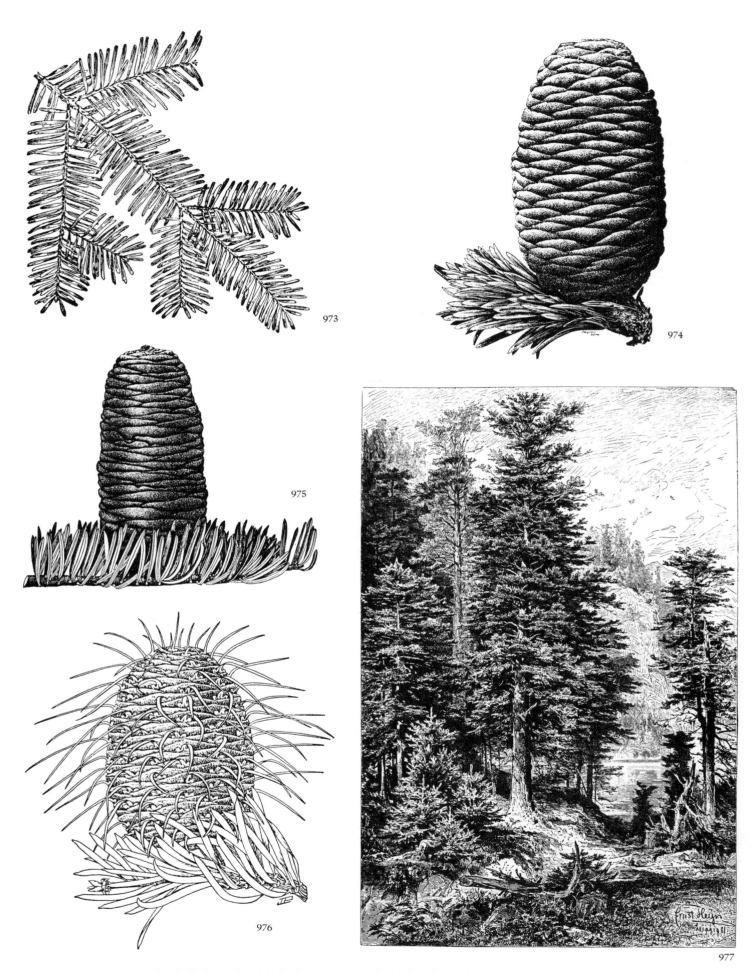

973. Balsam Fir (*Abies balsamea*). **974, 977.** Silver Fir (*Abies amabilis*). **975.** White Fir (*Abies concolor*). **976.** Spider-Cone Fir (*Abies bracteata*).

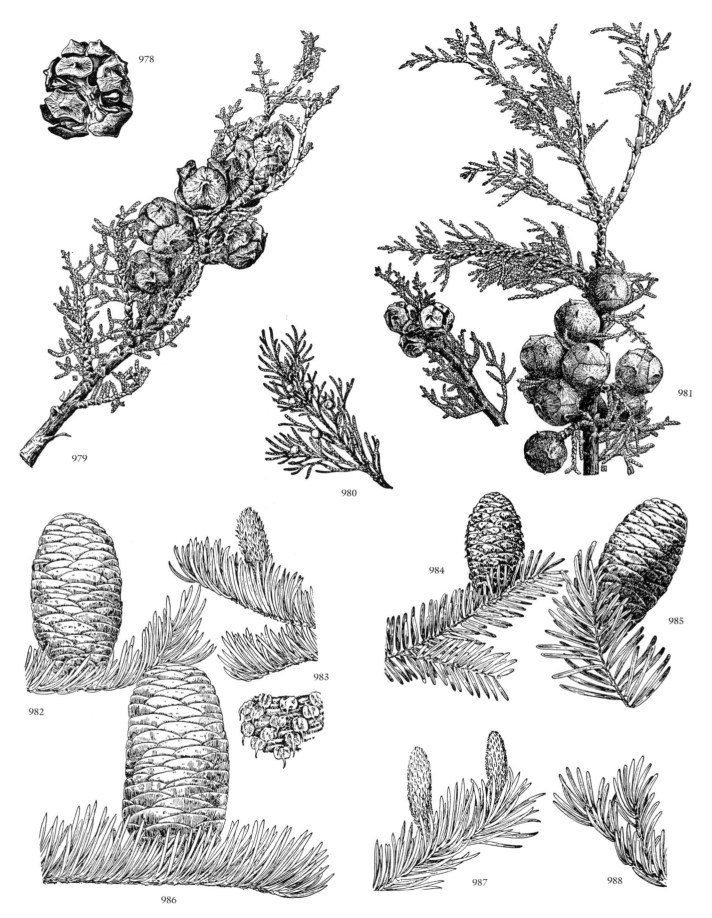

978. Evergreen Cypress (*Cupressus sempervirens*). **979.** Tangle Cypress (*Cupressus pygmaea*). **980.** Red Cedar (*Juniperus virginiana*). **981.** Gowen Cypress (*Cupressus goveniana*). **982.** Grand Fir (*Abies grandis*). **983.** Noble Fir (*Abies procera*). **984.** Fraser Fir (*Abies fraseri*). **985.** Alpine Fir (*Abies lasiocarpa*). **986.** White Fir (*Abies concolor*). **987.** Silver Fir (*Abies amabilis*). **988.** Red Fir (*Abies magnifica*).

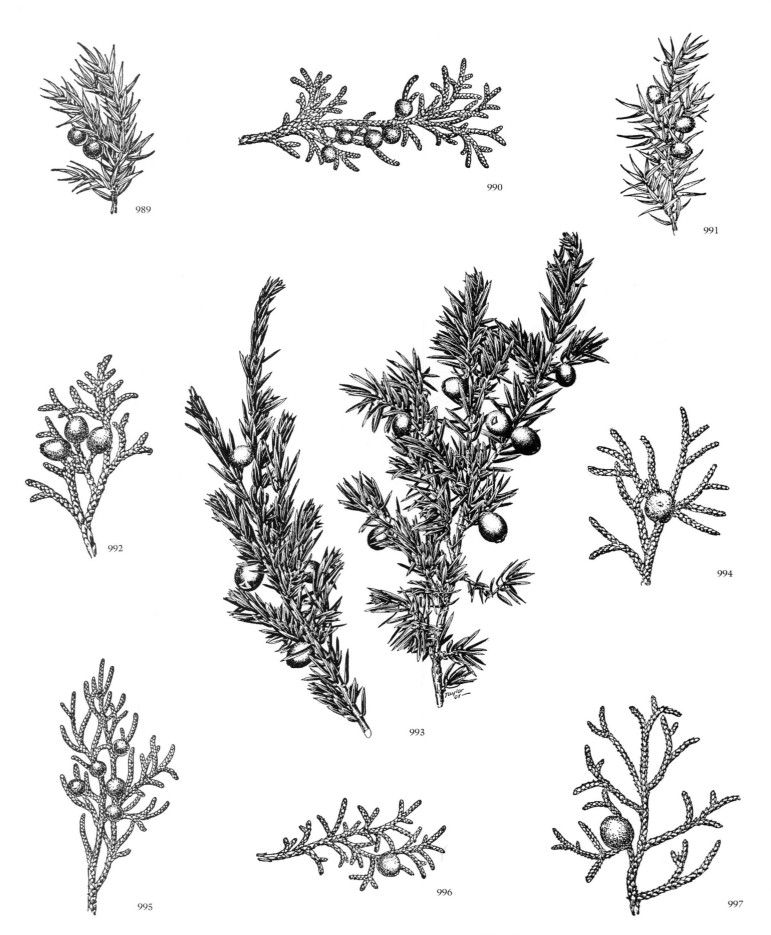

989, 991, 993. Erect Juniper (*Juniperus communis*). **990.** Prostrate Savin (*Juniperus horizontalis*). **992.** Rocky Mountain Red Cedar (*Juniperus scopulorum*). **994.** Utah Juniper (*Juniperus osteosperma*). **995.** Red Cedar (*Juniperus virginiana*). **996.** Western Juniper (*Juniperus occidentalis*). **997.** California Juniper (*Juniperus californica*).

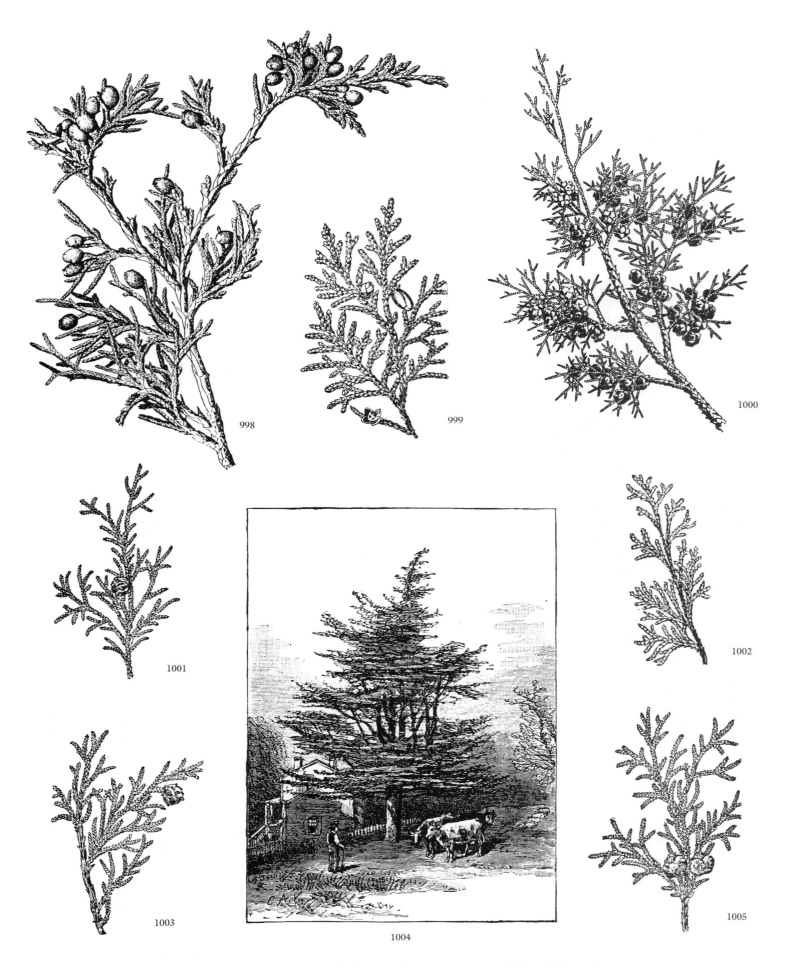

998. Rocky Mountain Red Cedar (*Juniperus scopulorum*). **999, 1002.** Arbor Vitae (*Thuja occidentalis*). **1000, 1001.** Southern White Cedar (*Chamaecyparis thyoides*). **1003.** Port Orford Cedar (*Chamaecyparis lawsoniana*). **1004.** Cedar of Lebanon (*Cedrus libani*). **1005.** Alaska Cedar (*Chamaecyparis nootkatensis*).

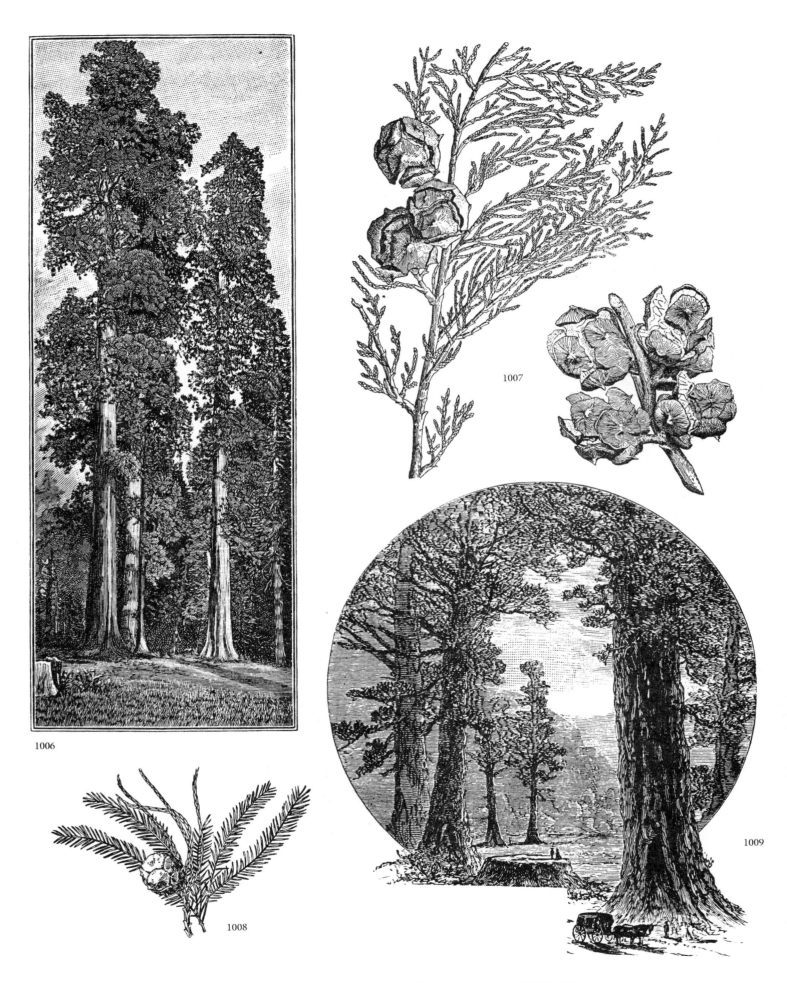

1006, 1009. Giant Sequoia (*Sequoiadendron giganteum*). **1007.** Monterey Cypress (*Cupressus macrocarpa*). **1008.** Bald Cypress (*Taxodium distichum*).

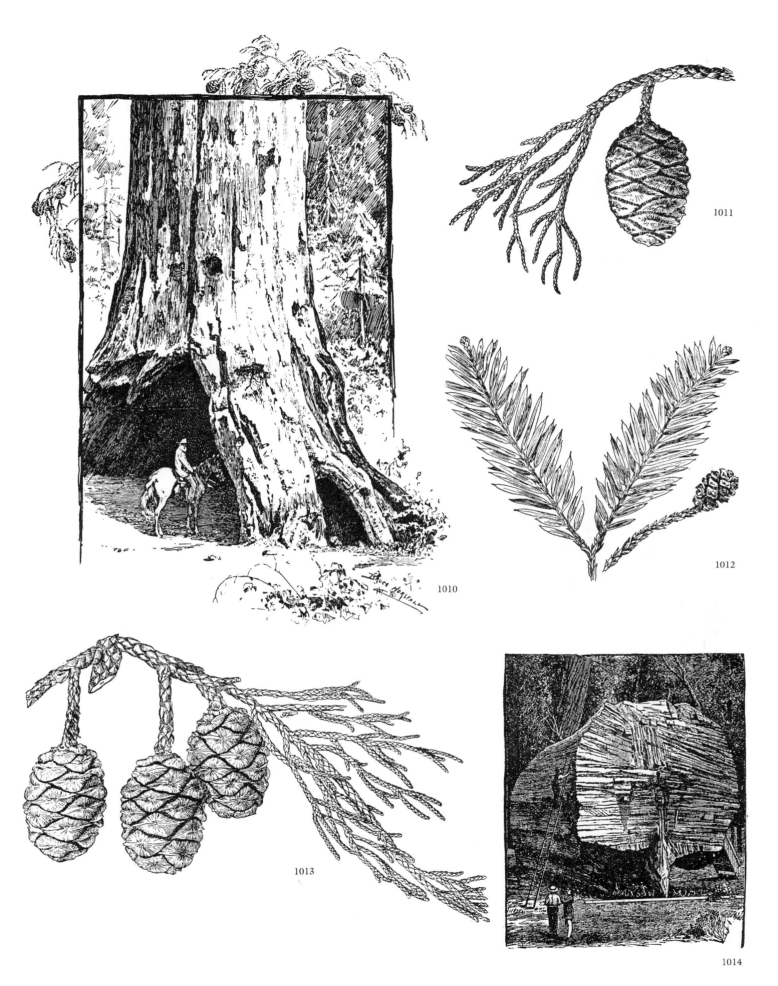

1010, 1011, 1013, 1014. Giant Sequoia (*Sequoiadendron giganteum*). **1012.** Redwood (*Sequoia sempervirens*).

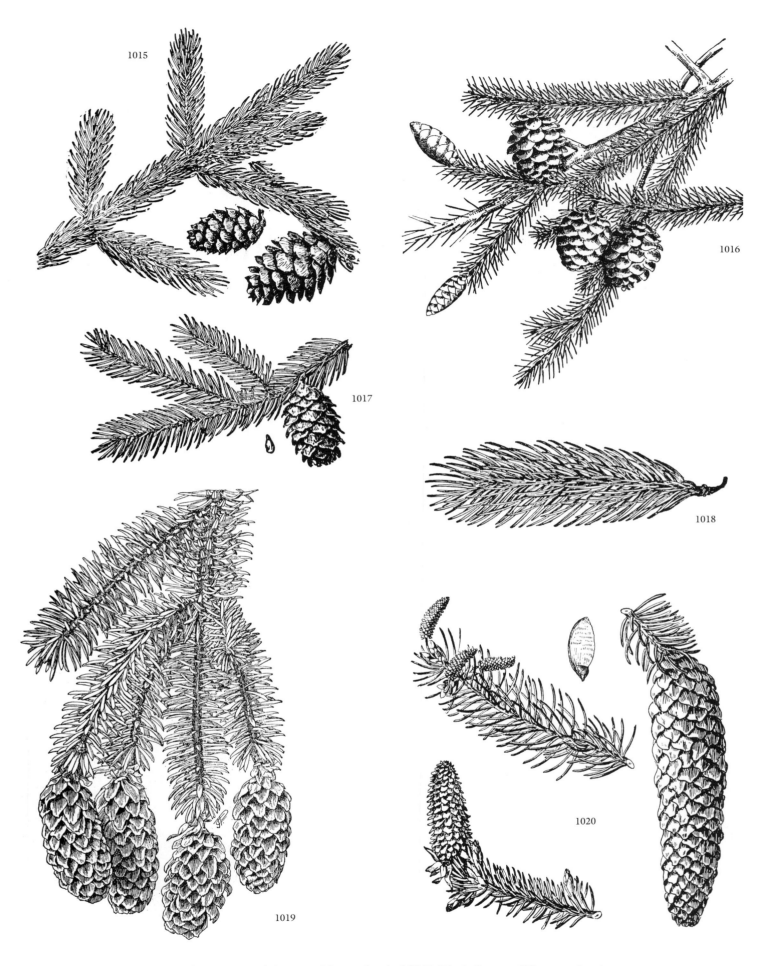

1015, 1016. Red Spruce (*Picea rubens*). **1017.** Black Spruce (*Picea mariana*).
1018. Colorado Blue Spruce (*Picea pungens*). **1019.** Sitka Spruce (*Picea sichensis*).
1020. Norway Spruce: Reproductive Structures and Seed (*Picea abies*).

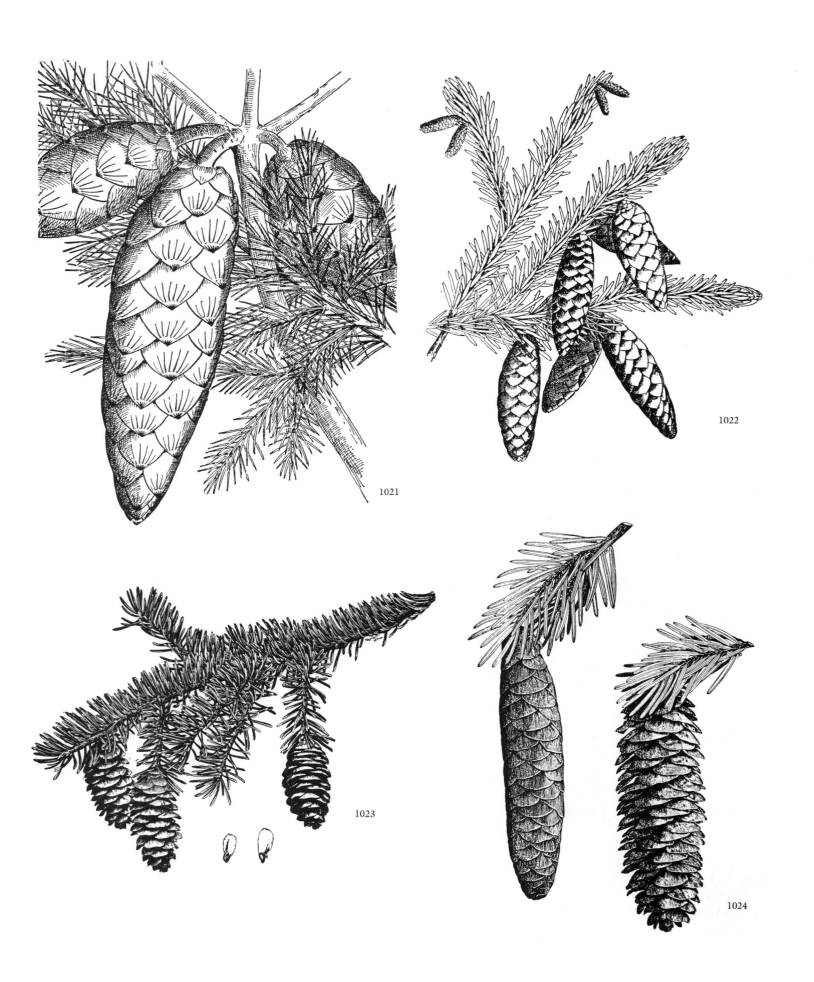

1021. Norway Spruce (*Picea abies*). **1022, 1023.** White Spruce (*Picea glauca*).
1024. Western Spruce (*Picea·brewerana*).

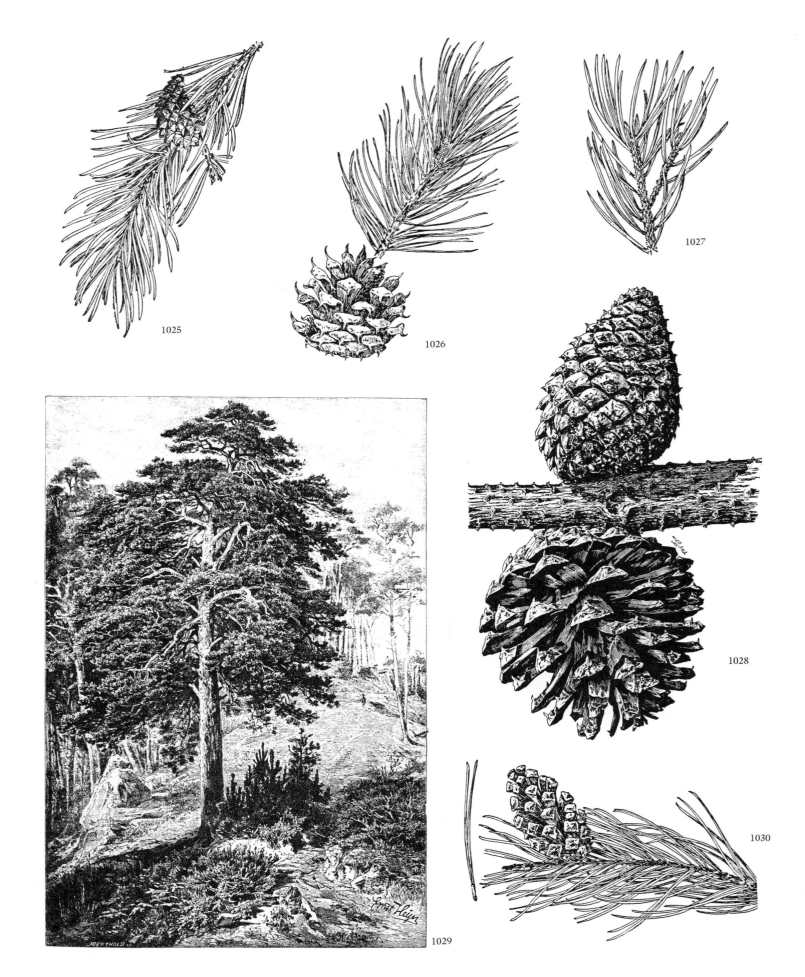

1025, 1029, 1030. Scotch Pine (*Pinus sylvestris*). **1026.** Table Mountain Pine (*Pinus pungens*). **1027.** Single-leaved Pine (*Pinus monophylla*). **1028.** Rough Pine (*Pinus muricata*).

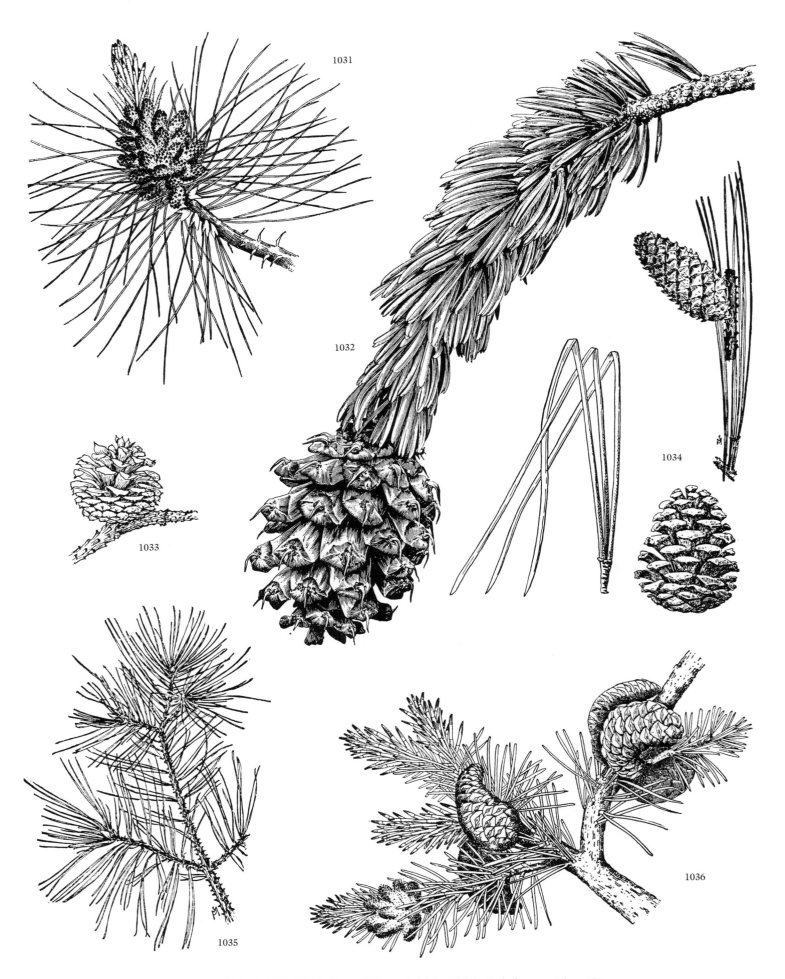

1031, 1033, 1035. Pitch Pine (*Pinus rigida*). **1032.** Bristlecone Pine (*Pinus aristata*). **1034.** Loblolly Pine (*Pinus taeda*). **1036.** Jack Pine (*Pinus banksiana*).

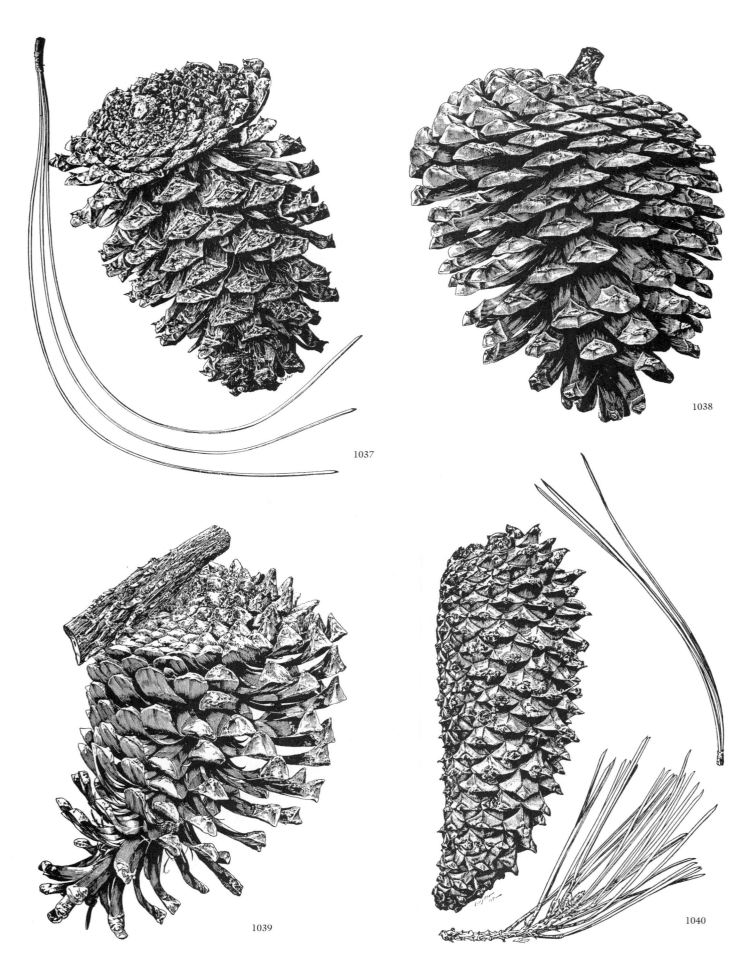

1037. Ponderosa Pine (*Pinus ponderosa*). **1038.** Monterey Pine (*Pinus radiata*).
1039, 1040. Knobcone Pine (*Pinus attenuata*).

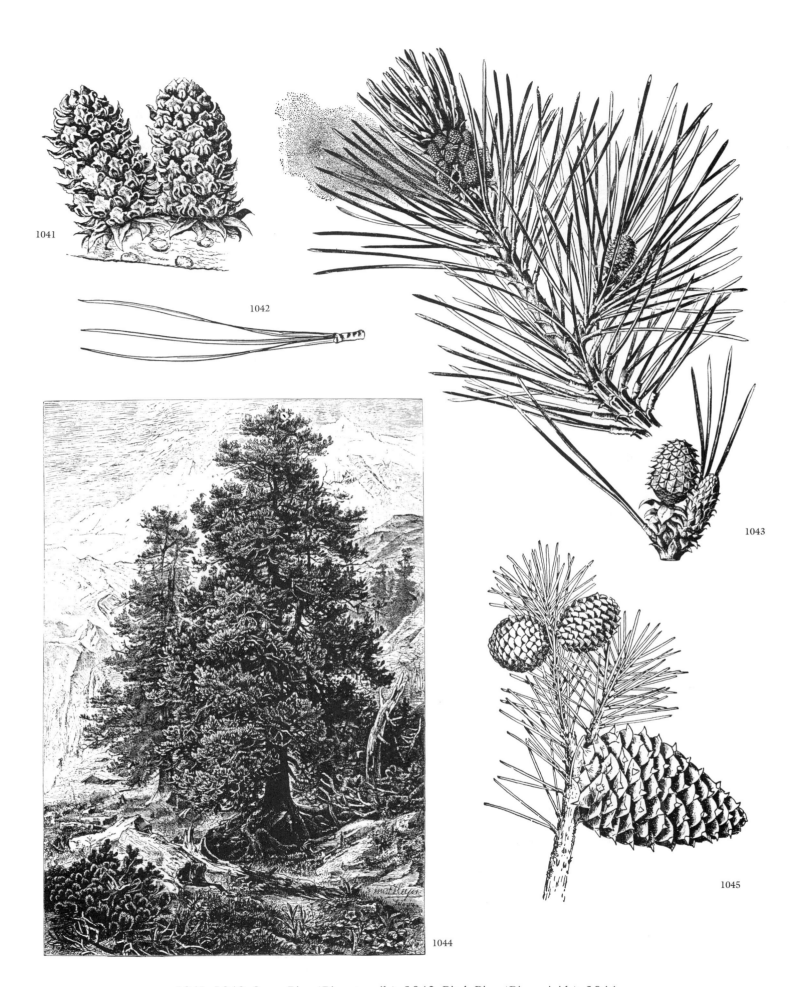

1041, 1043. Stone Pine (*Pinus pumila*). **1042.** Pitch Pine (*Pinus rigida*). **1044.**
Siberian Pine (*Pinus cembra*). **1045.** Table Mountain Pine (*Pinus pungens*).

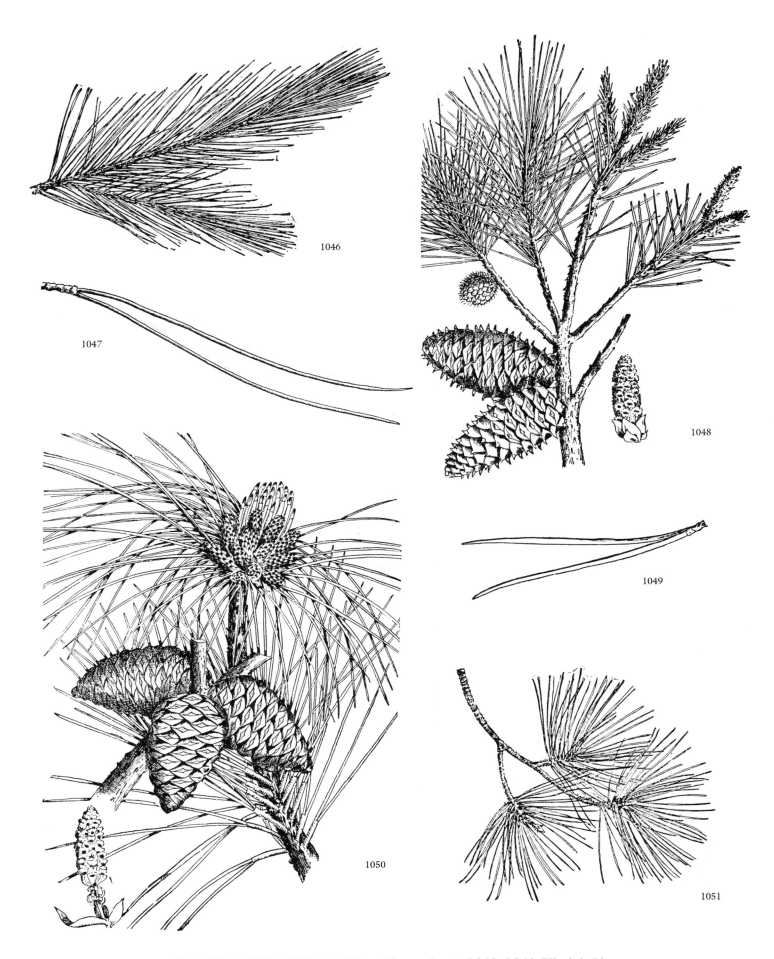

1046, 1047, 1050, 1051. Red Pine (*Pinus resinosa*). **1048, 1049.** Virginia Pine (*Pinus virginiana*).

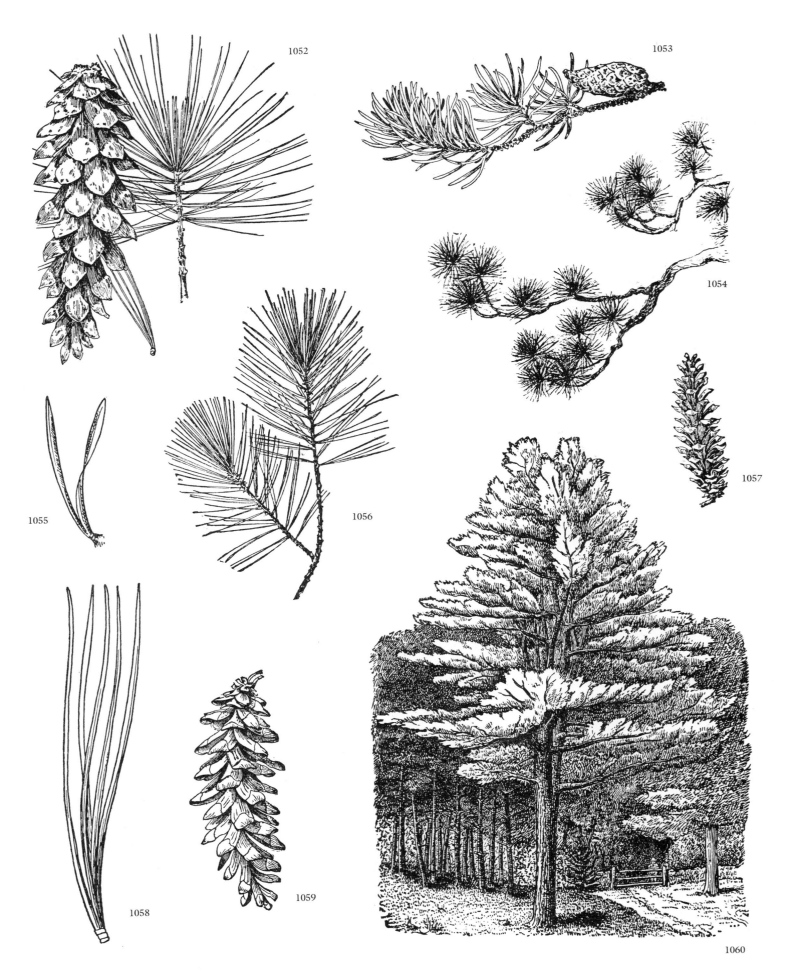

1052, 1056–1060. White Pine (*Pinus strobus*). **1053–1055.** Jack Pine (*Pinus banksiana*).

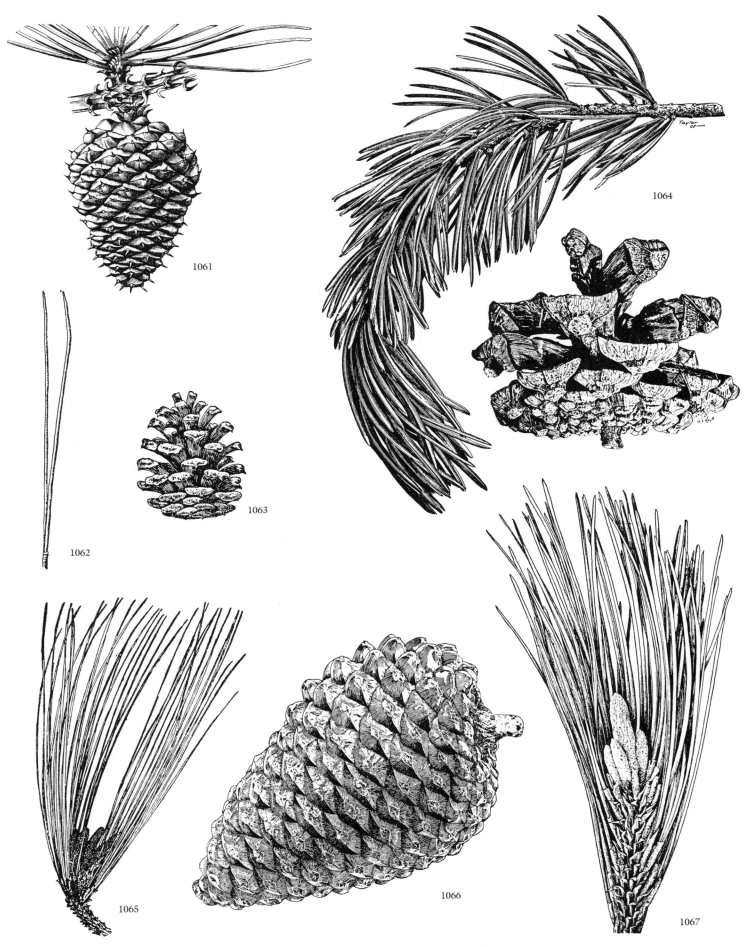

1061. Swamp Pine (*Pinus serotina*). **1062, 1063.** Shortleaf Pine (*Pinus echinata*). **1064.** Parry Pinyon Pine (*Pinus quadrifolia*). **1065.** Longleaf Pine (*Pinus palustris*). **1066.** Monterey Pine (*Pinus radiata*). **1067.** Bishop Pine (*Pinus muricata*).

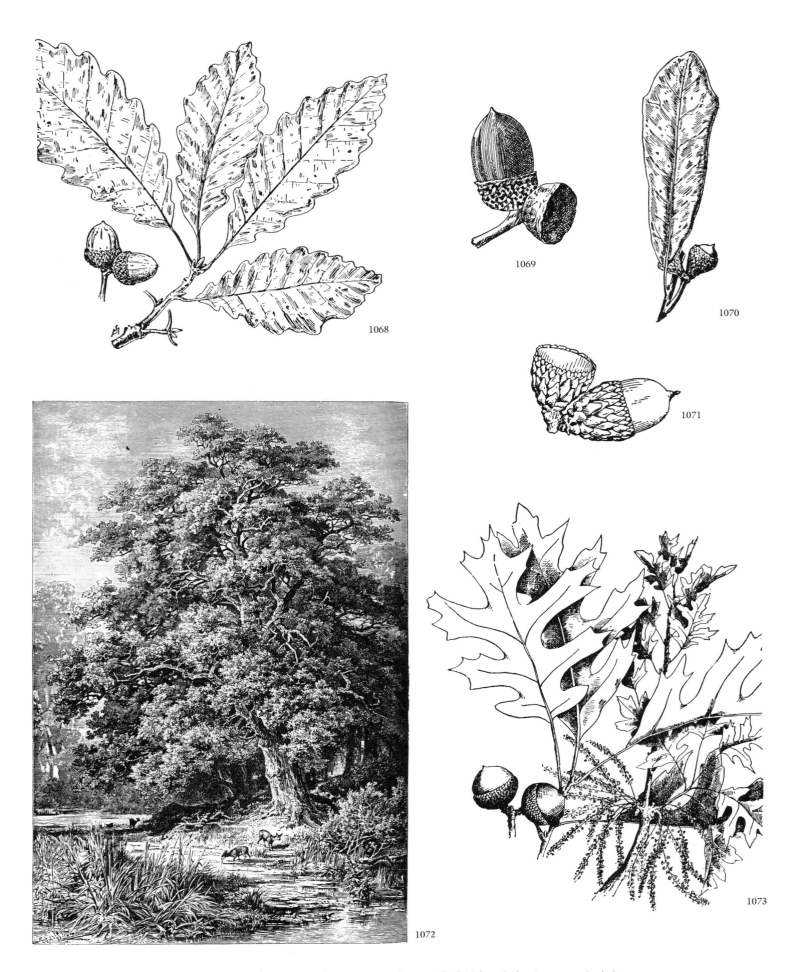

1068, 1069. Chestnut Oak (*Quercus prinus*). **1070.** Live Oak (*Quercus virginiana*). **1071, 1073.** Scarlet Oak (*Quercus coccinea*). **1072.** European Oak with Roedeer.

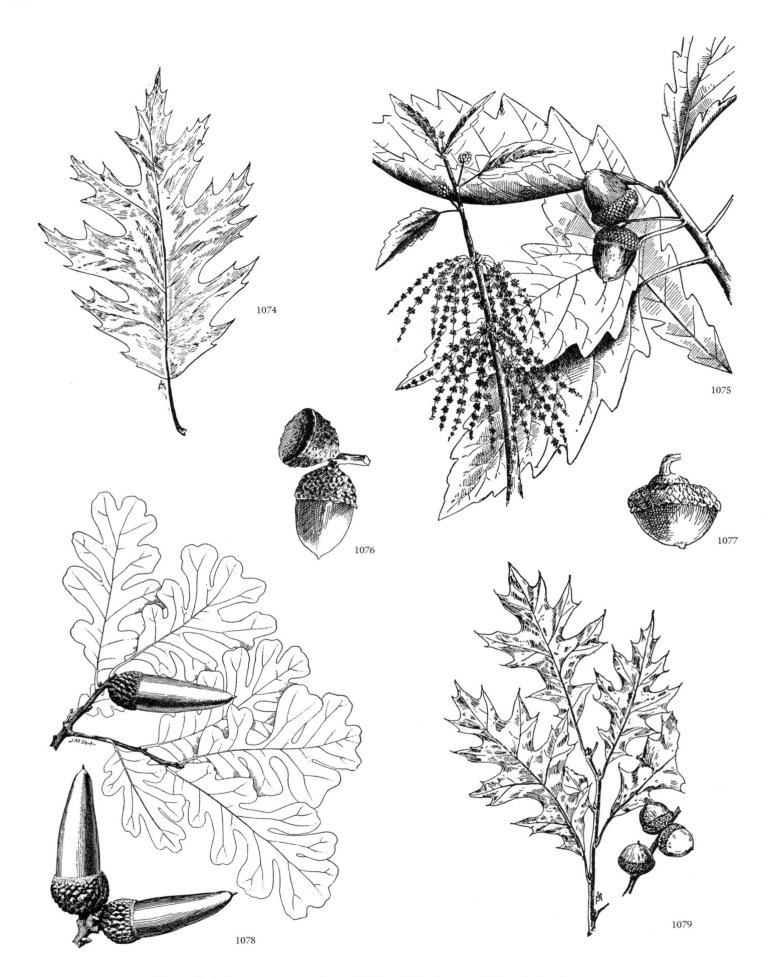

1074. Red Oak (*Quercus rubra*). **1075, 1076.** Swamp White Oak (*Quercus bicolor*). **1077, 1079.** Pin Oak (*Quercus palustris*). **1078.** California White Oak (*Quercus lobata*).

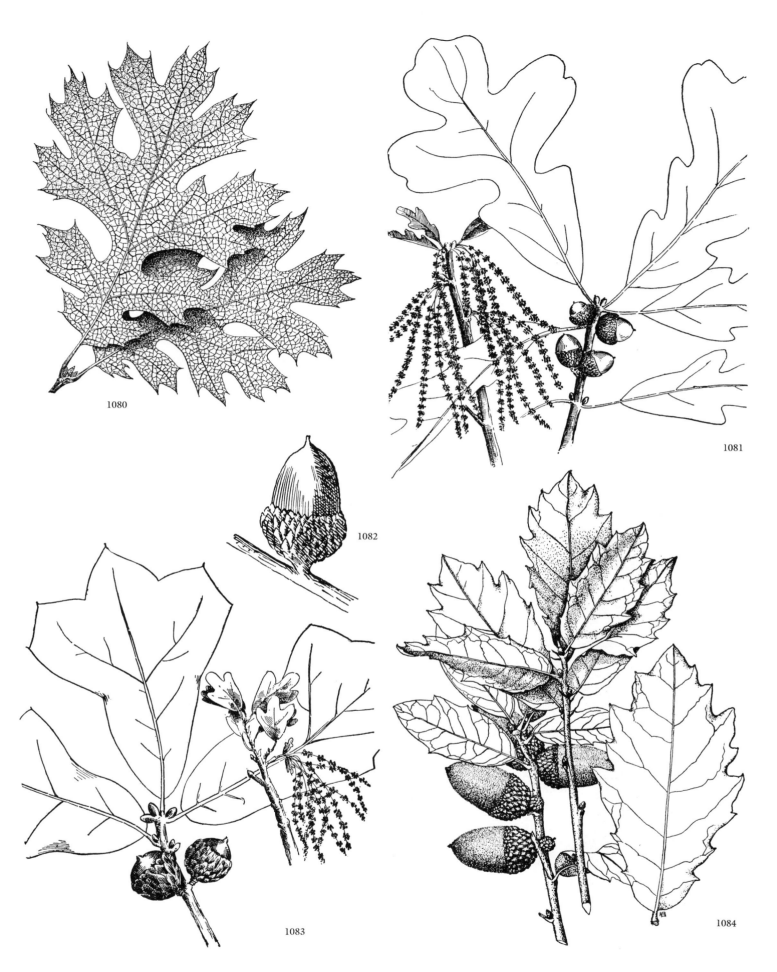

1080. California Black Oak (*Quercus kelloggii*). **1081.** Post Oak (*Quercus stellata*). **1082, 1083.** Blackjack Oak (*Quercus marilandica*). **1084.** Engelmann Oak (*Quercus engelmannii*).

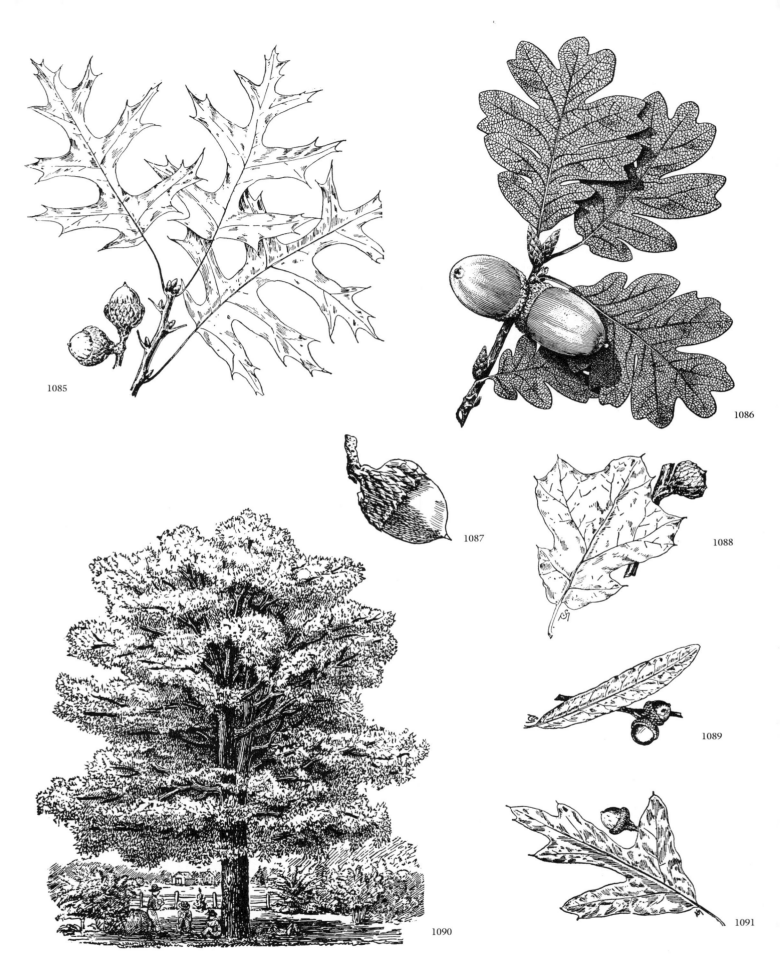

1085, 1087. Scarlet Oak (*Quercus coccinea*). **1086.** Oregon White Oak (*Quercus garryana*). **1088.** Blackjack Oak (*Quercus marilandica*). **1089.** Willow Oak (*Quercus phellos*). **1090.** White Oak (*Quercus alba*). **1091.** Southern Red Oak (*Quercus falcata*).

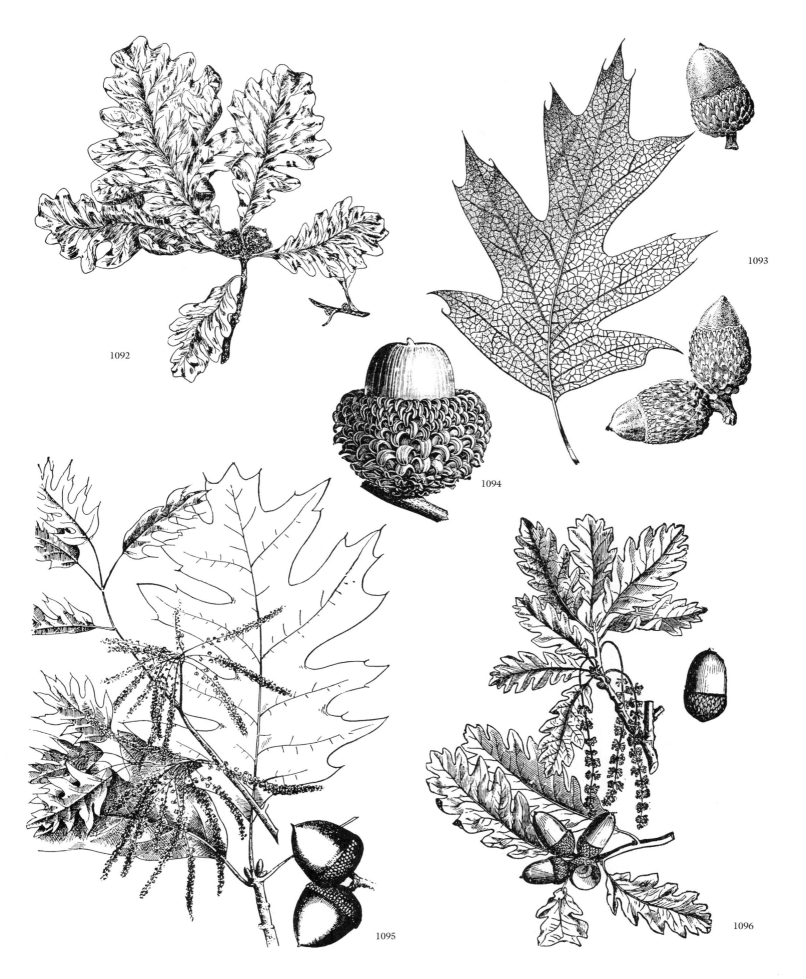

1092. Bur Oak (*Quercus macrocarpa*). **1093.** California Black Oak (*Quercus kelloggii*). **1094.** Rhine Oak (*Quercus macrolepis*). **1095.** Red Oak (*Quercus rubra*). **1096.** Shatter Oak (*Quercus petraea*).

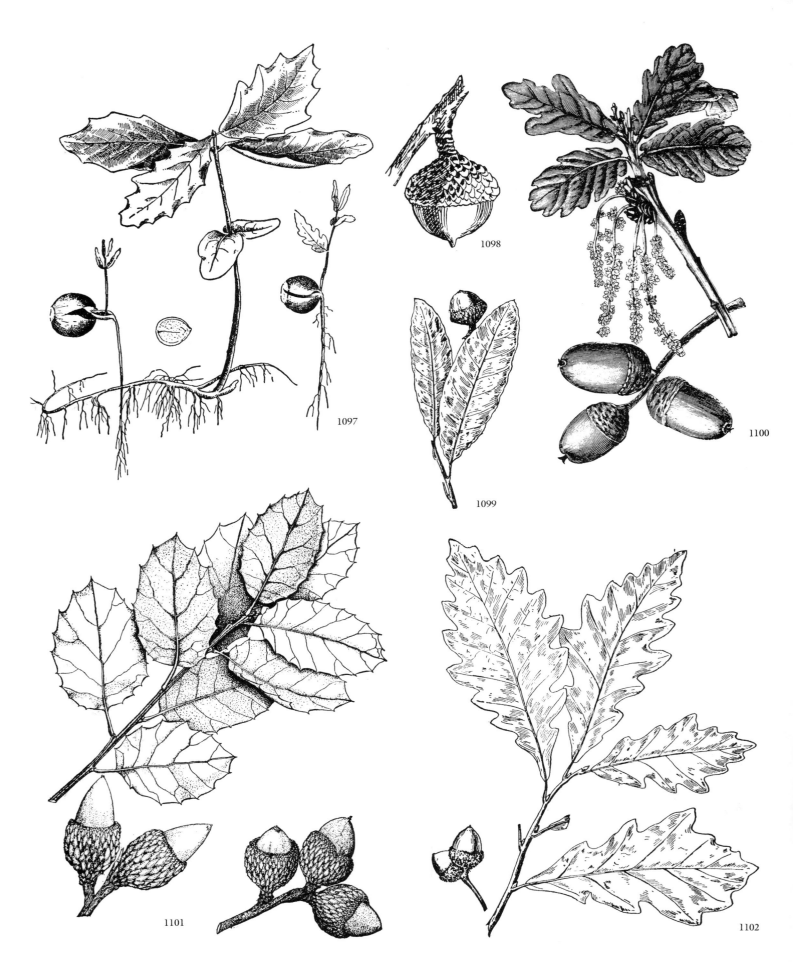

1097. Germinating Oak. 1098, 1099. Shingle Oak (*Quercus imbricaria*). 1100. Oak (*Quercus robur*). 1101. Interior Live Oak (*Quercus wislizenii*). 1102. Swamp White Oak (*Quercus bicolor*).

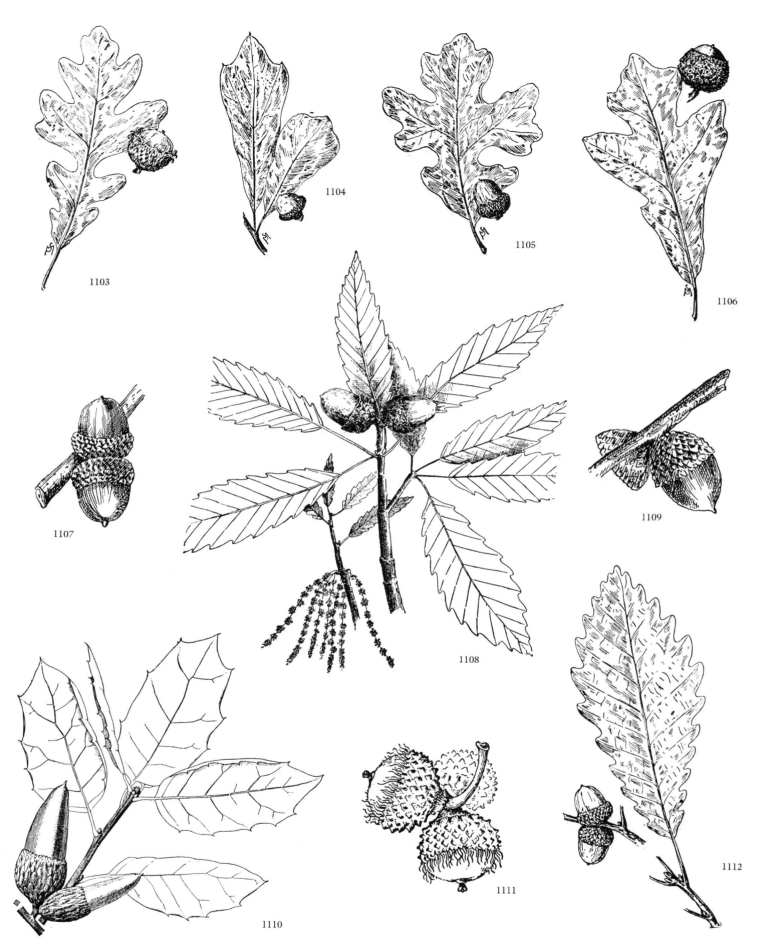

1103, 1111. Bur Oak (*Quercus macrocarpa*). **1104.** Water Oak (*Quercus nigra*).
1105, 1107. Post Oak (*Quercus stellata*). **1106.** Southern Overcup Oak (*Quercus lyrata*). **1108, 1109.** Chestnut Oak (*Quercus prinus*). **1110.** California Live Oak (*Quercus agrifolia*). **1112.** Swamp Chestnut Oak (*Quercus michauxii*).

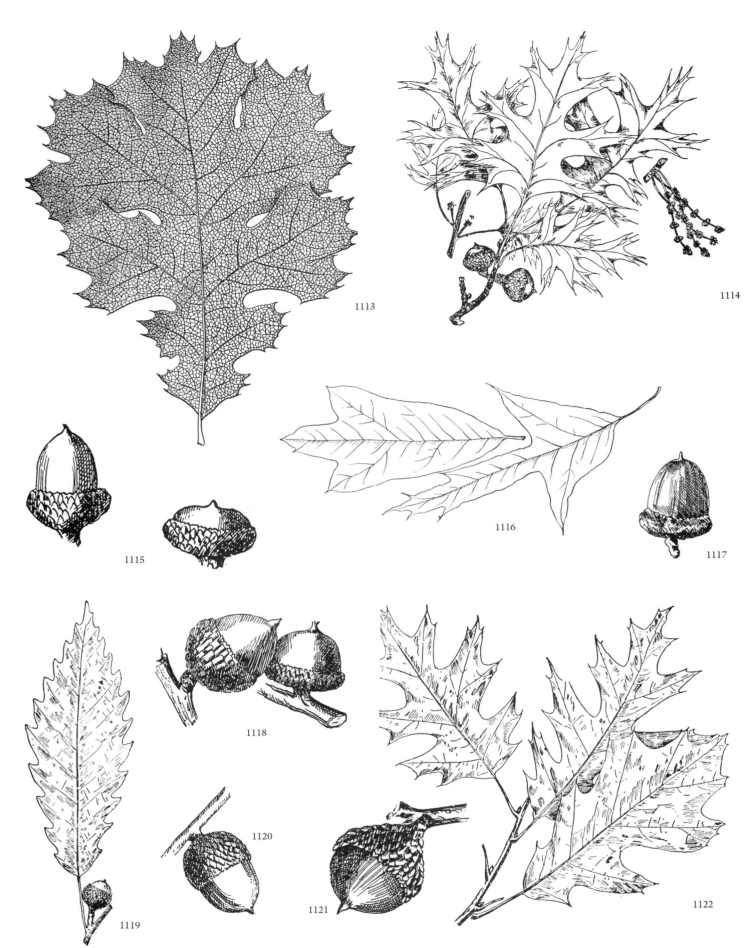

1113. California Black Oak (*Quercus kelloggii*). **1114.** Scarlet Oak (*Quercus coccinea*). **1115.** Bear Oak (*Quercus ilicifolia*). **1116, 1118.** Spanish Oak (*Quercus falcata*). **1117.** Red Oak (*Quercus rubra*). **1119.** Chinquapin Oak (*Quercus muehlenbergii*). **1120.** Dwarf Chinquapin Oak (*Quercus prinoides*). **1121, 1122.** Black Oak (*Quercus velutina*).

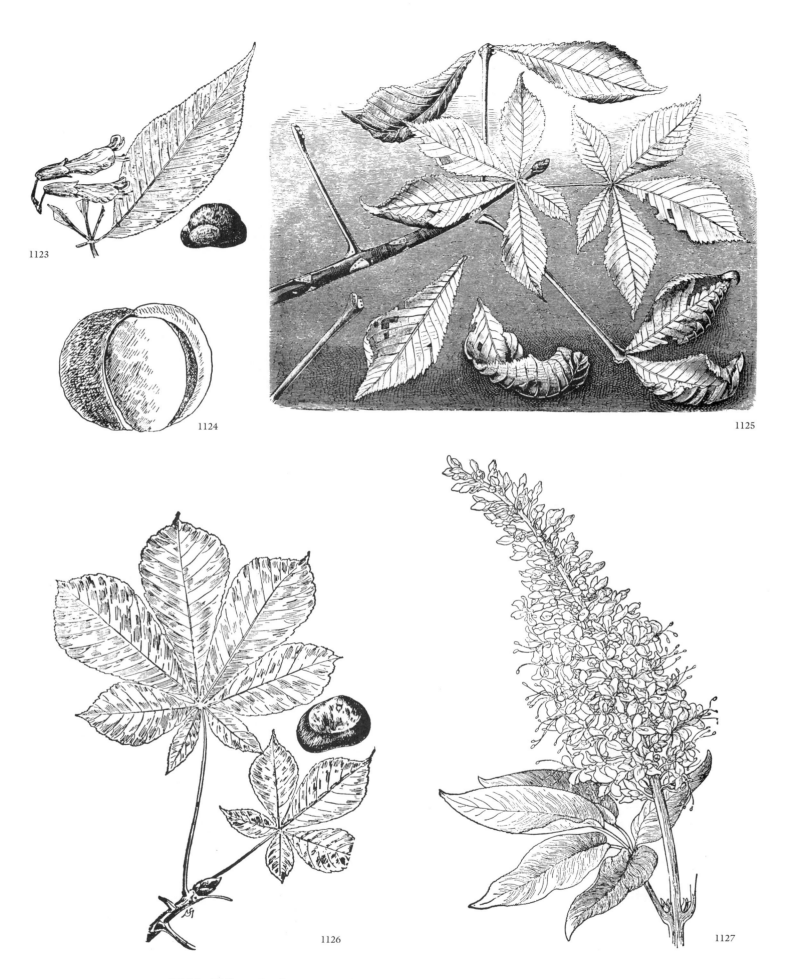

1123. Yellow Buckeye (*Aesculus octandra*). **1124.** Ohio Buckeye (*Aesculus glabra*). **1125, 1126.** Horsechestnut (*Aesculus hippocastanum*). **1127.** California Buckeye (*Aesculus californica*).

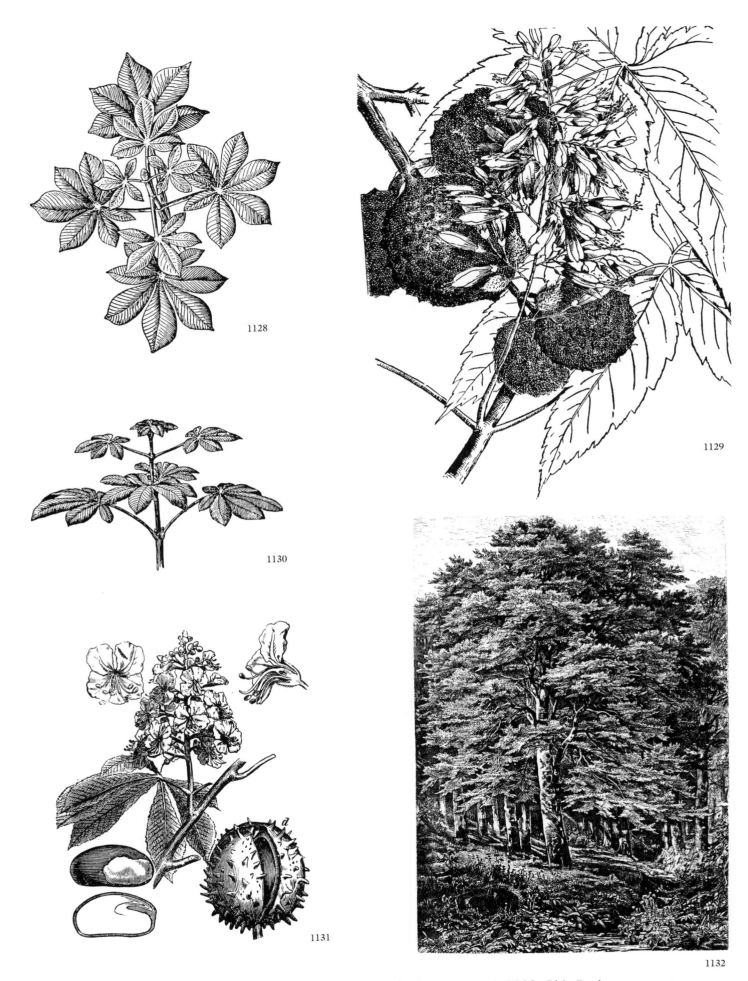

1128, 1130, 1131. Horsechestnut (*Aesculus hippocastanum*). **1129.** Ohio Buckeye (*Aesculus glabra*). **1132.** European Beech (*Fagus sylvatica*).

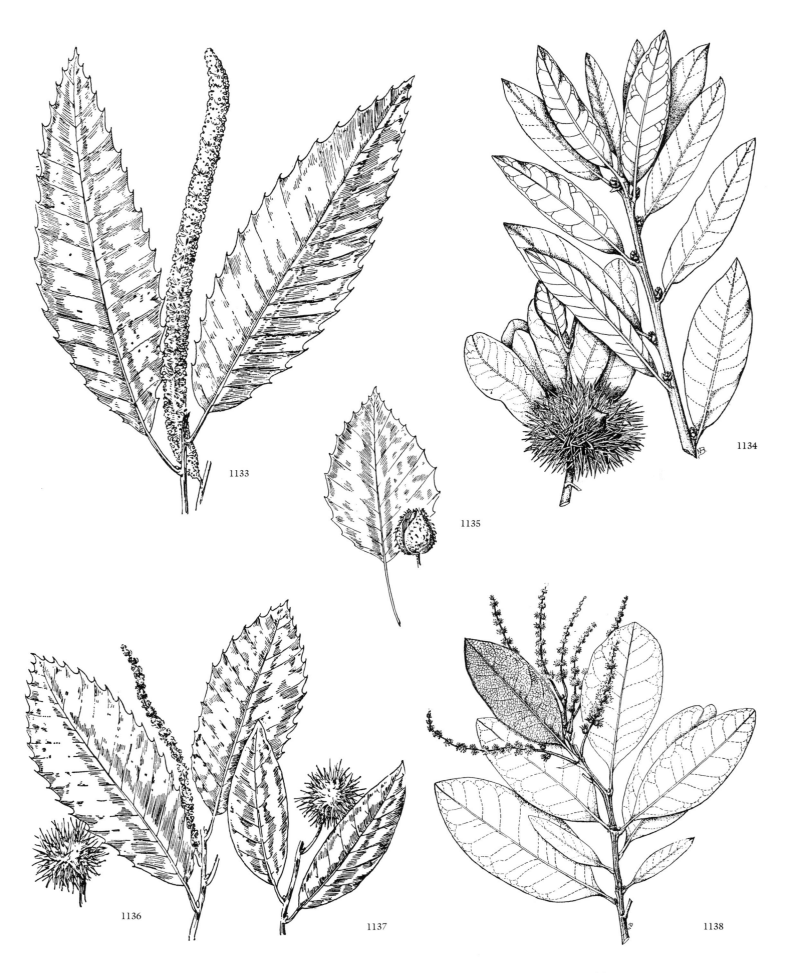

1133. American Chestnut (*Castanea dentata*). **1134, 1137, 1138.** Golden Chinquapin (*Castanopsis chrysophylla*). **1135.** American Beech (*Fagus grandifolia*). **1136.** Allegheny Chinquapin (*Castanea pumila*).

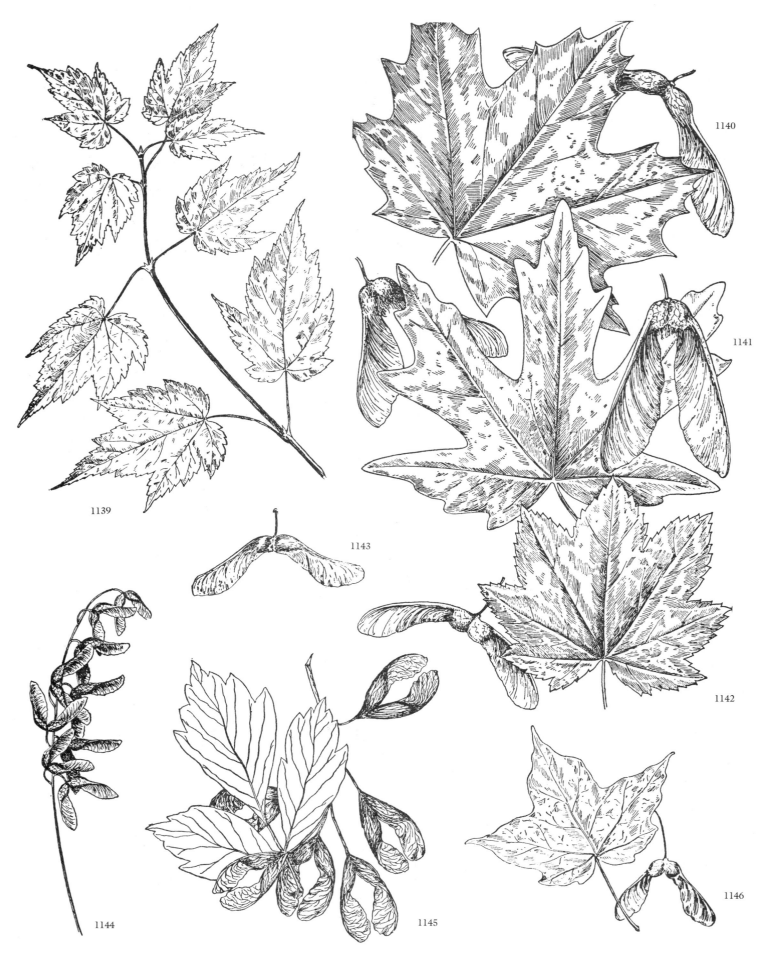

1139, 1144. Mountain Maple (*Acer spicatum*). **1140, 1143.** Norway Maple (*Acer platanoides*). **1141.** Bigleaf Maple (*Acer macrophyllum*). **1142.** Vine Maple (*Acer circinatum*). **1145.** Box Elder (*Acer negundo*). **1146.** Black Sugar Maple (*Acer saccharum*).

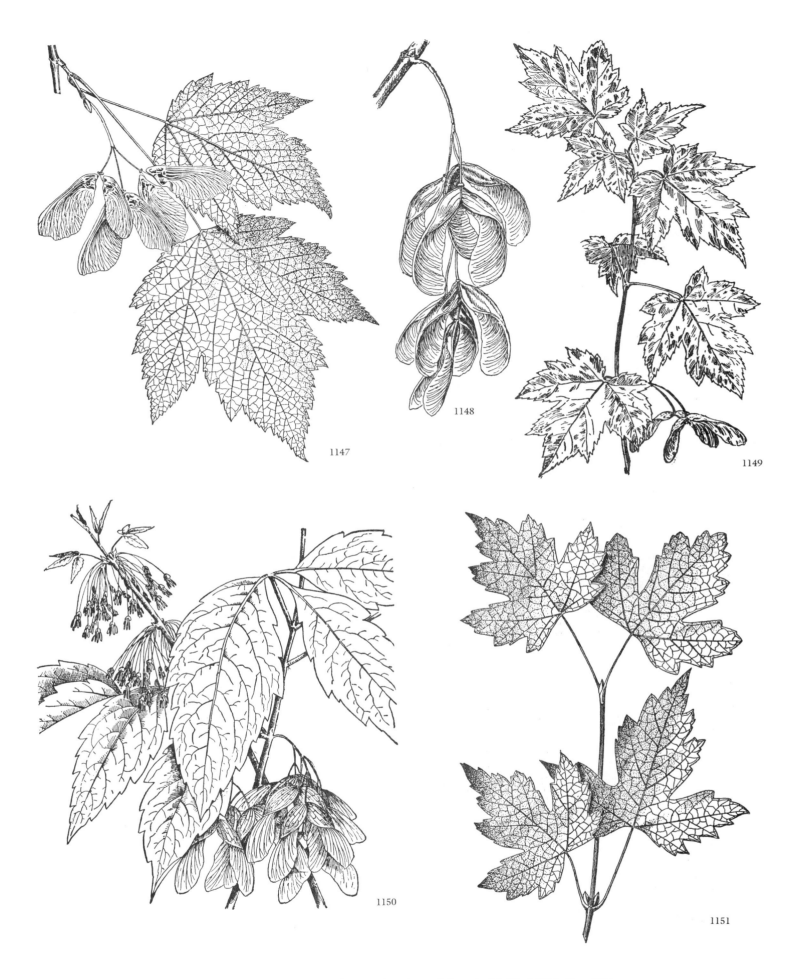

1147, 1151. Rocky Mountain Maple (*Acer glabrum*). **1148, 1150.** Box Elder (*Acer negundo*). **1149.** Silver Maple (*Acer saccharinum*).

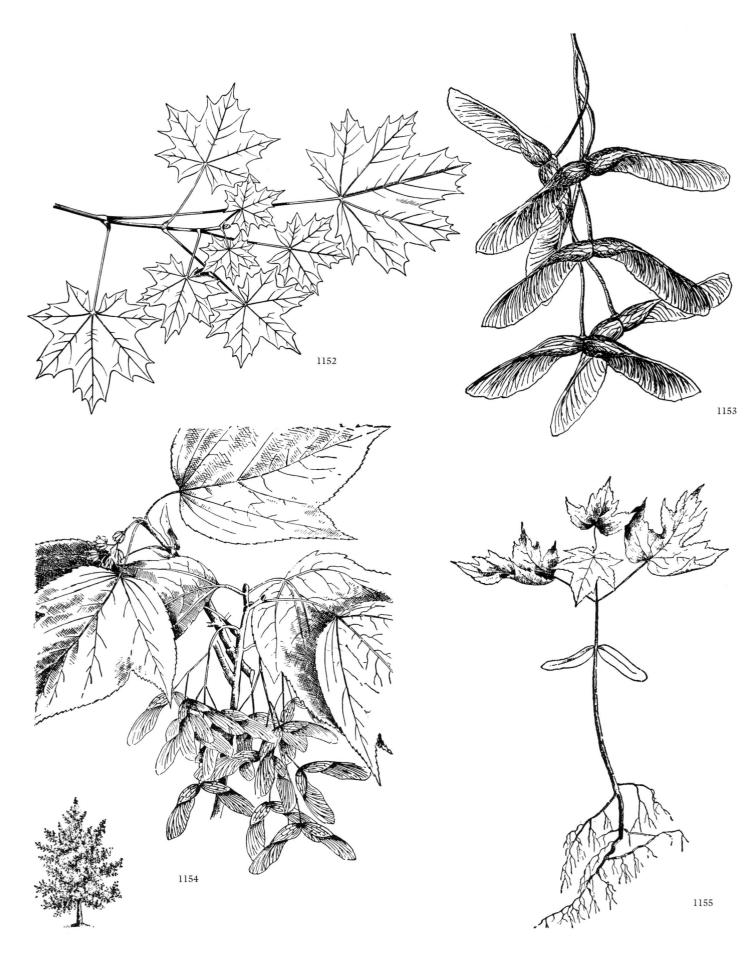

1152

1153

1154

1155

1152. Norway Maple (*Acer platanoides*). **1153, 1154.** Striped Maple (*Acer pensylvanicum*). **1155.** Germinating Maple.

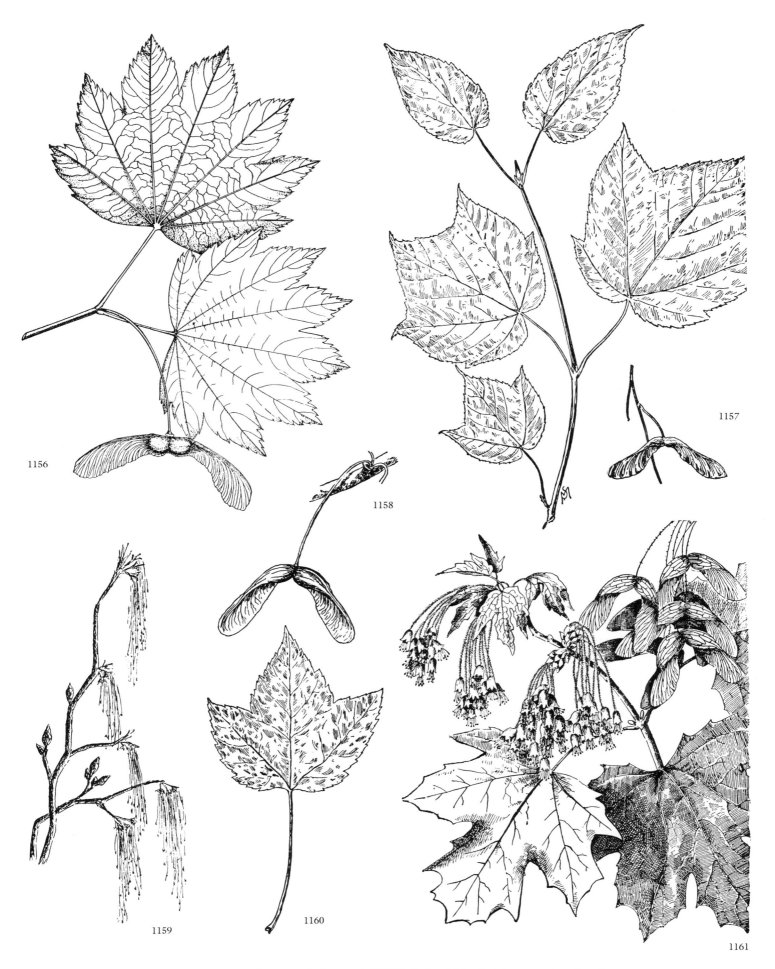

1156. Vine Maple (*Acer circinatum*). **1157.** Striped Maple (*Acer pensylvanicum*).
1158, 1160. Red Maple (*Acer rubrum*). **1159, 1161.** Sugar Maple (*Acer saccharum*).

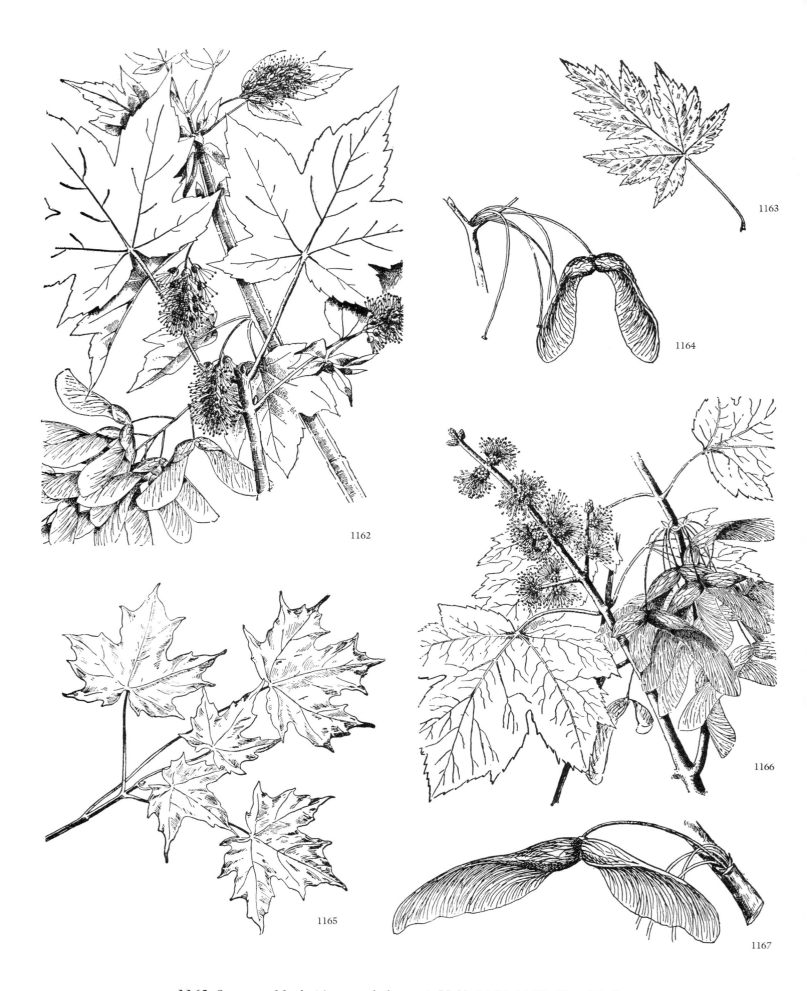

1162. Sycamore Maple (*Acer pseudoplatanus*). **1163, 1166, 1167.** Silver Maple (*Acer saccharinum*). **1164, 1165.** Sugar Maple (*Acer saccharum*).

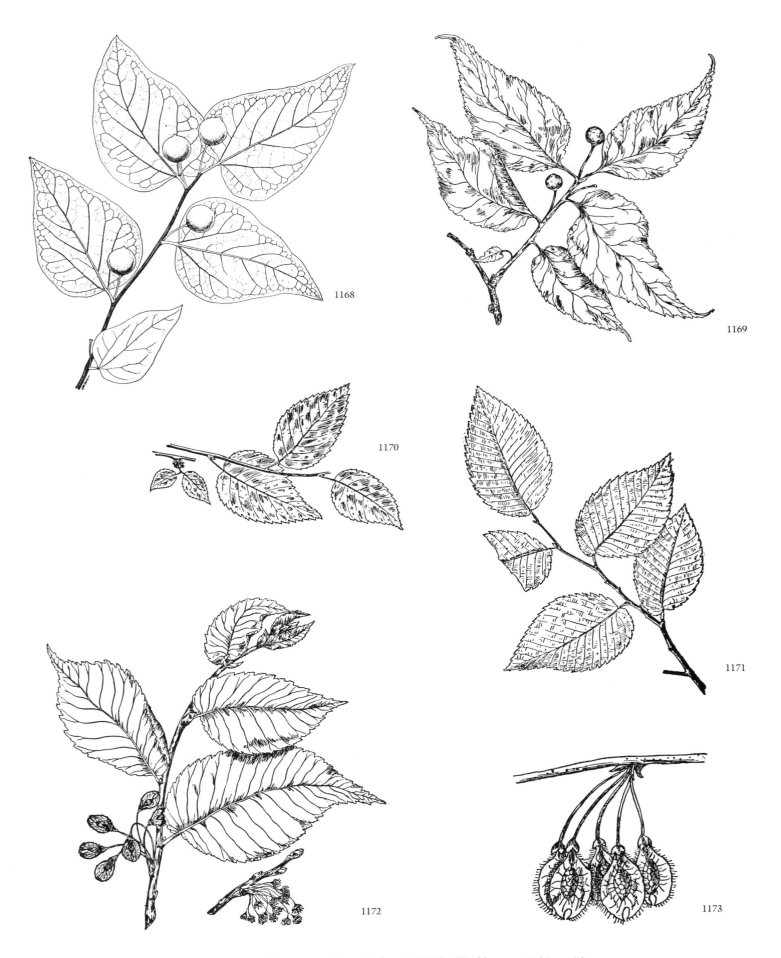

1168. Western Hackberry (*Celtis reticulata*). **1169.** Hackberry (*Celtis occidentalis*). **1170.** Planertree (*Planera aquatica*). **1171–1173.** White Elm (*Ulmus americana*).

ELM FAMILY **185**

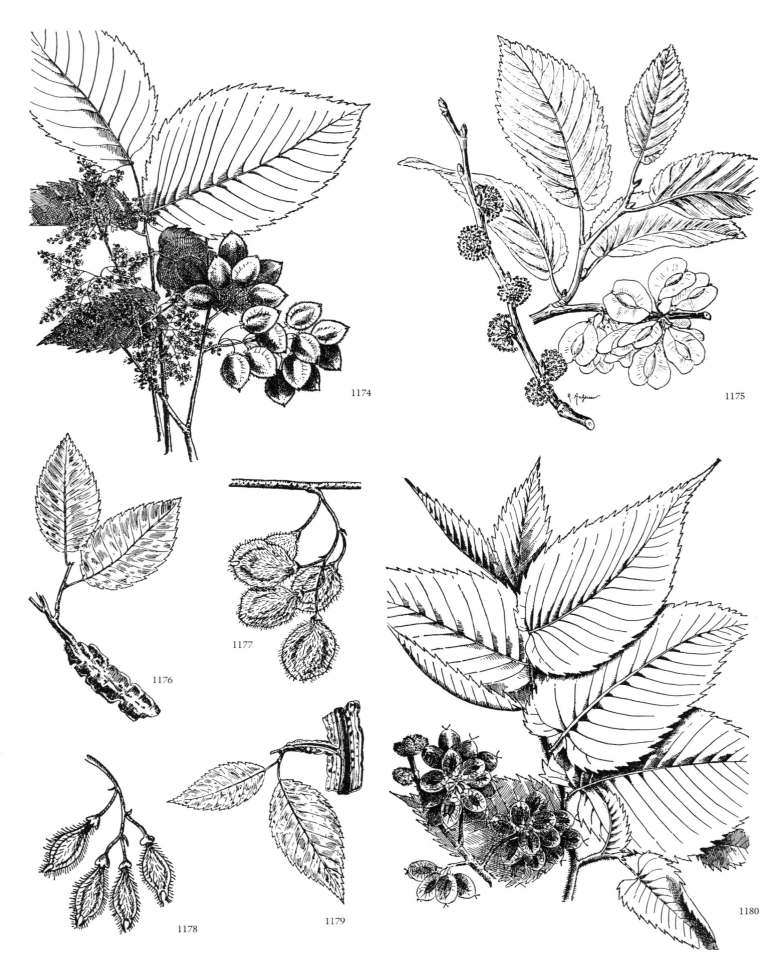

1174, 1176, 1177. Corky White Elm (*Ulmus thomasii*). **1175.** English Elm (*Ulmus procera*). **1178, 1179.** Winged Elm (*Ulmus alata*). **1180.** Slippery Elm (*Ulmus rubra*).

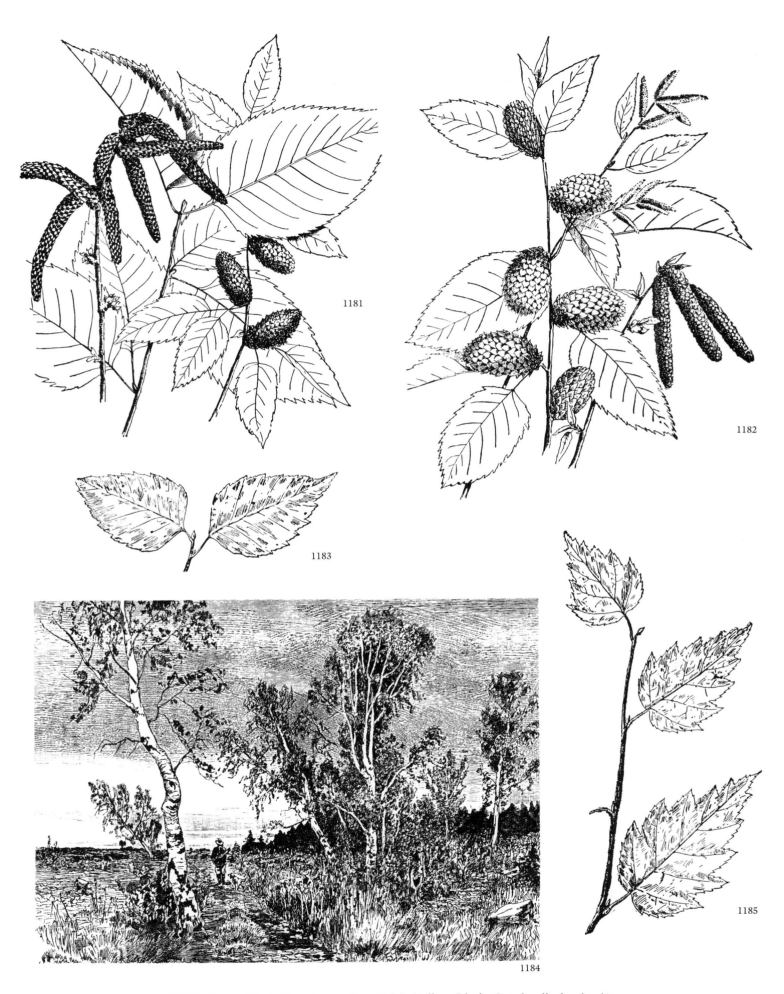

1181. Sweet Birch (*Betula pumila*). **1182.** Yellow Birch (*Betula alleghaniensis*).
1183. River Birch (*Betula nigra*). **1184, 1185.** Paper Birch (*Betula papyrifera*).

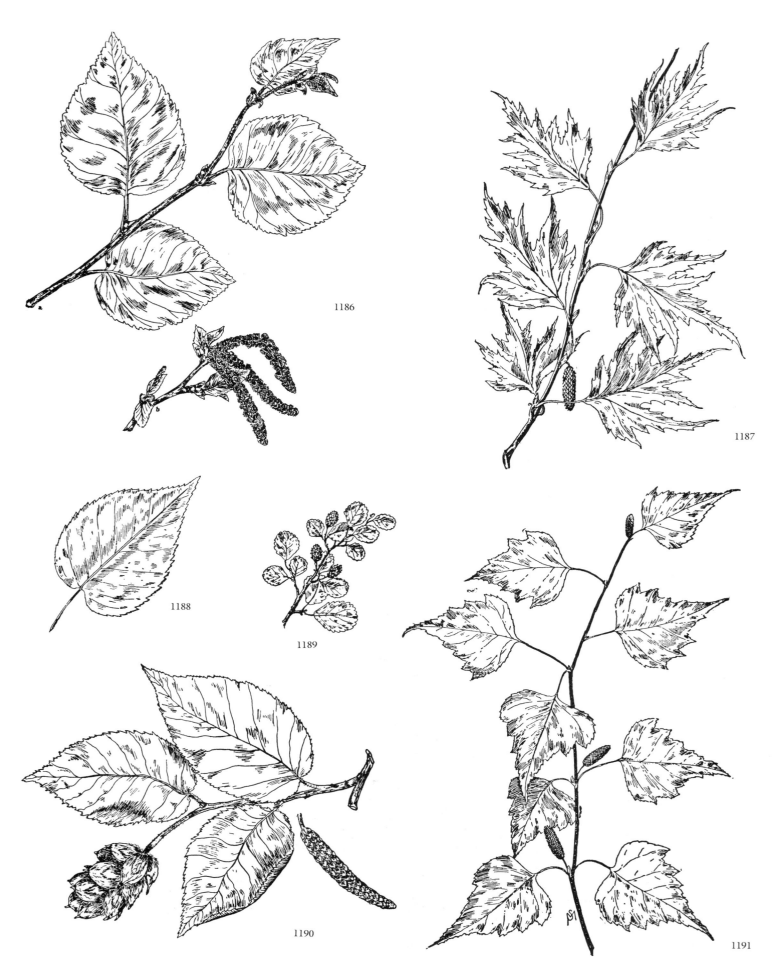

1186, 1188. Paper birch (*Betula papyrifera*). **1187.** European White Birch (*Betula pendula*). **1189.** Dwarf Birch (*Betula glandulosa*). **1190.** Ironwood (*Ostrya virginiana*). **1191.** Gray Birch (*Betula populifolia*).

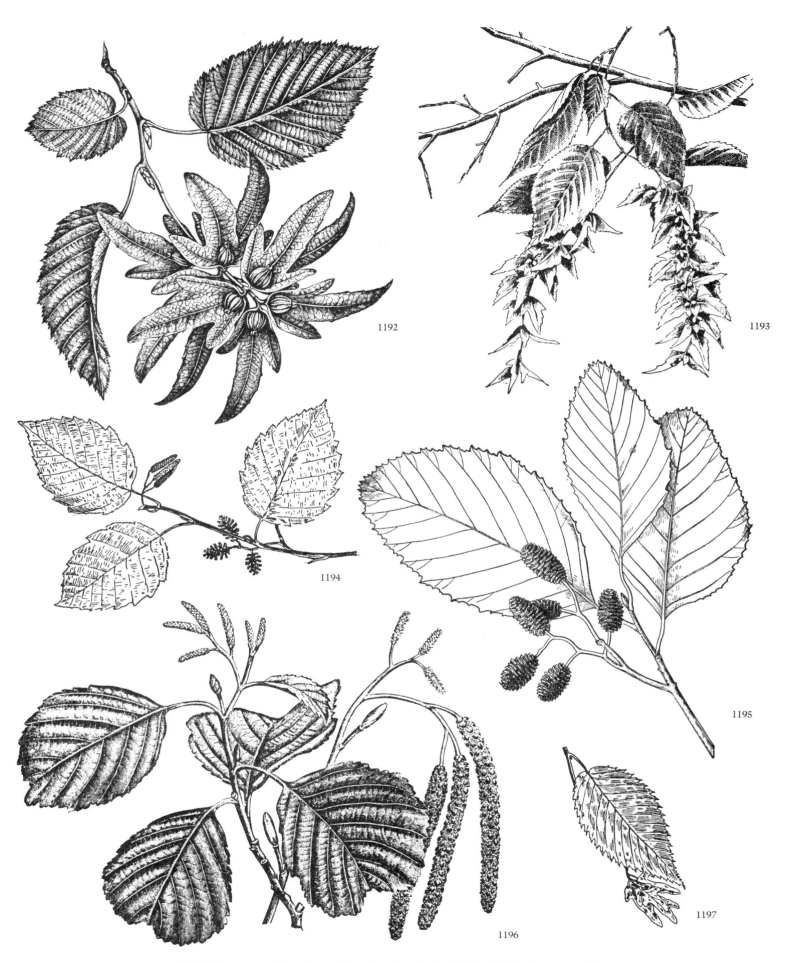

1192. European Hornbeam (*Carpinus betulus*). **1193, 1197.** American Hornbeam (*Carpinus caroliniana*). **1194.** Speckled Alder (*Alnus rugosa*). **1195.** White Alder (*Alnus rhombifolia*). **1196.** European Alder (*Alnus glutinosa*).

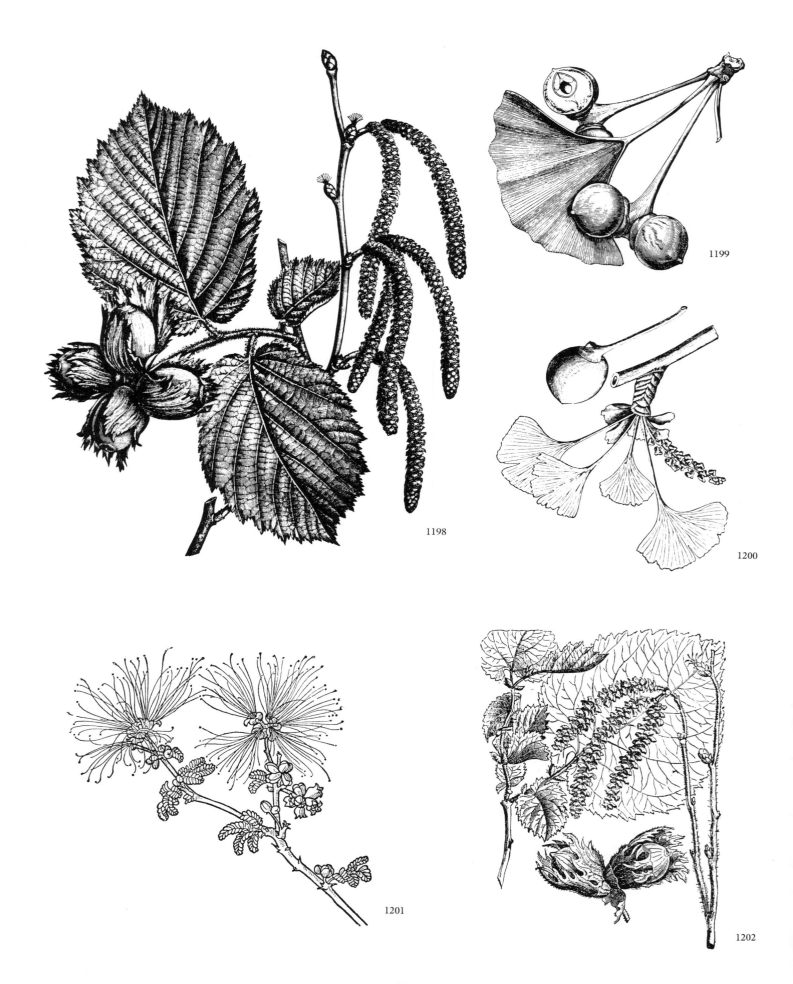

1198, 1202. Royal Hazel (*Corylus avellana*). **1199, 1200.** Ginkgo (*Ginkgo biloba*). **1201.** Fairy Duster (*Calliandra eriophylla*).

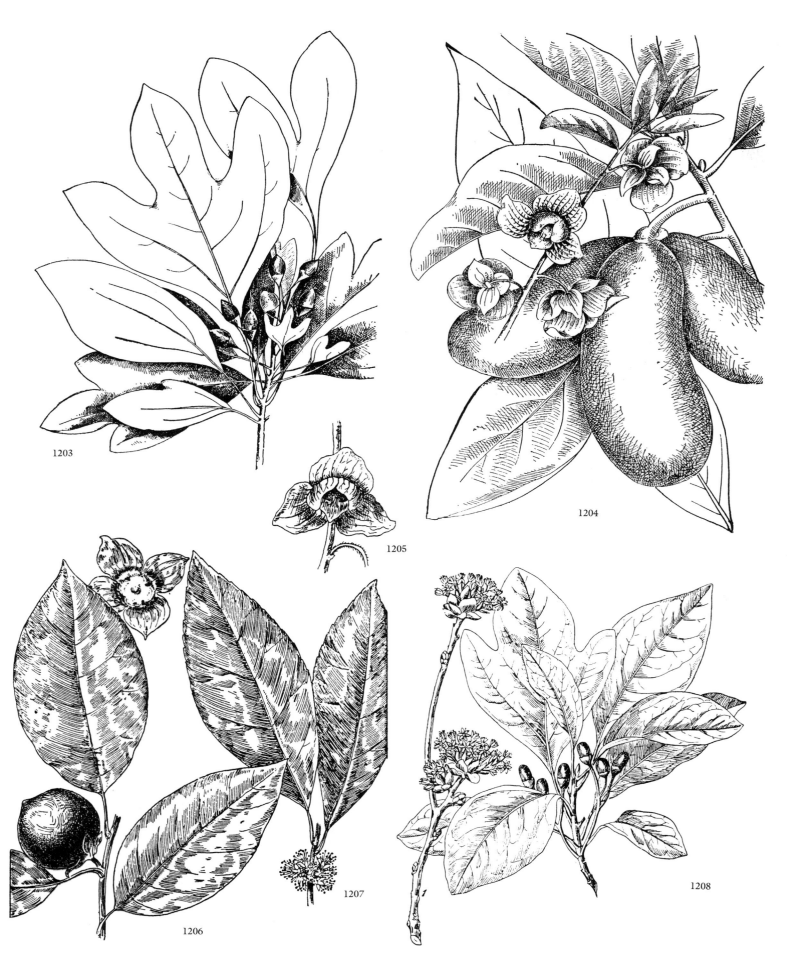

1203, 1208. Sassafras (*Sassafras albidum*). **1204, 1205.** Pawpaw (*Asimina triloba*). **1206.** Persimmon (*Diospyros virginiana*). **1207.** Common Sweetleaf (*Symplocos tinctoria*).

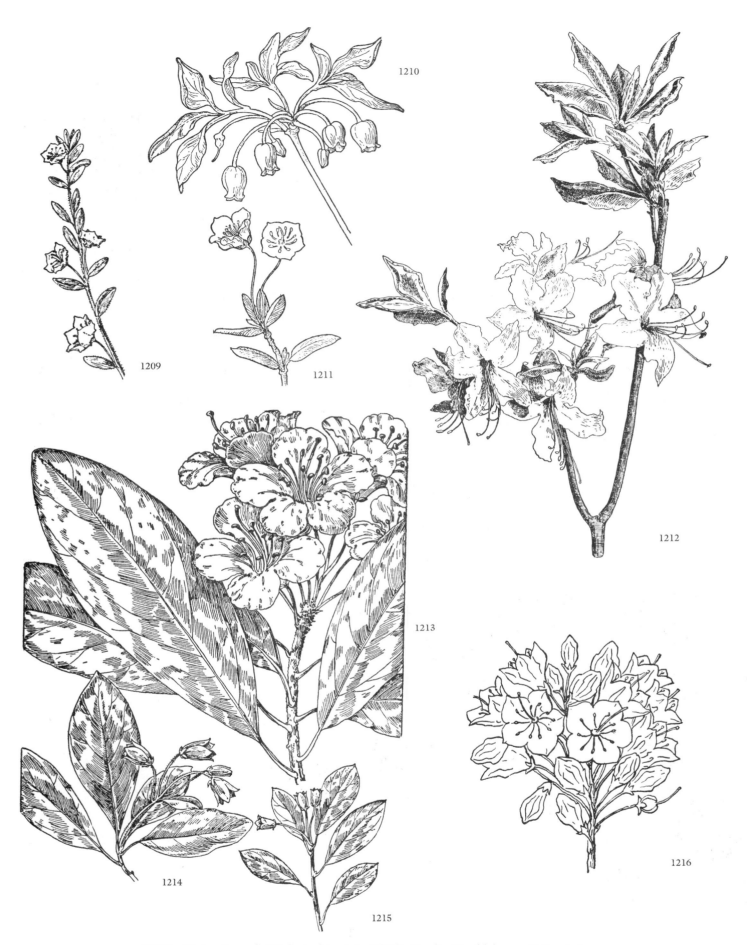

1209. Hairy Laurel (*Kalmia hirsuta*). **1210.** Fool's Huckleberry (*Menziesia urcelolaria*). **1211.** Swamp Laurel (*Kalmia microphylla*). **1212.** Pink Azalea (*Rhododendron periclymenoides*). **1213.** Great Laurel (*Rhododendron maximum*). **1214.** Alleghany Menziesia (*Menziesia pilosa*). **1215.** Smooth Menziesia (*Menziesia glabella*). **1216.** Mountain Laurel (*Kalmia latifolia*).

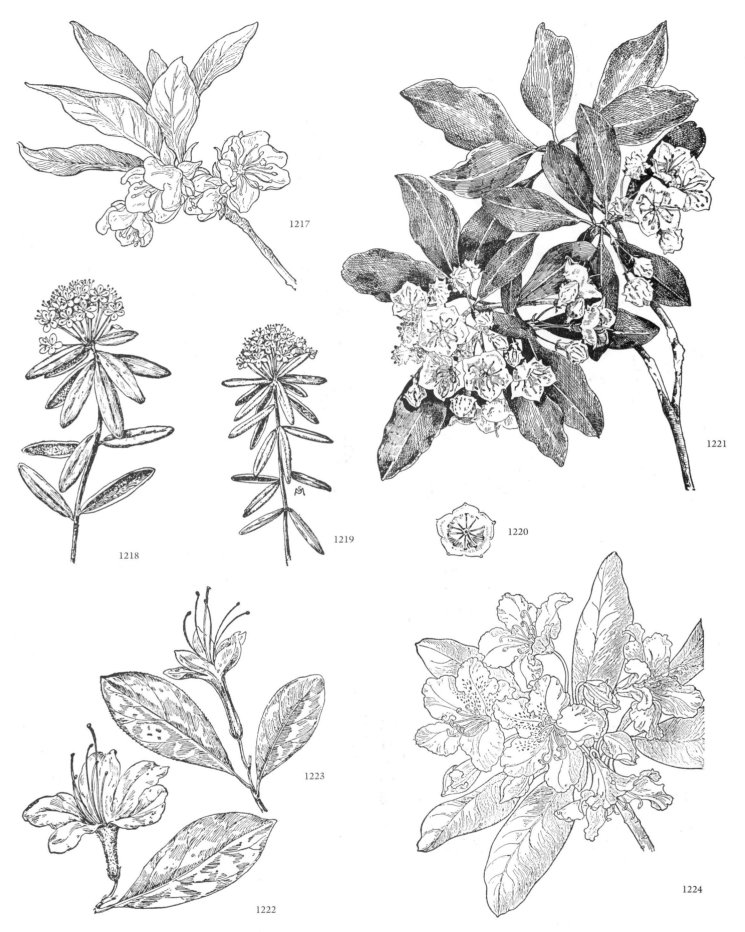

1217. Small Azalea (*Rhododendron albiflorum*). **1218.** Labrador Tea (*Ledum groenlandicum*). **1219.** Narrow-leaved Labrador Tea (*Ledum palustre*). **1220, 1221.** Mountain Laurel (*Kalmia latifolia*). **1222.** Flame Azalea (*Rhododendron calendulaceum*). **1223.** Smooth Azalea (*Rhododendron arborescens*). **1224.** California Rosebay (*Rhododendron macrophyllum*).

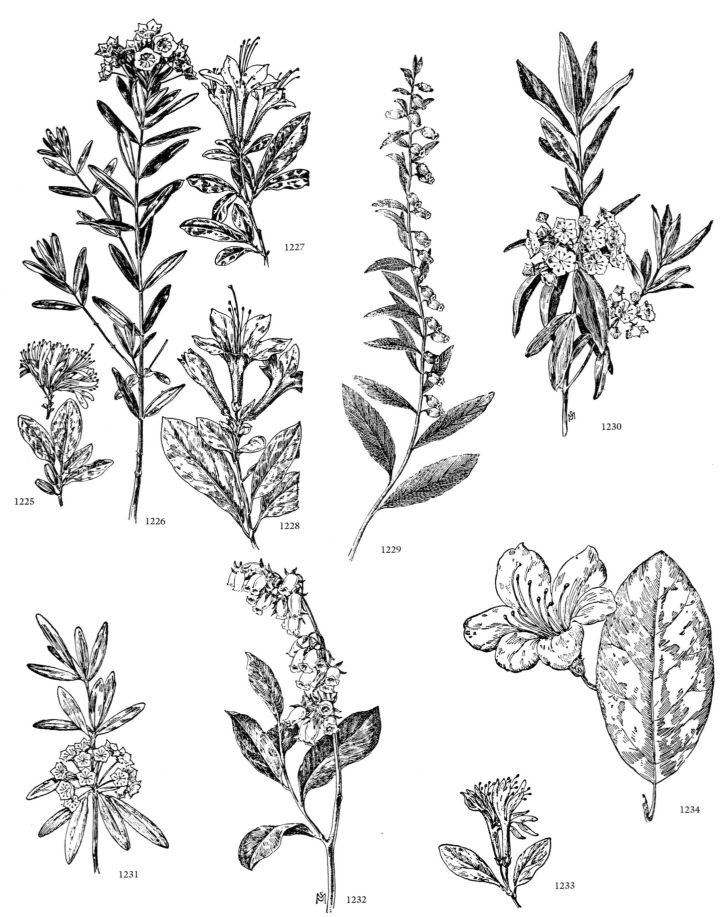

1225, 1233. Rhodora (*Rhododendron canadense*). **1226.** Pale Laurel (*Kalmia poliifolia*). **1227.** White Swamp Honeysuckle (*Rhododendron viscosum*). **1228.** Flame Azalea (*Rhododendron calendulaceum*). **1229.** Dwarf Cassandra (*Chamaedaphne calyculata*). **1230.** Sheep Laurel (*Kalmia angustifolia*). **1231.** Southern Sheep Laurel (*Kalmia angustifolia*). **1232.** Staggerbush (*Lyonia mariana*). **1234.** Rosebay (*Rhododendron catawbiense*).

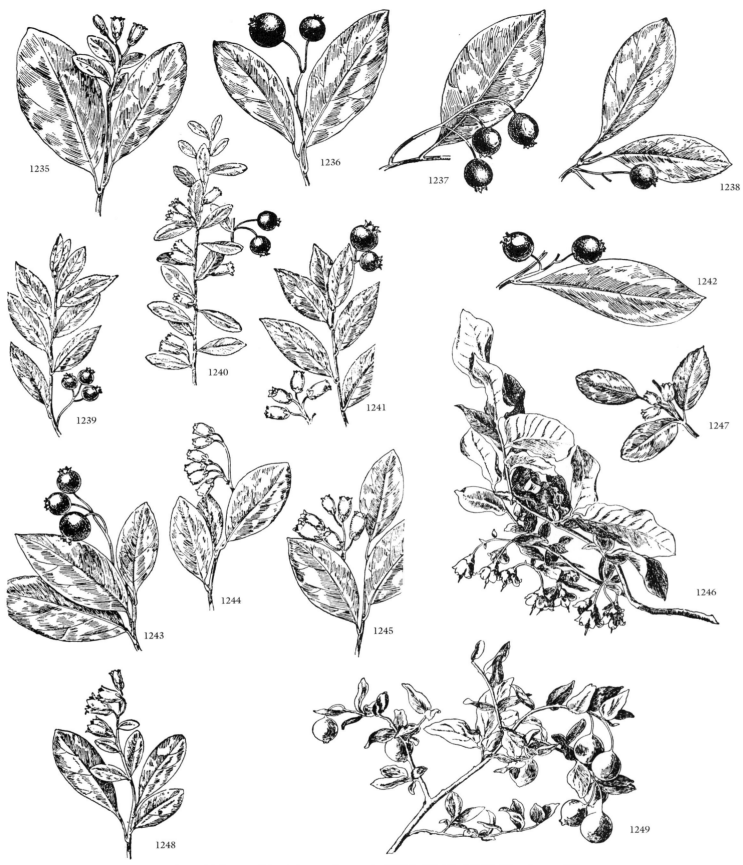

1235. Farkleberry (*Vaccinium arboreum*). **1236, 1246, 1249.** Deerberry (*Vaccinium stamineum*). **1237.** Dangleberry (*Gaylussacia frondosa*). **1238.** Highbush Huckleberry (*Gaylussacia baccata*). **1239.** Southern Blueberry (*Vaccinium virgatum*). **1240.** Evergreen Blueberry (*Vaccinium myrsinites*). **1241.** Low Sweet Blueberry (*Vaccinium angustifolium*). **1242.** Bear Huckleberry (*Gaylussacia ursina*). **1243.** Canada Blueberry (*Vaccinium myrtilloides*). **1244.** Late Blueberry (*Vaccinium vacillans*). **1245.** Highbush Blueberry (*Vaccinium corymbosum*). **1247.** Box Huckleberry (*Gaylussacia brachycera*). **1248.** Dwarf Huckleberry (*Gaylussacia dumosa*).

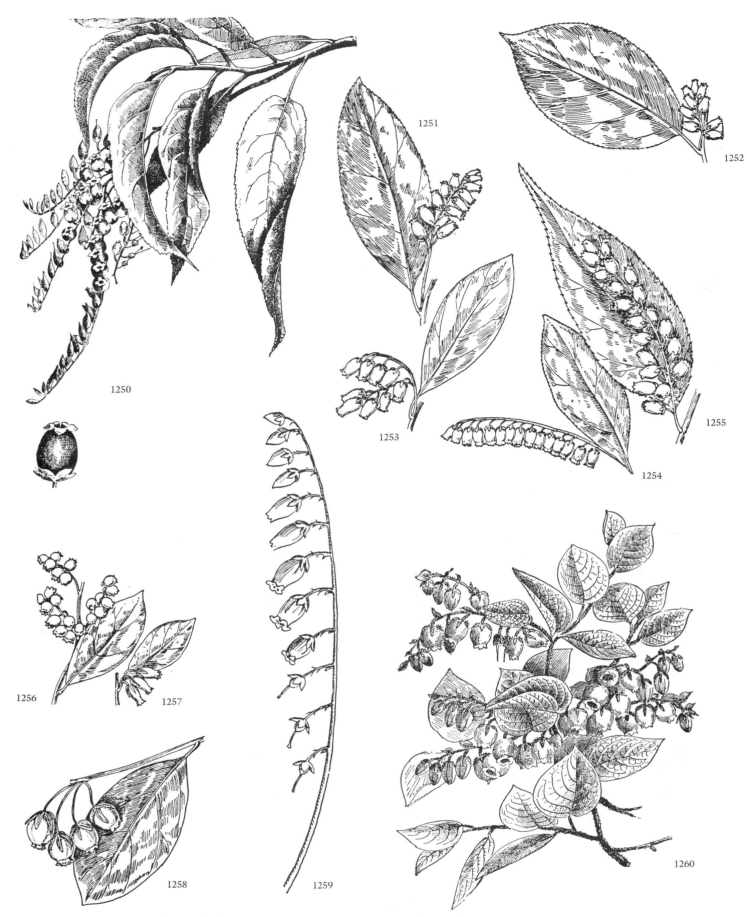

1250, 1259. Sourwood (*Oxydendrum arboreum*). **1251.** Downy Sweetbells (*Leucothoe axillaris*). **1252.** Sweetbells (*Leucothoe platyphylla*). **1253.** Mountain Sweetbells (*Leucothoe recurva*). **1254.** Swamp Sweetbells (*Leucothoe racemosa*). **1255.** Catesby's Sweetbells (*Leucothoe fontanesiana*). **1256.** Maleberry (*Lyonia ligustrina*). **1257.** Fetterbush (*Lyonia lucida*). **1258.** Staggerbush (*Lyonia mariana*). **1260.** Black Huckleberry (*Gaylussacia baccata*).

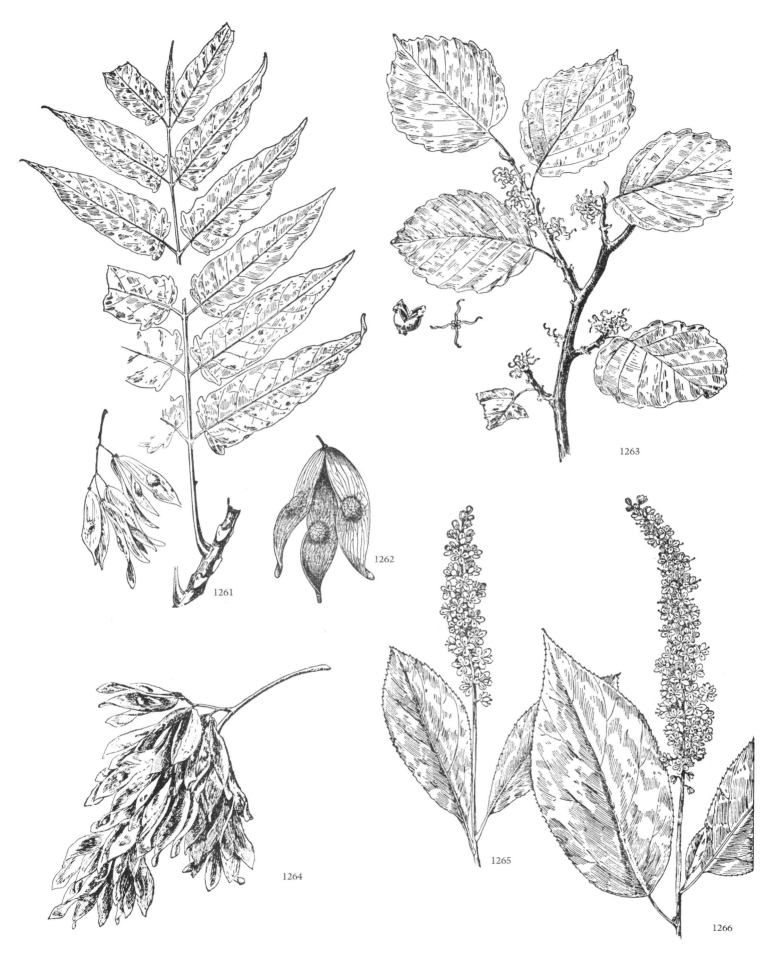

1261, 1262, 1264. Tree of Heaven (*Ailanthus altissima*). **1263.** Witch-Hazel (*Hamamelis virginiana*). **1265.** Sweet Pepperbush (*Clethra alnifolia*). **1266.** Mountain Pepperbush (*Clethra acuminata*).

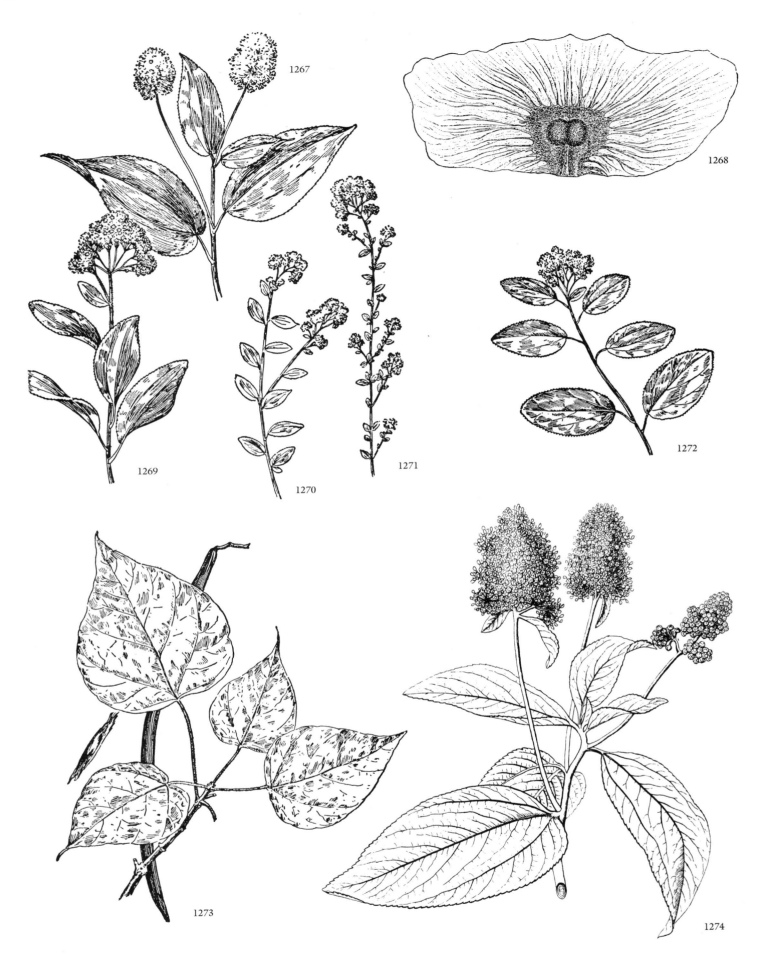

1267, 1274. New Jersey Tea (*Ceanothus americanus*). **1268.** *Bignonia* Seed (*Bignonia* sp.). **1269.** Common Redroot (*Ceanothus ovatus*). **1270.** Redroot (*Ceanothus serpyllifolius*). **1271.** Redroot (*Ceanothus microphyllus*). **1272.** Blue Ceanothus (*Ceanothus tomentosus*). **1273.** Catalpa (*Catalpa bignonoides*).

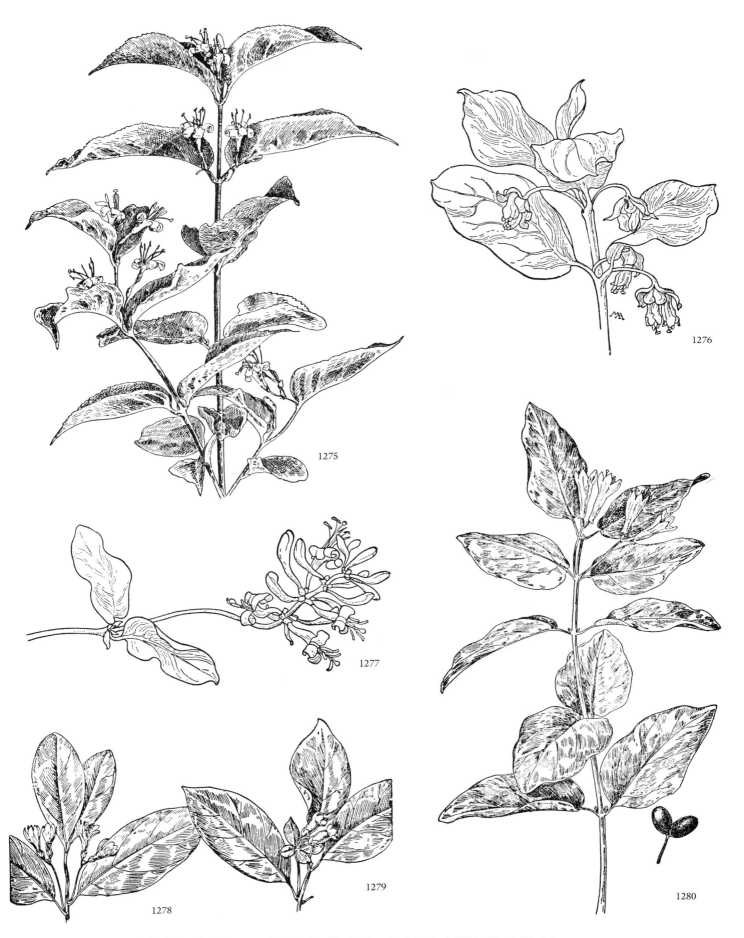

1275. Bush Honeysuckle (*Diervilla lonicera*). **1276, 1279.** Black Twinberry (*Lonicera involucrata*). **1277.** Pink Honeysuckle (*Lonicera hispidula*). **1278.** Swamp Fly Honeysuckle (*Lonicera oblongifolia*). **1280.** Early Fly Honeysuckle (*Lonicera canadensis*).

1281. Fox Elderberry (*Sambucus caerulea*). **1282.** Mediterranean Elder (*Sambucus nigra*). **1283.** Arrowwood (*Viburnum recognitum*). **1284.** Nannyberry (*Viburnum lentago*). **1285.** Blackhaw (*Viburnum prunifolium*).

1286, 1288. Arrowwood (*Viburnum recognitum*). **1287.** European Guelder Rose (*Viburnum opulus*). **1289, 1293.** Maple-leaved Viburnum (*Viburnum acerifolium*). **1290.** Blackhaw (*Viburnum prunifolium*). **1291.** Nannyberry (*Viburnum lentago*). **1292.** Hobblebush (*Viburnum alnifolium*).

1294. Hardhack (*Spiraea tomentosa*). **1295.** Chickasaw Plum (*Prunus angustifo-lia*). **1296.** Songbird on Rose (*Rosa* sp.). **1297.** Canada Plum (*Prunus nigra*). **1298.** Rum Cherry (*Prunus serotina*). **1299.** Meadowsweet (*Spiraea latifolia*). **1300.** Rowan Tree (*Sorbus aucuparia*).

1301. Chokecherry (*Prunus virginiana*). **1302.** Cockspur Thorn (*Crataegus crus-galli*). **1303, 1304.** Rum Cherry (*Prunus serotina*). **1305.** Crab Apple (*Malus coronaria*). **1306.** Hollyleaf Cherry (*Prunus ilicifolia*). **1307.** Apple (*Malus sylvestris*).

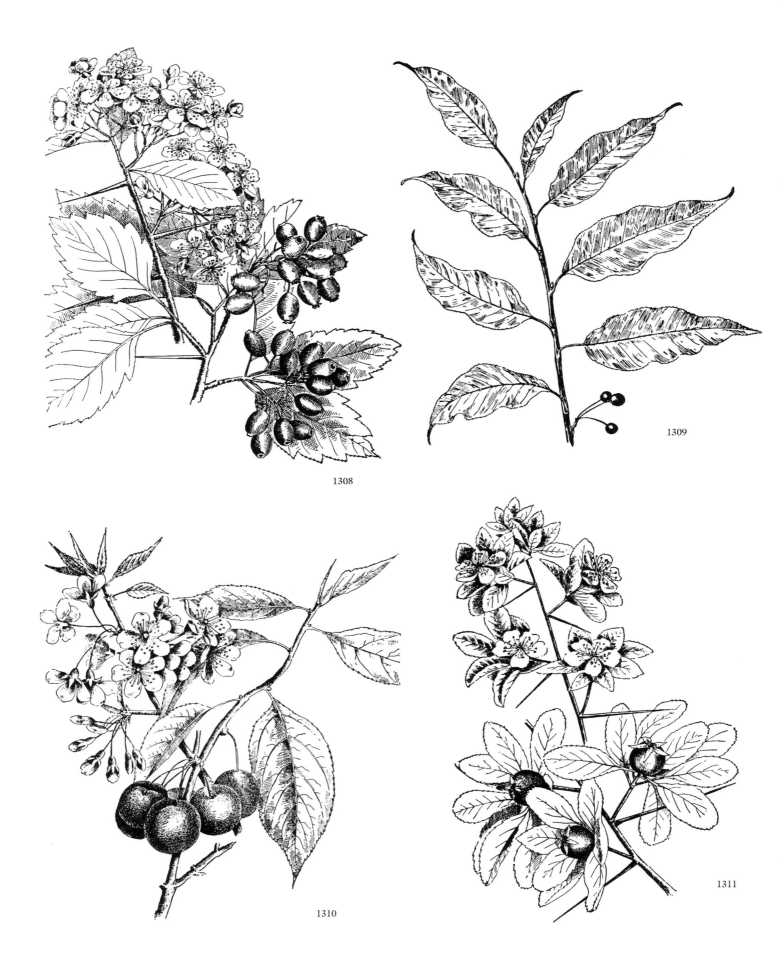

1308. Blackthorn (*Crataegus calpodendron*). **1309.** Fire Cherry (*Prunus pensyl-vanica*). **1310.** Wild Yellow Plum (*Prunus americana*). **1311.** Dwarf Thorn (*Crataegus uniflora*).

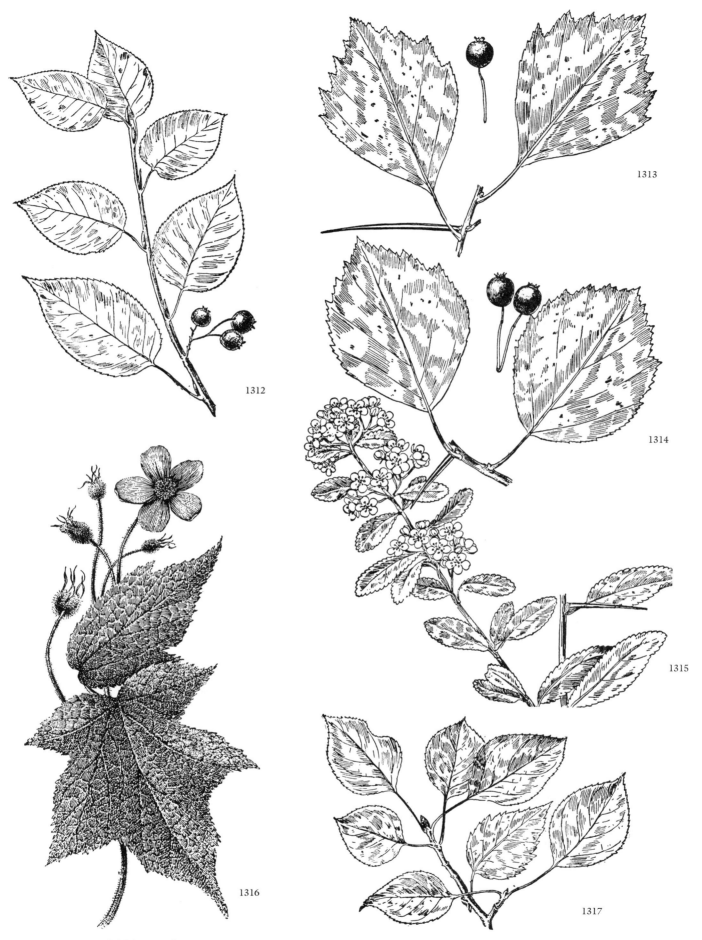

1312. Juneberry (*Amelanchier canadensis*). **1313.** New River Thorn (*Crataegus succulenta*). **1314.** Douglas's Thorn (*Crataegus douglasii*). **1315.** Fire Thorn (*Cotoneaster pyracantha*). **1316.** Purple Flowering Raspberry (*Rubus odoratus*). **1317.** Crab Apple (*Malus coronaria*).

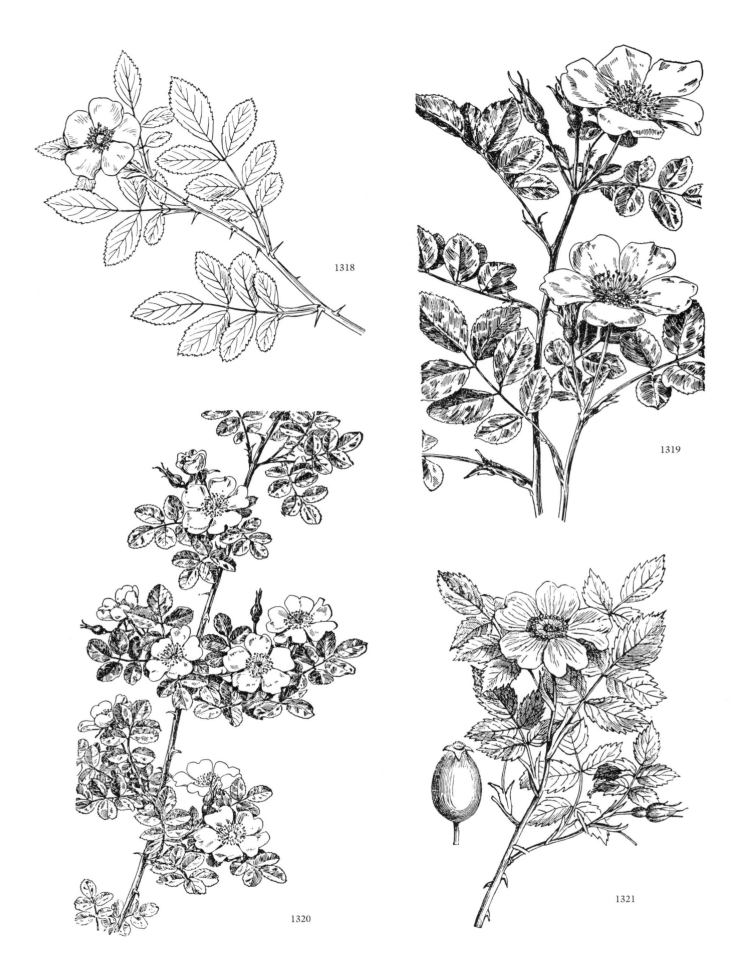

1318. Pasture Rose (*Rosa carolina*). **1319.** Smooth Rose (*Rosa blanda*). **1320.** Sweetbrier (*Rosa eglanteria*). **1321.** Dog Rose (*Rosa canina*).

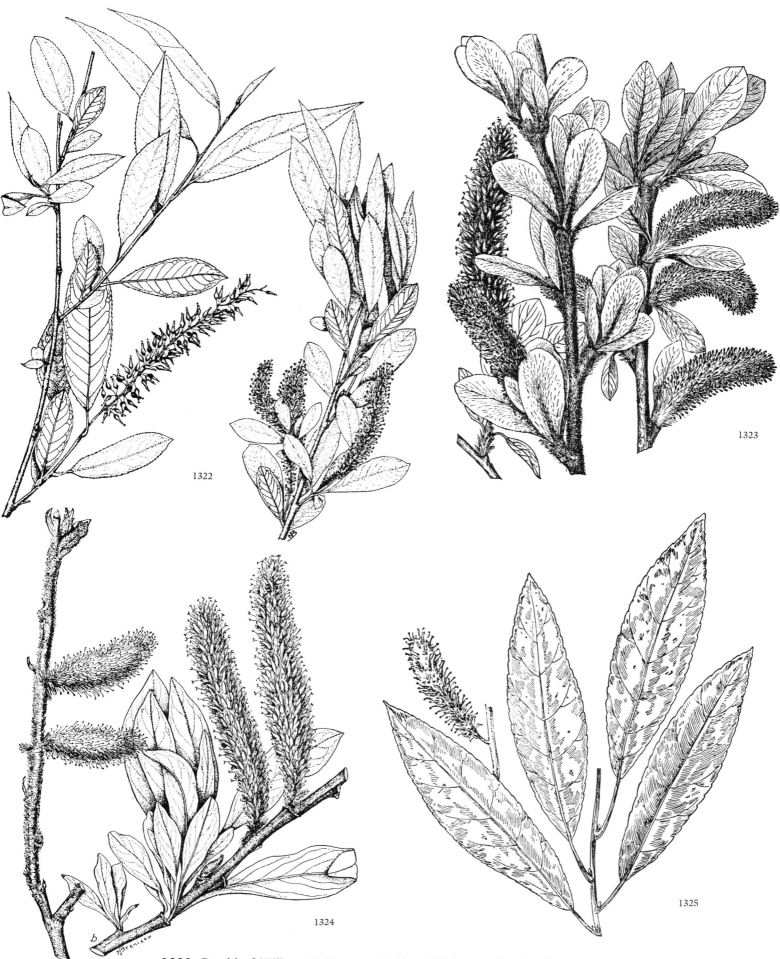

1322. Peachleaf Willow (*Salix amygdaloides*). **1323.** Broadleaf Willow (*Salix amplifolia*). **1324.** Feltleaf Willow (*Salix alaxensis*). **1325.** Common Pussy Willow (*Salix discolor*).

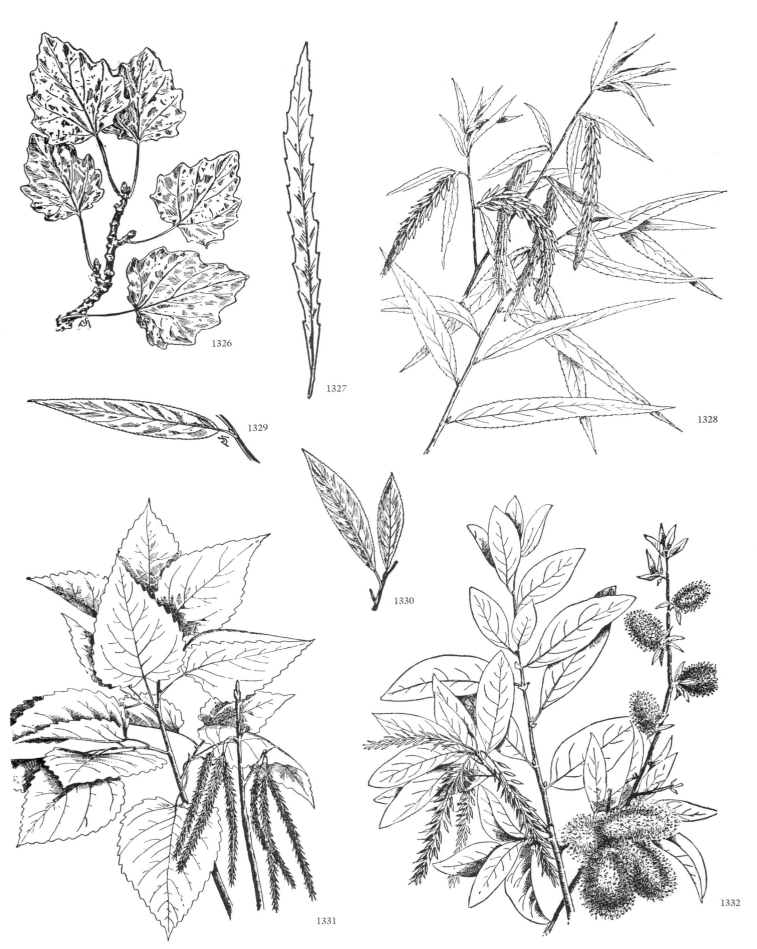

1326. European White Poplar (*Populus alba*). **1327.** Longleaf Willow (*Salix interior*). **1328.** Weeping Willow (*Salix babylonica*). **1329.** Black Willow (*Salix nigra*). **1330.** White Willow (*Salix alba*). **1331.** Lombardy Poplar (*Populus nigra*). **1332.** Bebb's Willow (*Salix bebbiana*).

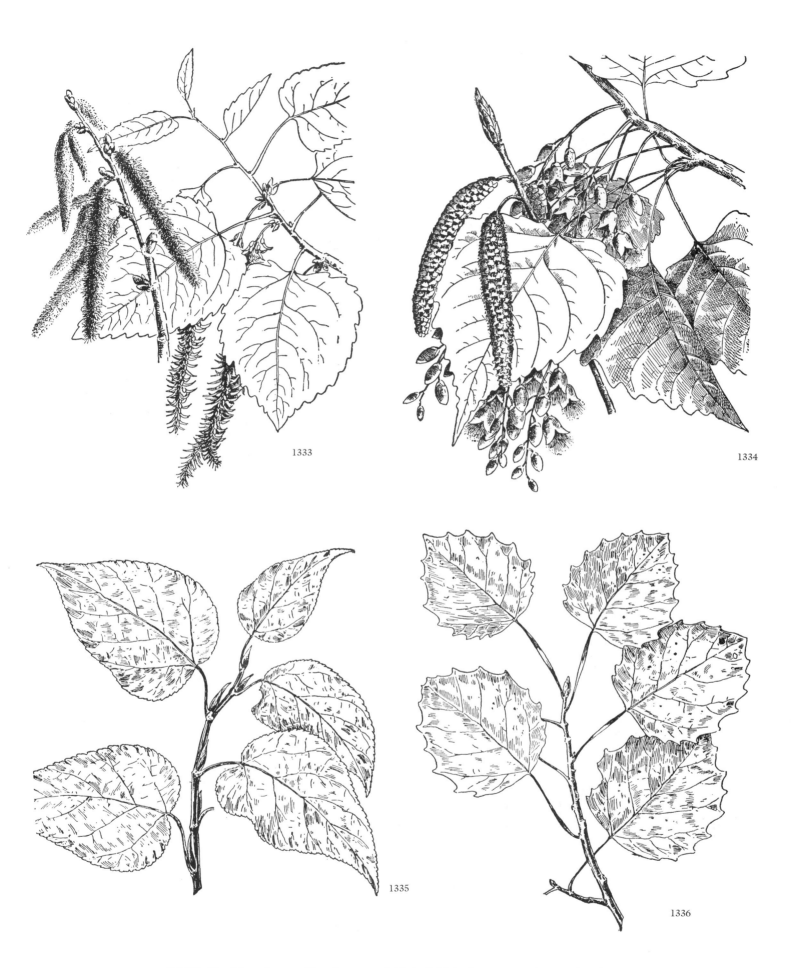

1333. Quaking Aspen (*Populus tremuloides*). **1334.** Cottonwood (*Populus deltoides*). **1335.** Balm of Gilead (*Populus gileadensis*). **1336.** Large-toothed Aspen (*Populus grandidentata*).

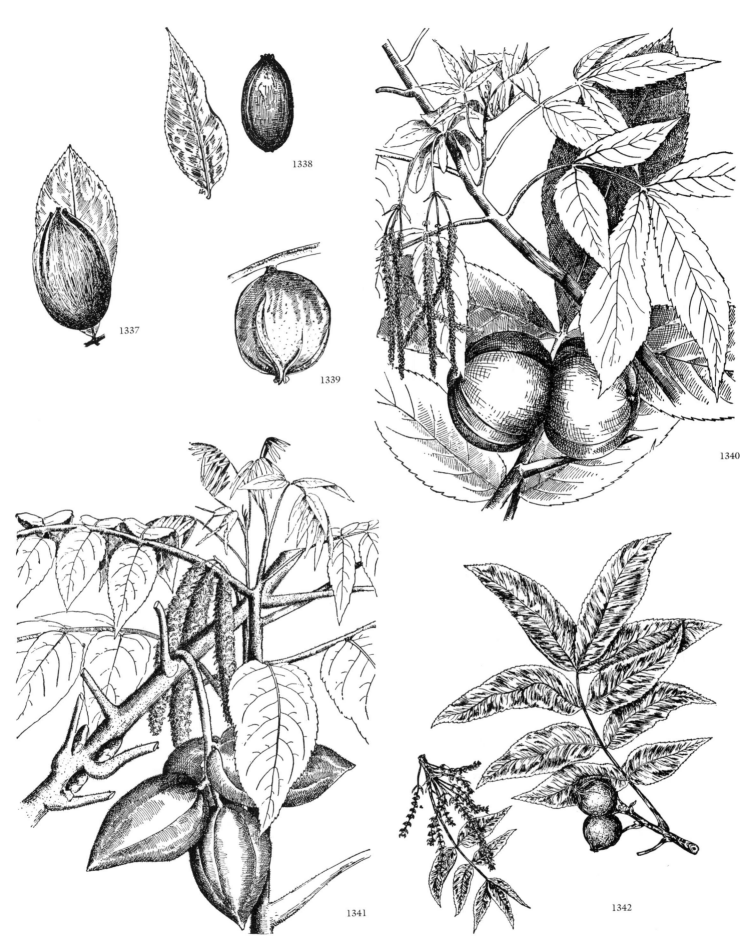

1337. Mockernut (*Carya tomentosa*). **1338.** Pecan (*Carya illinoiensis*). **1339,**
1342. Bitternut (*Carya cordiformis*). **1340.** Shagbark Hickory (*Carya ovata*).
1341. Butternut (*Juglans cinerea*).

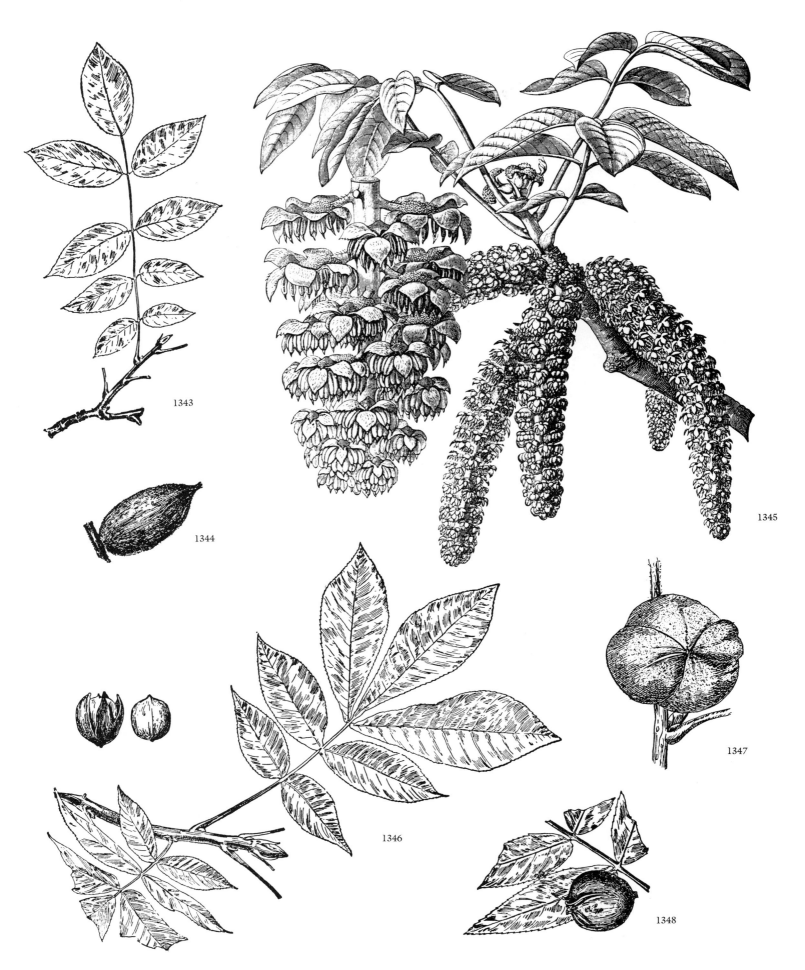

1343, 1344. Butternut (*Juglans cinerea*). **1345.** Walnut (*Juglans regia*). **1346.**
Pignut (*Carya glabra*). **1347.** Mockernut (*Carya tomentosa*). **1348.** Bitternut
(*Carya cordiformis*).

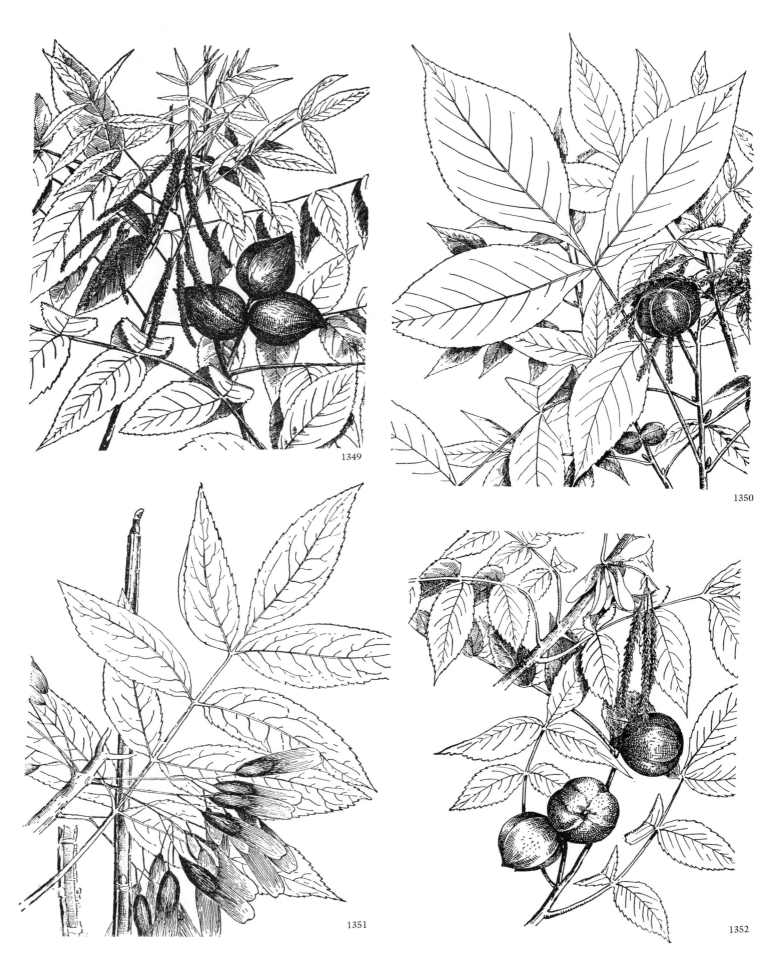

1349. Water Hickory (*Carya aquatica*). **1350.** Small-fruited Hickory (*Carya glabra*). **1351.** Blue Ash (*Fraxinus quadrangulata*). **1352.** Pignut (*Carya glabra*).

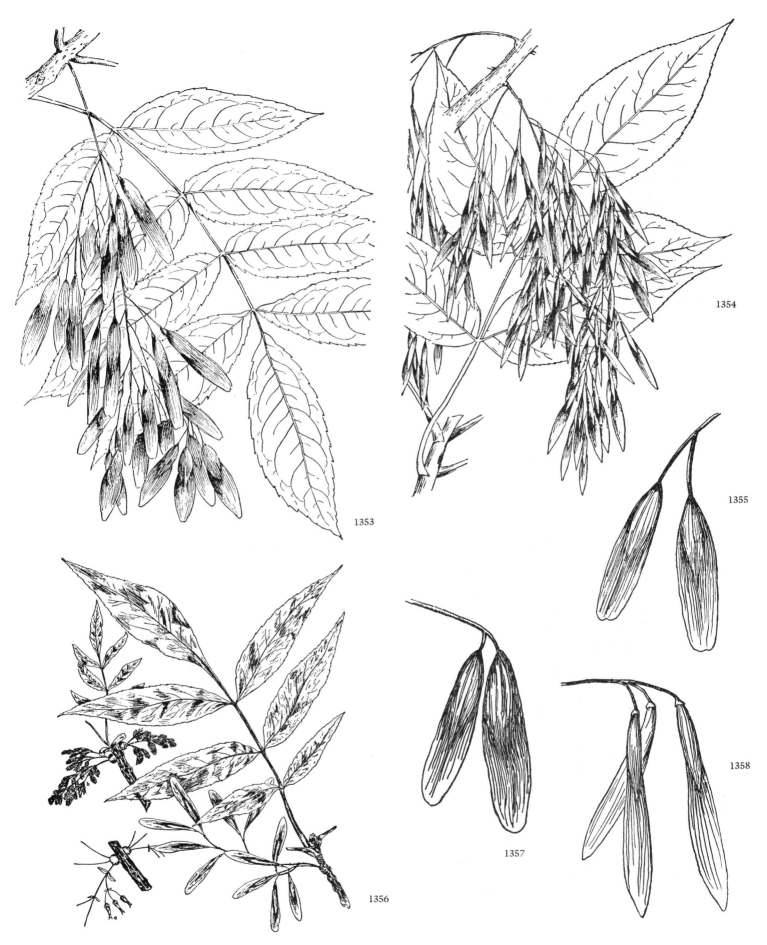

1353, 1357. Black Ash (*Fraxinus nigra*). **1354, 1358.** Green Ash (*Fraxinus pennsylvanica*). **1355.** Blue Ash (*Fraxinus quadrangulata*). **1356.** White Ash (*Fraxinus americana*).

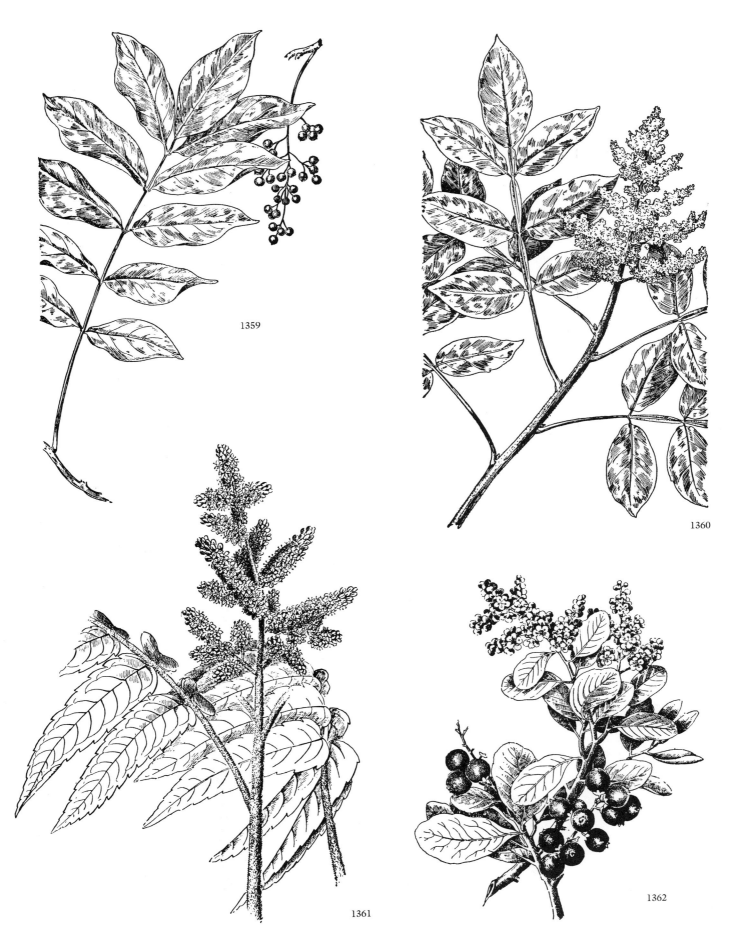

1359. Poison Sumac (*Rhus vernix*). **1360.** Shining Sumac (*Rhus copallina*). **1361.** Staghorn Sumac (*Rhus typhina*). **1362.** California Mahogany (*Rhus integrifolia*).

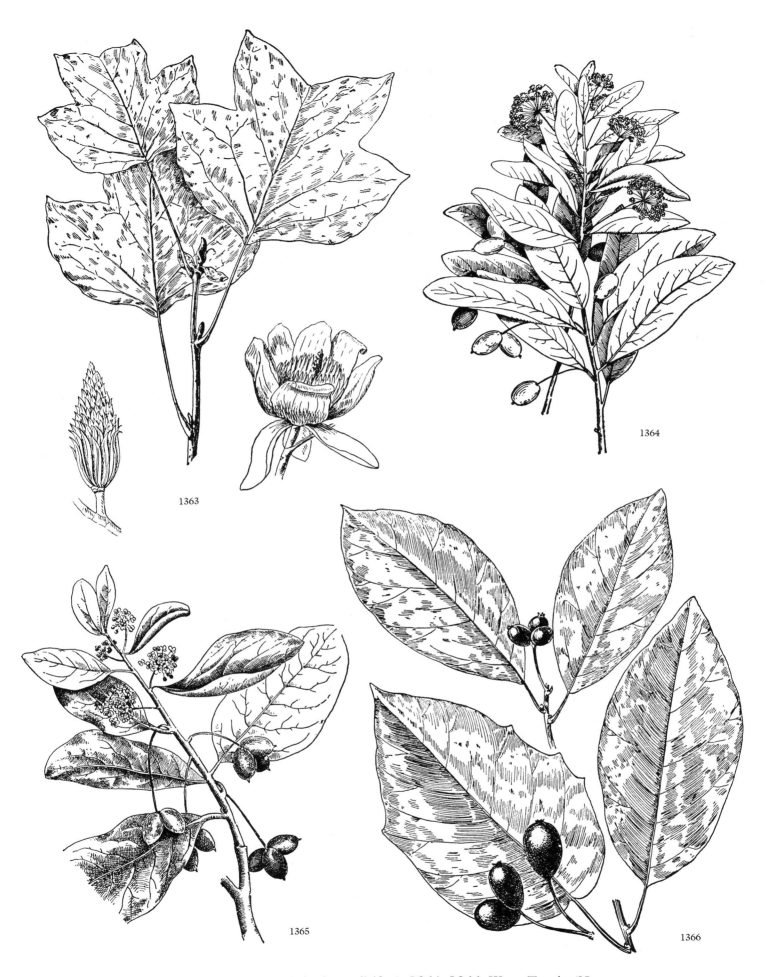

1363. Tulip Tree (*Liriodendron tulipifera*). **1364, 1366.** Water Tupelo (*Nyssa aquatica*). **1365.** Black Tupelo (*Nyssa sylvatica*).

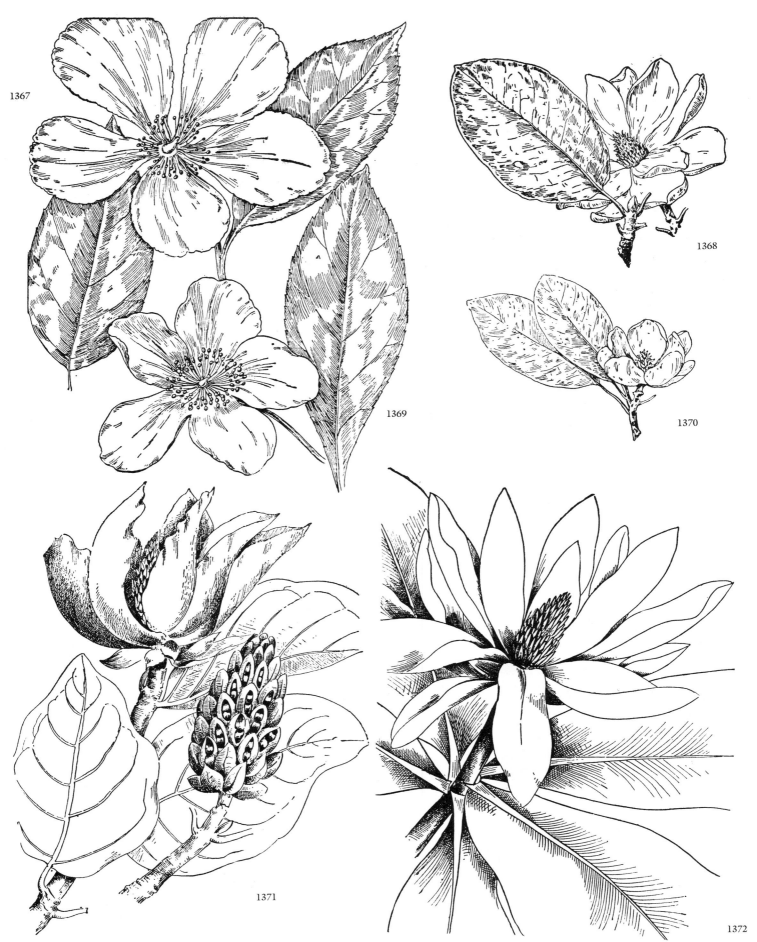

1367. Virginia Stewartia (*Stewartia malacodendron*). **1368.** Southern Magnolia (*Magnolia grandiflora*). **1369.** Loblolly Bay (*Gordonia lasianthus*). **1370.** Sweet Bay Magnolia (*Magnolia virginiana*). **1371.** Cucumber Tree (*Magnolia acuminata*). **1372.** Umbrella Magnolia (*Magnolia tripetala*).

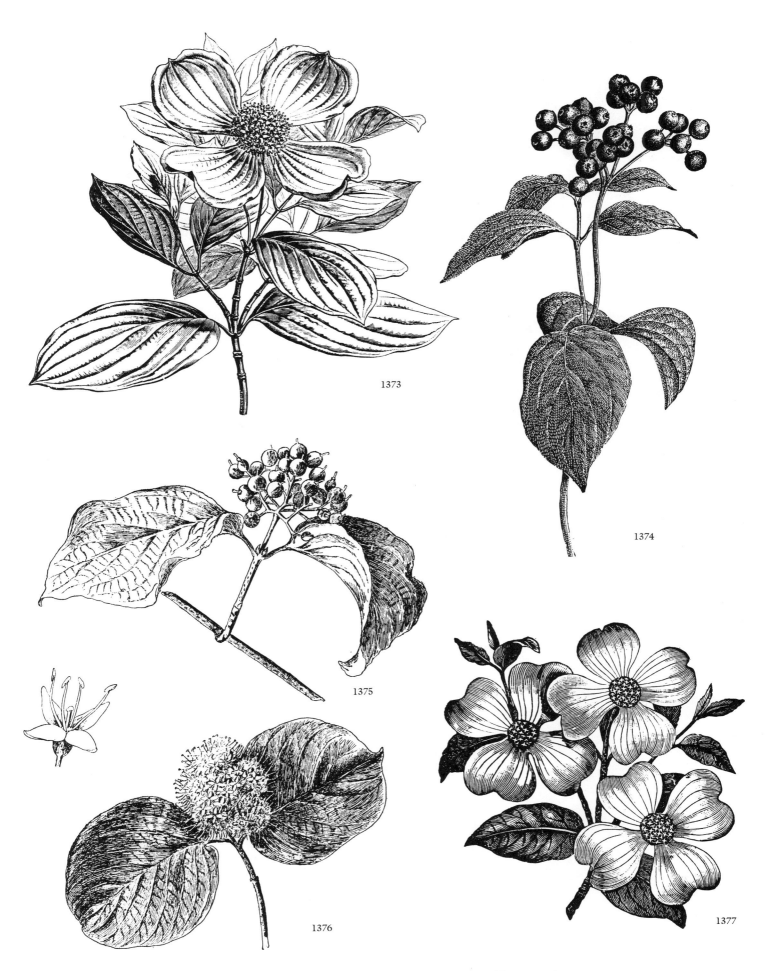

1373, 1377. Flowering Dogwood (*Cornus florida*). **1374.** Silky Cornel (*Cornus purpusii*). **1375, 1376.** Round-leaved Dogwood (*Cornus rugosa*).

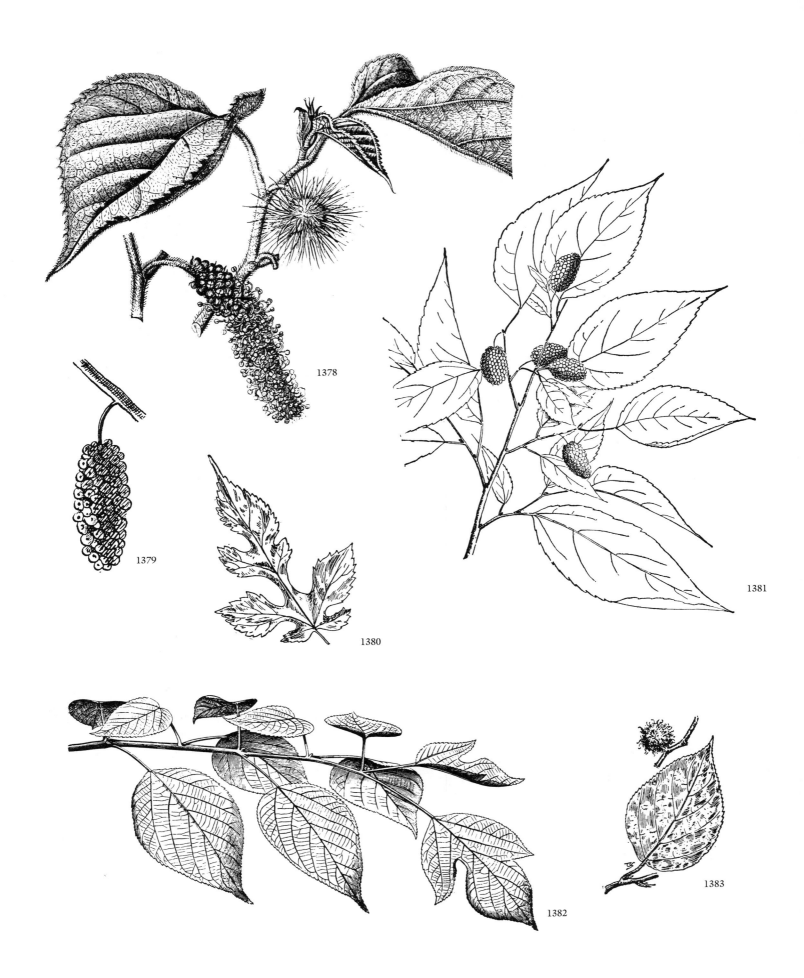

1378, 1382, 1383. Paper Mulberry (*Broussonetia papyrifera*). **1379, 1380.** Red Mulberry (*Morus rubra*). **1381.** White Mulberry (*Morus alba*).

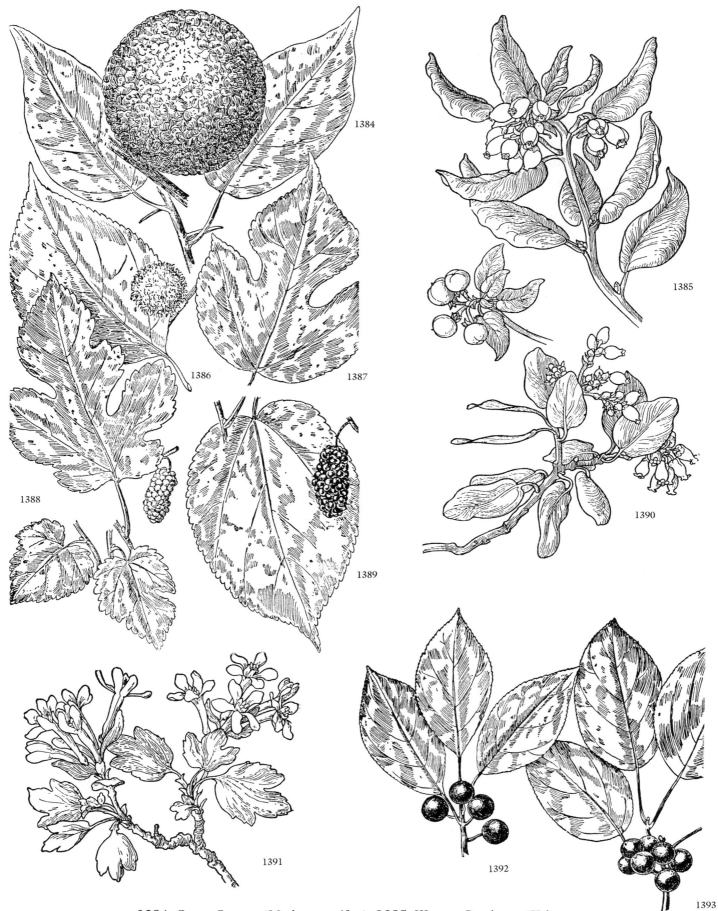

1384. Osage Orange (*Maclura pomifera*). **1385.** Western Bearberry (*Xylococcus bicolor*). **1386.** White Mulberry (*Morus alba*). **1387.** Paper Mulberry (*Broussonetia papyrifera*). **1388.** New Mexico Mulberry (*Morus celtidifolia*). **1389.** Red Mulberry (*Morus rubra*). **1390.** Green Bearberry (*Arctostaphylos patula*). **1391.** Golden Currant (*Ribes odoratum*). **1392.** Alder-leaved Buckthorn (*Rhamnus alnifolia*). **1393.** Common Buckthorn (*Rhamnus cathartica*).

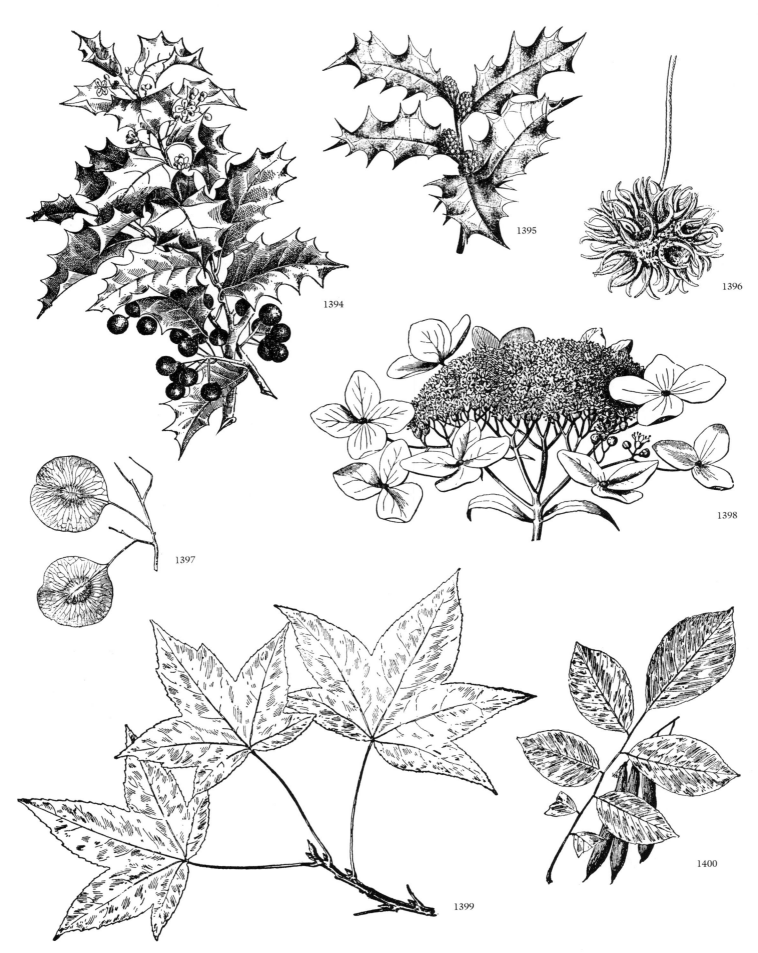

1394. American Holly (*Ilex opaca*). **1395.** Christmas Holly (*Ilex aquifolium*). **1396, 1399.** Sweet Gum (*Liquidambar styraciflua*). **1397.** Hop Tree (*Ptelea trifoliata*). **1398.** Hydrangea (*Hydrangea* sp.). **1400.** Yellowwood (*Cladastris lutea*).

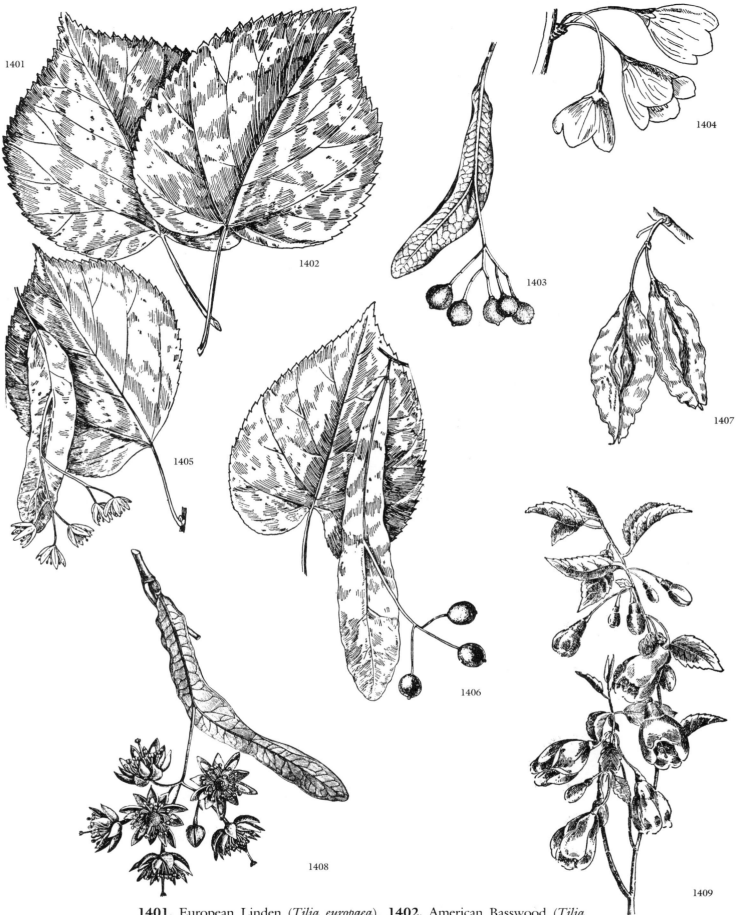

1401. European Linden (*Tilia europaea*). **1402.** American Basswood (*Tilia americana*). **1403.** Basswood Fruit (*Tilia* sp.). **1404.** Silverbell Tree (*Halesia carolina*). **1405.** Downy Basswood (*Tilia michauxii*). **1406.** White Basswood (*Tilia heterophylla*). **1407.** Two-winged Snowdrop Tree (*Halesia diptera*). **1408.** Silver Lime (*Tilia tomentosa*). **1409.** Four-winged Snowdrop Tree (*Halesia carolina*).

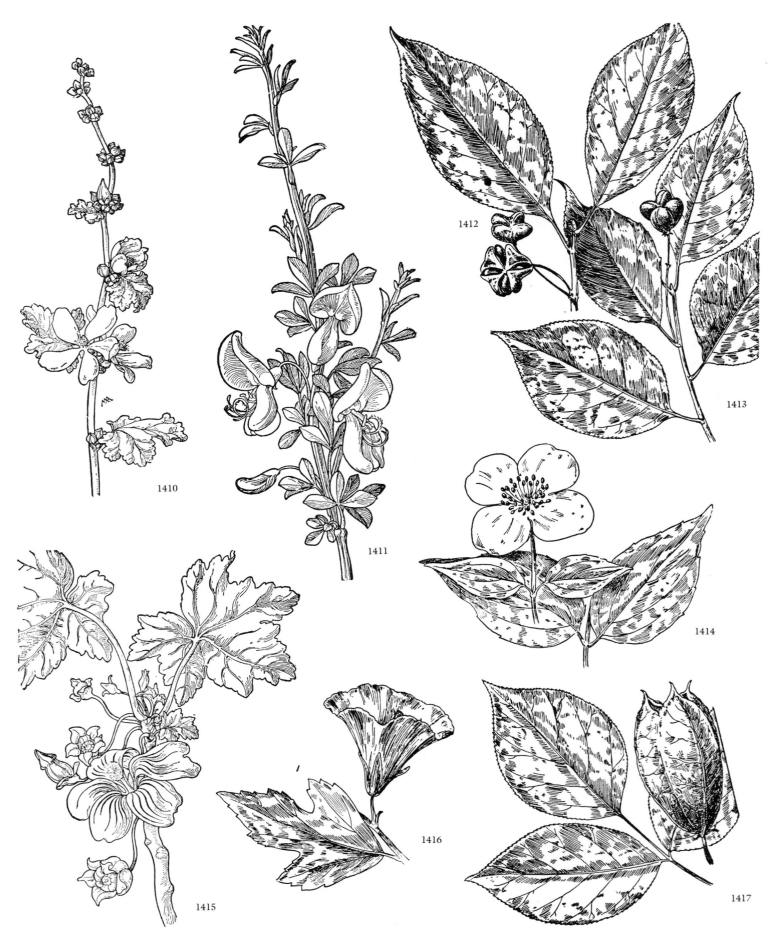

1410. False Mallow (*Malacothamnus fasciculatus*). **1411.** Scotch Broom (*Cytisus scoparius*). **1412.** Burning Bush (*Euonymus atropurpurea*). **1413.** European Spindle Tree (*Euonymus europea*). **1414.** Mock Orange (*Philadelphus inodorus*). **1415.** Tree Mallow (*Lavatera assurgertiflora*). **1416.** Rose of Sharon (*Hibiscus syriacus*). **1417.** American Bladdernut (*Staphylea trifolia*).

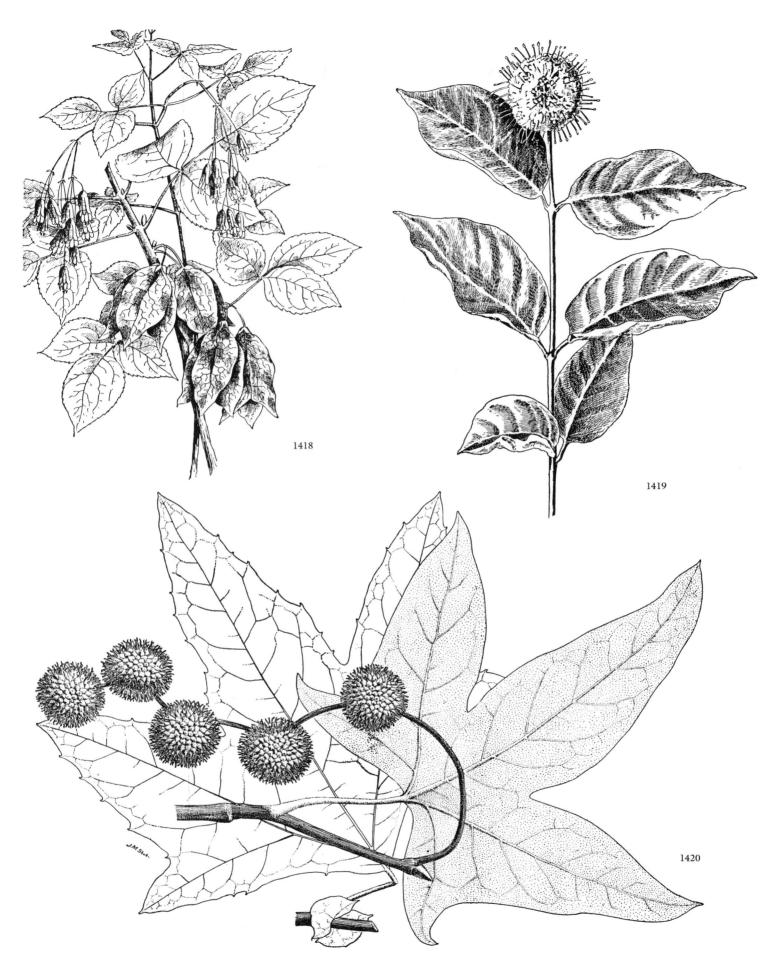

1418. Western Bladdernut (*Staphylea bolanderi*). **1419.** Buttonbush (*Cephalanthus occidentalis*). **1420.** California Sycamore (*Platanus racemosa*).

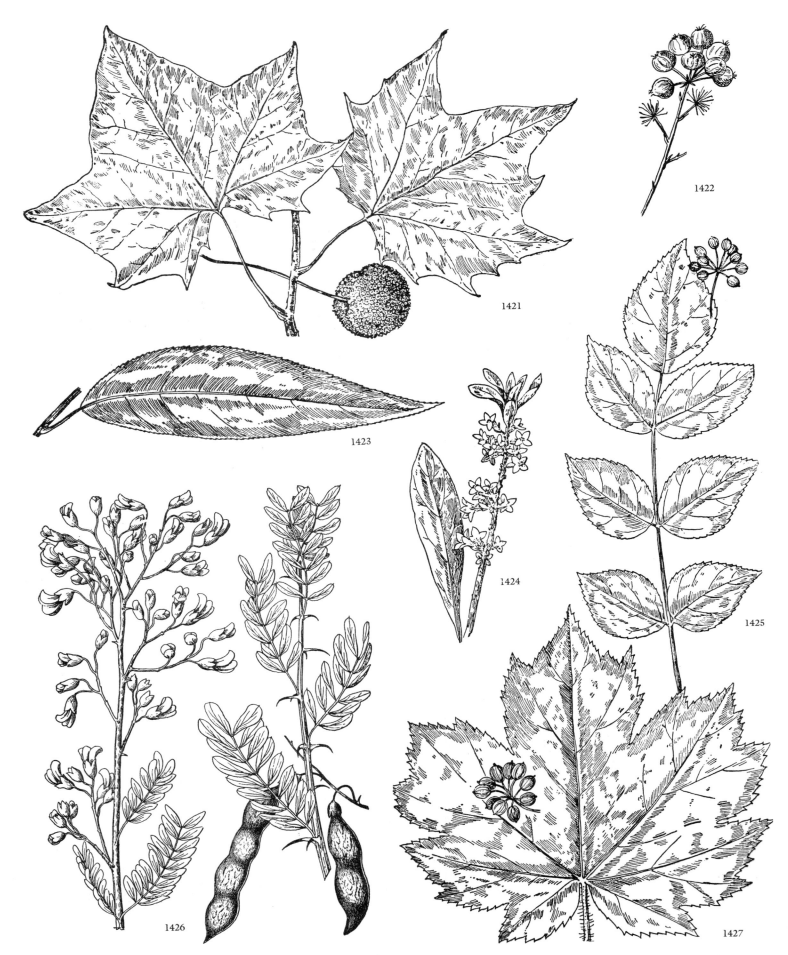

1421. Sycamore (*Platanus occidentalis*). **1422, 1425.** Hercules Club (*Aralia spinosa*). **1423.** Peach (*Prunus persica*). **1424.** Daphne (*Daphne mezereum*). **1426.** Mexican Ironwood (*Olneya tesota*). **1427.** Devil's Club (*Oplopanax horridus*).

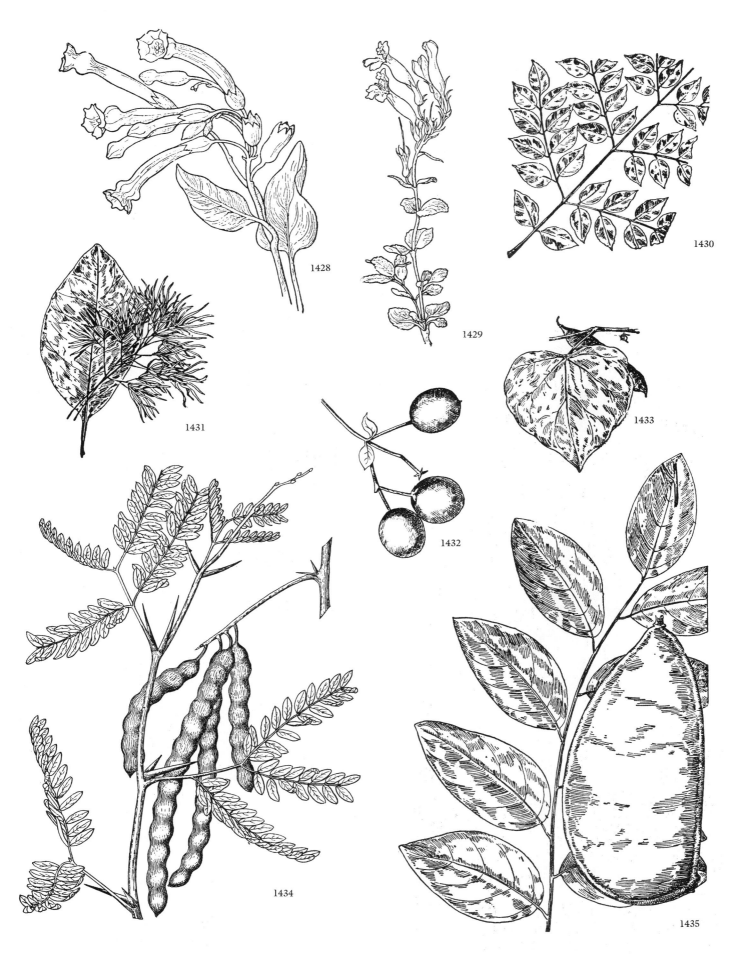

1428. San Juan (*Nicotiana glauca*). **1429.** Pride of the Mountain (*Penstemon newberryi*). **1430, 1435.** Kentucky Coffee Tree (*Gymnocladus dioica*). **1431, 1432.** Fringe Tree (*Chionanthus virginicus*). **1433.** Red Bud (*Cercis canadensis*). **1434.** Mesquite (*Prosopis glandulosa*).

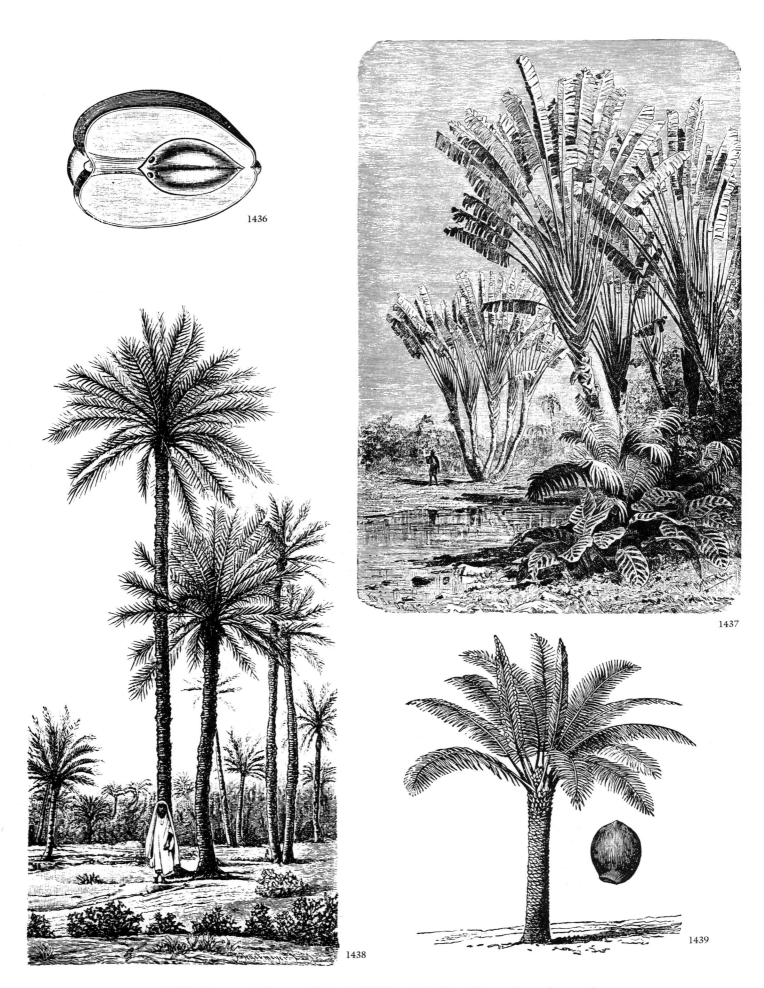

1436. Coconut (*Cocos nucifera*). **1437.** Traveler's Tree (*Ravenala madagascariensis*). **1438.** Date Palm (*Phoenix dactylifera*). **1439.** Sago Palm (*Cycas revoluta*).

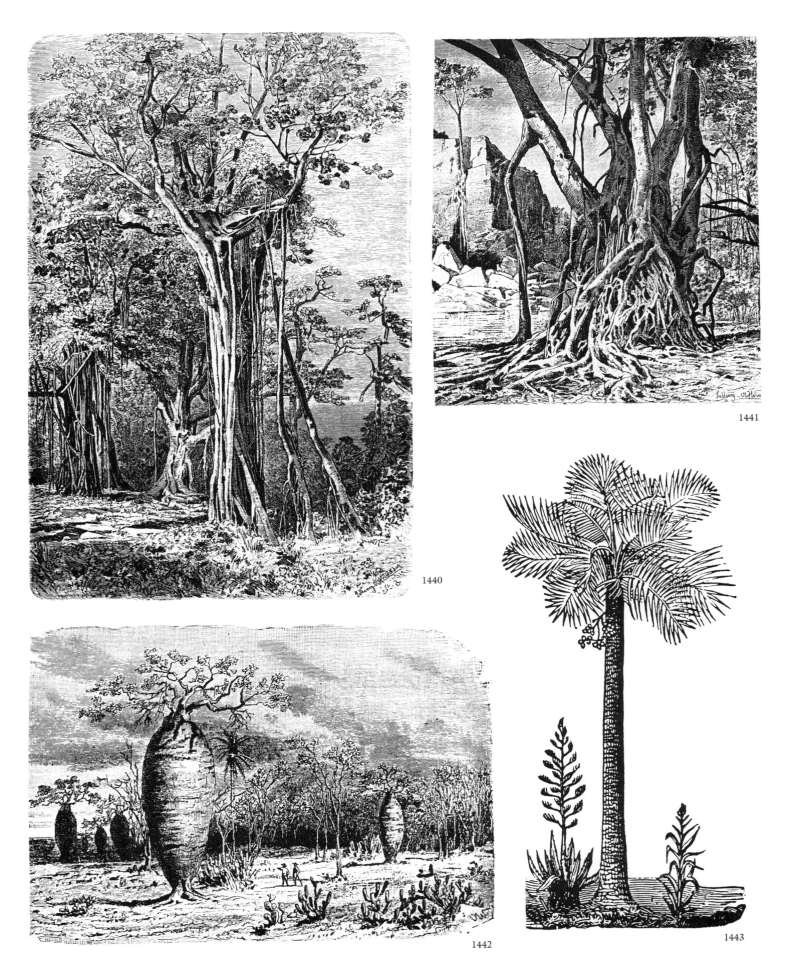

1440, 1441. Benjamin Fig (*Ficus benjamina*). **1442.** Cotton Tree (*Cavanillesia tuberculata*). **1443.** Palm Tree with Desert Plants.

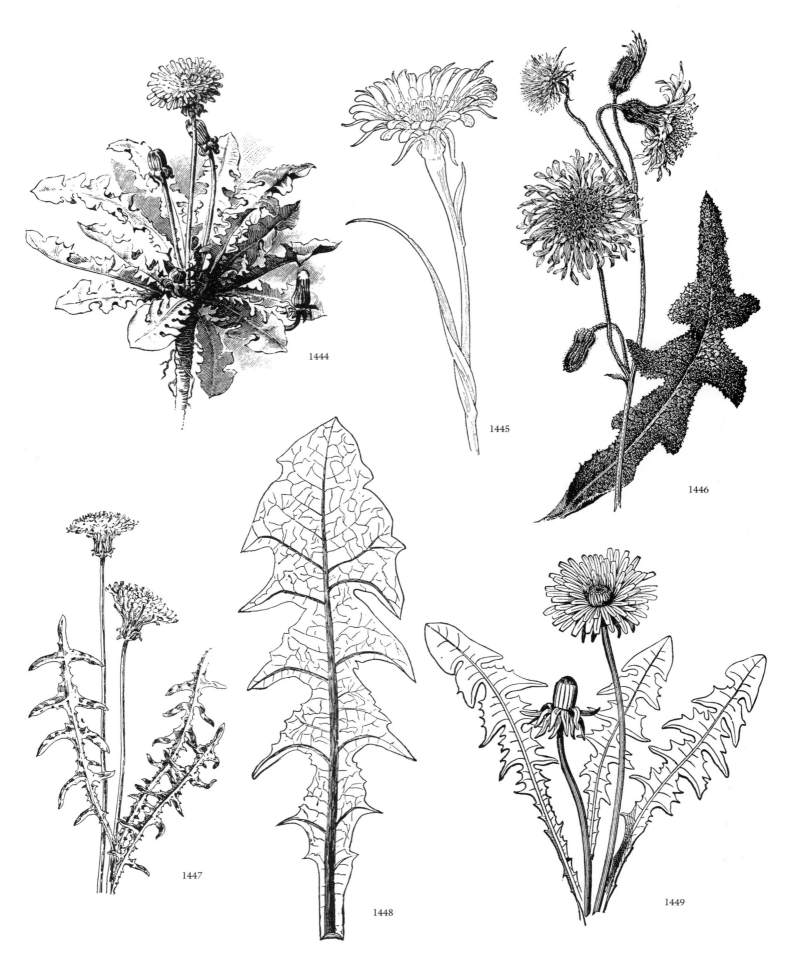

1444, 1448, 1449. Dandelion (*Taraxacum officinale*). **1445.** Western Salsify
(*Tragopogon porrifolius*). **1446.** Fall Dandelion (*Leontodon autumnalis*). **1447.**
Red-seeded Dandelion (*Taraxacum erythrospermum*).

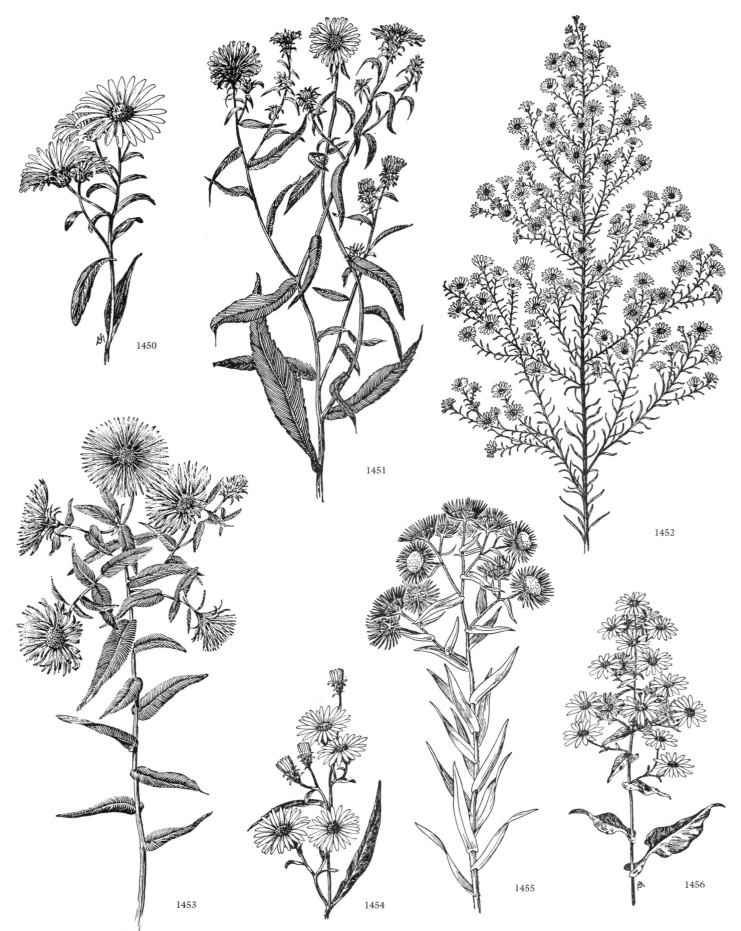

1450. Showy Aster (*Aster spectabilis*). **1451.** Bushy Aster (*Aster dumosus*). **1452.** Heath Aster (*Aster ericoides*). **1453.** Purple-Stem Aster (*Aster puniceus*). **1454.** Long-leaved Aster (*Aster simplex*). **1455.** New England Aster (*Aster novae-angliae*). **1456.** Wavy-leaved Aster (*Aster undulatus*).

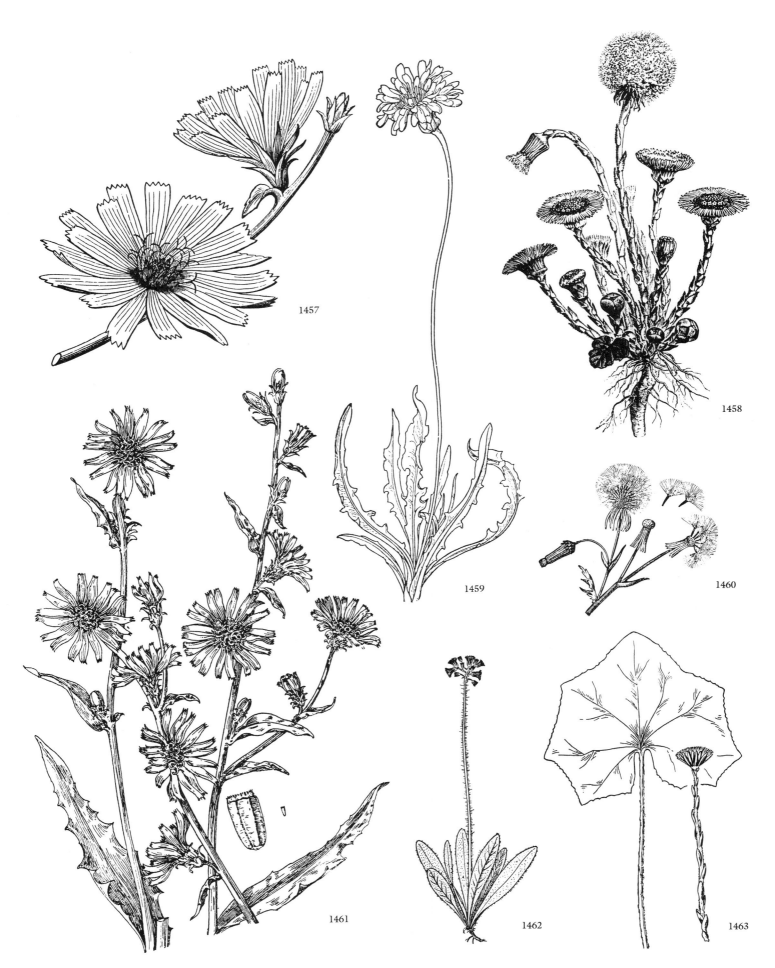

1457, 1461. Chicory (*Cichorium intybus*). **1458, 1463.** Coltsfoot (*Tussilago farfara*). **1459.** Goat Chicory (*Agoseris glauca*). **1460.** Dandelion (*Taraxacum officinale*). **1462.** Orange Hawkweed (*Hieracium aurantiacum*).

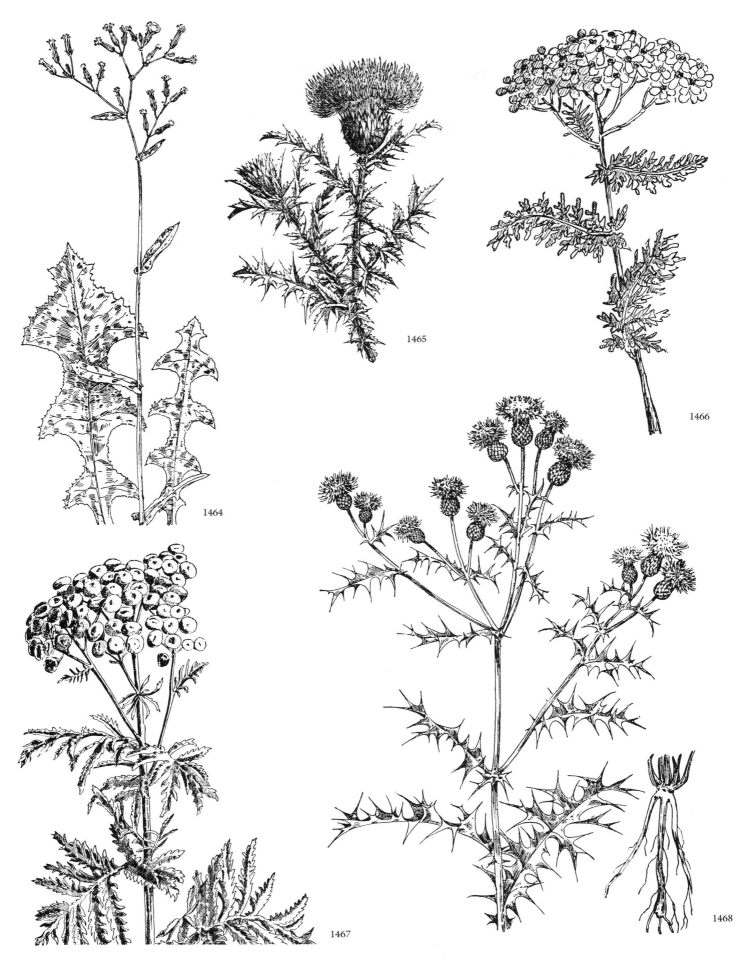

1464. Prickly Lettuce (*Lactuca scariola*). **1465.** *Carduus acanthoides.* **1466.** Yarrow (*Achillea millefolium*). **1467.** Tansy (*Tanacetum vulgare*). **1468.** Canada Thistle (*Cirsium arvense*).

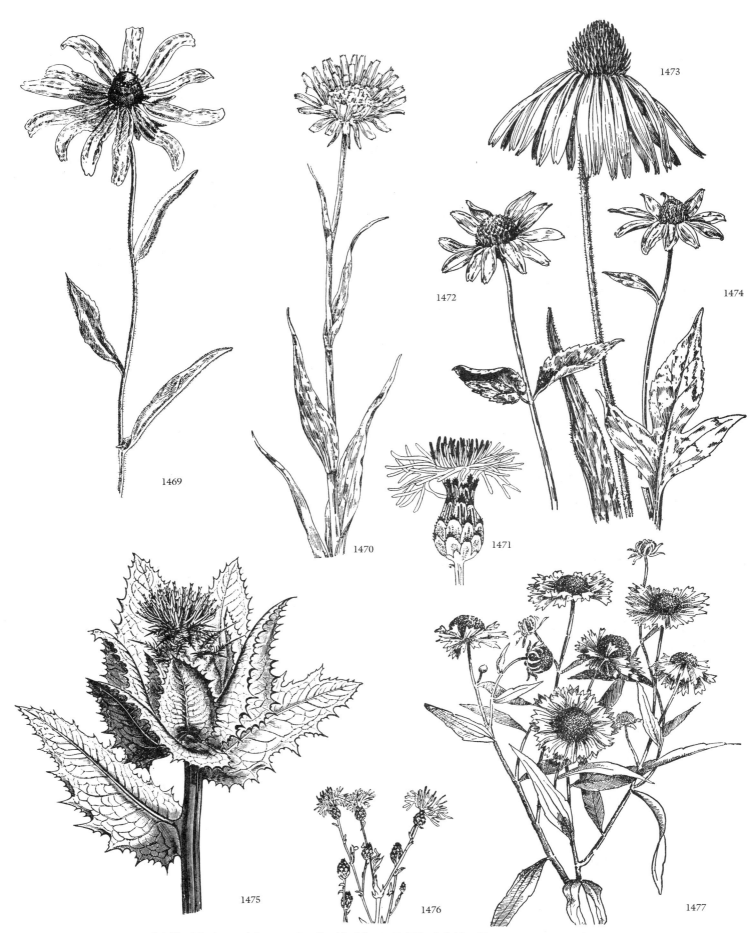

1469. Black-eyed Susan (*Rudbeckia hirta*). **1470.** Salsify (*Tragopogon pratensis*). **1471, 1476.** Spotted Knapweed (*Centauria maculosa*). **1472.** Oxeye Daisy (*Heliopsis helianthoides*). **1473.** Purple Coneflower (*Echinacea pallida*). **1474.** *Rudbeckia triloba*. **1475.** *Cnicus benedictus.* **1477.** Sneezeweed (*Helenium autumnale*).

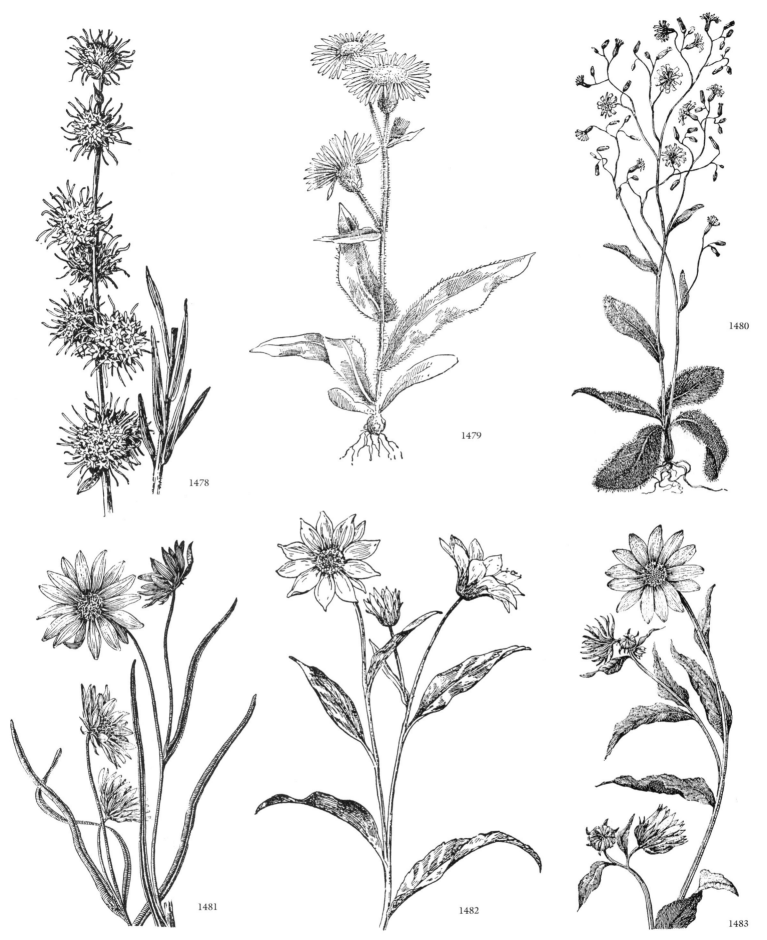

1478. Blazing Star (*Liatris scariosa*). **1479.** Robin's Plantain (*Erigeron pulchellus*). **1480.** Hairy Hawkweed (*Hieracium gronovii*). **1481.** Narrow-leaved Sunflower (*Helianthus angustifolius*). **1482.** Wild Sunflower (*Helianthus annuus*). **1483.** Tall Sunflower (*Helianthus giganteus*).

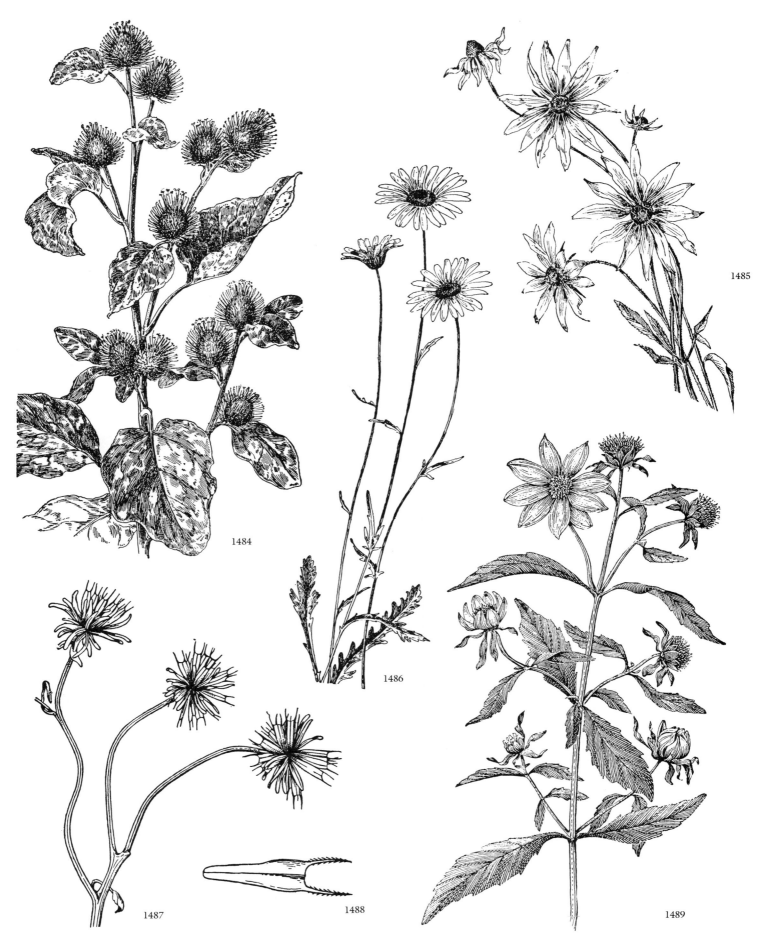

1484. Common Burdock (*Arctium minus*). **1485.** Black-eyed Susan (*Rudbeckia hirta*). **1486.** Oxeye Daisy (*Chrysanthemum leucanthemum*). **1487.** Common Bur Marigold (*Bidens frondosa*). **1488.** Bootjack—Fruit of Bur Marigold. **1489.** Larger Bur Marigold (*Bidens laevis*).

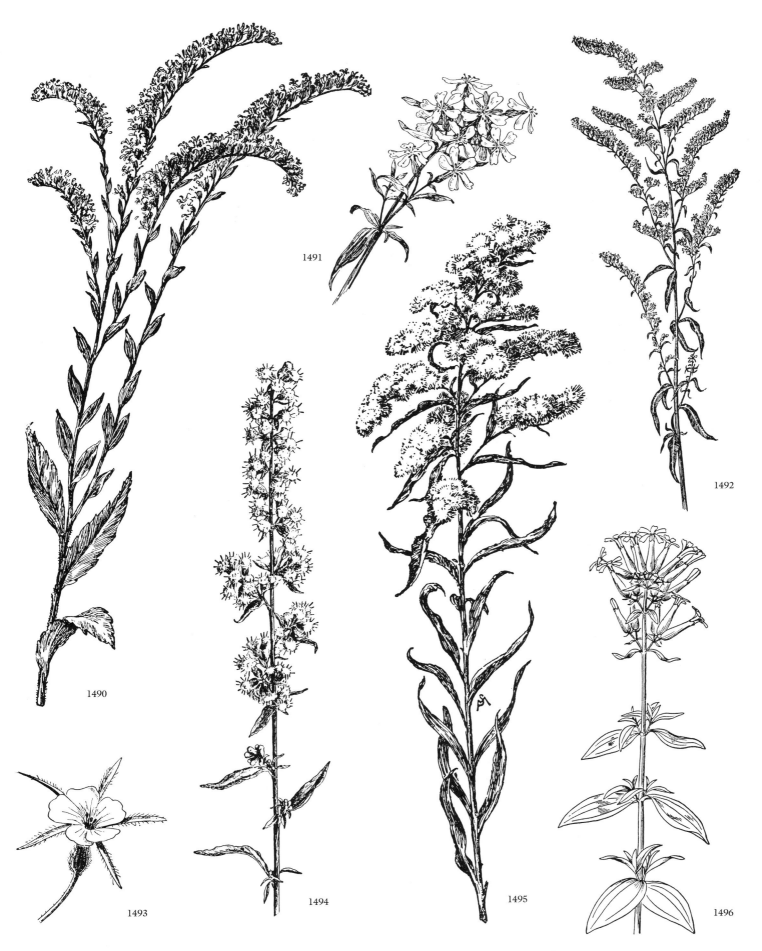

1490. Elm-leaved Goldenrod (*Solidago ulmifolia*). **1491, 1496.** Bouncing Bet (*Saponaria officinalis*). **1492.** Sweet Goldenrod (*Solidago odora*). **1493.** Corn Cockle (*Agrostemma githago*). **1494.** Silverrod (*Solidago bicolor*). **1495.** Goldenrod (Gone to Seed).

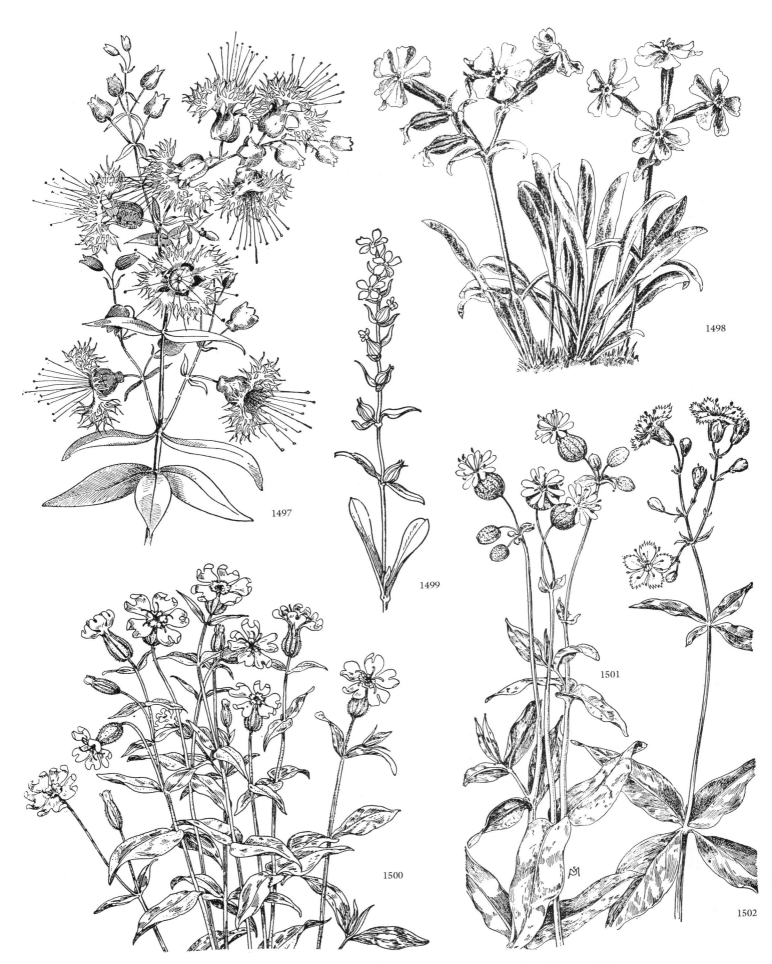

1497, 1502. Starry Campion (*Silene stellata*). **1498.** Wild Pink (*Silene caroliniana*). **1499.** Windmill Pink (*Silene gallica*). **1500.** White Campion (*Lychnis alba*). **1501.** Bladder Campion (*Silene cucubalus*).

236 WILDFLOWERS AND WEEDS OF FIELDS AND OPEN AREAS

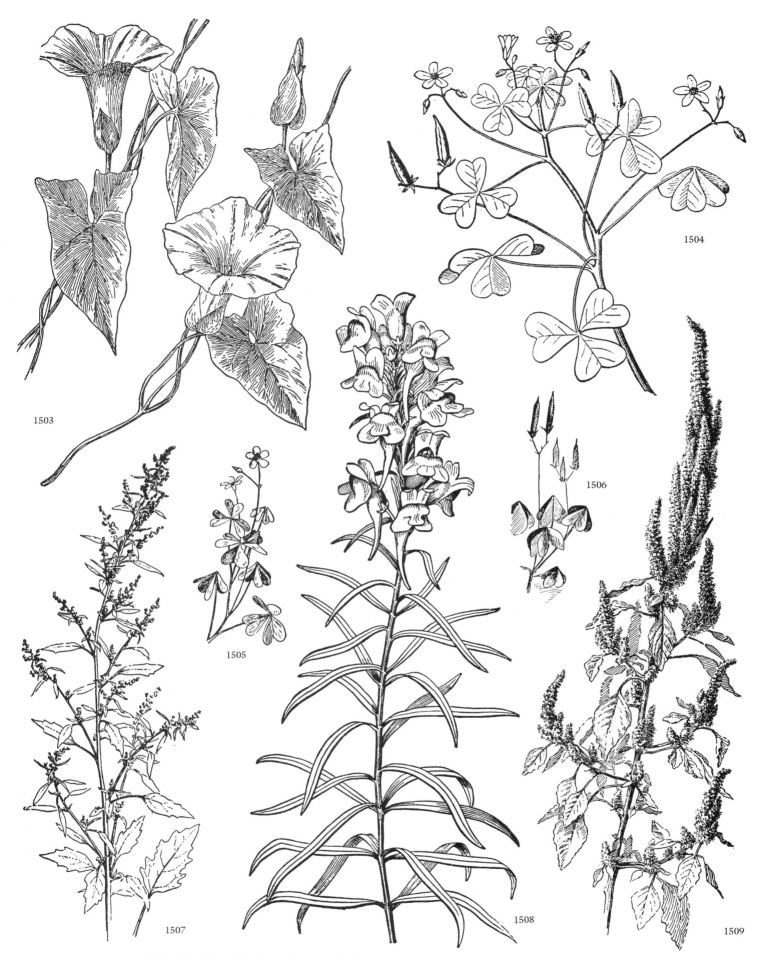

1503. Hedge Bindweed (*Convolvulus arvensis*). **1504–1506.** Yellow Wood Sorrel (*Oxalis stricta*). **1507.** Lamb's-Quarters (*Chenopodium album*). **1508.** Butter and Eggs (*Linaria vulgaris*). **1509.** Redroot Amaranth (*Amaranthus hybridus*).

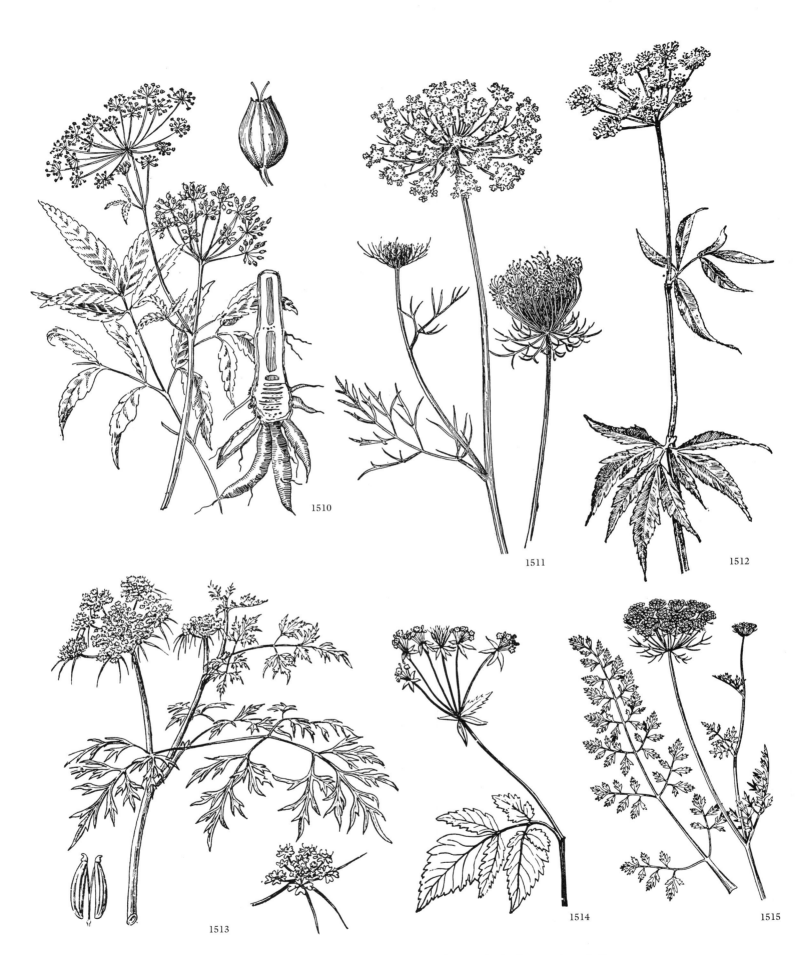

1510. Water Hemlock (*Cicuta maculata*). **1511, 1515.** Queen Anne's Lace
(*Daucus carota*). **1512.** Golden Alexanders (*Zizia aurea*). **1513.** Fool's Parsley
(*Aethusa cynapium*). **1514.** Sweet Cicely (*Osmorhiza longistylis*).

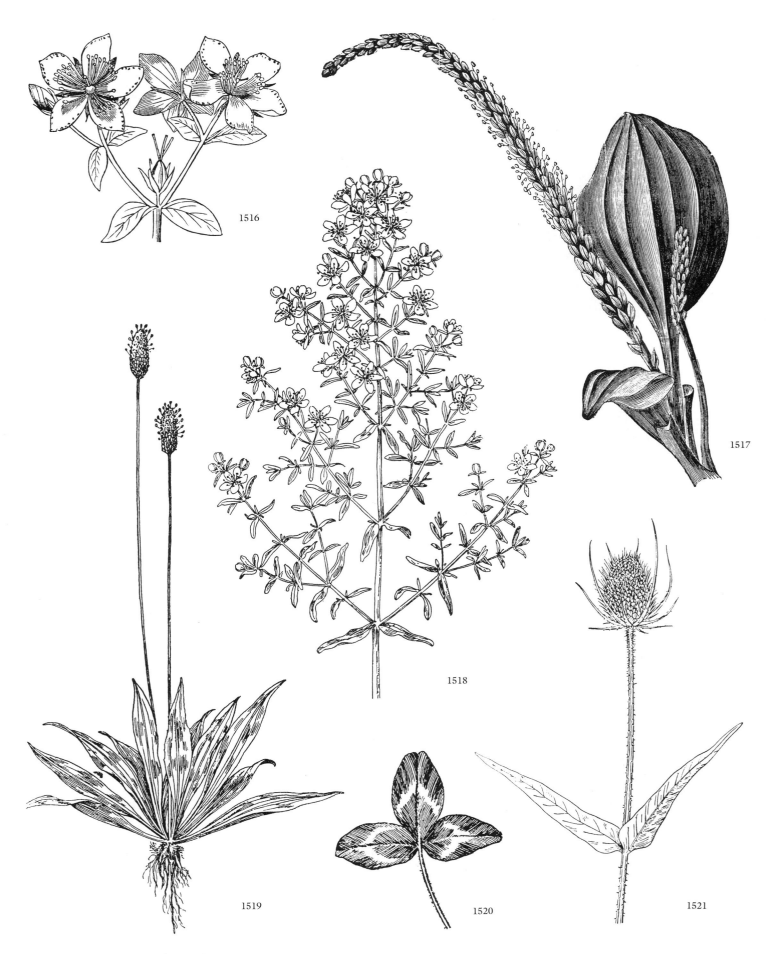

1516, 1518. Common St.-Johns-Wort (*Hypericum perforatum*). **1517.** Common Plantain (*Plantago major*). **1519.** English Plantain (*Plantago lanceolata*). **1520.** Red Clover (*Trifolium pratense*). **1521.** Teasel (*Dipsacus sylvestris*).

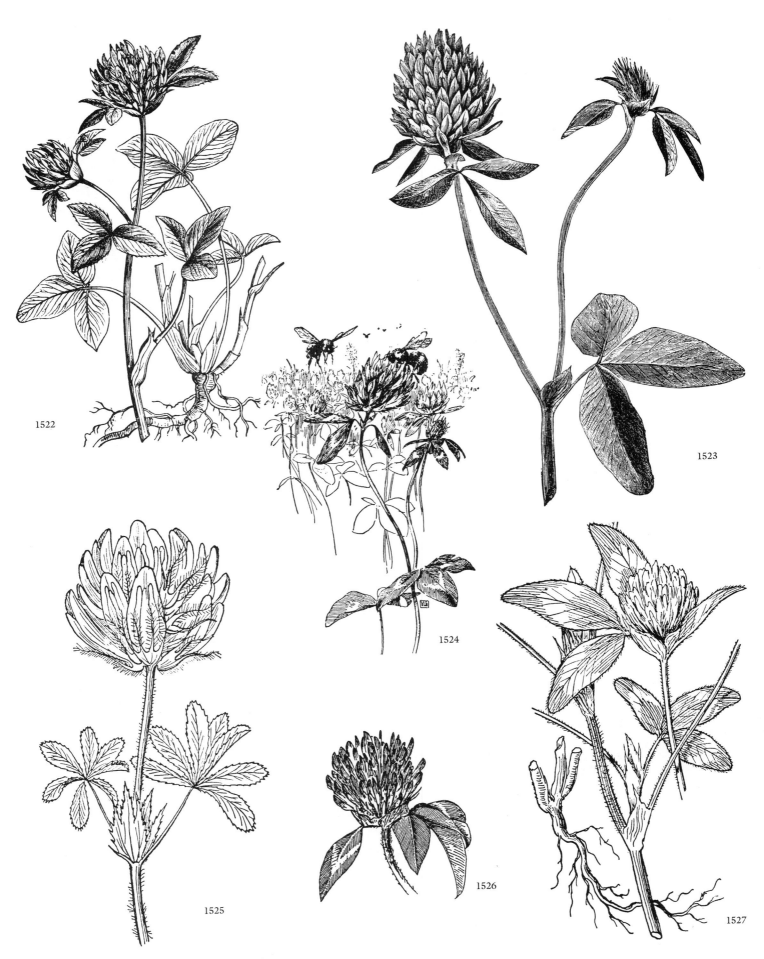

1522, 1523, 1527. Red Clover (*Trifolium pratense*). **1524.** Bees on Clover.
1525. Clover (*Trifolium megacephalum*). **1526.** Head of Clover.

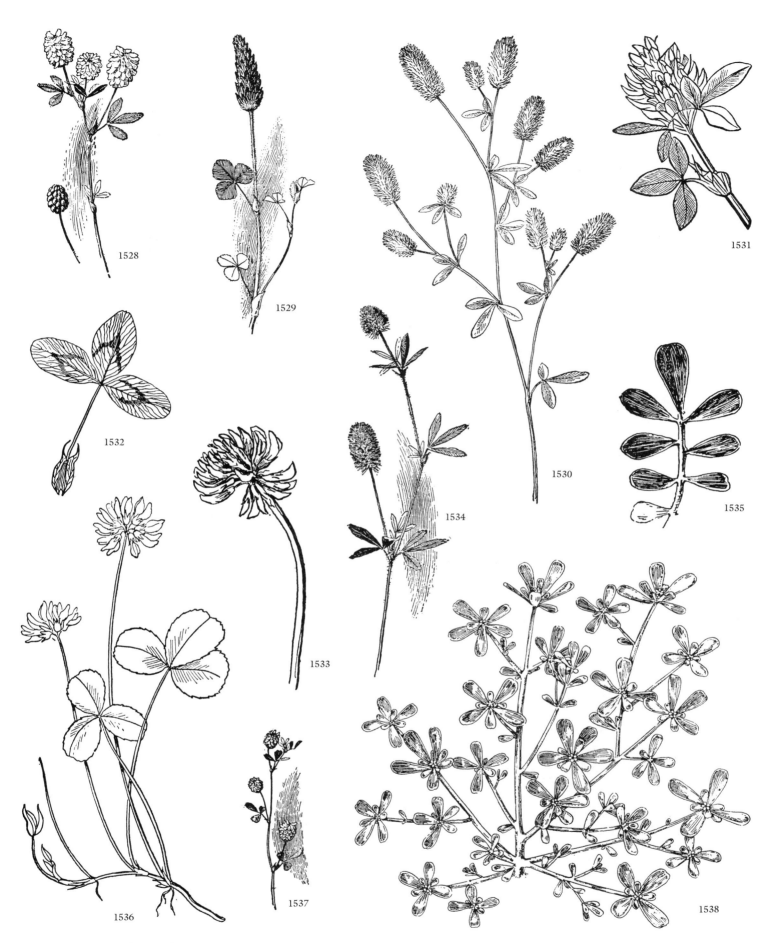

1528. Hop Clover (*Trifolium agrarium*). **1529.** Crimson Clover (*Trifolium incarnatum*). **1530, 1534.** Rabbit-Foot Clover (*Trifolium arvense*). **1531.** Clover (*Trifolium* sp.). **1532.** Leaf of Clover. **1533, 1536.** White Clover (*Trifolium repens*). **1535, 1538.** Purslane (*Portulaca oleracea*). **1537.** Lesser Hop Clover (*Trifolium procumbens*).

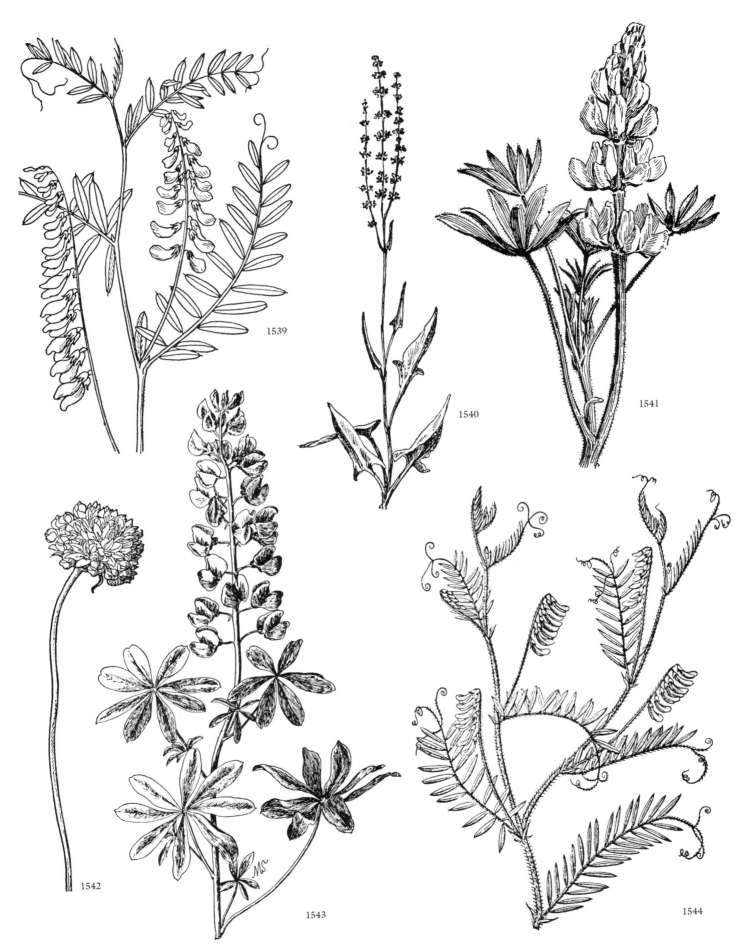

1539. Bird Vetch (*Vicia cracca*). 1540. Sheep Sorrel (*Rumex acetosella*). 1541.
Yellow Lupine (*Lupinus luteus*). 1542. Wild Onion (*Allium serratum*). 1543.
Wild Lupine (*Lupinus perennis*). 1544. Hairy Vetch (*Vicia villosa*).

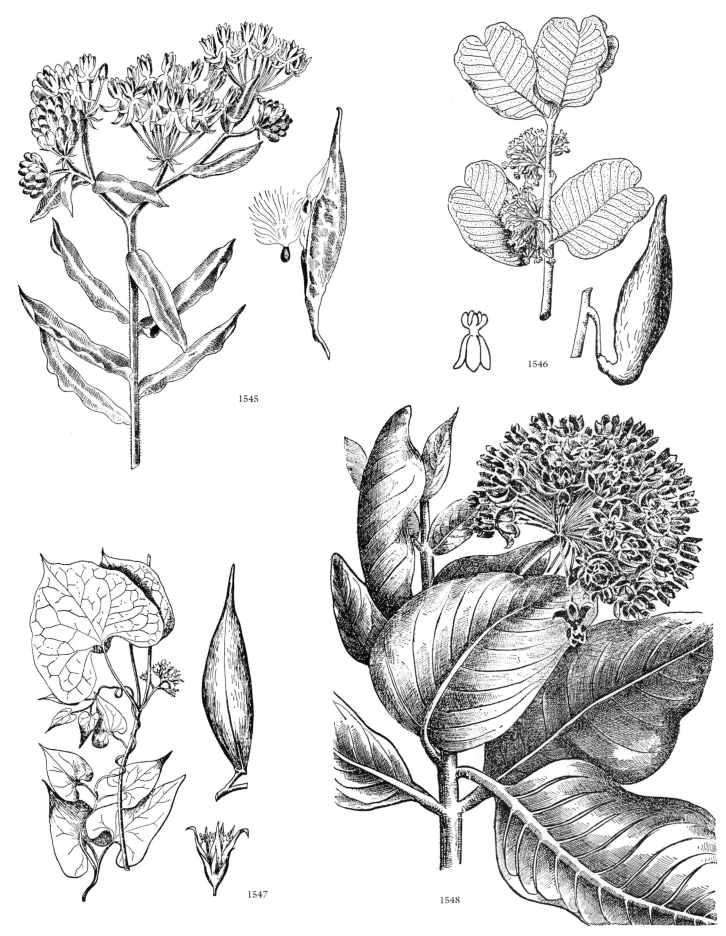

1545. Butterfly Weed (*Asclepias tuberosa*). 1546. Sand Milkweed (*Asclepias arenaria*). 1547. Sand Vine (*Gonolobus laevis*). 1548. Common Milkweed (*Asclepias syriaca*).

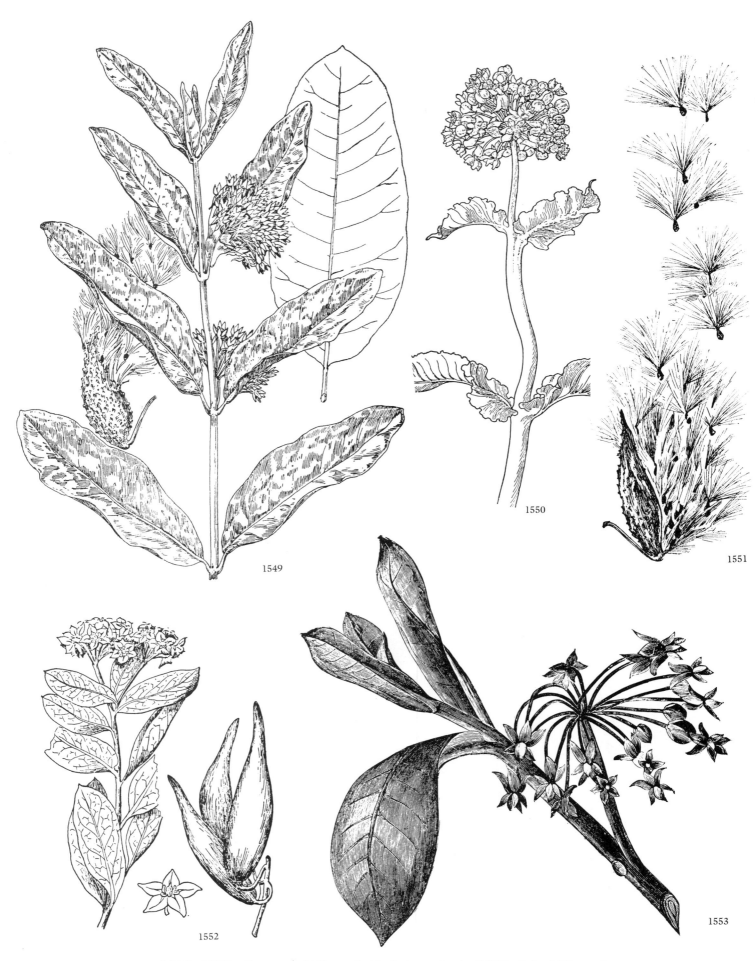

1549, 1551. Common Milkweed (*Asclepias syriaca*). **1550.** Pale Milkweed (*Asclepias erosa*). **1552.** Oblong-leaved Milkweed (*Asclepiodora viridis*). **1553.** Milkweed Flowers.

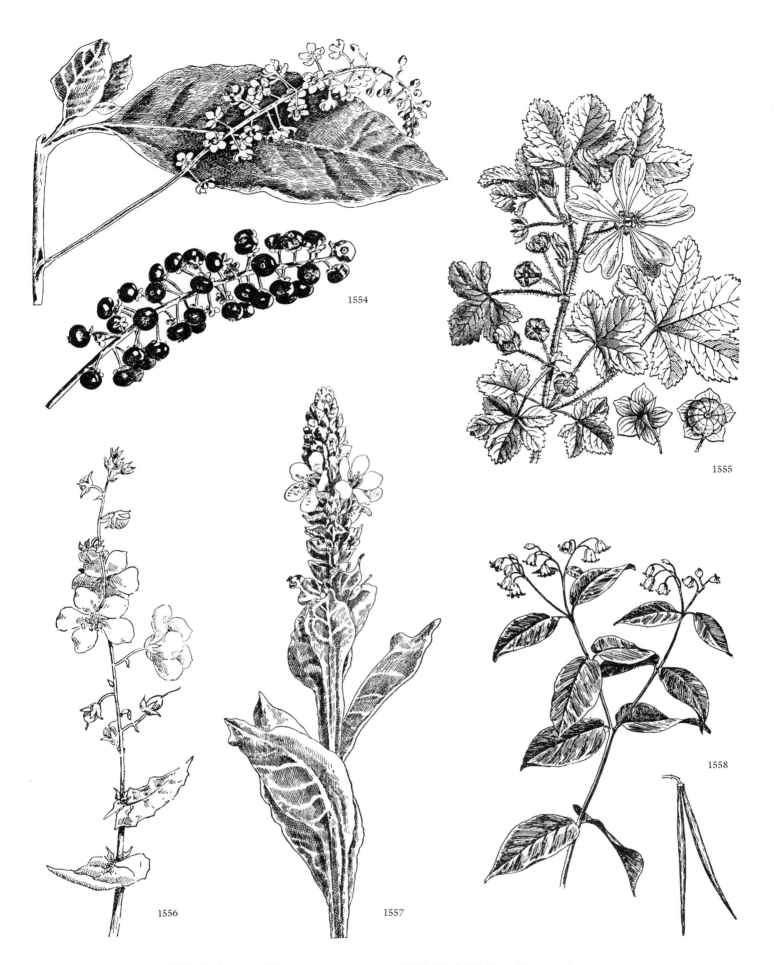

1554. Pokeweed (*Phytolacca americana*). **1555.** High Mallow (*Malva sylvestris*).
1556. Moth Mullein (*Verbascum blattaria*). **1557.** Common Mullein (*Verbascum thapsus*). **1558.** Spreading Dogbane (*Apocynum androsaemifolium*).

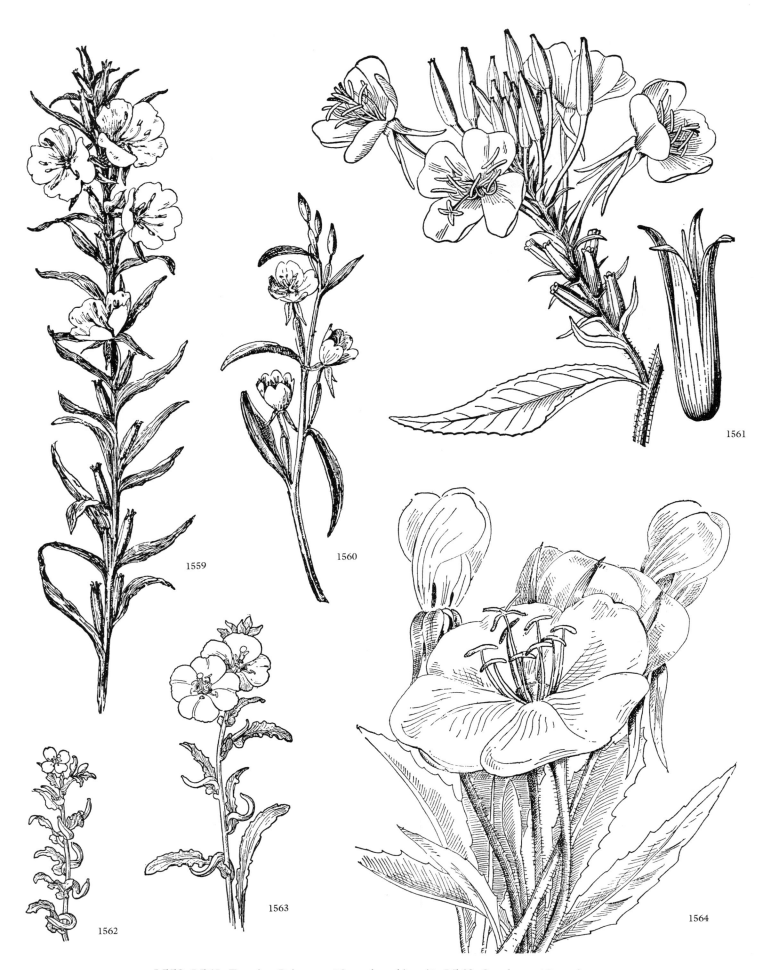

1559, 1561. Evening Primrose (*Oenothera biennis*). **1560.** Sundrops (*Oenothera fruticosa*). **1562.** Cotton Primrose (*Oenothera bistorta*). **1563.** Western Evening Primrose (*Oenothera bistorta*). **1564.** Scapose Primrose (*Oenothera caespitosa*).

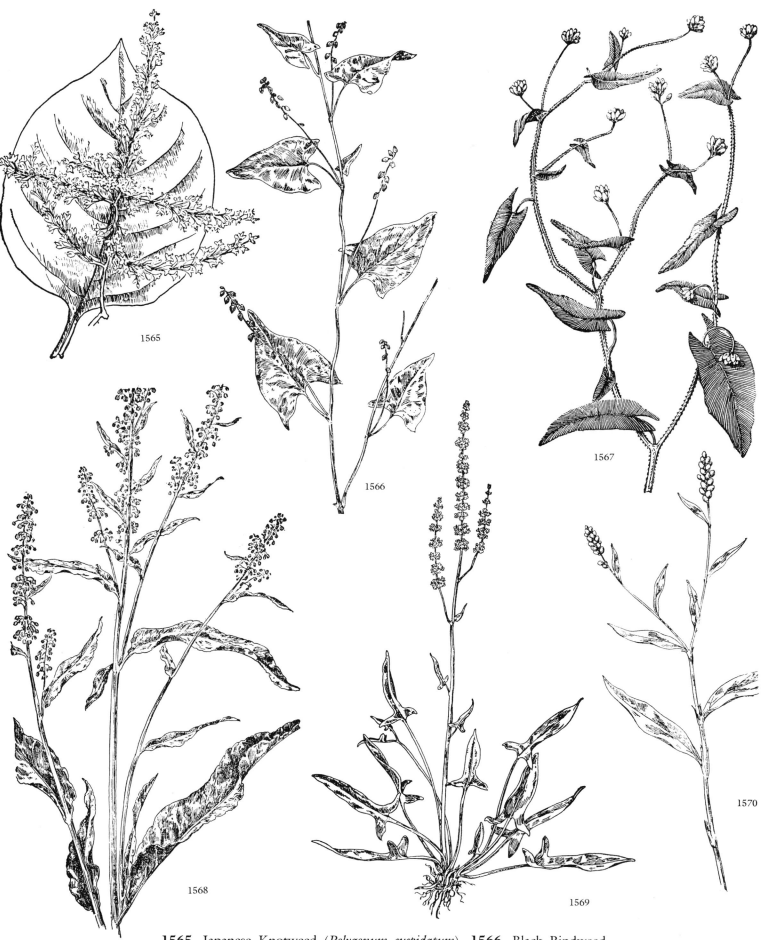

1565. Japanese Knotweed (*Polygonum cuspidatum*). **1566.** Black Bindweed (*Polygonum convolvulus*). **1567.** Arrow-leaved Tearthumb (*Polygonum sagittatum*). **1568.** Curled Dock (*Rumex crispus*). **1569.** Sheep Sorrel (*Rumex acetosella*). **1570.** Lady's-Thumb (*Polygonum persicaria*).

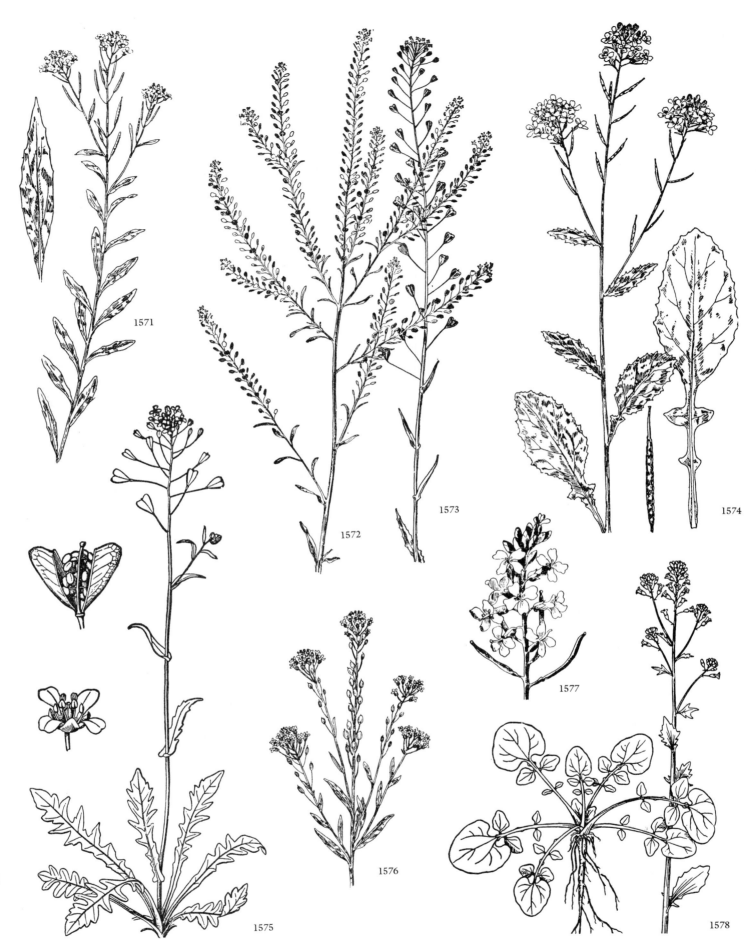

1571. Wormsweed Mustard (*Erysimum cheiranthoides*). **1572.** Peppergrass (*Lepidium virginicum*). **1573, 1575.** Shepherd's Purse (*Capsella bursa-pastoris*). **1574.** Charlock (*Brassica kaber*). **1576.** Hoary Alyssum (*Berteroa incana*). **1577, 1578.** Winter Cress (*Barbarea vulgaris*).

1579. Flower-of-an-Hour (*Hibiscus trionum*). 1580. Small Mallow (*Sphaeralcea miniata*). 1581, 1583. Purple Poppy Mallow (*Callirrhoe involucrata*). 1582. Hairy Mallow (*Anota hastata*). 1584. Cheese Mallow (*Malva neglecta*).

1585. Black Nightshade (*Solanum nigrum*). **1586, 1588.** Lobed Ground Cherry (*Physalis lobata*). **1587.** Horse Nettle (*Solanum carolinense*). **1589.** Henbane (*Hyoscyamus niger*). **1590.** Buffalo Bur (*Solanum rostratum*). **1591.** Bittersweet Nightshade (*Solanum dulcamara*).

1592. Purple Thorn-Apple (*Datura stramonium*). **1593, 1598.** Jimsonweed (*Datura stramonium*). **1594.** Horse Nettle (*Solanum carolinense*). **1595.** Purple Nightshade (*Solanum xantii*). **1596.** Leaf of Spiny Nightshade (*Solanum atropurpureum*). **1597.** Buffalo Bur (*Solanum rostratum*).

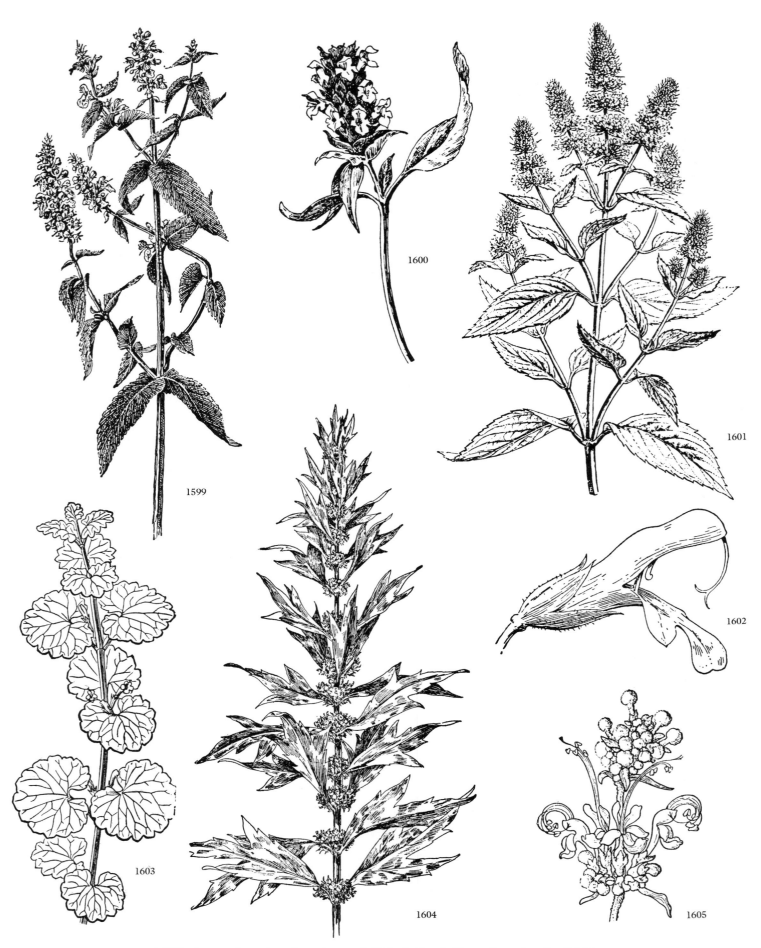

1599. Spearmint (*Mentha spicata*). **1600.** Selfheal (*Prunella vulgaris*). **1601.** Peppermint (*Mentha × piperita*). **1602.** Flower of Common Sage (*Salvia officinalis*). **1603.** Ground Ivy (*Glechoma hederacea*). **1604.** Motherwort (*Leonurus cardiaca*). **1605.** Romero (*Trichostema lanatum*).

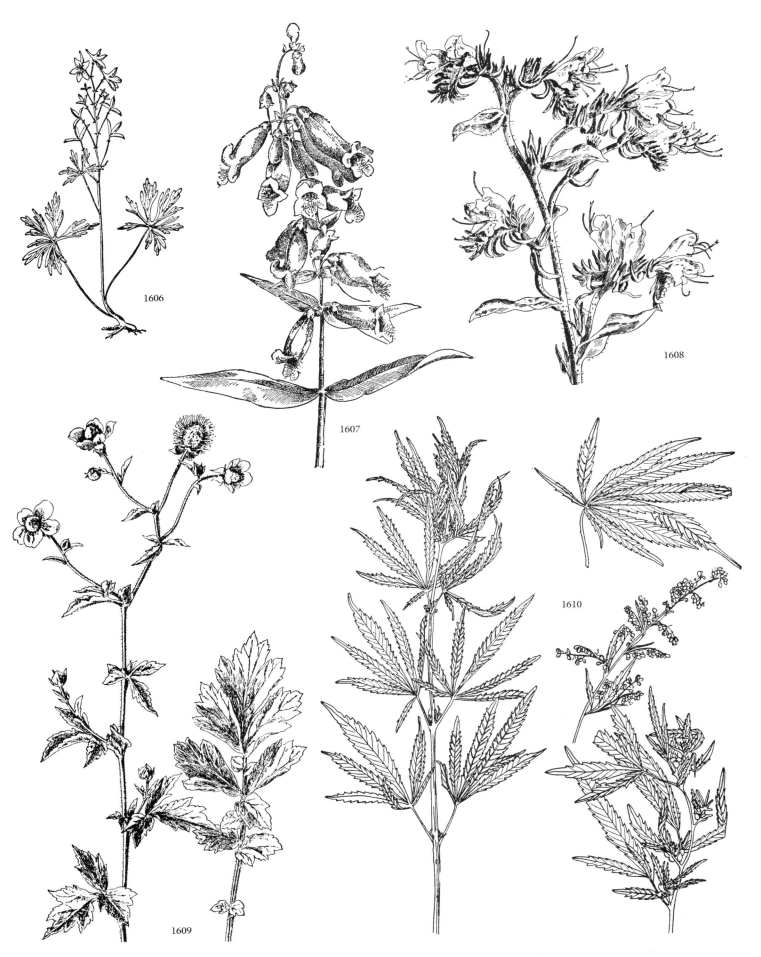

1606. Dwarf Larkspur (*Delphinium tricorne*). **1607.** White Beard's Tongue (*Penstemon digitalis*). **1608.** Viper's Bugloss (*Echium vulgare*). **1609.** Yellow Avens (*Geum aleppicum*). **1610.** Marijuana (*Cannabis sativa*).

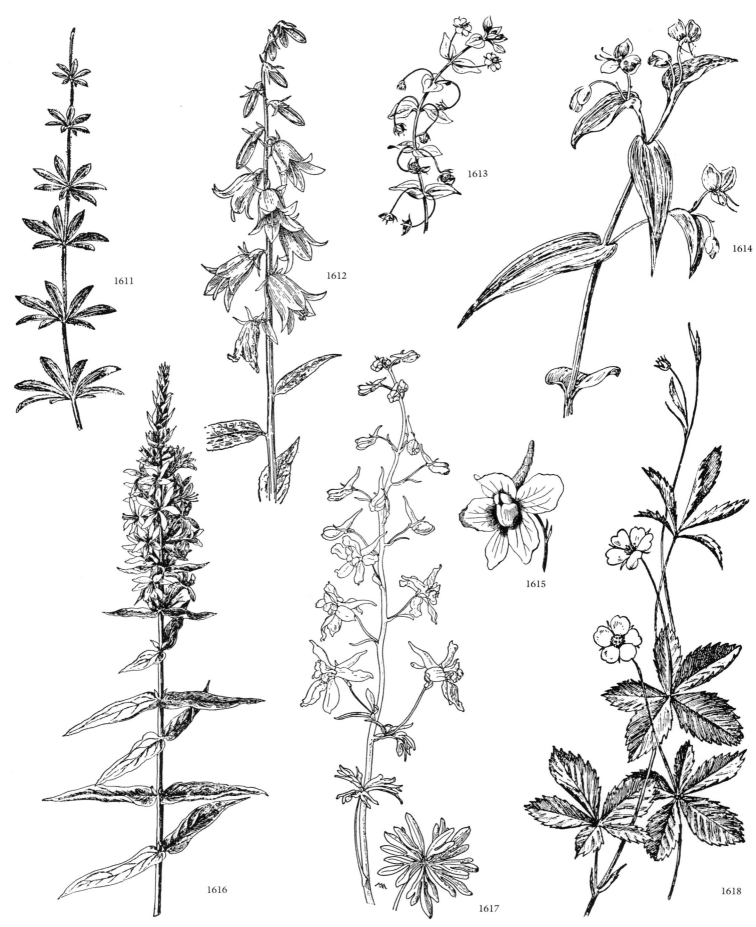

1611. Sweet-scented Bedstraw (*Galium triflorum*). **1612.** Creeping Bellflower (*Campanula rapunculoides*). **1613.** Scarlet Pimpernel (*Anagallis arvensis*). **1614.** Virginia Dayflower (*Commelina virginica*). **1615.** Larkspur Flower. **1616.** Purple Loosestrife (*Lythrum salicaria*). **1617.** Blue Larkspur (*Delphinium bicolor*). **1618.** Common Cinquefoil (*Potentilla simplex*).

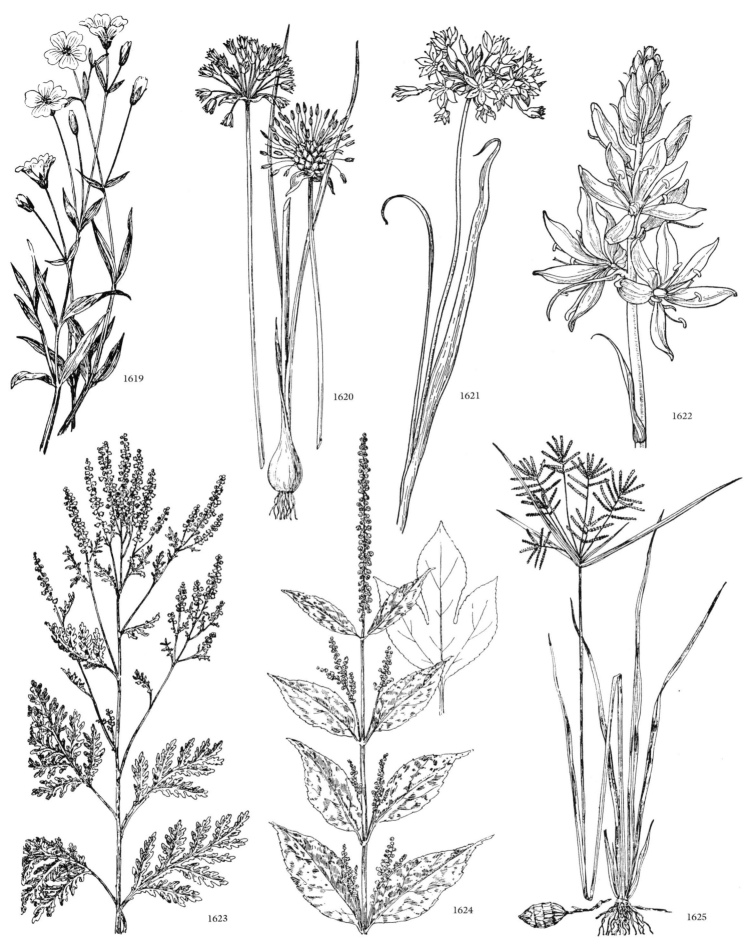

1619. Mouse-Ear Chickweed (*Cerastium vulgatum*). **1620.** Field Garlic (*Allium vineale*). **1621.** Rock Onion (*Allium bisceptrum*). **1622.** Western Camass (*Camassia quamash*). **1623.** Common Ragweed (*Ambrosia artemisiifolia*). **1624.** Great Ragweed (*Ambrosia trifida*). **1625.** Yellow Nutgrass (*Cyperus esculentus*).

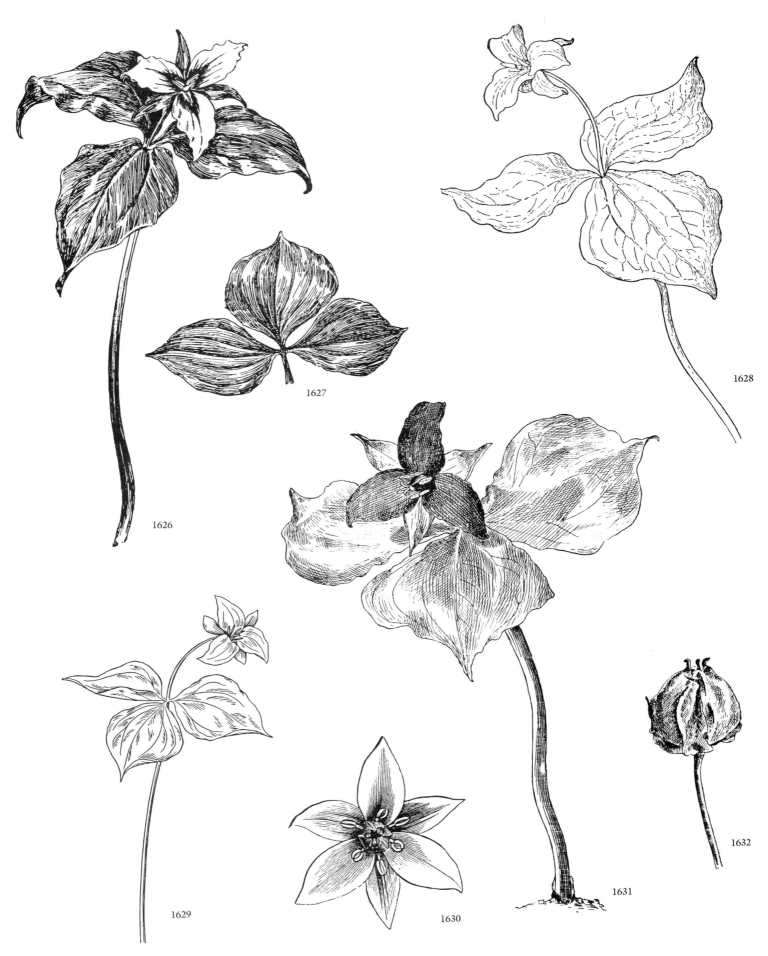

1626. Painted Trillium (*Trillium undulatum*). **1627, 1629.** White Trillium (*Trillium grandiflorum*). **1628.** Canyon Trillium (*Trillium ovatum*). **1630.** Trillium (*Trillium* sp.). **1631, 1632.** Wake Robin (*Trillium erectum*).

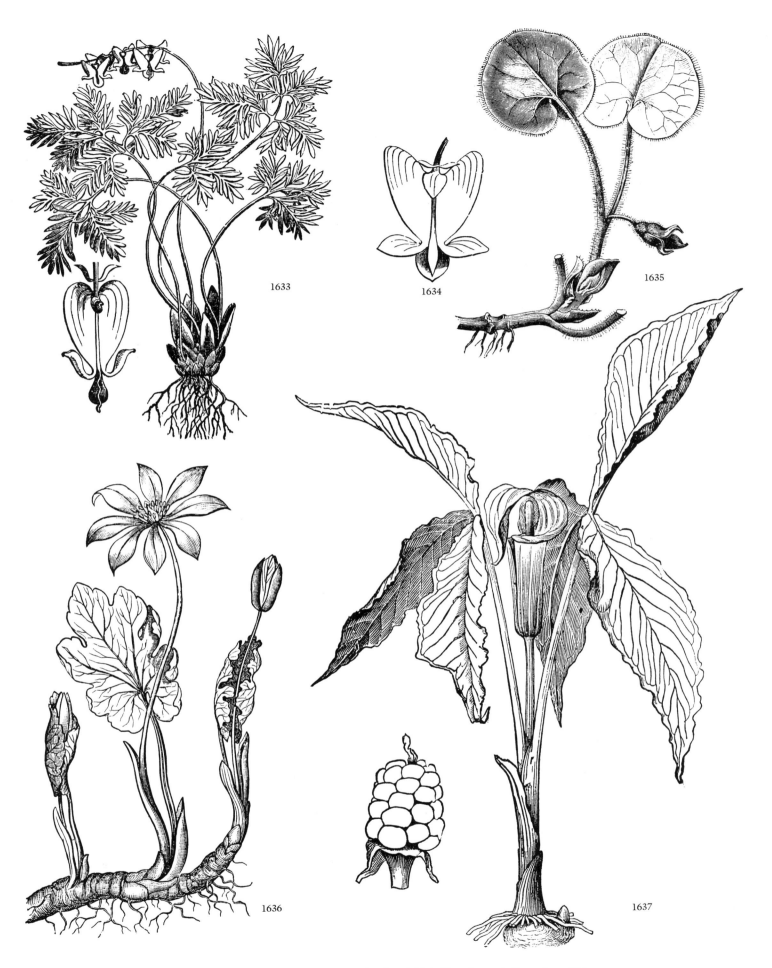

1633. Squirrel Corn (*Dicentra canadensis*). **1634.** Dutchman's Breeches (*Dicentra cucullaria*). **1635.** Rhine Ginger (*Asarum europaeum*). **1636.** Bloodroot (*Sanguinaria canadensis*). **1637.** Jack-in-the-Pulpit (*Arisaema triphyllum*).

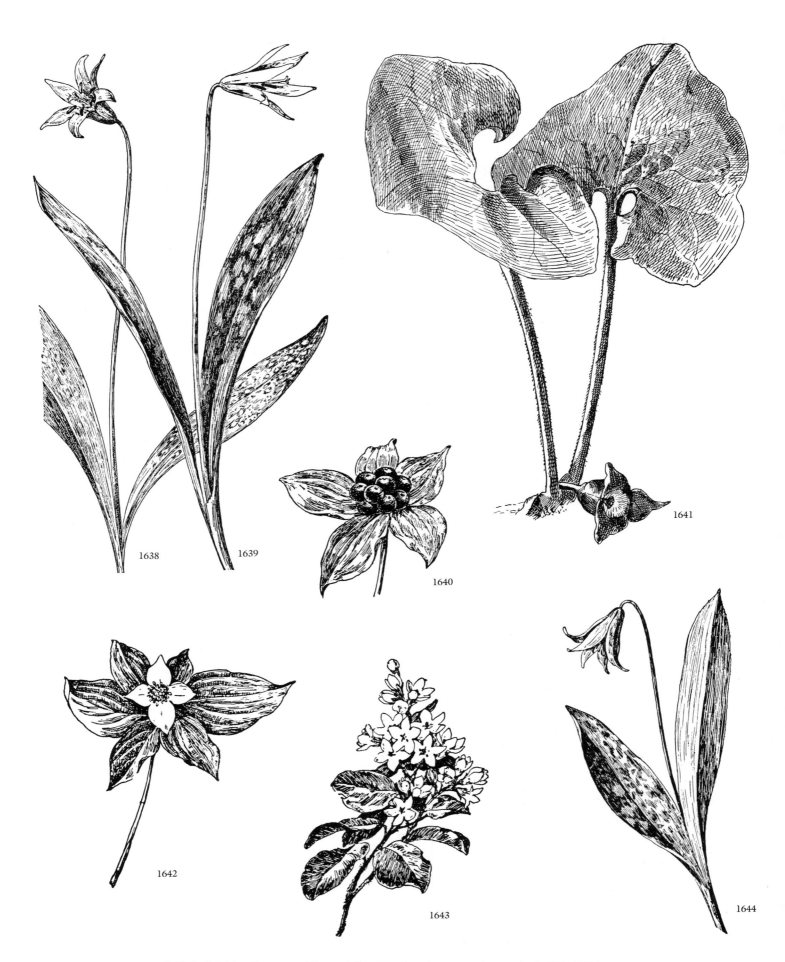

1638, 1644. Common Trout Lily (*Erythronium americanum*). **1639.** White Trout Lily (*Erythronium albidum*). **1640, 1642.** Bunchberry (*Cornus canadensis*). **1641.** Wild Ginger (*Asarum canadense*). **1643.** Trailing Arbutus (*Epigaea repens*).

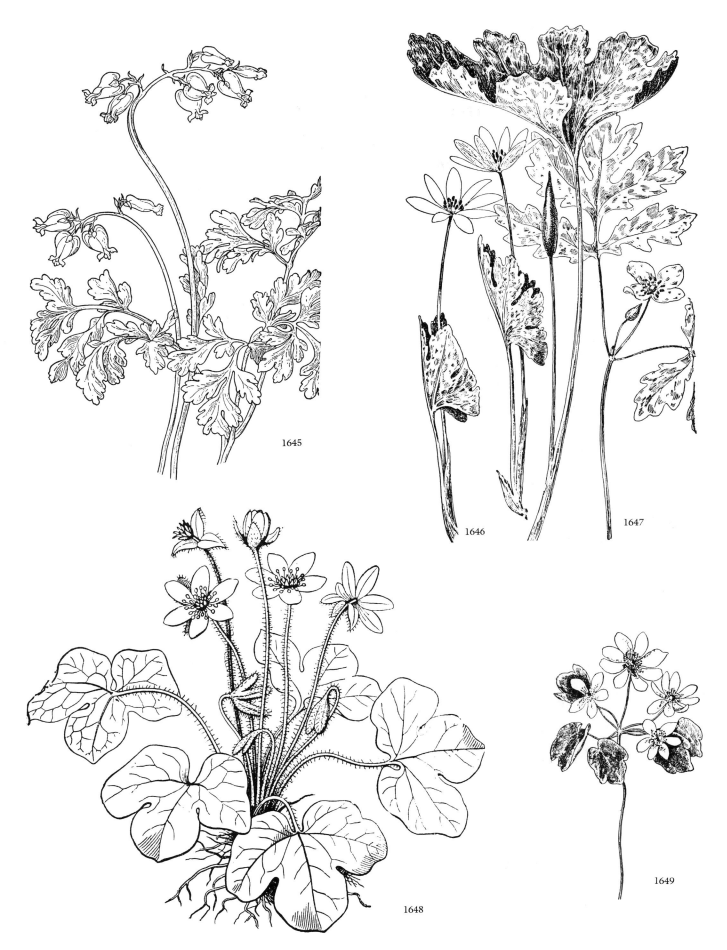

1645. Western Bleeding Heart (*Dicentra formosa*). **1646.** Bloodroot (*Sanguinaria canadensis*). **1647.** Celandine (*Stylophorum diphyllum*). **1648.** Hepatica (*Hepatica americana*). **1649.** Rue Anemone (*Anemonella thalictroides*).

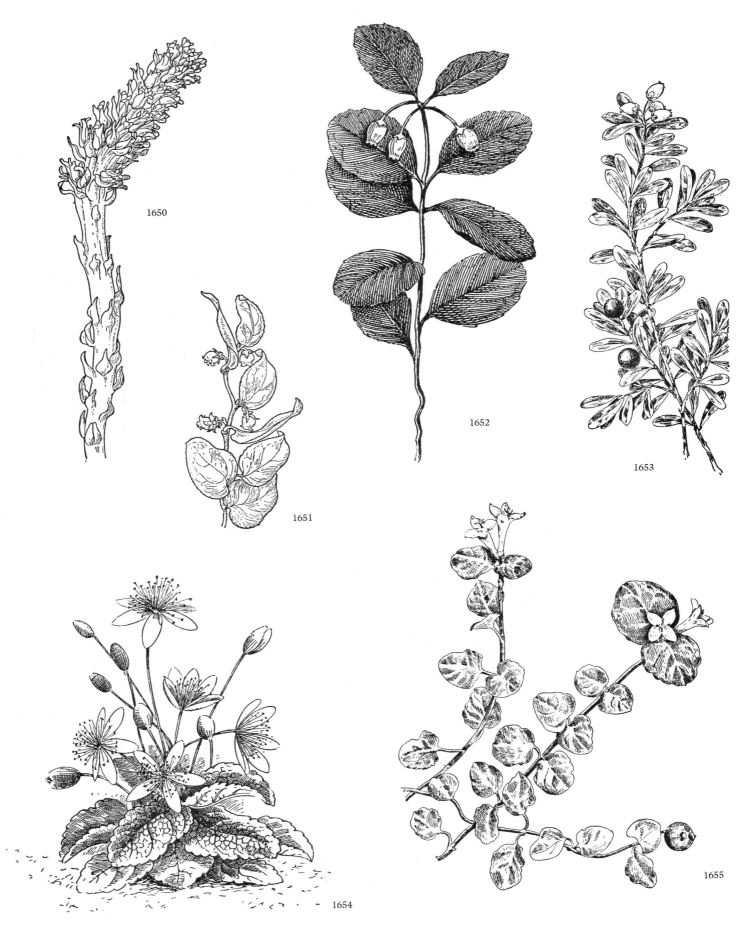

1650. Flowering Fungus (*Pleuricospora fimbriolata*). **1651.** Western Wintergreen (*Gaultheria ovatifolia*). **1652.** Creeping Wintergreen (*Gaultheria procumbens*). **1653.** Bearberry (*Arctostaphylos uva-ursi*). **1654.** Dewdrop (*Dalibarda repens*). **1655.** Partridgeberry (*Mitchella repens*).

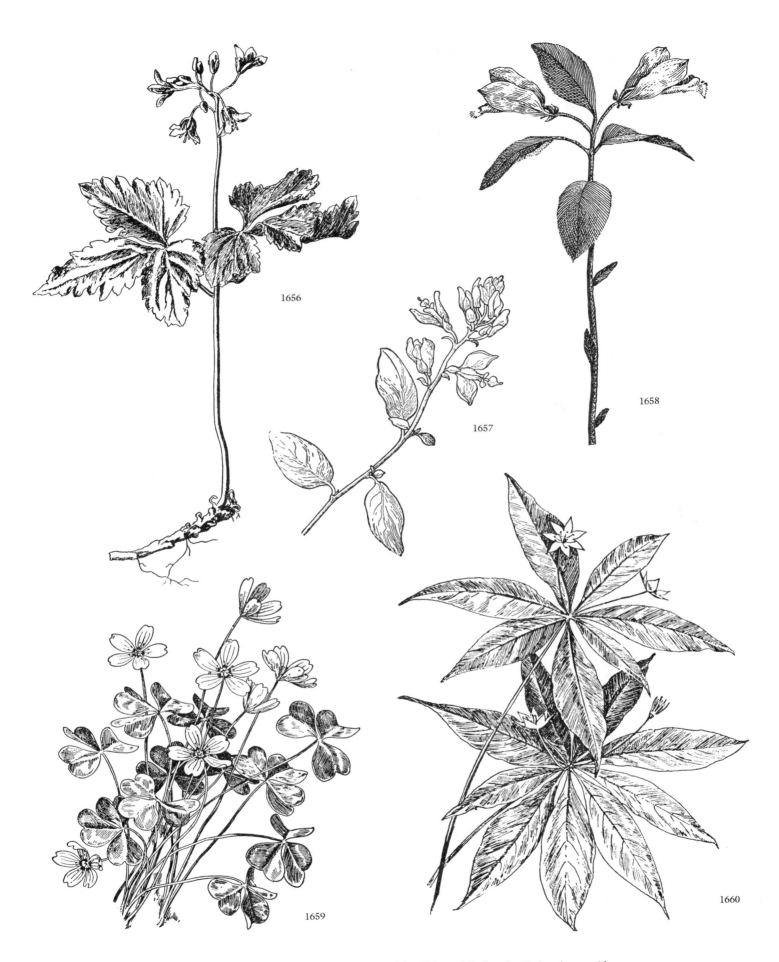

1656. Toothwort (*Dentaria diphylla*). **1657.** Fringed Polygala (*Polygala paucifo-lia*). **1658.** California Milkwort (*Polygala californica*). **1659.** Wood Sorrel (*Oxalis montana*). **1660.** Starflower (*Trientalis borealis*).

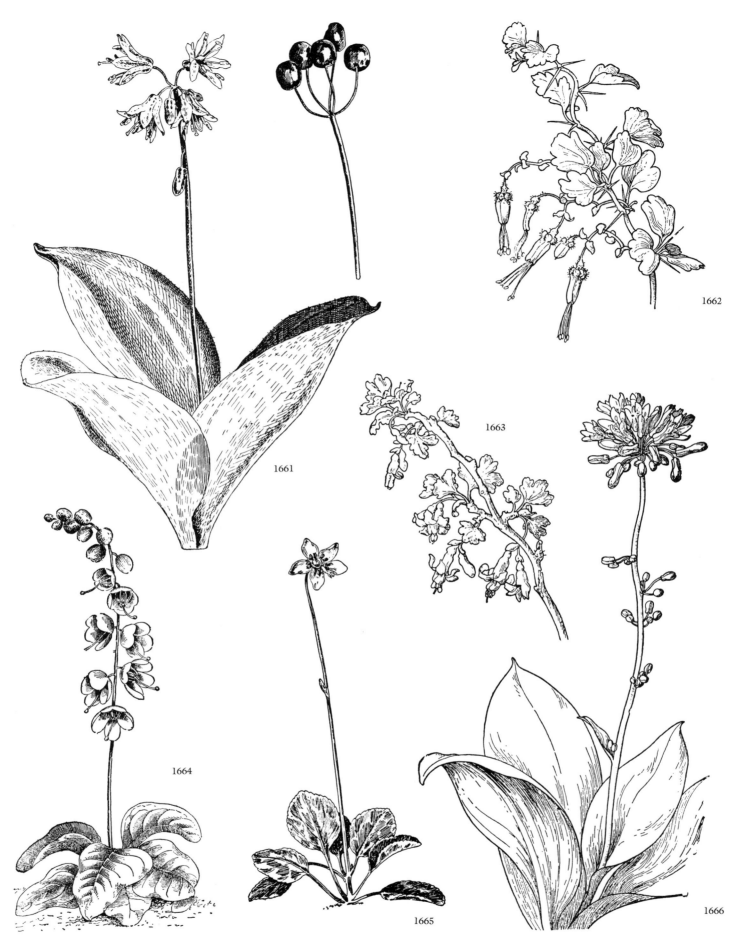

1661. Yellow Clintonia (*Clintonia borealis*). **1662.** Fuchsia-flowered Gooseberry (*Ribes speciosum*). **1663.** Wild Gooseberry (*Ribes roezlii*). **1664.** Shinleaf (*Pyrola elliptica*). **1665.** One-flowered Pyrola (*Moneses uniflora*). **1666.** Red Clintonia (*Clintonia andrewsiana*).

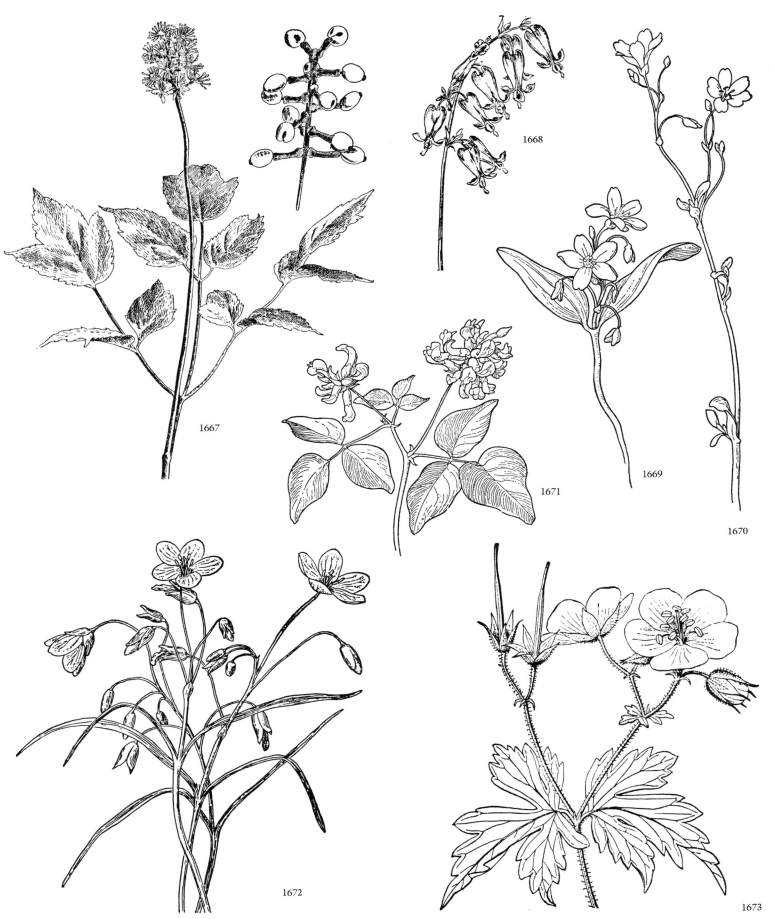

1667. White Baneberry (*Actaea pachypoda*). **1668.** Western Bleeding Heart (*Dicentra formosa*). **1669.** Spring Beauty (*Claytonia lanceolata*). **1670.** Spring Beauty (*Montia parvifolia*). **1671.** Native California Tea (*Psoralea physodes*). **1672.** Spring Beauty (*Claytonia virginica*). **1673.** Wild Geranium (*Geranium maculatum*).

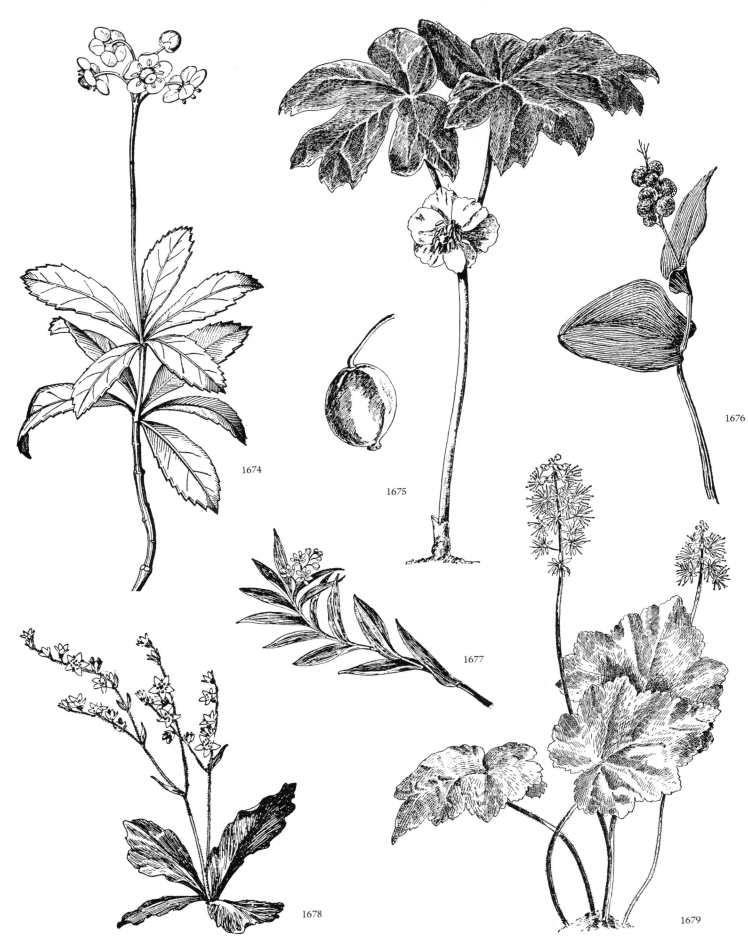

1674. Pipsissewa (*Chimaphila umbellata*). **1675.** Mayapple (*Podophyllum peltatum*). **1676.** Canada Mayflower (*Maianthemum canadense*). **1677.** Starry False Solomon's Seal (*Smilacina stellata*). **1678.** Early Saxifrage (*Saxifraga virginiensis*). **1679.** Foam Flower (*Tiarella cordifolia*).

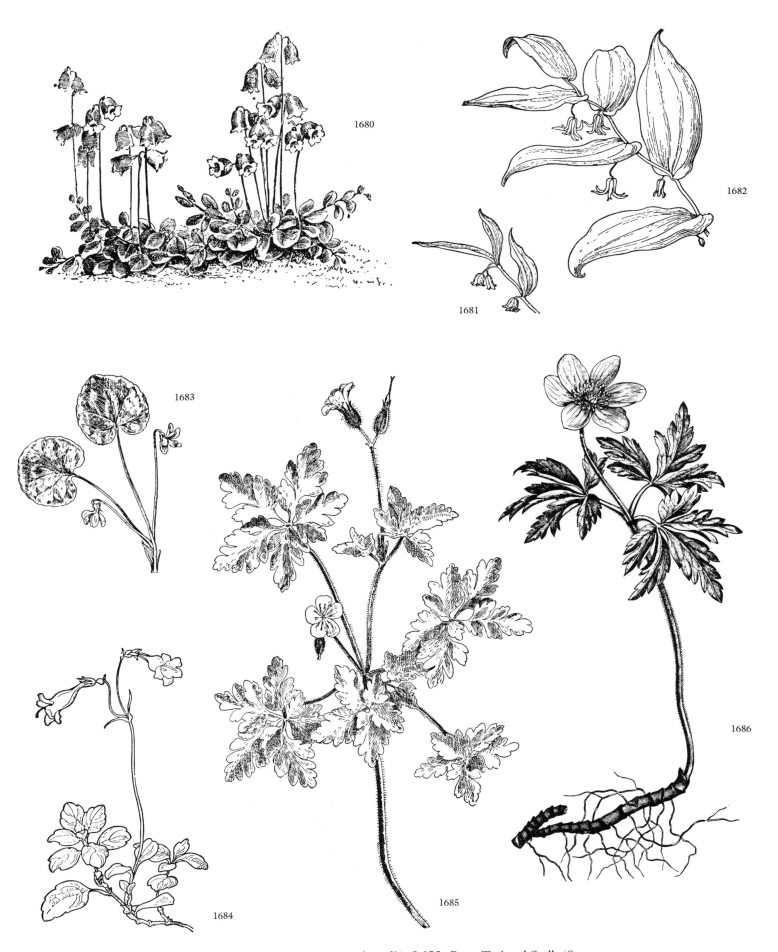

1680, 1684. Twinflower (*Linnaea borealis*). **1681.** Rose Twisted Stalk (*Streptopus roseus*). **1682.** White Twisted Stalk (*Streptopus amplexifolius*). **1683.** Alpine Marsh Violet (*Viola palustris*). **1685.** Herb-Robert (*Geranium robertianum*). **1686.** Wood Anemone (*Anemone quinquefolia*).

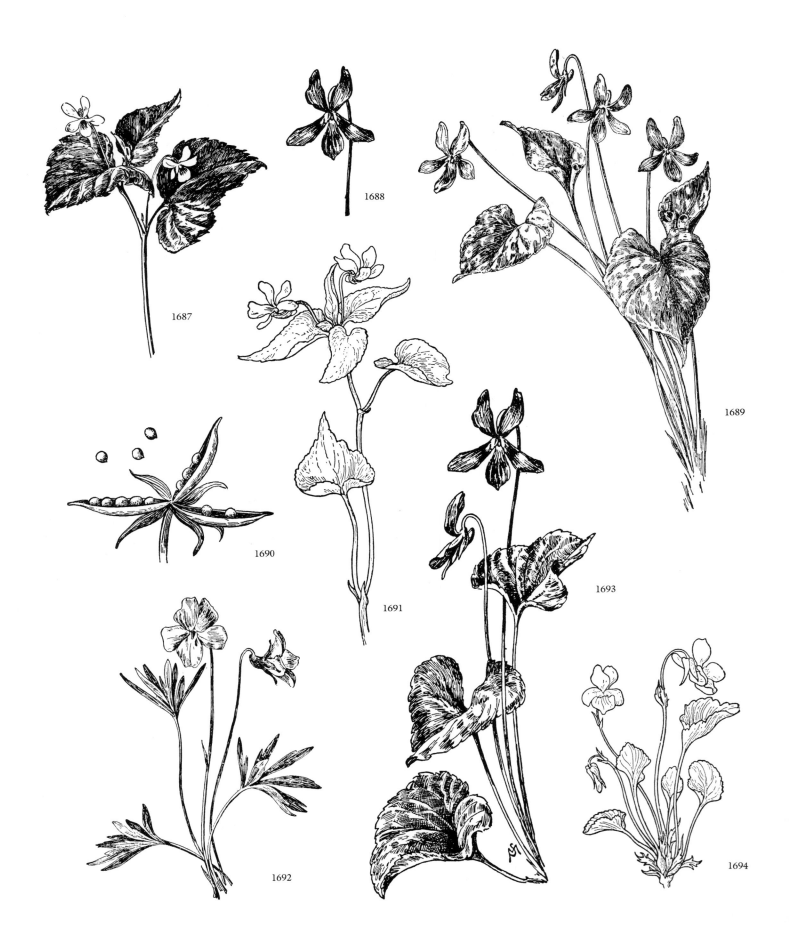

1687. Yellow Violet (*Viola pubescens*). **1688, 1693.** Purple Violet (*Viola cuculeata*). **1689.** Blue Violet (*Viola papilionacea*). **1690.** Violet Fruit. **1691.** Canada Violet (*Viola canadensis*). **1692.** Bird-Foot Violet (*Viola pedata*). **1694.** Pale Mountain Violet (*Viola adunca*).

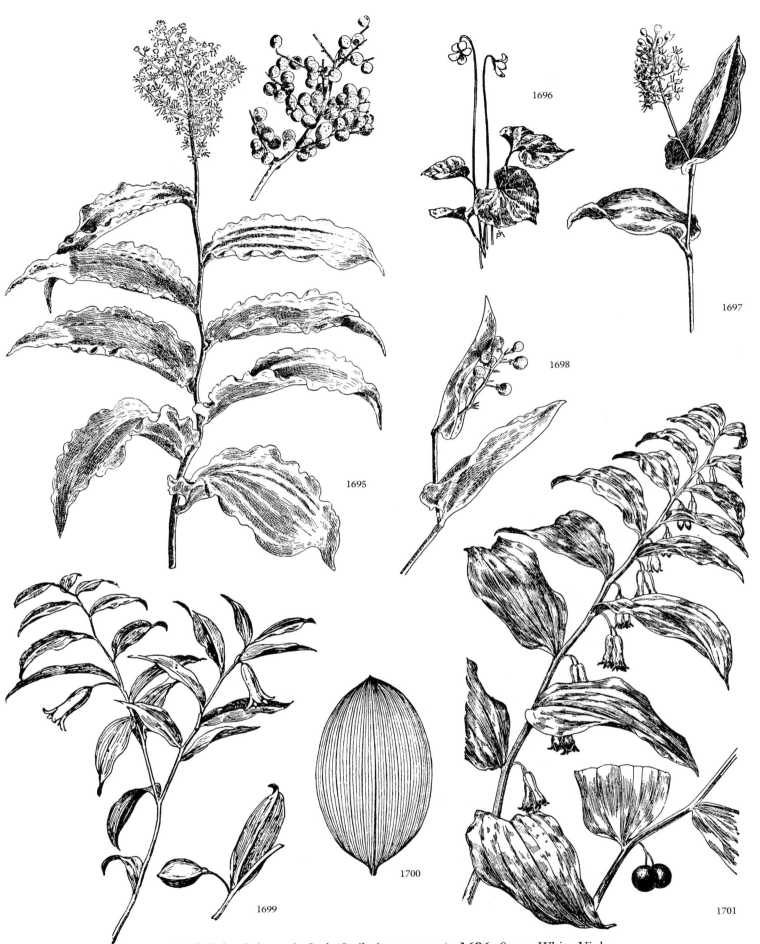

1695. False Solomon's Seal (*Smilacina racemosa*). **1696.** Sweet White Violet (*Viola blanda*). **1697, 1698.** Canada Mayflower (*Maianthemum canadense*). **1699.** Bellwort (*Uvularia sessilifolia*). **1700.** Solomon's Seal Leaf. **1701.** True Solomon's Seal (*Polygonatum biflorum*).

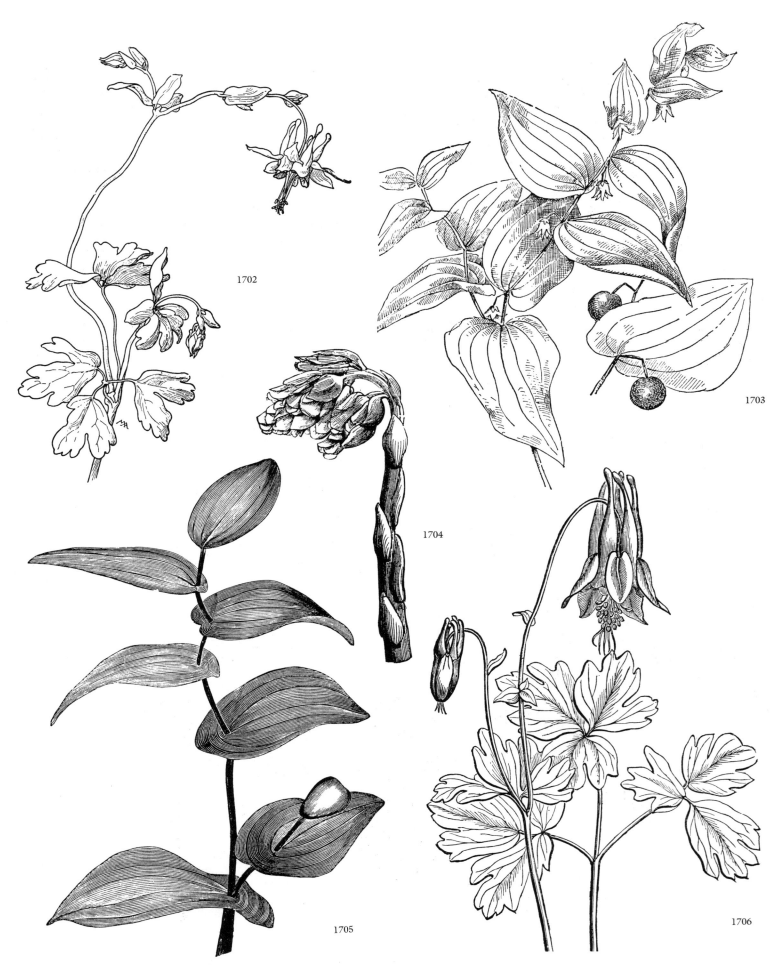

1702. Alpine Columbine (*Aquilegia truncata*). **1703.** Rose Twisted Stalk (*Streptopus roseus*). **1704.** Indian Pipe (*Monotropa uniflora*). **1705.** Perfoliate Bellwort (*Uvularia perfoliata*). **1706.** Scarlet Columbine (*Aquilegia canadensis*).

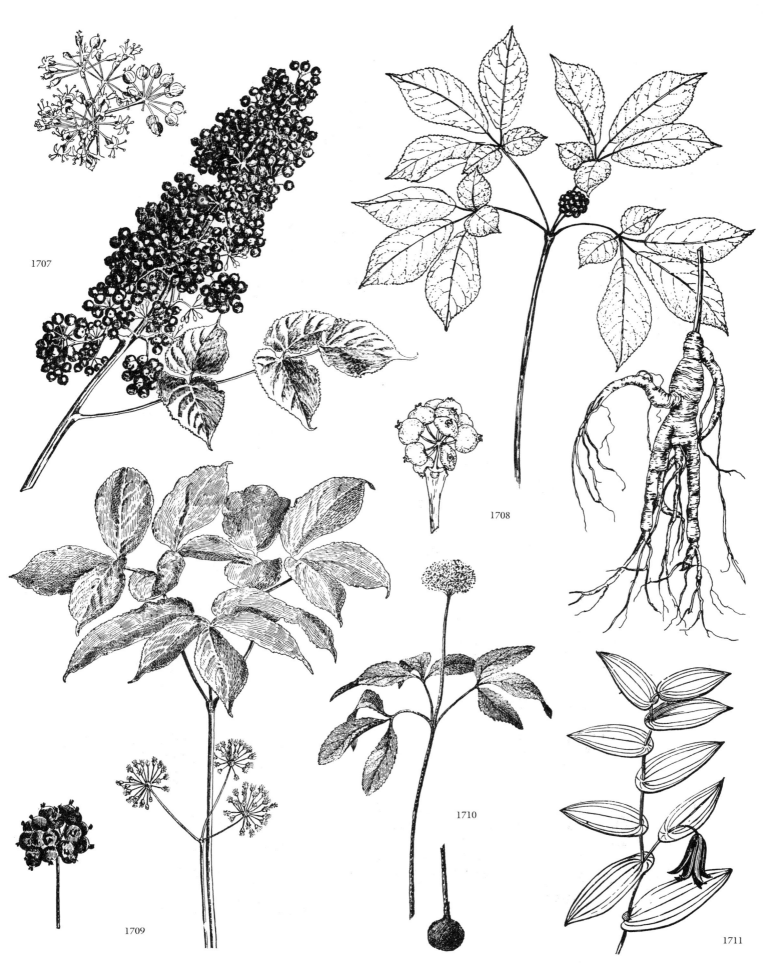

1707

1708

1709

1710

1711

1707. Spikenard (*Aralia racemosa*). **1708.** American Ginseng (*Panax quinquefolius*). **1709.** Wild Sarsaparilla (*Aralia nudicaulis*). **1710.** Dwarf Ginseng (*Panax trifolius*). **1711.** Perfoliate Bellwort (*Uvularia perfoliata*).

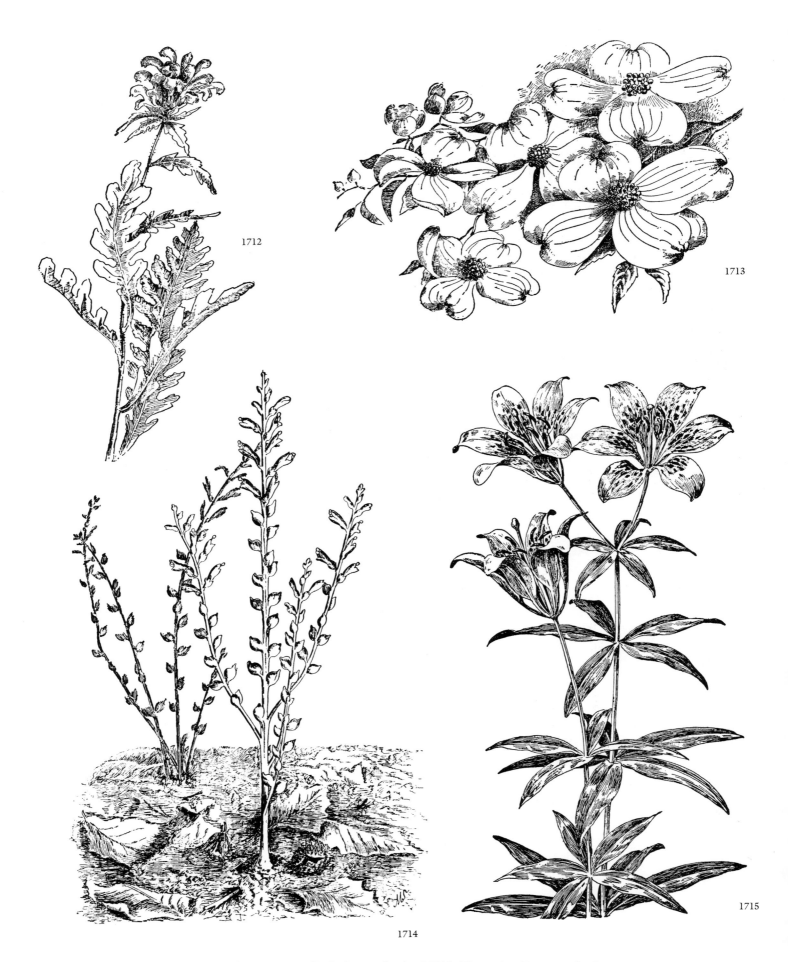

1712 · 1713 · 1714 · 1715

1712. Wood Betony (*Pedicularis canadensis*). **1713.** Flowering Dogwood (*Cornus florida*). **1714.** Beech-Drops (*Epifagus virginiana*). **1715.** Wood Lily (*Lilium philadelphicum*).

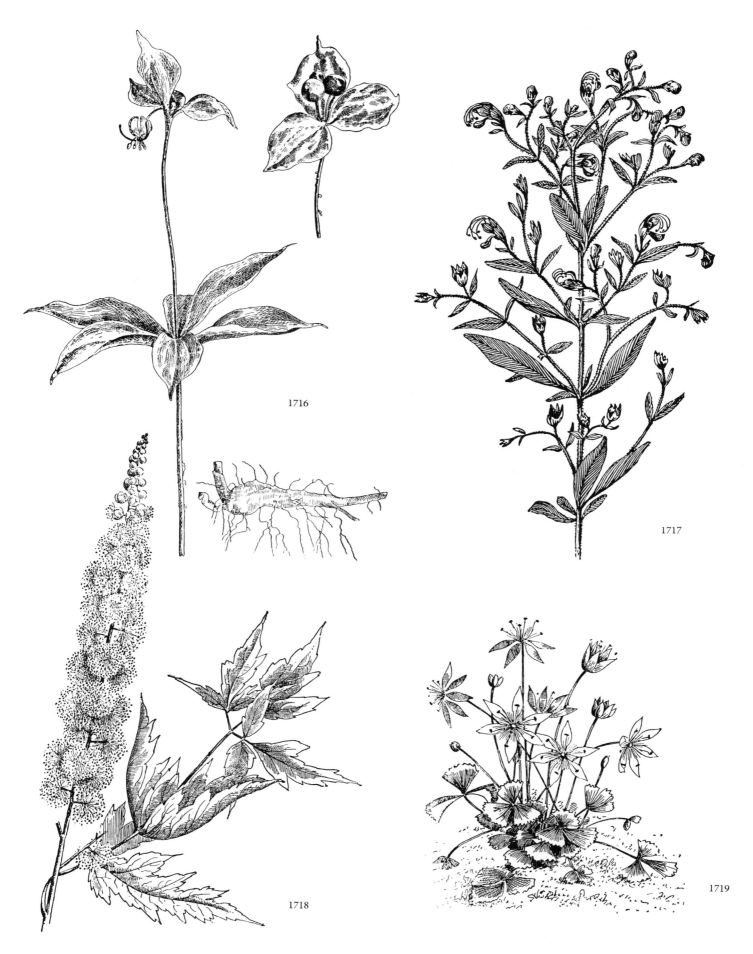

1716. Indian Cucumber Root (*Mediola virginiana*). **1717.** Blue Curls (*Trichostema dichotomum*). **1718.** Black Cohosh (*Cimicifuga racemosa*). **1719.** Goldthread (*Coptis groenlandica*).

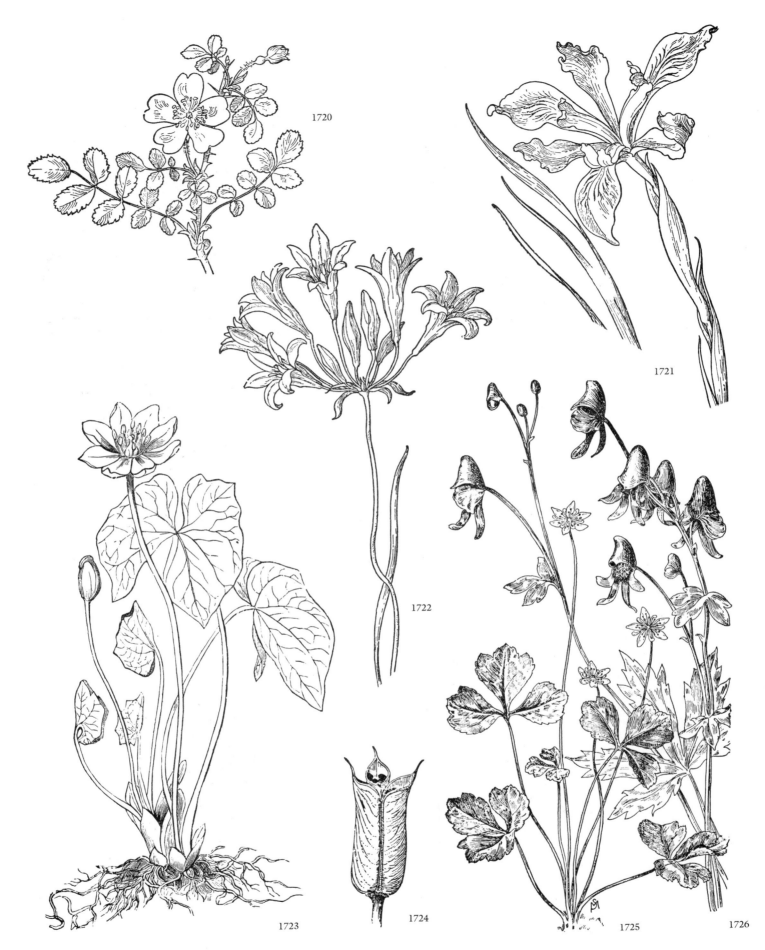

1720. Redwood Rose (*Rosa gymnocarpa*). **1721.** Western Wood Iris (*Iris douglasiana*). **1722.** Harvest Brodiaea (*Brodiaea coronaria*). **1723.** Twinleaf (*Jeffersonia diphylla*). **1724, 1726.** Monkshood (*Aconitum uncinatum*). **1725.** Goldthread (*Coptis groenlandica*).

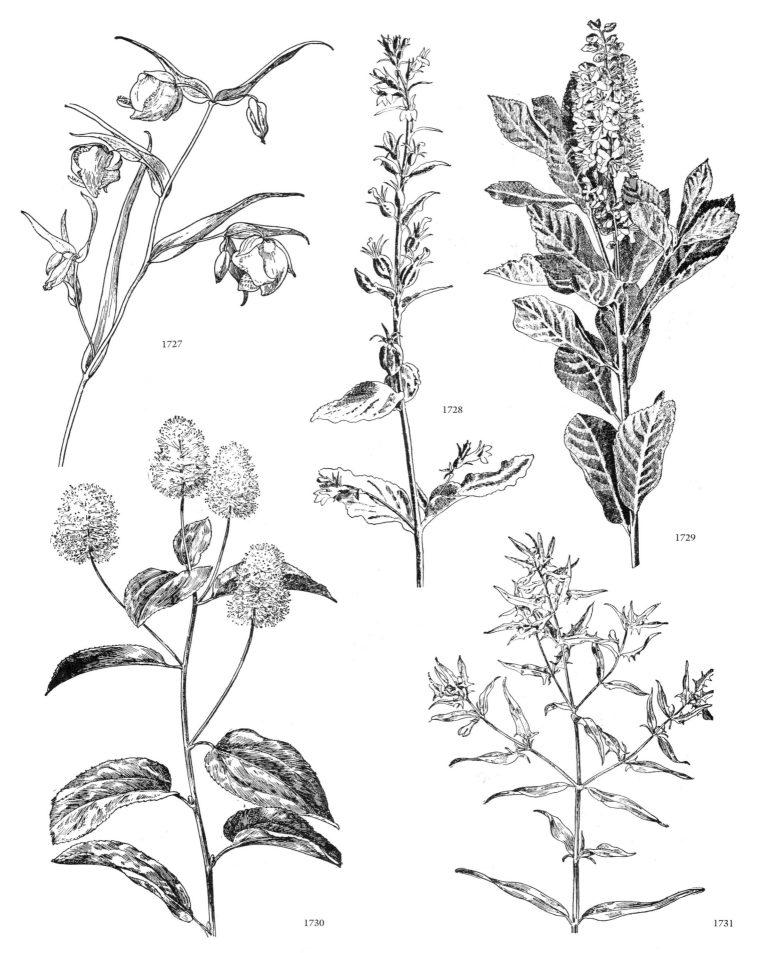

1727 1728 1729 1730 1731

1727. Satin Bell (*Calochortus albus*). **1728.** Indian Tobacco (*Lobelia inflata*). **1729.** Sweet Pepperbush (*Clethra alnifolia*). **1730.** New Jersey Tea (*Ceanothus americanus*). **1731.** Cow-Wheat (*Melampyrum lineare*).

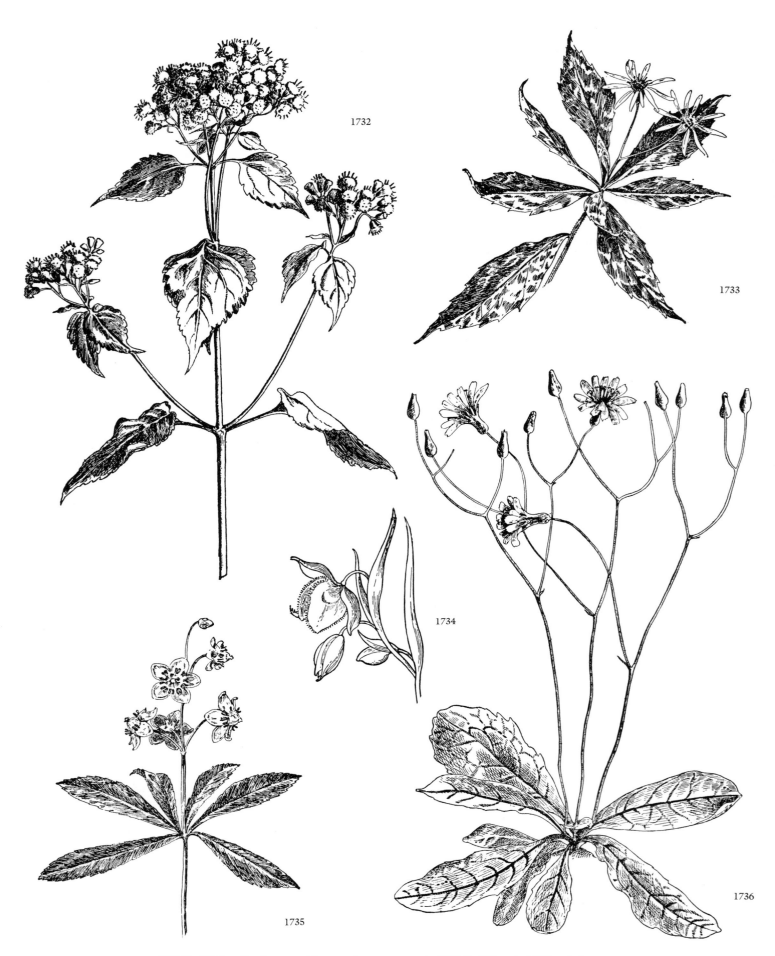

1732. White Snakeroot (*Eupatorium rugosum*). 1733. Whorled Wood Aster (*Aster acuminatus*). 1734. Yellow Globe Tulip (*Calochortus amabilis*). 1735. Pipsissewa (*Chimaphila umbellata*). 1736. Rattlesnake Weed (*Hieracium venosum*).

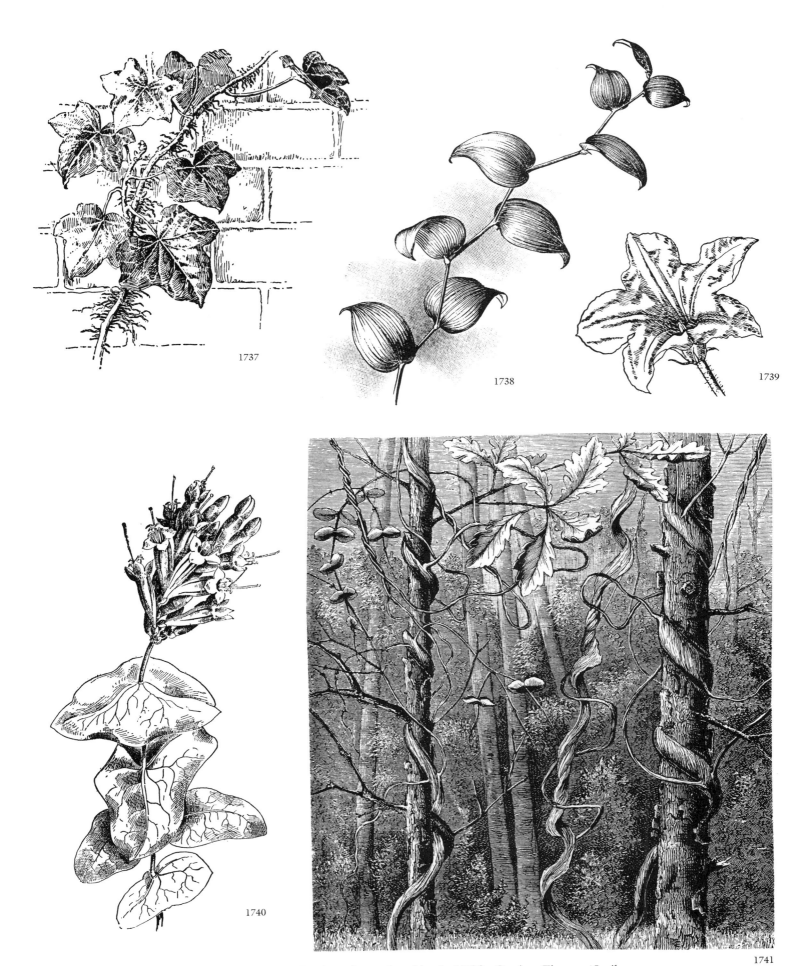

1737. Boston Ivy (*Parthenocissus tricuspidata*). **1738.** Carrion Flower (*Smilax herbacea*). **1739.** Hubbard Squash (*Cucurbita pepo*). **1740.** Trumpet Honeysuckle (*Lonicera sempervirens*). **1741.** Carolina Honeysuckle Vine (*Lonicera ciliosa*).

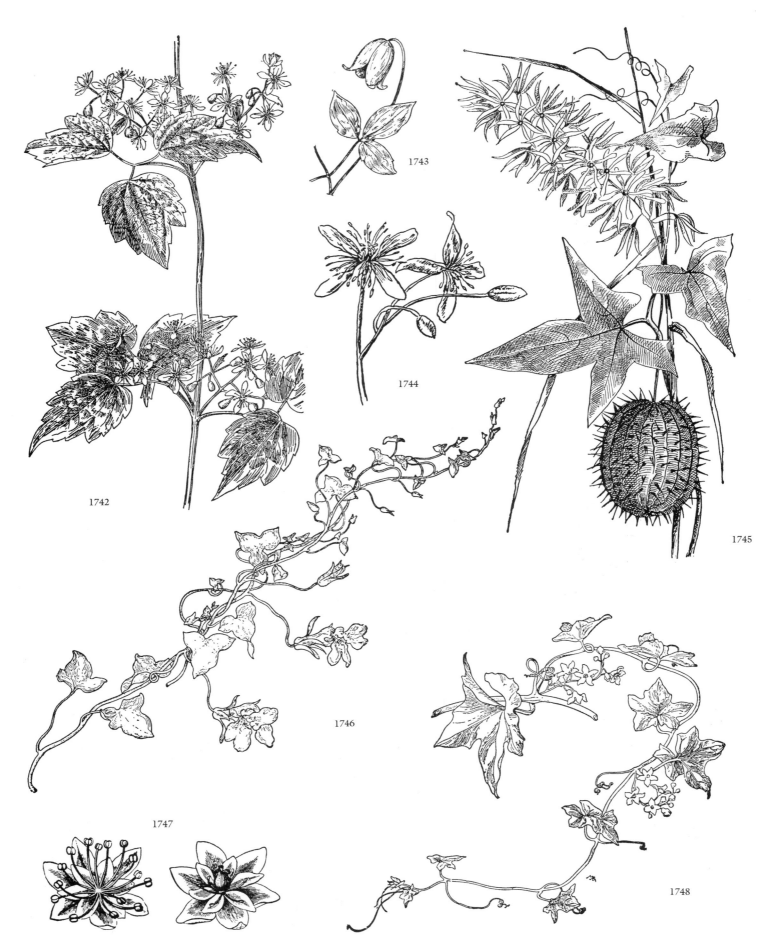

1742, 1744. Virgin's Bower (*Clematis virginiana*). **1743.** Leatherflower (*Clematis crispa*). **1745.** Balsam Apple (*Echinocystis lobata*). **1746.** Snapdragon Vine (*Asarina antirrhinifolia*). **1747.** Moonseed Flowers (*Menispermum canadense*). **1748.** Chilicothe (*Marah fabaceus*).

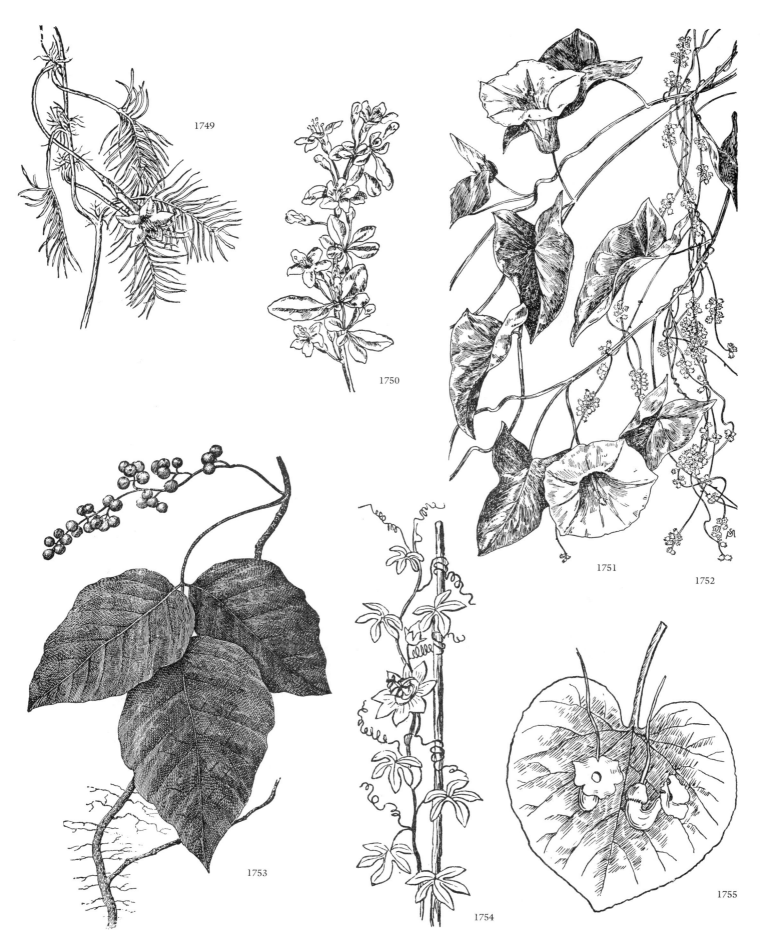

1749. Feather Vine (*Ipomoea quamoclit*). **1750.** Matrimony Vine (*Lycium halimifolium*). **1751.** Hedge Bindweed (*Calystegia sepium*). **1752.** Dodder (*Cuscuta gronovii*). **1753.** Poison Ivy (*Rhus radicans*). **1754.** Passion Flower (*Passiflora* sp.). **1755.** Pipe Vine (*Aristolochia macrophylla*).

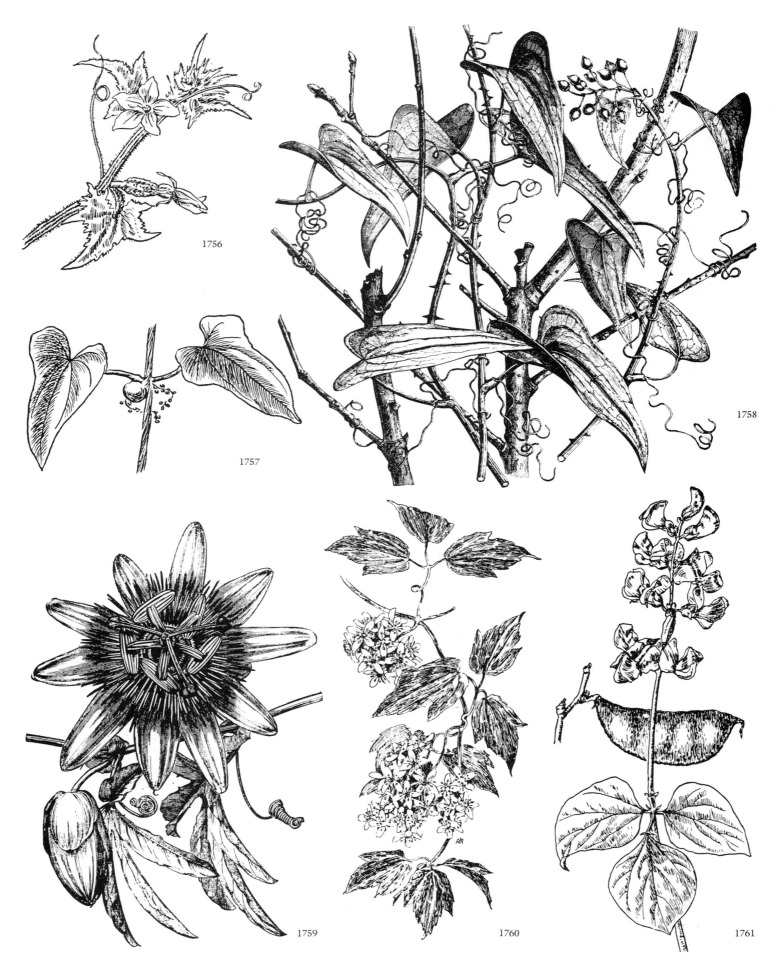

1756. Cucumber (*Cucumis sativus*). **1757.** Cinnamon Vine (*Dioscorea batatas*).
1758. Common Smilax (*Smilax aspera*). **1759.** Passion Flower (*Passiflora* sp.).
1760. Virgin's Bower (*Clematis virginiana*). **1761.** Hyacinth Bean (*Dolichos lablab*).

INDEX OF COMMON NAMES

Papyrus, 17
Parasites, 112
Parsley, Fool's, 238
Parsnip, 106
Partridgeberry, 260
Passion Flower, 95, 277, 278
Pawpaw, 191
Pea, Garden, 105, 106
Peach, 95, 224
Peanut, 108
Pear, 94
Pecan, 210
Pennywort
 Beach, 29
 Water, 15, 25
Peony, 82
Pepper, Black, 103
Pepperbush
 Mountain, 197
 Sweet, 197, 273
Peppergrass, 248
 Wild, 45
Peppermint, 252
Periwinkle, 83
Persimmon, 191
Petunia, 90
Phacelia
 Desert, 50
 Fremont's, 50
Phlox, Garden, 84
Pickerel Weed, 6
Pig's Ear, 124
Pignut, 211, 212
Pimpernel, Scarlet, 254
Pine
 Bishop, 168
 Bristlecone, 163
 Jack, 163, 167
 Knobcone, 164
 Loblolly, 163
 Longleaf, 168
 Monterey, 164, 168
 Parry Pinyon, 168
 Pitch, 163, 165
 Ponderosa, 164
 Princess, 149
 Red, 166
 Rough, 162
 Scotch, 162
 Shortleaf, 168
 Siberian, 165
 Single-leaved, 162
 Stone, 165
 Swamp, 168
 Table Mountain, 162, 165
 Virginia, 166
 White, 167
Pineapple, 95
Pinesap, 112
Pink
 Grass, 63
 Swamp, 18
 Wild, 236
 Windmill, 236
Pinxter Flower, 21
Pipe Vine, 277
Pipsissewa, 264, 274
Pitcher Plant, 18, 20, 30, 31, 34
 Cobra, 19, 34
 Short-leaved, 34
 Spotted, 33, 34
 Trumpet, 31, 34
Planertree, 185
Plantain
 Common, 239
 English, 239
 Mud, 6
 Robin's, 233
 Water, 6
Platycodon, 89
Plum
 Canada, 202
 Chickasaw, 202
 Wild Yellow, 204

Pogonia, Whorled, 61
Pokeweed, 245
Polygala, Fringed, 261
Polypody, Common, 144
Polypore
 Cinnamon Funnel, 124
 Multicolor Gill, 124
 Split-Gill, 124
 Thick-Maze Oak, 124
Pond Lilies, 2
Pondweed
 Curly, 4, 22
 Floating, 4
Poplar
 European White, 208
 Lombardy, 208
Poppy
 Garden, 83
 Oriental, 84
 Thistle, 47
Potato, 107
 Sweet, 107
Prickly Pear, Common, 35, 36, 40,
 41
Pride of the Mountain, 225
Primrose
 Cotton, 246
 Desert, 50
 European, 79
 Evening, 49, 246
 Scapose, 246
 Western Evening, 246
Proso, 52
Ptilonella, 47
Puffball, 125
 Desert Stalked, 125
 Dye-Maker's False, 125
 Gem-studded, 125
 Pear-shaped, 125
 Spiny, 125
 Stalked, 122, 125
Pumpkin, 104
Purslane, 241
Pyrola, One-flowered, 262

Queen Anne's Lace, 238
Quillwort, 148

Radish, 108
Rafflesiacea, Parasitic, 113
Ragweed
 Common, 255
 Great, 255
Ramaria, Scarlet-footed, 120
Raspberry, 97
 Purple Flowering, 205
Rattlesnake Plantain
 Downy, 60, 62
 Lesser, 64
 Loddige's, 64
Rattlesnake Weed, 274
Red Bud, 225
Red Hot Poker Plant, 86
Redroot, 198
 Common, 198
Redwood, 159
Rhododendron, 89
Rhodora, 19, 194
Rocket, Dame's, 88
Rockweed, 22
Romero, 252
Rose, 88, 202
 Dog, 206
 Old-fashioned, 88
 Pasture, 206
 Prairie Queen Garden, 82
 Queen's Scarlet Garden, 78
 Redwood, 272
 Smooth, 206
Rosebay, 194
 California, 193
Rosemary, Marsh, 27
Rose of Sharon, 222
Rowan Tree, 202

Rubber Tree, 101
Rush
 Bog, 56
 Common Wood, 57
Rye, 52

Safflower, 102
Saffron, 102
Sage, 103
 Common, 252
 Hop, 47
St.-Andrew's-Cross, 6
St.-John's-Wort
 Common, 239
 Marsh, 13, 21
Salsify, 232
 Western, 228
Sandspur, 53
San Juan, 225
Sargassumweed, 23
Sarsaparilla, Wild, 269
Sassafras, 191
Savin, Prostrate, 156
Savory, Summer, 102
Saxifrage, Early, 16, 264
Scaly Vase, 120
Scarlet Elf Cup, 119
Scotch Broom, 222
Sea Lettuce, 23
Sea Pink, 25, 29
 Slender, 27
Sedges, 2
Selaginella, Rowan's, 147
Selfheal, 252
Senecio, African, 29
Sequoia, Giant, 158, 159
Shaggy Mane, 116
Sheep Sorrel, 247
Shepherd's Purse, 248
Shinleaf, 262
Silverbell Tree, 221
Silverrod, 235
Silverweed, 12
Skullcap
 Larger, 13
 Western, 17
Skunk Cabbage, 10
Smilax, Common, 278
Snakeroot, White, 274
Snapdragon, Trailing, 29
Snapdragon Vine, 276
Sneezeweed, 232
Snowberry, Creeping, 20
Snowdrop, 80, 83
Snowdrop Tree
 Four-winged, 221
 Two-winged, 221
Solomon's Seal, 267
 False, 267
 Starry False, 264
 True, 267
Sorrel
 Sheep, 242, 247
 Wood, 261
 Yellow Wood, 237
Sourwood, 196
Southernwood, 102
Spanish Bayonet, 42, 43
Spatterdock, 1
Spearmint, 252
Spelt, 52
Spikenard, 269
Spindle Tree, European, 222
Splash Cups, 122
Spleenwort
 Black, 140
 Bradley's, 139
 Ebony, 145
 Forked, 142
 Green, 132
 Hudson's, 141
 Maidenhair, 135, 142, 144
 Mountain, 139, 143

Narrow-leaved, 131
Pinnatifid, 145
Rue-leaved, 143
Scaly, 135, 138
Scott's, 145
Sea, 139, 142
Silvery, 131, 136
Spring Beauty, 263
Spruce
 Black, 18
 Black, 160
 Colorado Blue, 160
 Norway, 160, 161
 Red, 160
 Sitka, 160
 Western, 161
 White, 161
Squash, 104
 Hubbard, 275
 Long White, 104
Squawroot, 110
Squill, 92
Squirrel Corn, 257
Staggerbush, 194, 196
Starflower, 261
Star of Bethlehem, 88
Stewartia, Virginia, 216
Stinkhorn
 Common, 123
 Dog, 123
Stinkhorn Egg, 123
Stinking Hood, 8
Stonecrop
 Ditch, 3
 Nevins's, 2
Strawberry, 96
 Sand, 28
Sugarcane, 93
Sumac
 Poison, 214
 Shining, 214
 Staghorn, 214
Sun-Cups, 49
Sundew, 32, 34
 Long-leaved, 21
 Round-leaved, 21, 30
 Thread-leaved, 21, 32
Sundrops, 246
Sunflower
 Narrow-leaved, 233
 Tall, 233
 Wild, 233
Sweet-Scarlet Shrub, 91
Sweetbells, 196
 Catesby's, 196
 Downy, 196
 Mountain, 196
 Swamp, 196
Sweetbrier, 206
Sweet Flag, 10
Sweetleaf, Common, 191
Sweet Pea, Perennial, 80
Sweet William, 82
Sycamore, 224
 California, 223

Tamarack, 152
Tangerine, 95
Tansy, 231
Taro, 106
Tea, 99
 Labrador, 193
 Narrow-leaved Labrador, 193
 Native California, 263
 New Jersey, 198, 273
Tearthumb, Arrow-leaved, 247
Teasel, 239
Thistle
 Canada, 231
 Russian, 45, 46
Thorn
 Cockspur, 203
 Douglas's, 205
 Dwarf, 204

Index of Latin Names

Celtis reticulata, 185
Cenchrus pauciflorus, 53
Centaurea cyanus, 89
Centauria maculosa, 232
Cephalanthera austinae, 66
Cephalanthus occidentalis, 223
Cephalotus follicularis, 32
Cerastium vulgatum, 255
Cercis canadensis, 225
Ceterach officinarum, 135, 138
Cetraria islandica, 127
Chaenactis douglasii, 48
Chaenactis lanosa, 48
Chamaecyparis lawsoniana, 157
Chamaecyparis nootkatensis, 157
Chamaecyparis thyoides, 157
Chamaedaphne calyculata, 194
Chara fragilis, 23, 24
Chelone lyonii, 7
Chenopodium album, 237
Chimaphila umbellata, 264, 274
Chionanthus virginicus, 225
Chondrus crispus, 24
Chrysanthemum coronarium, 87
Chrysanthemum leucanthemum, 234
Chylisma scapoidea, 50
Chysis aurea, 69
Cichorium intybus, 230
Cicuta maculata, 238
Cimicifuga racemosa, 271
Cirsium arvense, 231
Citrus reticulata, 95
Cladastris lutea, 220
Cladonia furcata, 127
Cladonia pyxidata, 127
Cladophora sp., 22
Clarkia pulchella, 85
Clathrus cancellatus, 122
Claudopus variabilis, 118
Claviceps purpurea, 121
Claytonia lanceolata, 263
Claytonia virginica, 263
Clematis crispa, 276
Clematis virginiana, 276, 278
Clethra acuminata, 197
Clethra alnifolia, 197, 273
Clintonia andrewsiana, 262
Clintonia borealis, 262
Clitocybe nebularis, 118
Clitocybe nuda, 117
Clitopilus sp., 118
Cnicus benedictus, 232
Cocos nucifera, 226
Coffea arabica, 99
Coleus blumei, 90
Collema pulposum, 127
Colocasia esculenta, 86, 106
Coltrichia perennis, 124
Commelina erecta, 12
Commelina virginica, 254
Comparettia falcata, 73
Conopholis americana, 110
Convallaria majalis, 85
Convolvulus arvensis, 237
Convolvulus tricolor, 80
Coprinus atramentarius, 114
Coprinus comatus, 116
Coptis groenlandica, 271, 272
Cora pavonia, 124
Corallorhiza sp., 65
Corallorhiza maculata, 65
Corallorhiza mertensiana, 66
Corallorhiza striata, 111
Corallorhiza trifida, 65
Cordyceps taylori, 121
Coreopsis lanceolata, 89
Coreopsis maritima, 29
Coreopsis tinctoria, 91
Cornus canadensis, 258
Cornus florida, 217, 270
Cornus purpusii, 217
Cornus rugosa, 217
Corylus avellana, 190
Coryphantha vivipara, 39, 40

Cotoneaster pyracantha, 205
Crataegus calpodendron, 204
Crataegus crus-galli, 203
Crataegus douglasii, 205
Crataegus succulenta, 205
Crataegus uniflora, 204
Crinum kirkii, 91
Crocus sativus, 102
Cryptogramma crispa, 129
Ctenium aromaticum, 55
Cucumis melo, 104
Cucumis sativus, 278
Cucurbita sp., 104
Cucurbita maxima, 104
Cucurbita pepo, 104, 275
Cupressus goveniana, 155
Cupressus macrocarpa, 158
Cupressus pygmaea, 155
Cupressus sempervirens, 155
Cuscuta sp., 110
Cuscuta gronovii, 109, 277
Cyathus striatus, 122
Cycas revoluta, 226
Cynomorium coccineum, 113
Cyperus esculentus, 56, 255
Cyperus papyrus, 17
Cyperus strigosus, 56
Cypripedium acaule, 61, 64
Cypripedium arietinum, 60
Cypripedium calceolus, 60, 64
Cypripedium calceolus var. *parviflorum*, 62
Cypripedium calceolus var. *pubescens*, 62, 63
Cypripedium candidum, 65
Cypripedium irapeanum, 72
Cypripodium reginae, 66
Cyrtopodium punctatum, 69
Cystea angustata, 141
Cystea fragilis, 140
Cystopteris bulbifera, 145
Cystopteris fragilis, 137, 138
Cytinus hypocistus, 113
Cytisus scoparius, 222

Daedalea quercina, 124
Dalea californica, 48
Dalea emoryi, 48
Dalibarda repens, 260
Daphne mezereum, 224
Darlingtonia californica, 19, 34
Datura stramonium, 251
Daucus carota, 107, 238
Delesseria sanguinea, 23
Delphinum sp., 92
Delphinium bicolor, 254
Delphinium hansenii, 48
Delphinium tricorne, 253
Dendrobium fimbriatum, 71
Dentaria diphylla, 261
Deutzia crenata, 90
Deutzia scabra, 90
Dianthus sp., 89
Dianthus barbatus, 82
Dicentra canadensis, 257
Dicentra cucullaria, 257
Dicentra formosa, 259, 263
Dictamnus albus, 90
Diervilla lonicera, 199
Dionaea muscipula, 30, 31, 32, 33, 34
Dioscorea batatas, 278
Diospyros virginiana, 191
Dipsacus sylvestris, 239
Dolichos lablab, 278
Drosera filiformis, 21, 32
Drosera longifolia, 21
Drosera lusitanicum, 34
Drosera rotundifolia, 21, 30
Dryopteris filix-mas, 144

Echinacea pallida, 232
Echinacea purpurea, 88
Echinocereus reichenbachii, 41
Echinocereus viridiflorus, 40

Echinochloa crusgalli, 53
Echinocystis lobata, 276
Echium vulgare, 253
Encelia californica, 29
Ensete ventricosum, 81
Epidendrum alticola, 67
Epidendrum atropurpureum, 76
Epidendrum nocturnum, 77
Epidendrum radiatum, 77
Epidendrum sobralioides, 69
Epidendrum stamfordianum, 67
Epifagus virginiana, 270
Epigaea repens, 258
Epipactis gigantea, 66
Epipactis helleborine, 62
Epiphagus virginiana, 110
Equisetum limosum, 149
Equisetum palustre, 146
Equisetum sylvaticum, 147, 150
Equisetum telmateia, 148
Equisetum umbrosum, 149
Eranthis hyemalis, 81
Erdisia meyenii, 39
Erigeron glaucus, 27
Erigeron pulchellus, 233
Erimastrum bellidoides, 48
Eriogonum inflatum, 49
Eriogonum racemosum, 47
Eriophorum angustifolium, 19, 54
Erysimum cheiranthoides, 248
Erythronium albidum, 258
Erythronium americanum, 258
Euonymus atropurpurea, 222
Euonymus europea, 222
Eupatorium perfoliatum, 14
Eupatorium purpureum, 15
Eupatorium rugosum, 274
Euphorbia milii, 38
Euphorbia resinifera, 40
Exochorda racemosa, 82

Fagopyrum esculentum, 106
Fagus grandifolia, 179
Fagus sylvatica, 178
Ficus benjamina, 227
Ficus carica, 94
Ficus elastica, 101
Fragaria sp., 96
Fragaria chiloensis, 28
Fraxinus americana, 213
Fraxinus nigra, 213
Fraxinus pennsylvanica, 213
Fraxinus quadrangulata, 212, 213
Fritillaria imperialis, 92
Frullania dilatata, 146
Fucus platycarpus, 22
Fucus vesiculosis, 23

Gaillardia arizonica, 47
Galanthus nivalis, 80, 83
Galeopsis tetrahit, 13
Galium triflorum, 254
Gaultheria hispidula, 20
Gaultheria ovatifolia, 260
Gaultheria procumbens, 260
Gaylussacia baccata, 195, 196
Gaylussacia brachycera, 195
Gaylussacia dumosa, 195
Gaylussacia frondosa, 195
Gaylussacia ursina, 195
Geastrum berkeleyi, 122
Geastrum fornicatum, 122
Geastrum multifidum, 122
Geoglossum glutinosum, 119
Geranium maculatum, 263
Geranium robertianum, 265
Geum aleppicum, 253
Gigartina mamillosa, 23
Gilia rigidula, 47
Ginkgo biloba, 190
Glaux maritima, 25
Glechoma hederacea, 252
Gomphus clavatus, 124
Gomphus floccosus, 120

Gongora galeata, 74
Gongora maculata, 77
Gonolobus laevis, 243
Goodyera pubescens, 60, 62
Goodyera repens, 64
Goodyera tesselata, 64
Gordonia lasianthus, 216
Gossypium herbaceum, 100
Grayia polygaloides, 47
Gymnocladus dioica, 225
Gypsophila paniculata, 89
Gyromitra infula, 119

Habenaria blephariglottis, 58
Habenaria ciliaris, 21, 58
Habenaria clavellata, 63
Habenaria cristata, 58
Habenaria dilatata, 21, 61, 66
Habenaria flava, 63
Habenaria integra, 58
Habenaria lacera, 59, 65
Habenaria leucophaea, 58
Habenaria nivea, 58
Habenaria orbiculata, 58
Habenaria psycodes, 58, 59
Habenaria viridis, 58
Halesia carolina, 221
Halesia diptera, 221
Hamamelis virginiana, 197
Helenium autumnale, 232
Helianthus angustifolius, 233
Helianthus annuus, 233
Helianthus giganteus, 233
Heliopsis helianthoides, 232
Heliotropium curassavicum, 28
Heliotum tuba, 119
Helonias bullata, 18
Helosis gujanensis, 113
Helvella elastica, 119
Hemerocallis lilioasphodelus, 92
Hepatica americana, 259
Hesperis matronalis, 88
Heteranthera reniformis, 6
Hibiscus coccineus, 28, 85
Hibiscus moscheutos, 7, 85
Hibiscus syriacus, 222
Hibiscus trionum, 249
Hieracium aurantiacum, 230
Hieracium gronovii, 233
Hieracium venosum, 274
Homalopetalum pumilio, 68
Hordeum jubatum, 55
Hordeum vulgare, 52
Hottonia inflata, 22
Houstonia rubra, 47
Hyacinthus orientalis, 84
Hydnum imbricatum, 124
Hydnum repandum, 121
Hydrangea sp., 220
Hydrocharis morsus-ranae, 1
Hydrocotyle americana, 25
Hydrocotyle umbellata, 15
Hydrocotyle vulgaris, 29
Hygrophorus pratensis, 117
Hygrophorus virgineus, 117
Hyoscyamus niger, 250
Hypericum hypericoides, 6
Hypericum perforatum, 239
Hypericum virginicum, 13, 21

Iberis umbellata, 84
Ilex aquifolium, 220
Ilex opaca, 220
Impatiens capensis, 16
Impatiens palida, 17
Inula helenium, 14
Ipomoea batatas, 107
Ipomoea maxima, 86
Ipomoea quamoclit, 277
Iris cristata, 8
Iris douglasiana, 272
Iris kaempferi, 90
Iris versicolor, 9
Iris xiphium, 92

Vaccinium corymbosum, 195
Vaccinium macrocarpon, 19
Vaccinium myrsinites, 195
Vaccinium myrtilloides, 195
Vaccinium stamineum, 195
Vaccinium vacillans, 195
Vaccinium virgatum, 195
Vanda teres, 74
Vanilla pfaviana, 76
Vanilla planifolia, 71, 103
Veratrum californicum, 16
Verbascum blattaria, 245
Verbascum thapsus, 245
Verbena arizonica, 50

Verbena hastata, 16
Vernonia noveboracensis, 15
Viburnum acerifolium, 201
Viburnum alnifolium, 201
Viburnum lentago, 200, 201
Viburnum opulus, 201
Viburnum prunifolium, 200, 201
Viburnum recognitum, 200, 201
Vicia cracca, 242
Vicia villosa, 242
Viola sp., 86
Viola adunca, 266
Viola blanda, 267
Viola canadensis, 266

Viola cuculeata, 266
Viola palustris, 265
Viola papilionacea, 266
Viola pedata, 266
Viola pubescens, 266
Viola tricolor, 78
Viscum album, 109
Vitus labrusca, 95
Volvariella bombycina, 115

Woodsia alpina, 139
Woodsia glabella, 132
Woodsia ilvensis, 136, 143, 144
Woodwardia virginica, 129

Xanthoria parietina, 127
Xylococcus bicolor, 219

Yucca aloifolia, 42, 43
Yucca brevifolia, 42
Yucca filamentosa, 43
Yucca glauca, 42
Yucca gloriosa, 43
Yucca recurvifolia, 43

Zea mays, 93
Zizia aurea, 238
Zygopetalum grandiflorum, 75